W9-BDU-325

KANDINSKY

KANDINSKY

VIVIAN ENDICOTT BARNETT

TRACEY BASHKOFF

CHRISTIAN DEROUET

MATTHIAS HALDEMANN

ANNEGRET HOBERG

GILLIAN McMILLAN AND
VANESSA KOWALSKI

GuggenheimMUSEUM

This exhibition is organized by the Solomon R. Guggenheim Foundation, New York, in cooperation with the Städtische Galerie im Lenbachhaus und Kunstbau, Munich, and the Centre Pompidou, Paris.

Generous support is provided by a grant from the National Endowment for the Arts.

This exhibition is supported by an indemnity from the Federal Council on the Arts and the Humanities.

The Guggenheim Museum gratefully acknowledges the Leadership Committee for *Kandinsky*.

Published on the occasion of the exhibition *Kandinsky*

Organized by Tracey Bashkoff, Solomon R. Guggenheim Museum, New York; Christian Derouet, Centre Pompidou, Paris; and Annegret Hoberg, Städtische Galerie im Lenbachhaus, Munich

Städtische Galerie im Lenbachhaus und Kunstbau, Munich
October 25, 2008–March 8, 2009

Centre Pompidou, Paris
April 8–August 10, 2009

Solomon R. Guggenheim Museum, New York
September 18, 2009–January 13, 2010

©2009 Solomon R. Guggenheim Foundation, New York.
All rights reserved.

ISBN: 978-0-89207-390-0 (hardcover)
ISBN: 978-0-89207-391-7 (softcover)

Guggenheim Museum Publications
1071 Fifth Avenue
New York, New York 10128

Available through
D.A.P./Distributed Art Publishers
155 Sixth Avenue, 2nd Floor
New York, New York 10013
Tel.: 212 627 1999; fax: 212 627 9484

Design: Jean Wilcox, Wilcox Design
Production: Jonathan Bowen, Suzana Greene, Melissa Secondino
Editorial: Kamilah Foreman, Elizabeth Franzen, Stephen Hoban, Helena Winston
Printed in Germany by Engelhardt and Bauer

Cover and pp. 3, 5, 320: *Several Circles* (*Einige Kreise*, 1926, details of plate 67). Frontispiece (page 1): Kandinsky in front of his painting *Dominant Curve* (*Courbe dominante*, 1936, plate 83), 1936. Photo: Boris Lipnitzki

The chronology, some plate texts, and essays by Christian Derouet, Matthias Haldemann, and Annegret Hoberg are based on English translations provided by the Städtische Galerie im Lenbachhaus, Munich.

CONTENTS

LENDERS TO THE EXHIBITION

The Art Institute of Chicago

Fondation Beyeler, Riehen/Basel

Franz Marc Museum, Kochel am See, Germany

Gabriele Münter- und Johannes Eichner-Stiftung, Munich

Gemeente Museum, The Hague, Netherlands

Kunstmuseum und Museum für Gegenwartskunst, Basel

The Metropolitan Museum of Art, New York

Moderna Museet, Stockholm

Musée national d'art moderne, Centre Pompidou, Paris

Museum Boijmans Van Beuningen, Rotterdam, Netherlands

Museum Ludwig, Cologne, Germany

The Museum of Modern Art, New York

Nahmad Collection

National Gallery of Art, Washington, D.C.

Peggy Guggenheim Collection, Venice

Philadelphia Museum of Art

The Phillips Collection, Washington, D.C.

Private collections

Collection J. Shafran, London

The Solomon R. Guggenheim Museum, New York

Staatsgalerie Stuttgart, Germany

Städtische Galerie im Lenbachhaus, Munich

State Art Museum, Nizhny Novgorod, Russia

The State Pushkin Museum of Fine Arts, Moscow

The State Tretyakov Gallery, Moscow

Yale University Art Gallery, New Haven

SOLOMON R. GUGGENHEIM FOUNDATION

Honorary Trustees in Perpetuity

Solomon R. Guggenheim†

Justin K. Thannhauser†

Peggy Guggenheim†

Honorary Chairman

Peter Lawson-Johnston

Chairman

William L. Mack

President

Jennifer Blei Stockman

Vice-Presidents

Wendy L-J. McNeil

Edward H. Meyer

Stephen C. Swid

Mark R. Walter

Director

Richard Armstrong

Treasurer

Edward H. Meyer

Secretary

Edward F. Rover

Director Emeritus

Thomas M. Messer

Trustees

Jon Imanol Azua

Robert C. Baker

Janna Bullock

John Calicchio

Mary Sharp Cronson

Carl Gustaf Ehrnrooth

David Ganek

Peter Lawson-Johnston

Peter Lawson-Johnston II

Howard W. Lutnick

William L. Mack

Linda Macklowe

Wendy L-J. McNeil

Edward H. Meyer

Amy Phelan

Vladimir O. Potanin

Stephen M. Ross

Mortimer D. A. Sackler

Denise Saul

James B. Sherwood

Jennifer Blei Stockman

Stephen C. Swid

John S. Wadsworth, Jr.

Mark R. Walter

John Wilmerding

Honorary Trustee

Hannelore Schulhof

Trustees Emeriti

Robert M. Gardiner

Barbara Jonas

Samuel J. LeFrak†

Seymour Slive

Trustees Ex Officio

Tiqui Atencio Demirdjian,
 President, International Director's Council

John Leopoldo Fiorilla di Santa Croce,
 Chairman, Executive Committee,
 Peggy Guggenheim Collection Advisory Board

PREFACE

Kandinsky is a joint exhibition project between the Städtische Galerie im Lenbachhaus und Kunstbau, Munich; the Centre Pompidou, Paris; and the Solomon R. Guggenheim Museum, New York. For the first time in more than thirty years, Vasily Kandinsky's life and work is represented through outstanding examples that cover the entire oeuvre of this important painter. Over the past three decades, other exhibitions, focused on particular aspects of Kandinsky's work or on specific collections, have provided invaluable perspectives on the artist. The present international exhibition, spanning the years from 1907 to 1942, offers a rare chance to consider Kandinsky's unique contribution to modern art. The logical growth of his painting toward abstraction and the particular transformations it underwent during the individual periods of his life turn out to have been the result of a well-considered path developed directly during the process of painting. Kandinsky always accompanied his practical artistic work with theoretical deliberations. Often, his written works—such as the well-known book *On the Spiritual in Art: And Painting in Particular*, first published as *Über das Geistige in der Kunst. Insbesondere in der Malerei* in 1912— anticipated the steps he would later implement in his canvases. Our three museums in Munich, Paris, and New York, have drawn on the wealth of material in our archives—writings, essays, letters, and personal items, such as photos and the art that Kandinsky himself collected—in order to facilitate new evaluations and insights.

Kandinsky was cosmopolitan and this quality is reflected in our project. Born in Moscow, he called Munich his second home, Paris his third. As a Russian, he had to leave Germany immediately upon the outbreak of World War I. After his return in 1921 and his years at the Bauhaus, the Nazis forced him into exile for a second time in 1933. From 1913 on, Kandinsky had connections with America through purchases by collectors and gallery owners such as Arthur Jerome Eddy and Alfred Stieglitz, as well as through his contacts with Katherine Dreier, Solomon R. Guggenheim, and Hilla Rebay. Around 1935, particularly due to the invitation of his former Bauhaus colleague Josef Albers, who had immigrated to the United States, he briefly toyed with the idea of likewise immigrating to America and escaping the uncertain political situation in Europe. But Paris detained him, and in 1939 the man who was granted German citizenship in 1928 became a French citizen at the age of seventy-three. After the outbreak of World War II, he declared in no uncertain terms that he wanted to stay in France for good.

Presenting masterpieces from all of Kandinsky's creative periods from his years in Munich, Moscow, and the Bauhaus in the German cities of Weimar, Dessau, and Berlin, to the final years in Paris, this exhibition draws its strength from a unique, close, and friendly collaboration between the three largest Kandinsky collections in the world. Each of the three collections, possessing essential facets of Kandinsky's work, is the result of notable and personal connections with the artist. The Lenbachhaus houses the early work of his Munich and Murnau years (up to 1914), and thus the important era of Der Blaue Reiter (The Blue Rider), thanks to artist and Kandinsky's former partner Gabriele Münter's donation. The Centre Pompidou's collection is particularly rich, due to the legacy of his wife Nina Kandinsky, and contains a number of outstanding pictures from Kandinsky's Russian revolutionary years up to 1921, his Bauhaus period up to 1933, and the late years in Paris. Thanks to the forward-thinking Solomon R. Guggenheim and Hilla Rebay, the Guggenheim Museum has an overwhelming collection of masterpieces from Kandinsky's expressive start toward abstraction before 1914 into the early 1920s, as well as from the Paris years up to the artist's death in 1944.

Kandinsky is a rare showing of the artist's masterworks that stands on the foundation of previous major exhibitions in all three cities. At the Haus der Kunst in Munich in 1976, the exhibition

Wassily Kandinsky, 1866–1944 brought together works from the three Kandinsky collections in Munich, Paris, and New York. It was accompanied by personal texts by Thomas Messer, then director of the Guggenheim Museum, that were in line with the view of Kandinsky at that time. In 1982, art historian Peg Weiss and the Lenbachhaus's director Armin Zweite organized the remarkable exhibition *Kandinsky in Munich: 1896–1914* for the Guggenheim. This project, in turn, was the first part of a very ambitious trilogy of Guggenheim exhibitions. It was followed in 1983 by *Kandinsky: Russian and Bauhaus Years, 1915–1933*, presented together with the Bauhaus Archives in Berlin and the Kunsthaus Zurich; and in 1985 by *Kandinsky in Paris: 1934–1944*, produced with the collaboration of colleagues in Paris. The Lenbachhaus then organized the last comprehensive Kandinsky exhibition in Munich, *Das Bunte Leben* (*Colorful Life*), in 1995. With the help of loans, this was the first occasion on which the rich total oeuvre of more than six hundred original works from the pre–Blaue Reiter period was shown in full. It was accompanied by an extensive publication by Vivian Endicott Barnett.

In Paris, Kandinsky's last home, no major Kandinsky exhibitions have been on view since the Centre Pompidou's presentation of its Kandinsky holdings in 1984, when it distinguished itself with the contemporaneous catalogue of its Kandinsky collection. During the perestroika year of 1989, the Centre Pompidou, the Lenbachhaus, and the Guggenheim Museum were the most important Western lenders for *Die erste sowjetische Retrospektive. Gemälde, Zeichnungen und Graphik aus sowjetischen und westlichen Museen* (*First Soviet Retrospective: Paintings, Drawings, and Graphics from Soviet and Western Museums*) of Kandinsky in Leningrad, Moscow, and Frankfurt. For the first time in more than seventy years, items from the reserve stocks of the Russian museums were shown in both Russia and the West. Since then, there have been numerous Kandinsky exhibitions—in Italy, Spain, and

Switzerland, and most recently at the Tate Modern in London and the Kunstmuseum in Basel in 2005–06. All of these were limited to Kandinsky's "route to abstraction," covering works dated up to 1921 at the latest. It is therefore a challenge and particular opportunity for our project, given the favorable circumstances of a unique cooperation between the three collections concerned, to revisit the entire range of the oeuvre once again through a series of masterly paintings.

During the Blaue Reiter years (from 1896 to 1914), the artist mastered color; initially in small-format studies from nature, then in larger formats, during the course of which he increasingly discarded any representational intent. From 1900, he also produced "colored drawings" in tempera on dark backgrounds, in which scenes of an imagined past were evoked, mostly showcasing traditional Russian subjects. The two 1907 paintings *Riding Couple* (*Reitendes Paar*) and *Colorful Life* (*Motley Life*) (*Das bunte Leben*) are masterpieces concluding this part of his early work. They form the starting point of our exhibition. Kandinsky's experience in Murnau, starting in 1908, led to the further liberation of color in his canvases. Colors were now intended to affect the viewer directly, like musical sounds. The painter's energy came alive in the sweep of his brushstroke. However, even in this phase of his work, Kandinsky did not completely forgo pictorial representation, manifesting and depicting a "spiritual" reality behind apparent reality by including coded remnants of objects.

During this time, he divided his large-format pictures into the categories of *Impressions*, *Improvisations*, and *Compositions*. The last category, which for him represented the perfect union of impressions of external and inner nature, spontaneity, fantasy, and controlled artistic arrangement, was one he continued to use in his later oeuvre—this exhibition includes the 1909–10 sketch for *Composition II* (*Komposition II*, 1910), as the final version was destroyed in the war, as well as *Composition 8* (*Komposition 8*, 1923) and *Composition IX* (1936).

The Russian years, from 1915 to 1921, during World War I and the Bolshevik Revolution in Moscow, were a phase of reorientation for Kandinsky. The final break in his painting with relics of representational topics and the transition to the use of purely geometric shapes came, not least, as a result of contact with the Russian Constructivists and Suprematism, although Kandinsky always kept his distance from this "purely mechanical" art.

During his years as a teacher at the Bauhaus starting in 1922 (initially in Weimar, then in Dessau, up until the Nazi closing of the school in Berlin in 1933), Kandinsky systematized his repertory of geometric shapes for practical teaching purposes—the basic elements being lines, planes, triangles, rectangles, and circles. He was particularly taken with circles as "a connection to the cosmos." Paintings such as his large, impressive *Yellow–Red–Blue* (*Gelb–Rot–Blau*, 1925) display the variety and density of relationships that can be achieved with shapes of this kind, also introducing opposing elements—an approach that is typical of Kandinsky's particular way of trying out the infinite variability of abstraction. In his flat style, the choice of colors, and the combination of shapes, he opened up small and large "worlds" in his paintings, despite the reduction to geometric shapes.

Blue World (*Monde bleu*, 1934), *Capricious Forms* (*Formes capricieuses*, 1937), *Various Parts* (*Parties diverses*, 1940), and other important late paintings represent Kandinsky's Paris years (from 1933 to 1944). They feature a microcosm of floating elements—microbe-like, organic structures that are vivid and yet nonobjective at the same time. Their strikingly artificial coloration featuring pink, turquoise, violet, and gold has been interpreted as a distant memory of Kandinsky's Russian origins and the colors of Eastern cultures. Right down to the last great pictures of 1942, those such as *Reciprocal Accord* (*Accord réciproque*) and *Delicate Tensions* (*Tensions délicates*), the principle of antithesis, of confrontation and balancing opposites, is discernible.

The curators of the three museums, Annegret Hoberg, Christian Derouet, and Tracey Bashkoff, in collaboration with the museums' directors, originally chose approximately ninety paintings as the core of the exhibition. Along with the Munich, Paris, and New York collections' works (which consist of around two-thirds of the works in the exhibition), this selection also includes significant canvases generously loaned by other museums and private collections. Focusing on Kandinsky's paintings in order to showcase his practice as a painter, the decision was made not to include the artist's informative and beautiful preliminary studies, preparatory watercolors, and sketches of which each of the three organizing museums has a great wealth. The aim of the selection to bring out the artistic principles and ideals of the artist privileges Kandinsky's paintings as the real objective of his artistic endeavors. After more than two years of discussion, the list of preferred choices emerged with the declared intention of selecting only outstanding works that were of particular importance to Kandinsky and for his artistic development. The end result was limited only by our inability to borrow a few central works from the early 1920s and the 1930s. During the course of the discussion, the choice of works was confined almost exclusively to larger formats where the support is canvas. This meant completely omitting, for example, the smaller Murnau landscape pictures, painted in oil on cardboard, which the Lenbachhaus has in great quantity and which strongly convey the richly colorful Bavarian character of Kandinsky's art in the Blaue Reiter years. Likewise missing are the 1942 pictures in smaller formats on dark card. Kandinsky increasingly used this support during World War II due to the lack of canvas during the German Occupation of Paris.

For each venue, the host museum has added to the touring exhibition of core paintings an accompanying presentation of other works or documents taken from the museum's own holdings and shown in a parallel exhibition. For the first time since 1966, the

Lenbachhaus exhibited its almost complete collection of Kandinsky's printed graphics. The Centre Pompidou showed newly purchased watercolors from the estate of Kandinsky's nephew Alexandre Kojève, as well as recently acquired documents. The Guggenheim Museum is presenting works on paper selected from the extensive holdings of drawings and watercolors in the Solomon R. Guggenheim Founding Collection and the collection of the Hilla von Rebay Foundation.

The shared distinction of the Lenbachhaus, Centre Pompidou, and Guggenheim Museum is the depth and breadth of our Kandinsky holdings. The individual institutional histories are based on unique and personal connections to the artist and those directly involved in his life and oeuvre.

With the exception of a lithograph acquired from a Bauhaus folio in 1926, the Städtische Galerie im Lenbachhaus had no other works by Kandinsky until 1957. Thanks to the magnanimous donation by Münter, who gave her entire collection of Kandinsky works from 1904 to 1914 to the museum on the occasion of her eightieth birthday, the Lenbachhaus became an institution of international importance. The outstanding feature of Kandinsky's legacy, which Münter had preserved for decades, is its complexity. Every individual development in Kandinsky's career up to his departure from Munich in 1914 and including his path to abstraction is documented with virtually no gaps in the variety of media included in this gift—paintings, watercolors, drawings, graphic works, even *Hinterglasbilder* (reverse glass paintings), carved pictorial works, and painted furniture. The thought springs to mind that there was an orderly intention behind this. It suggests that the artist defined, systematically pursued, and paced his self-development, supplemented by theoretical deliberations and written records begun in Munich, and his private catalogues that gave him an overview of his growth.

Münter's donation left more than simply a large number of works. What passed into the care of the Lenbachhaus was a collection that contained one of the core chapters of twentieth-century art history— the road to abstraction.

It must have affected the artist all the more tragically when Kandinsky had to leave behind, on the outbreak of war in 1914, all the work he had done in Munich. Although he was aware of the threatening danger of confrontation between Germany and Russia, even in 1912, the sudden need to leave Munich came to him as such a surprise that he no longer had time to arrange for the further care of his works during the war. He could hardly have suspected that his departure from Munich would be for good and that he would be separated from the greater part of what he had created to that date.

Before Münter left Munich in 1915 and went to Scandinavia for the next five years, she arranged for Kandinsky's works to be stored. During their last meeting in Stockholm in 1916, Kandinsky tried to get an overview of where all his scattered possessions were by copying Münter's private catalogue into Cyrillic. In addition to checking up on his possessions, Kandinsky was looking for ideas for his "imaginary museum," as can be seen in the pictures and sketches for compositions that he made at the time.

After his return to Germany in 1922 as a teacher at the Bauhaus in Weimar, Kandinsky sought to recover the possessions he had left with Münter. The dispute that followed was shaped primarily by the deep disappointment and hurt that Münter inevitably had felt when Kandinsky returned from Russia with a new wife, née Nina Andreevskaya, whom he had married in Moscow in February 1917. In the end, after years of legal dispute, in a declaration signed by Kandinsky in Dessau in April 1926, Münter received nearly half of Kandinsky's existing oil paintings from the period up to 1908, in addition to numerous other works, as well as, with a few exceptions, all

of his Hinterglasbilder. After 1933, Münter retrieved this rich stock of pictures from storage in Munich and hid it in the cellar of her house in Murnau.

Due to the understanding, adroitness, and commitment of Hans Konrad Roethel, the director of the Lenbachhaus at the time, this treasure, which had meant to Münter the "whole" Kandinsky, was secured in its entirety. The complete Münter donation that passed to the Städtische Galerie in 1957 comprised 88 paintings, 24 Hinterglasbilder, 116 watercolors and tempera works, 160 drawings, 28 sketchbooks and notebooks, and Kandinsky's entire oeuvre of printed graphic works. Münter's extensive archive containing many manuscripts by the artist, the correspondence between the two of them and with numerous other artists, plus the house in Murnau and her own artistic estate were transferred to a foundation, the Gabriele Münter- und Johannes Eichner-Stiftung, which legally came into being in 1966.

In 1971, the masterpiece of the earlier Paris period of 1907, *Colorful Life*, came to the Lenbachhaus as a permanent loan of the Bayerische Landesbank. *Red Spot II* (*Krasnoe Pyatno II*, 1921) came from Nina Kandinsky into the Lenbachhaus in 1976 and passed into the ownership of the collection in 1982 with assistance from the Bayerische Hypotheken- und Wechsel-Bank of Munich. In 1969, the Gabriele Münter- und Johannes Eichner-Stiftung also bought *Various Parts* from the artist's estate. The foundation then received, from Nina Kandinsky, a mixed-technique drawing of 1927 as a gift. Finally, five years ago, with the help of the Société Kandinsky and a private bene-factor, a painting from the Moscow period, *Zubovsky Platz* (*Zubovsky Square*) of around 1916, was also acquired. With these acquisitions, Kandinsky's work after the Munich years can be selectively illustrated at the Lenbachhaus as well, though without the museum being able to offer an overall picture.

The creation of the Fonds Kandinsky by the Musée national d'art moderne is a fascinating story that began slowly, with direct pur-chases from the artist. In 1937, André Dézarrois, curator of the musée des Écoles étrangères at the musée du Jeu de Paume, bought a gouache called *White Line* (*La Ligne Blanche*, 1936). In 1939, he arranged with Georges Huisman, director general of the Beaux Arts, to buy *Composition IX*, circumventing all the usual commissions of the time. In 1959, Jean Cassou, director of the Musée national d'art moderne at the Palais de Tokyo, bought *Development in Brown* (*Entwicklung in Braun*, 1933) from Nina Kandinsky, while the Friends of the Museum acquired *Complex–Simple* (*Complexité simple*) of 1939. In 1966, Bernard Dorival put one room of the museum at the disposal of Nina Kandinsky, who therein placed some important works on permanent loan, also gifting *Improvisation 14* (1910), two watercolors by Paul Klee, and a painting by August Macke.

Ten years later, in 1976, the Centre Pompidou was under con-struction. The friendship between Georges and Claude Pompidou, Nina Kandinsky, as well as the good offices of Pontus Hulten, secured an exceptional donation of fifteen paintings and fifteen watercolors. Nina Kandinsky waived the right of usufruct and also added five sketches done by Kandinsky for the 1922 Berlin exhibition *Juryfreie Kunstschau* (*Juryless Art Show*), which was reconstructed in the entrance to the new museum.

Following the success of the exhibition *Kandinsky. Trente peintures des musées soviétiques* (*Kandinsky: Thirty Paintings from Soviet Museums*), on January 12, 1980, Nina Kandinsky bequeathed to the Centre Pompidou everything that remained in her possession concerning Kandinsky's work. She died in Gstaad, Switzerland, the same year. The Tribunal de grande instance de Nanterre entrusted the Centre national d'art et de culture Georges Pompidou with her collec-tion, which was accepted on October 8, 1981.

Apart from universally acknowledged masterpieces, the bequest included an extraordinary collection of works on paper, the jewel of which was a series of fifty-four drawings and twenty-two watercolors from the Moscow period, which were placed in the Cabinet d'art graphique. The rest was comprised of the inventory of Kandinsky's paintings and watercolors kept by the artist in six note-books; ethnographic objects from his apartment on Ainmillerstraße in Munich; the dining-room set offered by Marcel Breuer to furnish the Bauhaus apartment in Burgkühnauer Allee in Dessau; an invalu-able collection of paintings and drawings by other artists; and many of his letters. Kazimir Malevich's *Head of a Peasant* (1911), for example, rubbed shoulders with Klee's *K N the Blacksmith* (1922). Correspondence partners ranged from Anton von Webern to Joan Miró. In addition, there were easels and material from the studio in Neuilly-sur-Seine, the last place where he lived. A catalogue of this submerged continent of material was drawn up in 1984 under the supervision of Christian Derouet, curator of the Musée national d'art moderne, Centre Pompidou. The first two periods are less well repre-sented than at the Gabriele Münter- und Johannes Eichner-Stiftung in Munich (1900–1907: training, travel, and the first long stay in Paris; and 1908–1914: Munich and the brilliant period in Murnau), how-ever, the documentation becomes indispensable for the Moscow in-terlude from 1915 to 1921; the Bauhaus period from 1922 to 1933; and the artist's exile in Paris from 1934 to 1944.

The Fonds Kandinsky is a link between France, Germany, and Russia. This incomparable richness is in perpetual evolution: Nina Ivanov's gift of the correspondence between Kandinsky and Kojève, watercolors deriving from various donations (the former Karl Flinker Collection and former André Breton Collection), and above all con-stant efforts by the Société Kandinsky founded by Nina Kandinsky at the Centre Pompidou in 1979 to protect and promote the artist's

oeuvre, have all enhanced the collection. Under the chairmanship of Claude Pompidou and due to the efforts of Christian Derouet, treasurer of the Société Kandinsky, this association has, since 2001, furnished gifts to reintegrate parts of the heritage removed at the time of the bequest: the portfolio offered to Kandinsky for his sixtieth birthday in Dessau on December 4, 1926, as well as dedicated works by Albers, Herbert Bayer, Lyonel Feininger, Klee, László Moholy-Nagy, Oskar Schlemmer, and Gunta Stölzl. The most recent acquisition from 2008 is the German and Russian manuscript of "Über das Materielle in der Kunst" (On the Material in Art), written in Goldach, Switzerland, in 1914 and conserved by the Commission consultative des trésors nationaux. Furthermore, mention should be made of the watercolors and drawings of 1915 (originally part of the former Kojève Collection), works by Willi Baumeister and Klee, exceptional letters to Robert Delaunay, and so on, that are all a part of the Fonds Kandinsky. The overall collection is so impressive that it seemed a good idea to call the documentation at the Musée national d'art moderne the Bibliothèque Kandinsky.

Solomon R. Guggenheim began his museum's collection and de-fined its initial mission to promote the art of our time when he began collecting nonobjective art in 1929, after German artist Hilla Rebay introduced him to the work of the European avant-garde. Prior to meeting Rebay, who had been commissioned to paint Guggenheim's portrait in 1928, the family collected works not unlike those sought by other prominent New York families. Irene Rothschild Guggenheim, for example, acquired examples of old masters, French Barbizon can-vases, Audubon prints, Flemish panel painting, and other traditional art forms. Rebay had studied art and music at an early age. Though extremely talented as a portrait painter, Rebay eventually gravitated toward the most radical tendencies in European art. The Dada artist

Jean Arp, Rebay's suitor from 1915 until 1917, initiated her into the avant-garde art world; he presented her with a copy of Kandinsky's treatise *On the Spiritual in Art* for Christmas 1916, and during that year introduced her to Herwarth Walden, owner of the Berlin gallery Der Sturm. Including the art of Delaunay, Albert Gleizes, Kandinsky, and the man who would become her longtime confidant and companion, Rudolf Bauer, Rebay also embraced the idea of nonobjectivity in art as both a style and an aesthetic philosophy. Differentiating between abstraction as an aesthetic derivation of forms found in the empirical world and nonobjectivity as pure artistic invention, Rebay devoted herself to the latter, believing it was infused with a mystical essence. Her own studies, at age fourteen, with Rudolf Steiner in the esoteric religion of Theosophy, laid the foundation for her lifelong pursuit of the spiritual in art.

Upon moving to America in 1927, Rebay began a personal crusade to promote the art in which she so profoundly believed. Guggenheim, impressed by Rebay's impassioned commitment and lured, perhaps, by the thought of pioneering a relatively untouched area of collecting, began to purchase works by nonobjective artists. During 1930, the Guggenheims accompanied Rebay on a European tour. Introduced to Kandinsky in the artist's studio in Dessau, Guggenheim acquired a number of masterpieces and promised additional purchases for the museum's collection over the next several years. Rebay's enthusiasm for experimental trends in contemporary European painting also spoke to Guggenheim's beliefs about innovation and ingenuity. Perhaps motivated by his recollections of having been thwarted when, as a young man, he invented a new way of extracting copper from the family mines, Guggenheim claimed to never underestimate those committed to a new vision: "Pioneering always attracted my attention as an advance, through contribution, to the increase of mankind's material and cultural wealth. Once I was convinced of the worthiness of the goal, difficulties could not deter me. The first time I saw nonobjective painting in Europe I was enchanted by its appeal and I saw in this art a medium for the American painter to exceed the past since the rhythmic element is a typical appealing faculty of the American."*

Even though Bauer held a privileged position in Rebay's vision of nonobjective art (she had arranged for Guggenheim to subsidize Bauer's production, providing a monthly income in return for paintings), the presence of Kandinsky's work ultimately defined the tenor of the collection. Indeed, it was Bauer who advocated collecting all periods and media of Kandinsky's opus and, over time, more than one hundred fifty works by Kandinsky would enter Guggenheim's collection. In 1937, the Solomon R. Guggenheim Foundation was established and planning began for a museum. Two years later, the Museum of Non-Objective Painting opened in Manhattan with Rebay as its director. Permanent galleries were devoted to Kandinsky (a practice the Guggenheim Museum has revived in recent years). In 1945, shortly after the artist's death, Rebay organized a memorial exhibition of more than two hundred fifty works and also translated some of Kandinsky's seminal writings into English. By 1943, plans were underway for a new building to house Guggenheim's growing collection and Frank Lloyd Wright was selected to design, in Rebay's words, "a temple of spirit." Solomon died in 1949, and Wright astutely suggested that the building project be reconceived as a memorial to Guggenheim. Renamed the Solomon R. Guggenheim Museum in 1952, the signature Wright building opened on New York's Fifth Avenue in 1959.

In 1952, Rebay resigned as director of the museum but continued her relationship with the institution in the role of director

*Solomon R. Guggenheim, typed statement, n.d., Box 551, Solomon R. Guggenheim records, A0040, Solomon R. Guggenheim Museum Archives, New York.

emerita. Through her perpetual contact with artists over the course of her lifetime, she amassed a significant art collection. Part of her estate, which included works by Bauer, Alexander Calder, Gleizes, Kandinsky, Klee, Piet Mondrian, and Kurt Schwitters was given to the Solomon R. Guggenheim Museum after her death in 1967 to form the dedicated Hilla Rebay Collection. In addition, holdings from the Hilla Rebay Foundation, including a vast group of Kandinsky works on paper, have been in the care of the Guggenheim Foundation since 1971.

Subsequent directors continued the mission of Guggenheim and Rebay. Thomas Messer is noted for his scholarship on Kandinsky and for the trio of landmark exhibitions he presented in the 1980s. Thomas Krens and Lisa Dennison were integral in the early conceptualization and planning of the current exhibition project. It was also under their administration that In 2007, to formally honor Solomon's legacy, and in celebration of the seventieth anniversary of the creation of the foundation, the Guggenheim Foundation assigned a special credit line to the more than six hundred works he acquired, designating them as part of the Solomon R. Guggenheim Founding Collection. In 2009, on the occasion of the fiftieth anniversary of the museum's landmark building, it is fitting that the spiral will be installed with Kandinsky's canvases, the very work that inspired the museum's creation.

The organization of this exhibition has also offered each of us the opportunity to examine the role of Kandinsky in each of our institutional identities and consider new avenues of inquiry. Together, we are grateful to the generous lenders for providing us with outstanding works by the artist, some of which are very rarely lent and which are indispensable to our exhibition's goal of illustrating Kandinsky's oeuvre. Their contributions, as well as those of essential museum staff, sponsors, and other individuals, are jointly appreciated and enumerated in the acknowledgments to this exhibition catalogue.

RICHARD ARMSTRONG

Director, Solomon R. Guggenheim Foundation and Museum, New York

HELMUT FRIEDEL

Director, Städtische Galerie im Lenbachhaus und Kunstbau, Munich

ALFRED PACQUEMENT

Director, Musée national d'art moderne–Centre de création industrielle, Centre national d'art et de culture Georges Pompidou, Paris

ACKNOWLEDGMENTS

The early identity of the Solomon R. Guggenheim Museum is inextricably linked to Vasily Kandinsky. Solomon Guggenheim embraced the artist for his innovative character and Hilla Rebay, Guggenheim's advisor and the museum's first director, championed Kandinsky's spiritual and utopian vision. It has been a privilege for the Solomon R. Guggenheim Foundation to work on this jointly organized exhibition with the Städtische Galerie im Lenbachhaus und Kunstbau, Munich, and the Centre Pompidou, Paris.

Collaborating with the esteemed staffs of the three institutions has been a pleasure. The dedication and support of directors Helmut Friedel, Städtische Galerie im Lenbachhaus; Alfred Pacquement, Centre Pompidou; and Richard Armstrong, Guggenheim Foundation and Museum, has ensured the endeavor's success at all venues. Thomas Krens, former director of the Solomon R. Guggenheim Foundation, and Lisa Dennison, former director of the Guggenheim Museum, were involved in the genesis of this exhibition and contributed greatly to the path it has followed. Curators Annegret Hoberg, Städtische Galerie im Lenbachhaus, and Christian Derouet, Centre Pompidou, have generously shared their knowledge, resources, and insight, and it has been an honor to work with them.

The presentation of *Kandinsky* at the Guggenheim Museum would not have been possible without the support of the National Endowment for the Arts. Its generous grant offers more than financial backing, and we appreciate the high regard its endorsement signals.

The members of the Société Kandinsky have been supportive of the exhibition and publication for many years. We appreciate their encouragement. The Hilla von Rebay Foundation, led by Chairman Robert F. Grele, is to be thanked for its continued relationship with the Guggenheim Museum. Its archives, housed at the Guggenheim, shed light on the founding of the museum, and the works on paper it has placed in our care are a significant addition to the New York presentation. I am indebted to Kandinsky expert Vivian Endicott Barnett for her many contributions to this project. In addition to her thoughtful catalogue essay, she helped with numerous aspects essential to the exhibition, including loans, research, and advice. Additionally, I am indebted to Vivian, Angelica Rudenstine, and Susan B. Hirshfield for their past research on the Kandinsky holdings of the Guggenheim Museum.

This exhibition would not have been possible without the generosity of the many individuals and institutions that kindly lent their canvases. I wish to thank the European and American lenders to all venues of this exhibition: Director James Cuno and Assistant Curator of Modern and Contemporary Art Stephanie d'Alessandro, Art Institute of Chicago; President Ernst Beyeler, Director Samuel Keller, and Conservator Philippe Büttner, Fondation Beyeler, Riehen/Basel; Artistic Director Cathrin Klingsöhre-Leroy, Franz Marc Museum, Kochel am See, Germany; President of the Board of the Foundation Helmut Friedel, Administrative Director Peter Paul Walter, Curator Isabelle Jansen, and Members of the Board Jan Ahlers, Sabine Helms, Michael Leonhart, and Hans-Werner Hürholz, Gabriele Münter- und Johannes Eichner-Stiftung, Munich; Director Wim van Krimpen, Gemeentemuseum Den Haag, The Hague, Netherlands; Director General David Lordkipanidé, Chief Conservator of Fine Arts Irina Arsenichvili, Assistant Manager of Collections Nino Taboutsadzé, and Curator of Russian Art Collections Nana Chervachidzé, Georgian National Museum, Tbilisi; Director Bernhard Mendes Bürgi and Curator of Nineteenth-Century and Modern Art Collections Nina Zimmer, Kunstmuseum und Museum für Gegenwartskunst, Basel; Director Matthias Frehner, Kunstmuseum Bern; Interim Director Pia Müller-Tamm and Curator of Collections Annette Kryszynski, Kunstsammlung Nordrhein-Westfalen, Düsseldorf, Germany; Director Thomas P. Campbell, former director Philippe De Montebello, and

Engelhard Chairman of the Department of Nineteenth-Century, Modern, and Contemporary Art Gary Tinterow, Metropolitan Museum of Art, New York; Director Lars Nittve, Moderna Museet, Stockholm; Curator Olivier Cousinou, Musée Cantini, Marseille, France; Director Lorand Hegyi and Chief Curator Jacques Beauffet, Musée d'art moderne, Saint-Etienne, France; Director of Museums of Strasbourg Joëlle Pijaudier-Cabot and Curator Marie-Jeanne Geyer, Musée d'art moderne et contemporain, Strasbourg, France; Director and Chief Curator Blandins Chavanne, Musée des Beaux-arts, Nantes, France; Director Sjarel Ex, Museum Boijmans Van Beuningen, Rotterdam, Netherlands; Director Kasper König and Curator of Paintings Stefan Diederich, Museum Ludwig, Cologne, Germany; Director Glenn Lowry, Chief Curator Ann Temkin, former chief curator of the Department of Painting and Sculpture John Elderfield, Adjunct Curator of Painting and Sculpture Cora Rosevear, and Curator in the Department of Painting and Sculpture Leah Dickerman, Museum of Modern Art, New York; Director Earl A. Powell III, National Gallery of Art, Washington, D.C.; Director Philip Rylands, Peggy Guggenheim Collection, Venice; former director Anne d'Harnoncourt and Muriel and Philip Berman Curator of Modern Art Michael Taylor, Philadelphia Museum of Art; Director Dorothy Kosinski, Phillips Collection, Washington, D.C.; Director Irina Antonova, Chief Curator Tatiana Potapova, Director of External Affairs Maria Kostaki, Associate Director of External Affairs Inna Orn, Curator of Nineteenth and Twentieth-Century European and American Collections Alexei Petukhov, Director of Private Collections Natalia Avtonomova, State Pushkin Museum of Fine Arts, Moscow; Director Sean Rainbird and Curator of Modern Art Ina Conzen, Staatsgalerie Stuttgart, Germany; Director General Marina Bratanova, State Art Museum, Nizhny Novgorod, Russia; Director General Valentin A. Rodionov, First Vice Director Lidia Iovleva, Coordinator in the Department of International Exhibitions Elena Maslova, and Coordinator in the Department of International Exhibitions Katerina Semenova, The State Tretyakov Gallery, Moscow; Director Gijys van Tuyl and Chief Curator of Collections Geurt Imanse, Stedelijk Museum, Amsterdam; Henry J. Heinz II Director Jock Reynolds, Yale University Art Gallery, New Haven; Mark E. Gill, London; Theobald Jennings, London; David, Helly, and Helly Nahmad, Nahmad Collection, New York and London; Pierre Sebastien, Paris; J. Shafran, London; Wolfgang Wittrock, Berlin, as well as those lenders who prefer to remain anonymous.

The catalogue, created with multiple venues and audiences in mind, includes insightful reconsiderations of Kandinsky's life and oeuvre. I am thankful for the thoughtful contributions of my coauthors: Annegret Hoberg has written a comprehensive essay and chronology detailing the correspondences between the artist's writing and work. Christian Derouet uncovers new research about the association between Kandinsky and Christian Zervos. Vivian Endicott Barnett's perceptive study of Kandinsky's writing and artwork offers an original trajectory, based on moments of upheaval and change, through Kandinsky's life. Matthias Haldemann contemplates the semiologic nature of Kandinsky's work. Gillian McMillan and Vanessa Kowalski reveal the early findings in a new conservation and scientific study of five Kandinsky canvases. Derouet's essay was translated from the French by Paul Aston, Sliema, Malta, and Tessa Frank, Ludlow, England; the essays by Haldemann and Hoberg were translated from the German by Aston; German plate entries were translated into English by Pauline Cumbers, Frankfurt, and Sarah Kane, Watford, England; and French plate entries were translated by Frank and Molly Stevens, New York. The staff at Prestel Verlag were instrumental in providing materials for the production of the catalogue. My appreciation goes to Jean Wilcox for her fresh and responsive design for the New York version of the book.

The Lenbachhaus had the pleasure and challenge of being the first venue of this complicated exhibition. Much appreciation is extended to the excellent staff in Munich, including Chief Registrar Susanne Boeller, Registrar Karin Dotzer, Assistant Curator Melanie Horst, Chief Conservator Iris Winkelmeyer, Paintings Conservators Ulrike Fischer and Judith Ortner, and Assistant Paintings Conservator Isa Pfäffgen. The archival resources of the Gabriele Münter- and Johannes Eichner-Stiftung were generously made available and are enormously appreciated.

In Paris, the exhibition has been graciously supported by President Alain Seban, General Director Agnès Saal, Director of the Department of Cultural Development Bernard Blistène, Director of Communication Françoise Pams, and President of the Society of the Friends of the Musée national d'art moderne François Trèves, Centre national d'art et de culture Georges Pompidou, as well as Associate Director, Collections, Brigitte Leal; Associate Director, Industrial Design, Frédéric Migayrou; Associate Director, Cultural Programs, Didier Ottinger; and Director Didier Schulmann, Bibliothèque Kandinsky, Musée national d'art moderne–Centre de création industrielle. The staff is gratefully acknowledged for their efforts: Angelika Weißbach in Research, Bruno Veret in Exhibition Production with Assistant Marie Bertran, Registrar Caroline Camus-Caplain with Assistant Jonathan Izzo, Registrar of Loans Olga Makhroff, Conservator and Department Head Jacques Hourrière, Conservators Anne-Catherine Courtois-Prud'homme, Benoît Dagron, Géraldine Guillaume-Chavannes, and Sylvie Lepigeon, Exhibition Management Director Catherine Sentis-Maillac, and Department Heads Martine Silie and Annie Boucher. With regard to the catalogue, I would like to thank Jeanne Alechinsky and Patrice Henry in production. In publications, thanks goes to Acting Director Jean-Christophe Claude; Françoise Marquet, Editorial; Benoît Collier, Sales; and Claudine Guillon and Matthias Battestini, Rights and Reproductions. The Bibliothèque Kandinsky and the Fonds Kandinsky were a wonderful resource for archival material, and we are appreciative of the access we were granted.

At the Guggenheim Museum, I am extremely grateful to the numerous colleagues who have focused their expertise on the realization of this project. I have especially benefited from working with Assistant Curator Karole Vail who handled each aspect of the exhibition and catalogue with her characteristic forethought and grace. Assistant Curator Megan Fontanella willingly contributed her time and knowledge whenever asked. I commend our curatorial interns, Natalie Greenberg, Luisa Gui, Anna Musini, Max Vallot, and Tina Wimmer for the invaluable assistance they provided during the many phases of exhibition planning. I am thankful for the support of Chief Curator Nancy Spector as well as for the sound advice and counsel of my curatorial colleagues, Senior Curator of Collections and Exhibitions Susan Davidson, Curator of Twentieth-Century Art Carmen Giménez, Curator of Nineteenth and Early Twentieth-Century Art Vivien Greene, and Assistant Curators Valerie Hillings and Nat Trotman. Manager of Library and Archives Francine Snyder and the staff of the Guggenheim library and archives were extremely helpful with research for both the catalogue and exhibition.

The coordination of an international exhibition requires the dedication of many individuals. Exhibitions Manager Yvette Lee Crowley carefully saw to the details of the institutional collaboration and the local incarnation. Associate Registrar for Exhibitions Maria Paula Armelin deftly coordinated the logistical details of transportation and insurance with the help of Associate Registrar for Exhibitions Isabel Stauffer. I am grateful again to Senior Conservator, Collection, Gillian McMillan for her thoughtful attention to our holdings and for sharing her insight with me. Associate Conservator Jeffrey Warda took great care for the numerous works on paper, and with the expert

help of Senior Preparator Elisabeth Jaff readied them for exhibition. Manager of Art Services and Preparations David Bufano, Exhibition Technician Paul Bridge, and Senior Exhibition Technician Barry Hylton supervised the preparation of our works for travel and installation in New York. I thank Director of Registration MaryLouise Napier and Director of Institutional Development Brynn Myers for their attention to the details of our submissions to the National Endowment for the Arts. Exhibition Design Coordinator Shraddha Aryal was endlessly creative and supportive in her work concerning the layout of the exhibition.

The Publications staff worked tirelessly and with an abundance of good humor to accomplish the successful realization of this catalogue. Director of Publications Elizabeth Levy and Associate Director of Publications, Editorial, Elizabeth Franzen, understood the complexities of this publication from the onset and carefully planned for our edition. I am grateful to Managing Editor Stephen Hoban for keeping us all on track and to Associate Editors Kamilah Foreman and Helena Winston for taking on much more than their titles indicate. I thank Associate Director of Publications, Production, Melissa Secondino, who skillfully attended to design and production matters, and Associate Production Manager Jonathan Bowen and Production Associate Suzana Greene for their great organization. Photo Researcher and Rights and Reproductions Manager Sharon Dively was unwavering in her efforts. For his work on the online Guggenheim Forum, thanks go to Senior Editor Domenick Ammirati. For their work on the Web site, I am grateful to Web Designer Jennifer Otten; Associate Editor, Web site, Kimberly Riback; and Assistant Editor, Web site, Greg Gestner.

I offer my sincere appreciation to the Development Department for its efforts to secure support for this exhibition: Executive Director for Corporate and Institutional Development John L. Wielk, Director of Institutional Development Brynn Myers, Director of Individual Development Helen Warwick, Associate Director of Museum Events Stephen Diefenderfer, and Associate Director of Special Events Bronwyn Keenan. I am thankful to Director of Media and Public Relations Betsy Ennis, Director of Visitor Services Maria Celi, and Director of Marketing Laura Miller. I thank Founder and Producer Mary Sharp Cronson and Consulting Producer Charles Fabius, Works & Process, who, working with artist Rafael Lozano-Hemmer reenvisioned Kandinsky's Der gelbe Klang (Yellow Sound, 1912). The Education Department is instrumental in seeing to it that this exhibition reaches its audience, and I am grateful to Gail Engelberg Director of Education Kim Kanatani; Associate Director of Education, Public Programs, Christina Yang; and Associate Director of Education, School and Family Programs, Sharon Vatsky. Finally, I thank artist Grahame Weinbren for his filmwork inspired by our Kandinsky collection and for including me in his challenging and thought-provoking process.

TRACEY BASHKOFF
Associate Curator for Collections and Exhibitions
Solomon R. Guggenheim Museum

PROJECT TEAM

Solomon R. Guggenheim Museum

Richard Armstrong
*Director, Solomon R. Guggenheim
Foundation and Museum*

Marc Steglitz
Chief Operating Officer

Karen Meyerhoff
*Managing Director for Business
Development*

Brendan Connell
Director and Counsel for Administration

Boris Keselman
Chief Engineer, Facilities

Art Services and Preparations

David Bufano
*Manager of Art Services
and Preparations*

Barry Hylton
Senior Exhibition Technician

Paul Bridge
Exhibition Technician

Jeffrey Clemens
Senior Preparator

Elisabeth L. Jaff
Senior Preparator

Conservation

Carol Stringari
Chief Conservator

Gillian McMillan
Senior Conservator, Collection

Julie Barten
Conservator, Collection and Exhibitions

Jeffrey Warda
Associate Conservator, Paper

Vanessa Kowalski
*Samuel H. Kress Foundation Fellow
2007–08*

Construction

Michael Sarff
Exhibition Construction Manager

Curatorial

Nancy Spector
Chief Curator

Tracey Bashkoff
*Associate Curator for Collections
and Exhibitions*

Karole Vail
Assistant Curator

Megan Fontanella
Assistant Curator

Sharon Dively
*Photo Researcher and Rights
and Reproductions Manager*

Curatorial Interns
Natalie Greenberg
Luisa Gui
Anna Musini
Max Vallot
Tina Wimmer

Development

John L. Wielk
*Executive Director for Corporate
and Institutional Development*

Helen Warwick
Director of Individual Development

Brynn Myers
Director of Institutional Development

Brady Allen
*Associate Director, Development
Operations*

Stephen Diefenderfer
Associate Director of Museum Events

Bronwyn Keenan
Associate Director of Special Events

Irene Kim
Corporate Development Associate

Education

Kim Kanatani
Gail Engelberg Director of Education

Christina Yang
*Associate Director of Education,
Public Programs*

Sharon Vatsky
*Associate Director of Education,
School and Family Programs*

Exhibition Design

Melanie Taylor
Manager of Exhibition Design

Shraddha Aryal
Exhibition Design Coordinator

Exhibition Management

Jessica Ludwig
*Director of Exhibition Planning
and Implementation, New York*

Yvette Lee Crowley
Exhibitions Manager

External Affairs

Eleanor R. Goldhar
Deputy Director, External Affairs

Nora Semel
External Affairs Manager

Fabrication

Peter B. Read
*Manager, Exhibition
Fabrications and Design*

Richard Avery
Chief Cabinetmaker

David Johnson
Chief Framemaker

Doug Hollingsworth
Cabinetmaker

Peter Mallo
Cabinetmaker

Finance

Amy West
Director of Finance

Christina Kallergis
*Budget Manager for Program
and Operations*

Sari Sharaby
Senior Financial Analyst

Bennett Lin
Financial Analyst

Graphic Design

Marcia Fardella
Chief Graphic Designer

Concetta Pereira
Production Supervisor

Janice Lee
Senior Graphic Designer

Legal

Sarah Austrian
General Counsel

Sara Geelan
Associate General Counsel

Dana Wallach
Assistant General Counsel

Library and Archives

Francine Snyder
Manager of Library and Archives

Rebecca Clark
Art Librarian

Rachel Chatalbash
Archivist

Lighting

MaryAnn Hoag
Lighting Designer

Marketing

Laura Miller
Director of Marketing

Media and Public Relations

Betsy Ennis
Director of Media and Public Relations

Lauren Van Natten
Senior Publicist

Claire Laporte
Media Relations Associate

Photography

David M. Heald
Director of Photographic Services and Chief Photographer

Kim Bush
Manager of Licensing

Kristopher McKay
Assistant Photographer and Digital Imaging Specialist

Publications

Elizabeth Levy
Director of Publications

Elizabeth Franzen
Associate Director of Publications, Editorial

Melissa Secondino
Associate Director of Publications, Production

Stephen Hoban
Managing Editor

Domenick Ammirati
Senior Editor

Kamilah Foreman
Associate Editor

Helena Winston
Associate Editor

Kara Mason
Assistant Editor

Jonathan Bowen
Associate Production Manager

Suzana Greene
Production Associate

Registrar

MaryLouise Napier
Director of Registration

Maria Paula Armelin
Associate Registrar for Exhibitions

Isabel Stauffer
Associate Registrar for Exhibitions

Eliza Stoner
Registration Assistant

Retail

Ed Fuqua
Merchandise Manager

Katherine Lock
Retail Merchandise Manager

Theater Services

Michael P. Lavin
Director of Theater and Media Services

Stephanie Gatton
Assistant Theater Manager

Norman Proctor
Projectionist

Jesse Hulcher
Theater Technician

Visitor Services

Maria Celi
Director of Visitor Services

Trevor Tyrrell
Manager of Visitor Services Operations

Emily Johnson
Manager, Group Sales and Box Office

Web Site

Jennifer Otten
Web Designer

Kimberly Riback
Associate Editor, Web site

Greg Gestner
Assistant Editor, Web site

Société Kandinsky

Claude Pompidou†
Edouard Balladur, *President*
Richard Armstrong
Vivian Endicott Barnell
Christian Derouet
Helmut Friedel
Fabrice Hergott
Thomas Messer
Alfred Pacquement
Alain Seban
Peter Vergo
Armin Zweite

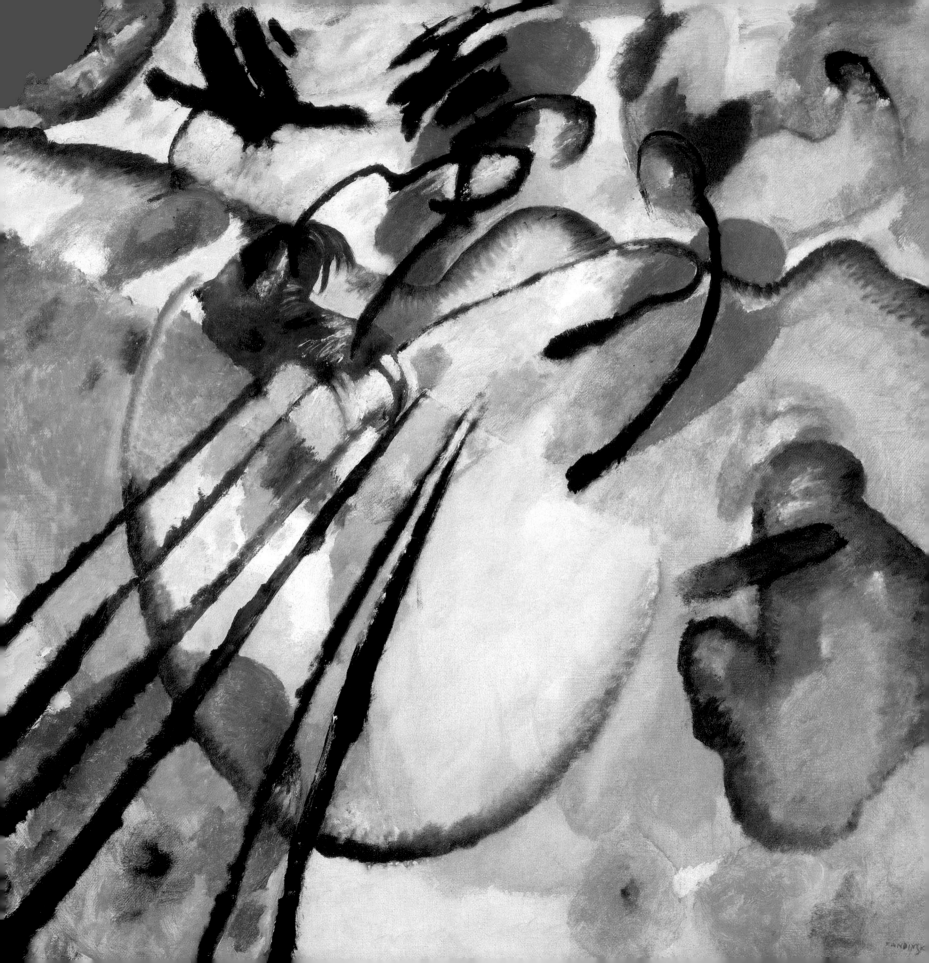

VASILY KANDINSKY: ABSTRACT. ABSOLUTE. CONCRETE.

ANNEGRET HOBERG

Vasily Kandinsky can undoubtedly be described as the most important founder of abstract painting, even if other artists such as František Kupka and Kazimir Malevich were setting about it in different ways at nearly the same time. Kandinsky did his first abstract picture around 1911. Arriving at abstraction was a long and complicated process that has been described in numerous studies of his oeuvre through 1914, including some by the present author. In this essay the challenge is to outline Kandinsky as an important figure whose work spans a period of more than fifty years and, in his way, illustrates some of the great problems that surrounded painting in the first half of the twentieth century. To a certain extent, my focus is thus on the less investigated periods of Kandinsky's Bauhaus and Paris years. Yet the artist's specific approach to abstraction during his time in Munich, especially his amazingly tenacious sense of mission and his commitment to representing that which he felt to be avant-garde, stands out as clearly some of his other, more recognized work. All his life, Kandinsky was deeply convinced of the "spiritual in art" and its analogy in abstract painting.

ABSTRACT, ABSOLUTE: MUNICH, 1896–1914

Kandinsky studied law and economics in his native Moscow before deciding, at age thirty, to become a painter, departing for Munich in 1896 to follow his dream. Instructive studies have recently been published about the spiritual background of his University of Moscow environment and the pronounced rejection of materialism and positivism in Russian intellectual circles of the

1 **Artist friends in Vasily Kandinsky's studio apartment, Munich, ca. 1901**

Page 22: Detail of *Improvisation 26 (Rowing)* (*Improvisation 26 [Rudern]*), 1912 (plate 29)

late nineteenth century in favor of inner and spiritual values, notably under the influence of the philosophers and writers Vladimir Sokolov and Dmitry Merezkovsky, or Kandinsky's university professors Sergei Bulgakov and Alexander Chuprov.[1] Some hitherto unknown details have been published about Kandinsky's university education, particularly relating to Kandinsky's liberal-minded and influential teacher Chuprov.[2] It appears that, due to Chuprov's influence, Kandinsky not only left his secondary school in Odessa (now in Ukraine) to spend a year at home, but also deferred his studies in Moscow for more than three years, starting in September 1889.[3] From June to early July of the same year, he undertook a now famous field trip on behalf of the Tsarist Society for Natural Science, Ethnography, and Anthropology to the province of Vologda, where he studied the surviving forms of pagan religion and peasant law.

Kandinsky described his "initial artistic experiences" favorably in his "Rückblicke" ("Reminiscences," 1913), particularly the deep impression made on him by the gaily painted interiors of the peasant houses he visited on his journey to the remote northeast: "They taught me to move within the picture, to live in the picture. . . . When I finally entered the room, I felt surrounded on all sides by painting, into which I had

thus penetrated. The same feeling had previously lain dormant within me, quite unconsciously, when I had been in the Moscow churches, and especially in the main cathedral of the Kremlin."[4]

The excursion into ethnography, a move beyond the frontiers of his discipline, seemed more attractive to Kandinsky than studying law. In the following period, he published book reviews in the *Etnograficheskoe obozrenie*, as well as legal essays.[5] In May 1890, he failed his legal exams. A year later he successfully completed the first part, passing the second part only in April–May 1892. In the same year, he married his cousin Anja Shemiakina. In November 1895, he abandoned the doctoral thesis in economics he was planning to write for Professor Chuprov on issues surrounding Russian workers' wages, and for a year worked as a "manager" at a printer. Kandinsky's description of his job, which was inflated into "artistic director" in scholarly literature about the artist, appears in his first brief autobiography as follows:

> Previously, my involvement with the problem of workers' wages had been largely theoretical. I now wanted to approach the same issue from the practical side, and took the job of a manager at one of the largest printing firms in Moscow. My field was collotypes, which to some extent brought me into contact with art. My environment was workers. However, I only remained in this field for a year, as the thought came over me when I was thirty that it was now or never. The gradual inner work, which I had not hitherto been aware of, had progressed so far that I could feel my artistic powers with complete clarity at this time, and was inwardly mature enough that the justification for becoming a painter was likewise just as clear.[6]

Other important experiences that reinforced his longing to be a painter were the impression made on him by a Claude Monet *Haystack* painting, a performance of Richard Wagner's *Lohengrin* (1850) in Moscow, and an intense experience of color at sunset in his native city:

> This image does not last long: a few minutes, and the sunlight grows red with effort, redder and redder, cold at first, and then

increasing in warmth. The sun dissolves the whole of Moscow into a single spot, which, like a wild tuba, sets all one's soul vibrating. No, this red fusion is not the most beautiful hour! It is only the final chord of the symphony, which brings every color vividly to life, which allows and forces the whole of Moscow to resound like the *fff* of a giant orchestra. Pink, lilac, yellow, white, blue, pistachio green, flame red houses, churches, each an independent song—the garish green of the grass, the deeper tremolo of the trees, the singing snow with its thousand voices, or the *allegretto* of the bare branches, the red, stiff, silent ring of the Kremlin walls, and above, towering over everything, like a shout of triumph, like a self-oblivious hallelujah, the long, white, graceful, serious line of the Bell Tower of Ivan the Great. And upon its tall, tense neck, stretched up toward heaven in eternal yearning, the golden head of the cupola, which among the golden and colored stars of the other cupolas, is Moscow's sun. To paint this hour, I thought, must be for an artist the most impossible, the greatest joy.[7]

Recently described as "orgiastic,"[8] this description can be traced through Kandinsky's output like a hidden leitmotif, in terms of both color and subject matter, and formally as a consonance of many contrasts.

Kandinsky arrived in Munich with his wife Anja in December 1896, and at the beginning of the following year enrolled at the private painting school of Anton Azhbe, which at the time was particularly popular with Eastern European and Russian students. Among others enrolling at the same time were his fellow countrymen Igor Grabar, Alexei Jawlensky, Dmitry Kardovsky, Nikolai Seddeler, and Marianne von Werefkin.[9] The Kandinskys initially rented various spacious studio apartments in Schwabing, before taking a long-term rental for their final married years together at 1 Friedrichstraße. A photo of a visit by fellow students to their apartment reflects something of Kandinsky's life and work that existed in this period between tradition and Bohemianism (fig. 1).

The fairly close contact between Kandinsky, Jawlensky, and Werefkin is documented even in these early years—that is, long before

their important and well-known joint trip to Murnau in 1908, which eventually led to the formation of Der Blaue Reiter (The Blue Rider)— as is Kandinsky's profound preoccupation with color, especially its technical aspects and practical effects. For example, Kandinsky visited Werefkin's flat at 23 Giselastraße as early as 1899. A "chemical laboratory" had been installed there in 1898 for Jawlensky to experiment with color.[10] Grabar, a painter, had set up this laboratory during Werefkin, Jawlensky, and Kardovsky's nearly one-year-long trip to Russia. Werefkin's apartment was also entrusted to Kandinsky during her second long trip with Jawlensky, from September 1901 to November 1902, to Ansbaki, Russia, where their son Andreas was born. With the precision of a scientist, Kandinsky also studied, in depth, the color theories of his immediate predecessors, ranging from those of Eugène Delacroix to Paul Signac to Max Klinger. From 1904, he started writing occasional notes on "the language of color," which later formed a major chapter in his most important theoretical work *Über das Geistige in der Kunst. Insbesondere in der Malerei* (*On the Spiritual in Art: And Painting in Particular*, 1912).[11] Likewise, he was equally interested in the Symbolists, and Arnold Böcklin particularly impressed him with the material quality of his painting and his ambition, as a "painting poet," to create a spiritual or fantastic aspect in his work, using an unconventional figurative style.[12] In literature, Maurice Maeterlinck, with his dissociation of language and meaning, sound and expressive effect, was, for Kandinsky, a step ahead on the way toward the goal of a free deployment of resources.[13] Particularly in Munich, following the lead of Böcklin and a group of German artists in Italy, there was much discussion about the spiritual content of art at the time. In the widely read contemporary art periodicals are essays whose sentiments bear a striking resemblance to Kandinsky's as expressed in *On the Spiritual in Art*.[14]

After a year of training at the Munich Academy with Franz von Stuck, Kandinsky finished his formal studies, and from 1900, left largely to his own resources, painted small oil studies directly from nature. Using a spatula, Kandinsky created work that had a distinctively pastose paint application and a Post-Impressionist style (fig. 2). This "spotted style," where the subject is almost buried beneath the spatula strokes,

2 *Schwabing–Nikolaiplatz*, winter 1901–02. Oil on cardboard, 23.7 x 32.9 cm.
Städtische Galerie im Lenbachhaus, Munich

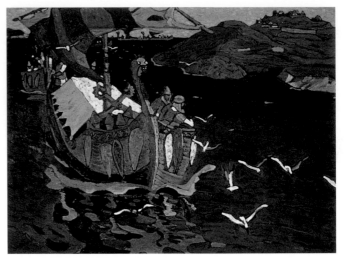

3 **Nicholas Roerich**, *Overseas Guests*, 1902. Oil on canvas, 70 x 100 cm.
State Russian Museum, St. Petersburg

in a way stylistically matches Kandinsky's early tempera paintings on dark backgrounds. There, variegated dots produce unreal figurative scenes set in the distant past. "It soon appeared to me," wrote the painter retrospectively, "that past ages, having no longer any real existence, could provide me with freer pretexts for that use of color which I felt within myself."[15] In the process, he adopted, in his mosaic-like tempera scenes, the approaches of Russian Symbolism and Art Nouveau, drawing, for example, on Ivan Bilibin, Nicholas Roerich (fig. 3), and Mikhail Vrubel. Interestingly, Kandinsky himself drew a line between his richly figurative tempera pictures *The Arrival of the Merchants* (*Ankunft der Kaufleute*, 1905, fig. 4) and *Colorful Life* (*Motley Life*) (*Das bunte Leben*, 1907, plate 2), and the already largely abstract, strikingly different, brightly sparkling *Composition II* (*Komposition II*, 1910, compare to *Sketch for Composition II* [*Skizze für Komposition II*, 1909–10, plate 12]).[16] Fundamental motifs of Kandinsky's personal iconography feature very distinctly in these early dark-background tempera pictures until 1907, including the colorful kremlin city on the hill and prehistoric-looking sailing boats, as well as the rider and the boat with the oarsman, as in the large-format panorama *Colorful Life*.

Obviously these remembered Russian images fused very early on with Kandinsky's intense color impressions of the Bavarian landscape,

as indicated by the notes for his watercolor *The King Arrives* (*Der König kommt*, ca. 1902, fig. 5): "Red trumpeters . . . in Seeshaupt and copper-green trumpets. Birch tree with yellow-white trunk as in Schlehdorf; in the shadow a crowd of people: cold knights, warm clothes (small contrast). Sweet background (mountains as in Bad Kochel, blue forest, and colorful boats with sails). White city with red roofs."[17]

That year, 1902, Kandinsky took his painting class from the Phalanx-Schule (Phalanx School) on a summer field trip to Kochel am See and Schlehdorf on Lake Kochel in the foothills of the Bavarian Alps. Despite his rather unassuming and slow beginnings, he and other progressive artists in Schwabing had founded the Phalanx as an exhibition association with an ancillary private art school. One of his pupils was Gabriele Münter, twenty-four at the time and new to Munich from the Rhineland.[18] A second summer field trip came in 1903, this time to the small village of Kallmünz in the Upper Palatinate, in whose fairy-tale Old German character (like that of other old towns in southern Germany) Kandinsky delighted. Here, he and Münter became a couple, although close contact and a correspondence between them had existed since 1902. In order to avoid private difficulties arising from his marriage with his cousin Anja (to whom Kandinsky still felt an obligation), Kandinsky and Münter set off, in the summer of 1904, on a

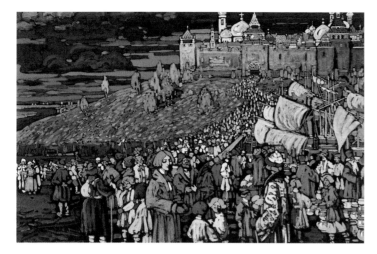

4 *The Arrival of the Merchants (Ankunft der Kaufleute)*, 1905. Tempera on canvas, 92.5 x 135 cm. Miyagi Museum of Art, Sendai, Japan

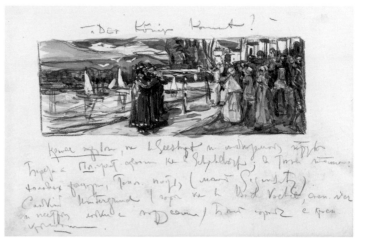

5 *The King Arrives (Der König kommt)*, ca. 1902. Watercolor and colored chalk over crayon, 23.5 x 29.6 cm. Städtische Galerie im Lenbachhaus, Munich

four-year rootless, peripatetic existence, during which he returned to Munich only for a week or so at a time and to different addresses, while his wife remained at the Friedrichstraße address. This is not the place to speculate about Kandinsky's relationship with Münter (nor indeed the later one with Nina Andreevskaya), although the correspondence between them provides deep insight. It is evident that, in the first years, up until 1905, Kandinsky was the driving force and delighted lover of the two. He saw the relationship as furnishing an intensity of experience, a liberation from bourgeois considerations, and a passionate artistic exchange. It probably did indeed provide all these things, even if a degree of alienation set in early on due to differences in temperament.[19] Münter initially shared in her partner's artistic development, although she repeatedly mentioned her difficulties with Kandinsky's dabbed, colorful pictures full of old Russian figures, criticizing them as *Spielereien* (fiddling about).

Kandinsky's responses during these discussions are highly illuminative of his very early, absolute conviction that he could achieve something new and special in art. To take just one of many similar statements, in a letter to Münter, Kandinsky stated: "I'm fairly well forward with the thing and the road ahead is fairly clear to me. I can claim without exaggeration that, if I carry it through, I shall come up with a new beautiful way of painting suited to infinite development."[20]

His correspondence with Münter also provides profound insight into his feelings about the dual nature of his Russian and German origins. He wrote to his partner (whom he often called Ella for short), from Odessa, on November 16, 1904, during a time of political upheavals: "Great, enigmatic Russian people! I believe in thee. . . . Thou are silent, giant, all the louder will thy voice ring through the world. I am not a patriot, Ella. And only half-Russian. The Russians consider me a foreigner and don't need me. The Germans are good to me (at least better than the Russians); I have become half-German, my first language, my first books were German, as a painter I 'feel' Germany and things German—German antiquities say more to me than to very many Germans. I have a good feeling towards Germany. And finally last of all . . . my little Ella is German (ho ho, and how!) And . . . yet!"[21] Kandinsky's dual roots (primarily in Russian culture, but also in German) are likewise evident in the fact that most of his manuscripts—even including those from the late Paris years—are written in German.[22]

After years of traveling, notably to Holland; Tunis, Tunisia; Rapallo, Italy; and a whole year in Sèvres near Paris (1906–07), he and Münter returned to Munich in early summer 1908, having decided to settle there permanently. Kandinsky rented a flat at the rear of 36 Ainmillerstraße in Schwabing, and Münter moved in one year later (fig. 6). On one of their excursions to the hinterland, when they were

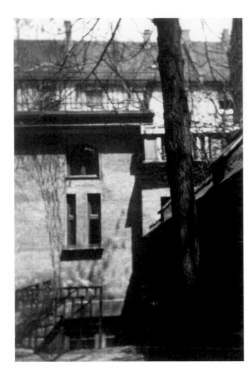

looking for a suitable place to paint, they discovered Murnau on Lake Staffel, located on a kind of terrace above the moorland plateau of Murnau Moos near Garmisch, southern Germany, with a broad view of the imposing peaks of the Alps. Delighted with the location, the gaily painted houses, and the reflected light of the Alpine foothills that often lent an unreal intensity to the colors, back in Munich they inspired Jawlensky and Werefkin with their enthusiastic comments. The result was a joint painting trip to Murnau involving all four artists in late summer 1908, during which the group soon found a new expressive form of painting for which they had long been looking. With their spirited technique and the power of the palette, they were torchbearers for a new style (fig. 7). Kandinsky switched immediately from the spatula to the brush, and over the next two years painted numerous views of Murnau and its environment with spontaneous, fluid strokes. He himself considered works painted directly from nature on smallish pieces of cardboard as "studies," from which he occasionally painted "a picture" in the studio, like the larger-format version of his *Murnau–Landscape with Tower* (*Murnau–Landschaft mit Turm*, 1908, plate 3).[23]

Kandinsky's close collaboration with Jawlensky and Werefkin in Murnau in 1908 led, during the following winter, to the idea of founding an artists' group, which eventually turned into the Neue Künstlervereinigung München (NKVM) (New Artists' Association of Munich), in January 1909.[24] At the end of 1910, Munich painter Franz Marc came into contact with the group, and in February 1911 was elected a member. He soon became a close ally of Kandinsky, sharing the progressive ideas and artistic innovations that had already set Kandinsky apart from the more moderate members of the group. When the conservative members of NKVM rejected Kandinsky's almost completely abstract *Composition V* (*Komposition V*, 1911, fig. 50) for their third exhibition, planned for early December 1911, Kandinsky, Marc, and Münter resigned from the association and organized an alternative exhibition at Heinrich Thannhauser's Moderne Galerie, which was known for exhibiting works by Heinrich Campendonk, Robert Delaunay, August Macke, and others. It opened to the public around the turn of the year 1911 to 1912 as *Die erste Ausstellung der Redaktion Der Blaue Reiter* (*First Exhibition of the Blue Rider Editorial*

6 Left: **Kandinsky's living quarters at 36 Ainmillerstraße, Schwabing, Munich (rear building), ca. 1908**

7 Below: *Grüngasse in Murnau*, 1909. Oil on cardboard, 33 x 44.6 cm. Städtische Galerie im Lenbachhaus, Munich

Office) (fig. 8). This title related to *Der Blaue Reiter* (*The Blaue Reiter Almanac*) that Kandinsky and Marc had been planning since June 1911 as a kind of yearbook, which was intended to become the vehicle for all new artistic movements both at home and abroad. It would also put into practice Kandinsky's already formulated idea of a synthesis of arts of all types. When *The Blaue Reiter Almanac* finally appeared in May 1912, it included among other things Kandinsky's important essay "Über die Formfrage" ("On the Question of Form") and the stage directions for his abstract stage composition *Der gelbe Klang* (*Yellow Sound*), in which painting, music, color, sound, light, movement, and the spoken word would form a new unity.[25] Kandinsky and Marc, as the editors of *The Blaue Reiter Almanac*, had also collected and included numerous examples of "primitive" art in the publication, including popular Bavarian *Hinterglasbilder* (reverse glass paintings), which Kandinsky and Münter had begun to collect in the Munich years (fig. 9). Notably, the Hinterglasbilder, with their plain black outlines and bright unmixed colors, were a powerful inspiration for their painting in this period. Their religious subject matter was likewise reflected in Kandinsky's paintings, watercolors, woodcuts, and his own Hinterglasbilder, particularly around 1911, and form an undercurrent of encoded symbols in his major paintings up until the outbreak of World War I. The figure of Saint George played an especially important role in Kandinsky's work; he appealed to the artist for his position as the patron saint of both Moscow and Murnau, and is therefore present in numerous works. For the cover image of *The Blaue Reiter Almanac*, Kandinsky transformed the motif of Saint George as a dragon killer—detaching him from all Christian allusions—into a symbolic figure representing the triumph of the spirit over materialism (figs. 10, 11; see *St. George III* [*St Georg III*], 1911, plate 24).

In the years after 1909, Kandinsky merged the hitherto separate fields of landscape painting, nostalgic figurative scenes, and religious subject matter in his large oil paintings. Meanwhile, color and line increasingly went their separate ways, so that while the depiction of objects was often limited to drawn ciphers, color flowed freely over the picture and soon formed completely abstract islands. Also in 1909, Kandinsky began to divide his larger oil pictures into three

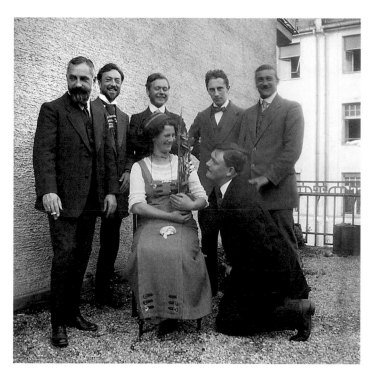

8 Friends of Der Blaue Reiter (The Blue Rider) and the Moderner Bund, Zurich, on the balcony of Kandinsky and Münter's apartment at 36 Ainmillerstraße, 1912. Standing, left to right: Cuno Amiet, Kandinsky, Helmuth Macke, Heinrich Campendonk, and Louis Moiller; front: Mrs. Anna Amiet and August Macke

9 Wall with glass paintings in Kandinsky and Münter's apartment, 36 Ainmillerstraße, ca. 1913

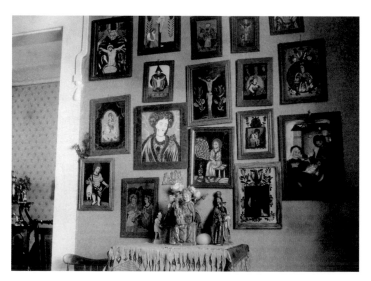

categories, which in the final passage of *On the Spiritual in Art* he describes as follows:

> 1. The direct impression of "external nature," expressed in linear-painterly form. I call these pictures "Impressions."
> 2. Chiefly unconscious . . . impressions of "internal nature." I call this type "Improvisations."
> 3. The expressions of feelings that have been forming within me in a similar way (but over a very long period of time), which, after the first preliminary sketches, I have slowly and almost pedantically examined and worked out. This kind of picture I call a "Composition." Here, reason, the conscious, the deliberate, and the purposeful play a preponderant role. Except that I always decide in favor of feeling rather than calculation.[26]

Whereas, up until 1914, Kandinsky had painted over thirty-five *Improvisations*, he only painted ten *Compositions* in his entire life, some before World War I, one during the Bauhaus period, and two in his later Paris years. It is, at any rate, certainly no accident that *Compositions V*, *VI* (1913, fig. 39), and *VII* (1913, fig. 51) are strongly imbued with figurative relics of religious subject matter (motifs of salvation), and are devoted to the subjects of the Last Judgment and the Deluge.

Regarding the principal characteristics of Kandinsky's abstraction before 1914, it is important to emphasize that his process of abstraction was effected by encoding and concealing representational relics that lent the pictures their "inner sound" despite their increasingly unrecognizable condition. In the process of concealment, the inner resonance could thoroughly deviate from the external shell, which further highlights another important aspect of Kandinsky's work, namely his penchant for thinking in terms of contrasts and oppositions in his disposition of forms. This is described in much greater detail in "Kandinsky über seine Entwicklung," (Kandinsky's "Cologne Lecture"), of 1914, than in his much-quoted "Reminiscences":

> Secondly (and this is closely bound up with my inner development), I did not want to banish objects completely. I have in

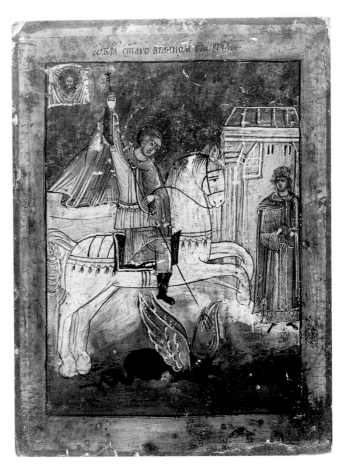

10 **St George, nineteenth-century icon from Kandinsky's estate.** Oil on wood, 29.5 x 22.5 x 2.3 cm, Musée national d'art moderne, Centre Pompidou, Paris

many places spoken at length about the fact that objects, in themselves, have a particular spiritual sound, which can and does serve as the material for all realms of art. And I was still too strongly bound up with the wish to seek purely pictorial forms having *this* spiritual sound. Thus, I dissolved objects to a greater or lesser extent within the same picture, so that they might not all be recognized at once and so that these emotional overtones might thus be experienced gradually by the spectator, one after another. Here and there, purely abstract forms entered of their own accord, which therefore had to produce a purely pictorial effect without the above-mentioned coloration. In other words, I myself was not yet sufficiently mature to

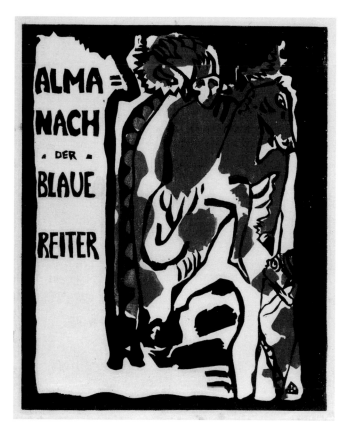

11 Woodcut cover of *Der Blaue Reiter* (*The Blaue Reiter Almanac*, 1912),
1911. 27.9 x 21.1 cm. Städtische Galerie im Lenbachhaus, Munich

experience purely abstract form without bridging the gap by
means of objects. If I had possessed this ability, I would
already have created absolute pictures at that time.[27]

Here we observe a key term that appears alongside the word "abstract"
and was critical for Kandinsky's artistic efforts in the prewar years,
namely "absolute." For him, absolute painting meant the creation of a
wholly abstract art created with "purely painterly" means, independent
of representation and in accordance with its own autonomous com-
positional laws such as he saw in music:[28] "Thus the period of transi-
tion to pure painting, which is also called absolute painting, and the
attainment of the abstract form necessary for me."[29]

Another important stylistic resource for the complicated pro-
cess whereby Kandinsky achieved this objective was the principle of

antithesis, mentioned above, which ultimately runs through his oeu-
vre. Opposing tensions involved not just those regarding subject mat-
ter—for example, the conflict between light and darkness—but also
those of an increasingly formal nature. For instance, he himself said
in his writings that he distributed colors not only on a single plane,
but over different pictorial depths, thereby pushing forward into a new
dimension of color space—for example, in *Improvisation 26 (Rowing)*
(*Improvisation 26 [Rudern]*, 1912, plate 29) or the highly complex
Composition VII (fig. 51). In addition, Kandinsky introduced the possi-
bility of a rotational movement in space, something that would later
became important for the trapezoidal shapes of his constructive works
of the Russian years and Bauhaus period: "I distributed my weights so
that they revealed no architectonic center. Often, heavy was at the top
and light at the bottom. Often, I left the middle weak and strength-
ened the corners. I would put a crushing weight between parts that
weighed little. I would let cold come to the fore and drive warm into
the background."[30] Kandinsky continued this approach in both his
writing and his work with almost infinite variability, and even in this
kind of formal procedure, his desire for encryption and polyphony is
discernible. As the artist explained of his approach, this variability of
form can adopt individual pictorial elements as resources for abstract
and "absolute" pictures. He discovered, he said, with the "prime color
white" that the character of a color or a line, for example, could be
redefined ad infinitum: "This revelation turned the whole of painting
upside-down and opened up before it a realm in which one had pre-
viously been unable to believe. i.e., the inner, thousandfold, unlimited
values of one and the same quality, the possibility of obtaining and
applying infinite series simply in combination with one single quality,
tore open before me the gates of the realm of absolute art."[31]

The gates of pictorial art (to continue Kandinsky's metaphor)
were indeed torn open with his large pictures of around 1913–14, such
as *Fugue* (*Fuga*, plate 43) and *Black Lines* (*Schwarze Linien*, plate 39),
and opened up new levels of meaning through the elimination of rep-
resentation. In an essay called "Abstrakt. Absolut" (Abstract. Absolute,
1912–13), only recently published, Kandinsky sought to put this devel-
opment into a historical context with a "first" and a "second" period.[32]

Even if one does not abide his faith in the "spiritual" and in an "epoch of the great spiritual,"[33] which he championed in the prewar period with an immense sense of mission, the pictures of his "heroic" period before World War I (and their expressive abstraction), are among the most outstanding works of twentieth-century painting.[34] His fellow artists, Marc and Alfred Kubin, and even his gallerist Herwarth Walden recognized the revolutionary importance of Kandinsky's work and described it impressively. Shortly before the outbreak of war, Kandinsky visited his close friend and companion Marc: "In those last days before the war, Kandinsky visited us [Maria and Franz Marc] again in Ried— in an extremely depressed mood—as if he suspected what was coming. They probably both—Kand.[insky]—Franz—foresaw that they would never see each other again. We went with him to Kochel—the goodbyes were heavy and gloomy."[35]

As a Russian and thus a citizen of an enemy power, Kandinsky had to leave Germany within a few days of the outbreak of World War I. He and Münter initially went to Goldach on the Swiss side of Lake Constance. Marc was killed in battle near Verdun in March 1916. In November 1914, Kandinsky and Münter parted in Zurich, and Kandinsky set off on an arduous six-week journey across the Balkans to Odessa with a group of relatives, including his former wife Anja, and then back to his home city of Moscow, arriving there at the end of December 1914. Shortly after arriving, he wrote to Münter: "I did of course read the note you gave me before I set off. . . . But it seems to me that the form I proposed is best. In recent times I have acquired many new gray hairs, and the journey was indeed not responsible for them. My conscience oppresses me. . . . But time will bring counsel. The enforced long separation will undoubtedly bring clarity to many things."[36]

LOOKING BACK, LOOKING FORWARD: RUSSIA, 1915–21

In early 1915, Kandinsky moved into the top floor of the tenement block he had built in Moscow's Dolgy Street in 1913, on the corner of Zubovsky Square. From the turret room, he had an extensive view over the square and the skyline of Moscow. Initially, the circumstances of his emigration and the abrupt end to his life in Munich continued

to have a numbing effect on his creativity. He had stopped painting in the summer of 1914, and throughout 1915 did only drawings and watercolors. Meanwhile, in May 1915, Münter moved to Stockholm so as to be able to meet Kandinsky in neutral territory, a promise of reunion she had exacted from him before his departure. However, he constantly postponed the visit and only arrived in the Swedish capital at the end of December, after Münter had arranged solo shows for both of them at Carl Gummeson's Konsthandel in Stockholm, the distinguished gallery in Strandvägen that was Walden's contractual partner. He stayed two and a half months until mid-March 1916, and then returned to Russia. It was the end of their affair. In Stockholm, Kandinsky did mainly works on paper, frequently watercolors with bright colors and forceful lines in black Indian ink, "in which [he] not only followed the abstract formal language of the previous years but also, compositionally, looked back on the paintings of the Munich period as a kind of 'ricordo.'"[37] But his watercolors and Hinterglasbilder reveal not only echoes of the Munich period with their surprisingly naively drawn figures, but whirl these elements through space in a novel floating way, detached from any terra firma such that their very instability emphasizes—indeed, treats ironically— their fairy-tale, fantastic character. In his hinterglas picture *Harbor* (*Hafen*, 1916, fig. 12), for example, two women in hoop skirts absorbed in conversation (left) and a mounted gallant, in similarly contemporary costume (right), flank a curious opening at centerstage containing a vision of two huge, archaic sailing ships apparently moving toward the viewer, while behind them Bavarian-looking landscape elements appear in a pile. At the top left, the distorted silhouette of the Akhtyrka house of the artist's Russian relatives seems to be hurled out of the picture by a flying force, while on the right a cloud or sun sends forth its rays, and below (at the center), a naively drawn dog trots along (its antecedants appear in Kandinsky's early work and in Russian Art Nouveau and *lubki*).

A watercolor of *The Firebird* (*Der Feuervogel*, 1916, fig. 13) shows a similar structure, with other figures that are borrowed from Russian fairy tales—the Firebird, the sleeping king, Baba Yaga the witch, and the young rider in a peasant shirt, whose emblematically

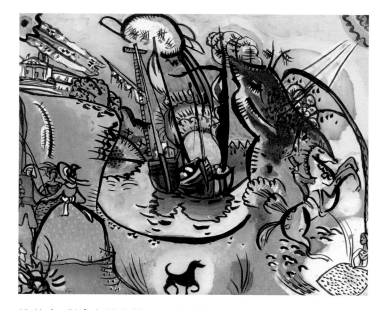

12 *Harbor (Hafen)*, 1916. Glass painting, 21.5 x 26.5 cm. The State Tretyakov Gallery, Moscow

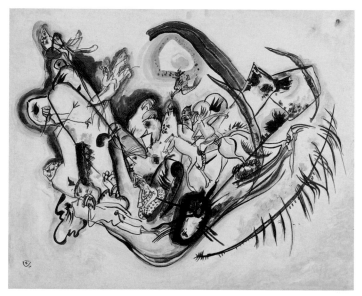

13 *The Firebird (Der Feuervogel)*, 1916. Watercolor and ink on cardboard, 51 x 61 cm. The State Pushkin Museum of Fine Arts, Moscow

turned-back posture art historian Peg Weiss has traced back to the ritual models of the folk art of northern Siberia.[38] Kandinsky combines them all with a rider (leaping upward at left, like a signal from the Blaue Reiter period) and (turning into the watercolor at the top left) a little horse that almost looks like an allusion to Marc. All the pictorial elements, together with the familiar landscape remnants, are laid out distinctly on a free-floating disk in space. Leaving zones free in the margin is a characteristic that crops up particularly in Kandinsky's paintings of the Russian years, and may possibly be seen here as an artistic expression of his personal situation. Along with these watercolors, which Kandinsky called *Trifles (Bagatellen)* (obviously at Münter's suggestion),[39] he also ventured back into paint again, doing three works in Stockholm—of which only *Painting on Light Ground (Na Svetlom Fone,* 1916, plate 46) has survived—and later continuing with *Moscow I (Mockba I,* 1916, plate 47) in autumn. The impressive metamorphosis of *Moscow I* in particular is a clear citation from his Munich period. Standing on a narrow mountain outcrop above a city exploding in every direction is a small couple with their backs to the viewer wearing Bavarian costumes very similar to and in almost

the same coloration as in the river scene in *Improvisation Gorge (Improvisation Klamm,* 1914, plate 44), where they are in frontal view.

Finally, Kandinsky did another series of six serially numbered etchings in Sweden, four of which elaborate the wholly abstract, fine linearity of his pure pen-and-ink drawings, while two of them feature the naive figures of the *Trifles,* who in *Etching III (Radierung III,* 1913–14) are whirled about almost comically.[40]

In autumn 1916, Kandinsky made the personal acquaintance of Andreevskaya, whose voice had so fascinated him when he heard it by chance in a telephone conversation. The almost fifty-year-old artist and the young officer's daughter, who was more than thirty years younger and lived at the time with her widowed mother and sister, soon became a couple. They married in February 1917, spent a large portion of the summer at the Akhtyrka estate, and in September their son Vsevolod was born. This is not the place to speculate whether the premature pregnancy was the reason for Kandinsky's decision to get married again. However, the couple lived in symbiosis. From then on, as Nina writes in her memoir (*Kandinsky und ich* [Kandinsky and I], 1976), they were hardly apart for a single day,

and she proved an understanding partner who looked after the practical side of Kandinsky's business affairs.

That year, up until October, Kandinsky did twenty paintings and a series of Hinterglasbilder. With the outbreak of the October Revolution, his output as a painter came to a halt until mid-1919. During the intervening period, his numerous duties on various revolutionary cultural and political committees claimed all his time (see the chronology in this catalogue).[41] His activity in the top ranks of the Department of Art at the newly established People's Commissariat for Enlightenment (IZO NKP) (to which he was appointed in early 1918), his teaching job in the Free State Art Studios (SVOMAS), and his involvement from 1920 with the Institute of Artistic Culture (INKhuk, also founded 1920) prompted him to further systematize his theoretical ideas about painting, and filter them into his teaching and major conceptual ideas. In 1919, he published inter alia the essay "Malenkie stateiki o bolshim: O tochke; O linii" ("Little Articles on Big Questions. 1. On Point 2. On Line"), which, like his paintings in this period, went back to ideas he had sketched out pre-1914 and at the same time anticipated his Bauhaus publication *Punkt und Linie zu Fläche. Beitrag zur Analyse der malerischen Elemente* (*Point and Line to Plane: A Contribution to the Analysis of Pictorial Elements*) of 1926.[42] The same year, he painted the many-layered composition *In Gray* (*V Serom*, 1919, plate 50), one of six new paintings that, in retrospect, he described as "the final flourish of my 'dramatic' period." Indeed, it is a late example of the accumulation of busy, vortexlike shapes, not only formally, but also in terms of subject matter. It is the final work in which largely "Munich" motifs are encrypted, as is made even more obvious in a preparatory sketch for the painting.

From 1920, a new repertory of forms made its appearance in Kandinsky's works under the unmistakable influence of the Russian Constructivists, including fellow artists such as Ivan Klyun, El Lissitzky, Ivan Puni, Alexander Rodchenko, and even the Suprematist Malevich. Summed up briefly, these motifs and tools included the introduction of geometrical shapes; the perception of an open visual space with expansive, often monochrome background fields, providing the possibility of rotating movement in space; and forms that underscore this sense of movement, such as trapezoids and chessboard patterns. Particularly

in 1921, Kandinsky tried out these tools in important large-format works such as *Multicolored Circle* (*Pestry Krug*, 1921, plate 57), *Red Spot II* (*Krasnoe Pyatno II*, 1921, plate 54), *Blue Segment* (*Siny Segment*, 1921, plate 55), *White Center* (*Bely Tsentr*, 1921, plate 56), and *Circles on Black* (*Krugi na Chyornom*, 1921, plate 58). In adopting geometrical figures (especially the circle), Kandinsky was by no means seeking a reduction of form, as had happened most radically with Malevich's *Black Square* (1915). Malevich's painting was a destruction of painting as an artistic process and form of expression; it was an "inflation" that would put the resources of art into everyone's hand, "so that the best way to do your works would be to order them from the house painter by telephone from your bed."[43] Constructivism, in its association with technology and mechanics, was also ultimately alien to Kandinsky, although he esteemed fellow artists such as Vladimir Tatlin and was in close contact with Rodchenko, who, with his partner Varvara Stepanova, lived with Kandinsky for a while as subtenants.[44] All his life, Kandinsky constantly drew a line between himself and the "mechanicalism" of the Constructivists, beginning in his interview with Charles Julien in Russia in 1921, and subsequently in his writings and letters of the late 1930s.[45]

What Kandinsky gained from Constructivism was encouragement in his search for purely painterly elements without any reference to reality, in his striving for ever purer forms: "Geometric or free boundaries that are not connected with any real object, and, like colors, create excitations that are nonetheless not as precisely defined as those of a real object. They are more open-ended, elastic, and abstract."[46] The fact that, in his form of abstraction, Kandinsky always adhered to the depiction of "figures," whether representational or abstract, distinguishes him not only from the Constructivists, but also from the abstraction of the De Stijl movement and from applied art in the Bauhaus context, as is briefly touched upon later.

This is not the place to go into detail about the political and artistic conflicts that increasingly left Kandinsky isolated in his Moscow environment, as this has been heavily discussed elsewhere.[47] However, it seems worth quoting a contemporary voice that is largely overlooked today, namely Konstantin Umansky, the Berlin art writer and Bohemian whom Kandinsky met several times in Moscow in 1919 and who, in his

1920 book on new art in Russia, described the factional divisions between the artists and the contradictions of Kandinsky's position very precisely:

> The "Spiritual in Art" triumphs today in Russia among artists who are striving for "absolute Expressionism." We need to distinguish two groups in this respect: 1. The solitary *Kandinsky* group, and 2. The K. *Malevich* group, which represents *"Suprematism."* Vasily Kandinsky's work is no less familiar and esteemed in Germany than it is in Russia. Though Kandinsky is not enough per se to characterize new Russian art, he is a shining example of the pace itself of Russian art and the almost prophetic role that it plays in the development of world art. (Those absolute values of abstract Expressionism, which are now, in 1920, considered the objectives of art outside Russia, were found by Kandinsky already in 1909.) If anyone, Kandinsky merits the epithet "the Russian Messiah." Yet his influence on Russian artistic life and squad of imitators is not as significant as Kandinsky's friends in Germany appear to think. But perhaps an artist like Kandinsky needs to remain solitary—it is the best guarantee of further revelations of his profound spirituality. With his work he has paved the way for the victory of absolute art—but today abstract painting is heading in a different direction.[48]

Also in 1920, Umansky wrote an essay entitled "Kandinskys Rolle im russischen Kunstleben" (Kandinsky's Role in Russian Art Life) for the May–June issue of Hans Goltz's *Der Ararat* periodical.[49] Also mentioned in it is Ludwig Baer, the young artist and go-between in establishing the first new contacts between the Russian and German art scenes in the period directly after World War I.[50] In response to Baer's intermediary work, the Berlin-based Arbeitsrat für Kunst (Workers' Council for Art) sent a letter of support to the new international bureau for the arts (charged with helping Russian artists establish connections with European artistic life), to whose executive committee Kandinsky had been elected along with Anatoli Lunacharsky, Malevich, Sergei Poliakov, Tatlin, and others.[51]

The signatories of the letter included Berlin architects Bruno Taut and Walter Gropius. In the spring 1919 issue of the official Moscow art periodical *Khudozhestvennaia Zhizn*, there appeared an article about these contacts signed simply "K," which, as is clear from a footnote, was Kandinsky. In it, he mentions for the first time the newly founded Bauhaus ("This synthetic association of architecture, painting, and sculpture has, as far as I know, been accomplished at the new academy at Weimar") and the name of Gropius.[52] Gropius for his part referred not much later to a Narkompros program that Baer had brought to Germany and published in an issue of the art periodical *Das Kunstblatt*.[53]

It was undoubtedly through these contacts that, in 1921, Kandinsky received an invitation to the Bauhaus in Weimar, to talk about the Russian art scene. In 1920, Kandinsky had become the head of the Department for Monumental Art at INKhuk. On June 16, his son Vsevolod died after a heavy bout of flu and probably also due to malnutrition.[54] The parents themselves were increasingly suffering from the deprivations of these years, as is documented by a delayed-action photo (fig. 14) taken in their Moscow apartment in front of *Improvisation 4* (1909, plate 8). Also in June, Kandinsky presented his INKhuk pedagogical program at the First Pan-Russian Conference of Teachers and Students, Moscow SVOMAS, which the representatives of Constructivism rejected as too subjective and bourgeois. At the end of that year, Kandinsky left the institute.

Even so, Kandinsky's faith in the "spiritual in art" remained undiminished until far into the revolutionary period, as is evident from a self-description that he wrote in 1919, in the third person, for a Russian encyclopedia that was never published. The text was, however, published in German by Paul Westheim in his periodical *Das Kunstblatt*. Prior to his involvement with the often quoted *Cahiers d'Art*, *Das Kunstblatt* was Kandinsky's regular journalistic forum, and he continued to write important articles for it. Among other things, the text contains the following statement: "Kandinsky considers the late nineteenth and early twentieth century the beginning of one of the greatest eras of mankind's spiritual life. He calls it 'the era of the great spiritual.'"[55]

In early 1921, despite his conflicts with INKhuk, Kandinsky was appointed a member of the committee charged with founding a Russian academy of arts. Among the papers in his estate in the Bibliothèque Kandinsky, Paris, is his typewritten scheme for the Russian Academy of Artistic Sciences (RAKhN), Moscow, written in German and dated June 1921. One of his proposals concerns the setting up of a "Physio-Psychology Department" in which artists, in collaboration with scientists, should, to cite just one example, carry out laboratory experiments on the effects of color and form. The brief program prefigures, in part, his Bauhaus idea of a synthesis of the arts and, over and above that, a synthesis of the arts and sciences. At the end of the document, he emphasizes that the skills of artists alone would not be adequate to achieve all the objectives outlined, so that scholars such as "physicists, mathematicians, biologists, psychologists, chemists, physiologists, etc., and finally philosophers and theologians" should also be involved.[56]

14 **Vasily and Nina Kandinsky in front of** *Improvisation 4*
 (1909, plate 8) in their Moscow apartment, ca. 1917

The Russian Academy of Artistic Sciences was officially established in October 1921. As Kandinsky was not a member of the Communist Party, he was only appointed vice president, and Pyotr Kogan was appointed president. This disappointment, less than a year after leaving INKhuk, and also, most likely, the wretched living conditions, reinforced Kandinsky's decision to leave Russia. He accepted the aforementioned invitation by Gropius with delight, and at the end of December 1921, he and his wife Nina arrived in Berlin with twelve of his pictures in his luggage. Berlin was, at the time, the epicenter of Russian emigration in Europe. The description of their arrival in a state of shabbiness and exhaustion is one of the most moving passages in Nina Kandinsky's memoir.[57] It was undoubtedly no accident that the Kandinskys rented a furnished room in Motzstraße in Charlottenburg, Berlin, once you have read, for example, Marc Chagall's memoir of the "Russian" Berlin of the early 1920s: "In the basements of the Russian restaurant in Motzstraße there were more Russian generals and captains than in a Tsarist garrison city, only now they were cooks and washers-up. As far as I'm concerned, I have never in my life seen so many *wunder rebbes* [East-European rabbis] as in Berlin in 1922, or as many Constructivists."[58]

SYSTEMATIZATION OF ARTISTIC MEANS:
THE BAUHAUS, 1922–33

In the annals of the Bauhaus, it is not wholly clear whether Kandinsky received the invitation from Gropius to join the Bauhaus in Weimar when he was in Moscow in 1921, as the aforementioned contacts and Nina Kandinsky's memoir suggest, or only at the end of the year, after his return from Moscow to Germany.[59] It is, however, definite that Gropius visited Kandinsky in Berlin in March 1922, offering him a teaching post at the Bauhaus, and that after signing the contract, Kandinsky took up the job in Weimar in June. At the Bauhaus, founded by Gropius in 1919 through the merging of the art academy with the former arts and crafts school in Weimar, Kandinsky found a stimulating artistic environment that, like the new institutes in Russia, was striving for reform of, if not a revolution in, the arts, through the creation of a social utopia. The inaugural manifesto of the Bauhaus,

dated April 1919, still couched in terms of Expressionist pathos, began with the now famous proclamation: "The ultimate objective of all artistic activity is building!" and outlined a program for a new architecture based on a return to craft and the participation of all disciplines of craft art. After 1923, the institution changed direction, exemplified in the motto and title for the major exhibition put on for its fifth anniversary, "art and technology—a new unity."

When Kandinsky joined the staff—a group that included Lyonel Feininger, who ran the graphics workshops; Oskar Schlemmer, who headed the Bauhaus stage; and Kandinsky's former companion from the Blaue Reiter days, Paul Klee, who was in charge of the stained-glass workshop—it was a momentous turning point from the old to the new. Kandinsky took over as master (*Formmeister*) of the Wall Painting Workshop and also taught the Preliminary Course during his first years there. The Bauhaus offered Kandinsky an opportunity—indeed, a duty—to systematize, for practical teaching, his ideas about artistic means, and he took this obligation with characteristic great seriousness, but also with a certain restraint that is evident in his accompanying writings.[60]

One of Kandinsky's first projects at the Bauhaus was ornamenting a reception room for a planned modern museum. His decorations were temporarily exhibited at the 1922 *Juryfreie Kunstschau* (*Juryless Art Show*) at the Lehrter Bahnhof, a train station in Berlin. He and his students painted large-format wall coverings, following his designs (fig. 15). Already evident here, in the vividly conceived figurations on a black ground, is his constant emphasis on the concept of "pure" painting, to which Kandinsky adhered, despite having to take the architectural setting into account. This was in distinct contrast to the principles of applied art that Bauhaus pupils Alfred Arndt, Herbert Bayer, and Rudolf Paris used not much later in their coloration proposals for Bauhaus architecture.

An official publication, which describes the activities of the school and included pictures of Kandinsky's and Klee's workshops (figs. 16, 17), was produced on the occasion of the fifth-anniversary exhibition at the Bauhaus in collaboration with Berlin gallery owner Karl Nierendorf.[61] *Staatliches Bauhaus, Weimar, 1919–1923* also

contained the first of the four important theoretical essays that Kandinsky wrote during his time at the Bauhaus and that were published in Bauhaus organs. The short article on "Die Grundelemente der Form" ("The Basic Elements of Form," 1923) stressed, right from the start, the synthetic work of the Bauhaus as an article of faith in which art, science, and industry are united. This concept only partly coincided with his frequently stated ideas on synthesis and synthetic art. The longer essay on teaching color ("Farbkurs und Seminar" ["Color Course and Seminar," 1923]) set out his ideas for the more practical objectives of his workshop on wall painting: "Here, a logical set of relationships has to be devised. The individual applications of color demand a special study of the organic makeup of color, its life-force and expectation of life, the possibility of fixing it with binding materials—according to the actual instance—the technique naturally associated with it, the way of putting on color—according to the given purpose and material—and the juxtaposition of color pigment with other colored materials, such as stucco, wood, glass, metal, etc."[62]

The photograph of the storeroom of Kandinsky's workshop vividly reflects his lifelong interest in the color techniques, pigments, and binders that compose the material side of his painting, which he was now obligated to systematize for practical teaching purposes (fig. 16). This obsessive craft-based approach to color also distinguished him

15 Installation view of *Juryfreie Kunstschau* (*Juryless Art Show*), Lehrter Bahnhof, Berlin, 1922, showing Kandinsky's wall decorations

16 **The wall painting workshop; Master: Vasily Kandinsky.** Illustration in *Staatliches Bauhaus in Weimar* and Karl Nierendorf, eds., *Staatliches Bauhaus, Weimar, 1919–1923* (Weimar and Munich: Bauhaus Verlag, 1923), not paginated

17 **The glass painting workshop; Master: Paul Klee.** Illustration in *Staatliches Bauhaus, Weimar, 1919–1923*

from the more filigreed painting of Klee, whose character seems to be reflected in the photograph of his glass-painting workshop (fig. 17).

But even at the Bauhaus, Kandinsky regarded the use of color only as a means to an end, that of attaining a sphere of independence through painting. His polemic against the idea of wall painting as purely applied art has to be seen in that context. From as early as 1924, Kandinsky distanced himself from what he saw as the Bauhaus's over-emphasis on mere "production" for external commissions. It was a view that he repeated again in 1929—in an environment of aggravated tensions—in his ironic essay "Die kahle Wand" ("Bare Wall").[63]

But more important for Kandinsky's contribution to the Bauhaus than these statements about wall painting was his teaching in the Preliminary Course, which he initially began with an analysis of the fundamental formal elements (triangles, squares, and circles) and their corresponding three-dimensional bodies (pyramids, cubes, and spheres), assigning the three primary colors of yellow, red, and blue to these basic elements.[64] This is not the place to go into the individual aspects of his teaching, as it has already been done in exemplary fashion elsewhere. Nor is it the place to discuss his certainly already marked dogmatism or his professorial and politely aloof appearance, as is

commented on in reports from pupils and colleagues and confirmed by photographs.[65] The aim here is to concentrate on his paintings and the principal aspects of his theories, touching on a few neglected points. One of many larger paintings from Kandinsky's first years at the Bauhaus is *Yellow Accompaniment* (*Gelbe Begleitung*, 1924, plate 64). The geometric reinforcement of the shapes is conspicuous, but so is their variety and complexity. The retraction of the multiply overlaid elements of irregular rectangles, circles, and semicircles, as well as the central oval and angle of the light edges in the picture's center link the work to paintings from around 1919 and even to those of the pre-war period. Zigzag lines and clusters of rays rush together in the center, and symbolic relics such as general shapes of small boats or the large curved outline of the back of a rider are discernable. Drama and emotion dominate the visual impression more than in any other abstract painting of the time. The picture is, of course, inconceivable without Kandinsky's familiarity with the Russian Constructivists' (for example, Lissitzky's or Klyun's) three-dimensional shapes, which seem to move forward and backward out of the picture plane. Similarly, the precisely drawn rays are reminiscent not only of pre-1921 experiments by Rodchenko, but also of the collages and "photo sculptures" of László

Moholy-Nagy, who joined the Bauhaus staff as a teacher in 1923, with the support of Kandinsky, among others.[66]

One also senses in Kandinsky's later Bauhaus pictures, such as *Pointed Structure* (*Spitzenbau*, 1927) and *Light Counterpressure* (*Leichter Gegendruck*, 1929), the influence of shapes pulled from industry and technology. After all, he taught at the Bauhaus, a center of design closely associated with industry, whose everyday outlook, particularly later, in Dessau, Germany, was increasingly influenced by such shapes. It is often forgotten that Kandinsky himself depicted examples of industrial shapes. For example, he had photographs of high-voltage electricity pylons and included a photograph of a radio-mast structure by Moholy-Nagy in his main theoretical work of those years, *Point and Line to Plane*, the manuscript of which he finished at the end of 1925 and which appeared as volume 9 in the series of Bauhaus books in 1926 (fig. 18).[67] Industrial photography of this kind was very visible in the 1920s and was published in widely distributed periodicals such as *Der Querschnitt* or Westheim's *Das Kunstblatt*, which included technical photos by Germaine Krull and others. The first number of Christian Zervos's *Cahiers d'Art* in 1926 likewise had photos of factory chimneys and electricity pylons under the heading "Le Lyrisme contemporain" (Contemporary Lyricism). Another influence on Kandinsky was perhaps the dead-straight intersecting diagonals of architectural designs by his Bauhaus colleague Ludwig Hilbersheimer.

Finally, depictions of physical processes, which formed part of Kandinsky's theoretical teaching at the Bauhaus and, to judge from his library, were of particular interest to him in these years, also played a part in his pictures of the time. His estate includes a richly illustrated volume by Felix Auerbach called *Physik in Graphischen Darstellungen* (Physics in Graphic Representations, 1912) that still includes strips of paper, written in Kandinsky's own hand, inserted, to mark, for example, illustrations of "radiant warmth" and the "deformation of a power curve." There are demonstrable connections between such illustrations and his paintings. In using such representational means, he sought to bring out the inner, "abstract" forces of nature and transforming them into the cosmos of painting.[68] Finally, in addition to these adoptions of new (that is, contemporary) optical shapes in his work of the

1920s, Kandinsky set out his views on geometry in art in the two-page manuscript "Kann Geometrie Kunst sein oder nicht?" (Can Geometry Be Art or Not?). Here, he mentions that technical drawings of machines, physical representations, or the like, can also be artistic: "And: *any* shape is a living shape, i.e. radiates inner forces." At the same time he took another swipe at the Constructivists in this discussion: "But woe to the painter who stops short at botany, anatomy, psychology, and geometry—he becomes a slave of lifeless realism. That can clearly be seen in the Constructivists, who remain immured in geometry and can't get out of it. They become lifeless realists."[69]

In December 1924, under the influence of the National Socialist party, the city council of Weimar decided to close the Bauhaus, and the following year the school and its staff moved into the residential and industrial city of Dessau, where initially they were housed in temporary accommodations. In summer 1925, construction began on a new Bauhaus building, following designs by Gropius, and on the master houses for the staff: double houses for Moholy-Nagy/Feininger, Georg Muche/Schlemmer, Kandinsky/Klee, and a single house for Gropius. After the move to Dessau, Kandinsky and Klee instituted their free (easel) painting classes, which took place in Klee's studio or, in Kandinsky's

18 **Industrial photographs.** Illustrations in Kandinsky's *Punkt und Linie zu Fläche* (*Point and Line to Plane*). Bauhaus Bücher 9 (Munich: Albert Langen, 1926), pp. 114–15

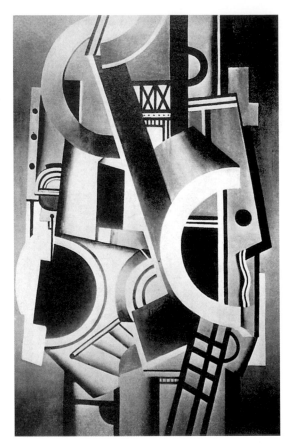

19 **Fernand Léger, *Peinture*, 1924.** Illustration in *Cahiers d'Art 4*
(May 1926), p. 63

case, on the premises of the Bauhaus building. Alongside this, Kandinsky continued to teach the compulsory Preliminary Course for the first terms, expanding it to include "abstract formal elements (color, form)" and "analytical drawing." He passed the class for wall painting to Hinnerk Scheper.[70]

In June 1926, Vasily and Nina Kandinsky moved into their new master house, where Paul and Lily Klee were their close neighbors. Within a short time, the Russian painter had designed his house in accordance with an ingenious color scheme.[71] Here again, he developed some of his thoughts on antitheses and contrasts that, taken together, were intended to produce a particular "sound," as he described it in an unpublished manuscript about his black-painted dining room. The manuscript had the apropos title "Bemerkungen zum schwarz-weißen

Esszimmer" (Remarks on the Black-and-White Dining Room, January 1927). The dining room, sparsely furnished by his Bauhaus colleague Marcel Breuer, had only one wall that did not contain architectural features such as windows, doors, or hatches, and it could be seen from a distance from the sitting room. Of it, Kandinsky wrote: "I had [it] painted smooth black." On this wall he hung a single square colored picture, initially his painting *On White II* (*Auf Weiß II,*1923), later exchanging it for a similar-sized picture called *Three Sounds* (*Drei Klänge*, 1926, plate 69) (fig. 20). "As a result of the almost mischievous division of the large surfaces into two very different smaller ones, the colors (and they are very serious colors) gained a double sound— seriousness and concentration on one side, stimulating merriment and cheerful agility on the other."[72]

Such constructive tension and dynamism, which is masterfully incorporated within the planar structure of *On White II*, is evident in other Kandinsky pictures from the Bauhaus period that suggest more three-dimensional volumes. This structure, however, is different from the three-dimensional plasticity, derived from Cubism, that was accentuated by contemporaneous painters, such as Fernand Léger (fig. 19).[73] There are always lines floating around in Kandinsky's works— straight, zigzag, curved, or arched—as well as bars, planes of a wide range of shapes, and formal elements such as triangles, circles, and rhomboids, apparently charged in the pictorial space with connotations of significance, making his painting in this period quite unmistakable, despite the reduction to basic geometric elements. Indeed, Kandinsky devoted a whole book to investigating elements of this kind in his Bauhaus period, the exhaustive *Point and Line to Plane*. Prima facie, as an analysis of graphic and painterly techniques ranging from points to whole compositions, this book sounds daunting and exhausting as well as exhaustive—and not without reason. According to his own statement in the foreword, he had started thinking about the subject and making notes in 1914 at Goldach on Lake Constance. In fact, he had already explored some aspects in his articles "On Point" and "On Line," published in 1919 during his time in Russia. But upon a closer look, there is a surprising degree of philosophical thought in it. He generally switches directly

20 Kandinsky's dining room with *Three Sounds* (*Drei Klänge*, 1926, plate 69), Bauhaus house, Dessau, Germany, ca. 1927

21 Kandinsky and Paul Klee, Bauhaus house terrace, Dessau, ca. 1929

from the driest formal analysis to loftier thoughts in his profound conviction that (dead) "materialism" should be rejected in favor of the (living) "spiritual" nonmaterial.[74] These interesting ideas, which would also lead deep into Kandinsky's Bauhaus pictures, unfortunately cannot be pursued here and can only be summed up with a terse comment by Kandinsky himself: "I have made an attempt in this direction in my book *Point and Line to Plane*. The analysis of the external element of form should act as a pointer to its internal element." This remark comes from Kandinsky's important theoretical essay "Und. Einiges über synthetische Kunst" ("And, Some Remarks on Synthetic Art," 1927), which he wrote in Amsterdam for international periodical *i10*.[75]

Shortly after they moved into the master house in Dessau, Kandinsky and Klee were visited by a young Viennese art historian of Russian origin, Fannina Halle, probably at the suggestion of Westheim. Her account of her visit, which was published in *Das Kunstblatt* in July 1926, gives another authentic glimpse of the design of the house and workshop and pleased Kandinsky so much that he made friends with her and often suggested her as an author about his work.[76] From outside, Halle said, the double houses built in the minimalist Bauhaus style looked rather the same:

However, a view of the interior of either of these houses makes us immediately aware of the great variety of worlds latent in all the white-on-white concrete walls, a difference that is probably nowhere as obvious in any of these double houses as in nos. 6–7, where two strong artistic personalities, Kandinsky and Klee, live under one roof, both of them working as master at the Bauhaus. Kandinsky's is the entrance on the left. Past a coolly subdued area in pale pink, one of whose partition walls is gilt, and past another in pure black, but lit from afar by a brightly colored picture and a shiny white round tabletop as if by two suns, you go up a narrow staircase, and even on the way up to the artist's studio you are led to the conclusion that he likes pure, cold colors and that every shape and every color tone has a meaning of its own and a meaning in combination. The door opens and there we are standing in the middle of a realm already detached from Earth whose tirelessly creative master, forever young and humanly outstanding, already in 1912—before war, revolution and the various successive "isms"—proclaimed an almost prophetic rebellion and the onset of a new age and a new spirituality. They now stream down on us on all sides, the large and small, endlessly new miracle

worlds conjured up in oil and tempera, watercolor and gouache, with a culture of mastery, eye, and taste prospering with the utmost refinement as the ripe fruits of recent years.[77]

During their five years as neighbors in Dessau, up until Klee's departure for the Düsseldorf Academy in 1931, Kandinsky and Klee built their friendship (fig. 21). In the first issue of the school periodical *bauhaus* (launched in December 1926), which celebrated Kandinsky's sixtieth birthday, Klee wrote a brief, friendly introduction, just as he wrote a personal introductory essay for the catalogue for Kandinsky's sixtieth-birthday exhibition at the Galerie Arnold in Dresden (*Kandinsky. Jubiläums-Ausstellung zum 60. Geburtstage*). Contributors to this latter catalogue included Katherine Dreier, Will Grohmann, and Halle, who wrote, by far, the longest article, with interesting remarks on the Russian origins of Kandinsky's art.[78] Attention has been drawn several times to Klee's influence, particularly on Kandinsky's works of the late Bauhaus years, for example, in the use of spraying techniques in Kandinsky's watercolors such as *Dark* (*Dunkel*, 1928) or *Wandering Veils* (*Wanderschleier*, 1930).[79] Kandinsky was also perhaps rather taken with Klee's imaginative titles, and tended to give his own titles increasing importance. With the exception of *Wandering Veils*, Kandinsky's titles were always restricted to colors, shapes, and their relationships, such as *Black Spot* (*Schwarzer Fleck*, 1921), *Double Ascension* (*Doppelter Aufstieg*, 1925), *Yellow–Red–Blue* (*Gelb–Rot–Blau*, 1925, plate 66), or *Accent in Pink* (*Akzent in Rosa*, 1926, plate 68), but in the late 1920s, emotional qualities such as *moody* (*launisch*), *cheerful* (*heiter*), or *heavy* (*schwer*) were added.[80] At this time, both artists seem to have been stimulated by the aerial photographs made by Junkers, whose headquarters was in Dessau close to the Bauhaus. The school commissioned the firm to take aerial photos of their own buildings and published them in *bauhaus* (fig. 22). Works by Klee such as *Highway and By-ways* (*Hauptweg und Nebenwege*, 1929) and *Monument in the Fertile Country* (*Monument im Fruchtland*, 1929) could have been influenced by them, as well as pictures of Kandinsky's, such as *Fragment* (*Ausschnitt*, 1929) or *Balance–Pink* (*Ausgleich–Rosa*, 1933), which look like geometrized impressions of landscape views.[81] Klee's

observation about similar works such as *Individualized Altimetry of Layers* (*Individualisierte Höhenmessungen der Lagen*, 1930) after his trip to Egypt in 1929, would also support such an assumption: "It is interesting that, despite all the abstraction, the thing remains real. . . . One could almost think that something has been painted from nature, from a model, as it were."[82]

In his turn, Kandinsky produced a fine valedictory article testifying to his friendship with Klee and the close neighborly relationship in the master houses for the 1931 issue of *bauhaus* magazine, which was devoted to Klee upon his departure:

As far as i personally am concerned, may i permit myself to express something subjective. more than twenty years ago, i moved into the ainmillerstraße in munich, and soon learned that the young painter paul klee, who had just made his first successful debut at the galerie thannhauser, lived almost next door to me. we remained neighbors up until the outbreak of war, and from this period dates the beginning of our friendship. we were blown away by the war. only eight years later did fate bring me to the bauhaus in weimar, and so we became—klee and i—neighbors for a second time: our studios at the bauhaus were situated almost side by side. soon followed another separation: the bauhaus flew from weimar with a rapidity that a zeppelin might have envied. to this flight klee and i owe our third and closest period of proximity: for more than five years we have been living right next to one another, our apartments only separated by a fireproof wall. but despite the wall, we can visit one another without leaving the building, by a short walk through the cellar. bavaria—thuringia—anhalt. what next? but our spiritual proximity would have existed even without access through the cellar.[83]

The Bauhaus was indeed cast out, due to growing pressure from the Nazis, though not with the same speed as it had been in Weimar. In August 1932, the Dessau community council decided to dissolve the Bauhaus on October 1. Toward the end of the year, the institute moved

with its last director, Ludwig Mies van der Rohe, and the surviving teaching staff to an empty former telegraph factory in Steglitz, Berlin, where it continued operating as a private school until it was finally closed down in summer 1933.[84] This is not the place to go into the details of this process (or the political tensions within the Bauhaus itself), in which Kandinsky took sides with the conservative members who, in 1930, had brought about the downfall of Communist sympathizer Hannes Meyer, who had run the school between Gropius's departure and the arrival of Mies van der Rohe.[85] Alongside his marked attitude of political abstinence learned during the years of the Russian Revolution, Kandinsky's concern in this dispute was mainly to defend "free art" and "free painting," which he saw as increasingly marginalized at the Bauhaus, due to their subordination to applied art in design, technology, and architecture, which served only practical purposes. This concern is evident not only in his letters to Mies van der Rohe, but also in his writings in the second half-decade of the Bauhaus years.

In the earlier-mentioned 1926 first issue of the *bauhaus* periodical, Kandinsky had published his third important art-theoretical work, "der wert des theoretischen unterrichts in der malerei" ("The Value of Theoretical Instruction in Painting"). This was followed in issue 2/3, 1928, by his article "kunstpädagogik" ("Art Pedagogy").[86] There is a philosophical summary of these two rather pedagogically minded contributions in the 1927 article "And, Some Remarks on Synthetic Art." The word "and" indicated, for him, in all three texts, both the synthesis of the individual arts and that of the arts and sciences. It also represented an enhancement of his old idea regarding the overthrow of positivist materialism—the "either/or" of analysis—in favor of a comprehensive dimension of the spiritual: "then young people would desert the petrified atmosphere of 'either–or' for the flexible, living atmosphere of 'and'—analysis as a means to synthesis."[87] He mentions inter alia, as surviving examples of synthetic art, the Church, the theater, and (with some qualifications) architecture. The new synthesis of the arts would have to integrate the circus and the cinema. Surprisingly, in the middle of his modern-sounding arguments about the model of the ideal of the unity of the arts, he unequivocally names the Russian Church.[88] But in his historical analysis he leaves the past, in particular

22 **Aerial photograph taken from a Junkers aircraft.** Illustration in *bauhaus* 1 (1926), p. 5

the nineteenth century and the tremors of the turn of the century, behind him: "But just as, at that time, those with acute hearing were able to perceive the rumblings within the ordered calm, the sharp-eyed can see within the present chaos a new order. This order departs from the basis of the 'either–or' and gradually attains a new—*and*. The twentieth century stands on the shadow of the device 'and.'"[89]

In 1931, Kandinsky received his second and last commission for a wall design, the likewise temporary ceramic fitting-out of a music room for the "Bachelor Apartment" designed by Mies van der Rohe for his major architectural exhibition on the Radio Tower site in Berlin (*Deutsche Bauausstellung* [*German Construction Exhibition*], fig. 23). On the three walls float delicate, sharply drawn conglomerations from Kandinsky's repertory of forms on an almost black or white background. The press reviews were rather standoffish and described the designs as cool. In correspondence with the artist, the head of the ceramic workshop described the difficulties of carrying out his detailed drawings on ceramic tiles.[90] Quite unlike, for example, the wall designs of Piet Mondrian's or Theo van Doesburg's De Stijl buildings or the "Rhythms" and "Circles" of Delaunay's wall paintings in Paris of the same period,

Kandinsky saw walls always as pictorial space for the interrelating position of bodies. An abstract wall picture was still representation, even if of geometric forms.

In December 1932, the Kandinskys belatedly followed the expelled Bauhaus from Dessau to Berlin, renting accommodation in the villa of architect Paul Henning at 9 Bahnstraße in Berlin's Südende, not too far from Steglitz and the factory building that the Bauhaus now occupied in Birkbuschstraße. At the end of 1933, they then left Germany for good, and after a brief pause in Bern went on to Paris. In Bern, they spent a companionable evening with collectors Hermann and Margrit Rupf, museum director Max Huggler, and Otto Nebel, a one-time artist colleague from the Moderner Bund. Nebel wrote afterward in his diary on December 19, 1933: "They've given up their apartment in Berlin because of the anti-art attitude of the brownshirt government. Our conversation was about the situation of those affected." On December 21, he added: "Kandinskys left for Paris by the midday train. We went to the train and said goodbye."[91]

CONCRETE: PARIS, 1933–44

The Kandinskys moved into a smallish rental apartment to which Marcel Duchamp had drawn their attention, in a newly built residential

23 **Ceramic wall painting for the music room of "Bachelor Apartment," designed by Ludwig Mies van der Rohe for the** *Deustche Bauausstellung* **(***German Construction Exhibition***) in Berlin, 1931**

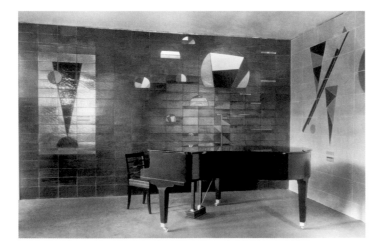

block at 135, boulevard de la Seine, in Neuilly-sur-Seine, near the Bois de Boulogne. At the beginning of January 1934, Kandinsky told his Bauhaus friend Josef Albers, who had in the meantime emigrated to the United States, about all the difficulties of the recent weeks and the move itself: "But we are very well installed here. From the windows of the three rooms in a row, we look down on the Seine flowing beside the boulevard ('down' because we live on the sixth floor), then there's an undeveloped island, then the Seine again and after that the hills start, which slowly disappear over the horizon. Over that a huge sky. In the evening, the hills look like the night sky with all the lights on."[92] The view from the window of his studio toward the west became one of the key vistas of Kandinsky's Paris period, particularly in the late 1930s and during World War II, when the Kandinskys lived largely in seclusion and the artist was wholly focused on his painting. Even two years after moving in, Kandinsky could write to Alfred Barr, Jr., director of the Museum of Modern Art in New York: "When I moved to Paris, I was so shaken by the light and nature here that I didn't want to look at anybody else's pictures and for two months could hardly paint. I had first to digest my impressions. . . . Paris with its wonderful (strong but soft) light loosened my palette. Other colors surfaced, other quite new shapes, I started using things that I hadn't used for years. All of it unconsciously, of course. A different kind of brushwork emerged, often in fact a new technique."[93]

The late oeuvre in Paris, from 1934 to 1944, did indeed represent yet another decisive change in Kandinsky's work. New, often biomorphic configurations of shapes and bright coloration appeared and looked like a mixture of the artist's impressions from the distant past and the current day. But before we take a closer look at these, we need to step back briefly in time, since the start of Kandinsky's Paris period and contacts, as has justly been emphasized in the recent literature, dates not to 1933 but to the Bauhaus period in Dessau. As is described in detail in Christian Derouet's essay in this catalogue, Kandinsky made the acquaintance of Zervos, publisher of the ambitious French periodical *Cahiers d'Art* (founded 1926), via Klee, in Dessau in 1927. Kandinsky soon pinned hopes for exhibitions on his contact with Zervos, whose good offices eventually led to one at the Galerie Zak

in Saint-Germain-des-Prés planned for the end of 1928 (it opened slightly late in January 1929). It contained only watercolors and showed Kandinsky's work to a Parisian public for the first time since the days of his pre–World War I work. The foreword, initially intended to be written by Zervos, was actually done by E. Tériade, and it introduced the artist sensitively and thoughtfully to the new environment in France. Tériade described the spiritual unity of Kandinsky's entire oeuvre and also the variability in the choice of artistic means to achieve abstraction: "La voici: first, establish a new three-dimensional language made up of pictorial symbols derived either from the painter's trade as such or from scientific research, which we should not fear to introduce when we need to set up a repertoire of expression." Therewith, Tériade was already emphasizing (as French critics from 1934 to the present still do) the "Eastern" character of his art, in this case through the sense of a freedom of abstraction, "which he considers to be the contribution of Slav and Germanic races, free of any encumbering tradition, as heirs of the east," in contrast to the Roman tradition of figuration.[94]

To accompany the exhibition at the Galerie Zak, Grohmann wrote an article about Kandinsky in *Cahiers d'Art*, which at the latter's repeated urging appeared in autumn 1929, followed three issues later by a first contribution from Zervos. Kandinsky manifested extraordinary gratitude for both essays, particularly as he had in the meantime found he was making no headway with the established galleries in Paris, such as Galerie Bernheim-Jeune or Léonce Rosenberg's Galerie L'Effort Moderne. Grohmann, an art historian, writer, and teacher from Dresden closely associated with the Bauhaus, had known Kandinsky since the early 1920s. In 1924 he had written a slender volume on him in the *Junge Kunst* series, and in the following decades would become the most important interpreter of both Kandinsky and Klee. After World War II, Grohmann wrote about both of them and the theories of other modernist artists in Germany, such as Willi Baumeister and Karl Schmidt-Rottluff, in pioneering monographs including catalogues raisonnés. Grohmann became Kandinsky's most important confidant in art matters in the second half of his life, alongside Klee (fig. 24). Their correspondence runs to hundreds of documents. Grohmann's essays, written in connection with Kandinsky's exhibitions in Paris, also emphasized the

24 **Kandinsky and Will Grohmann, Berlin, 1933**

Eastern origin of his style, with the frontier being pushed back from Russia to Mongolia in the far east.[95] Grohmann's essay was followed a year later by the first monograph about Kandinsky in the pathbreaking series of books published by Editions Cahiers d'Art. It appeared in Paris, in January 1931, shortly after Grohmann's book about Klee, and was followed by a German edition specially published by the Kandinsky Gesellschaft in Brunswick.[96] Kandinsky expressed enthusiastic gratitude to Zervos for this book as well, with the remark that German periodicals did not show anything like such interest in him or Klee.[97]

In the meantime, in March 1930, a second Kandinsky exhibition was put on in Paris, this time at the Galerie de France. Its small catalogue featured short essays by Maurice Raynal, Tériade, Zervos, and at Kandinsky's special request, Halle, from Vienna. Kandinsky had not only previously drawn Zervos's attention to Halle's publication on old Russian art in Vladimir-Suzdal, Russia, for his periodical, but

also, in a letter dated January 30, 1931, sent him and the head of the gallery a one-page manuscript by Halle in German, with an article about his work.[98] This essay was subsequently translated into French and published in the exhibition catalogue. It makes clear to what extent Kandinsky wanted his work to be seen in the context of his Russian origins, even in an exhibition that exclusively displayed more recent works from the Bauhaus years (1927–29):

> 'If you want to really understand the artist, you have to go to the artist's country.' This maxim applies to Vasily Kandinsky more than to any other artist of our day. Because although in his artistic development and for half a lifetime he has been absorbed into German culture and ways, this father of abstract painting— and that should in no way be forgotten—is Russian by birth. Which means, coming from Moscow, the most fantastic, oldest, and most picturesque city with forty by forty churches, he bears within him a transfigured world of old Russian icons (pictures of saints) that is forever turned away from the here and now, whose mysticism is poured into coloration, pure color, line, silhouette, and harmony of form in full measure, and at the same time signifies a visual revelation of spirituality, not sensuality. . . . And thus, as there, we are uplifted into an atmosphere in which we are liberated from all pressure of materialism, beyond the frontiers of what we can perceive with our senses, thinking that we are present at an invisible divine service that takes place not within the confines of a church, but in the cosmos, the universe.[99]

Interpretations like this and pictures from the Dessau years had thus made Kandinsky known to the French art scene some years before he actually moved to Paris. The passages between the "Eastern" element in Kandinsky's work, his self-perception, his actual environment (which would feature so strongly again as the basic tenor of the Paris late oeuvre), and the Bauhaus years (superficially notable for their cool objectivity) were indeed fluid. A second glance into the furnishing and decoration of his master house in Dessau, which young Felix Klee is supposed to have described as an "East Asian Museum," may serve to

illustrate this.[100] For example, Kandinsky had the walls of his small living room painted light pink and ivory, the doors black, the ceiling gray, and the niche in it layered with gold leaf (fig. 25).[101] The use of icon-style gold contributed considerably to the exotic-looking color effects in the context of Gropius's sober architecture, just like the colors of the painting that Kandinsky chose to hang on this wall, *Deepened Impulse* (*Vertiefte Regung*, 1928), which anticipates the artificial diversity of the late work in Paris.

Among the first pictures painted in March and April 1934, after the move to Paris, was *Graceful Ascent* (*Montée Gracieuse*, fig. 45) with its unstable level structure of thin horizontal and vertical lines, more heavily occupied toward the top with delicate geometric shapes such as triangles, semicircles, and circles, but also a number of organically transformed entities with invaginations clinging to them. These are

25 Living-room niche of Kandinsky's master house with *Deepened Impulse* (*Vertiefte Regung*, 1928), Bauhaus, Dessau, ca. 1930

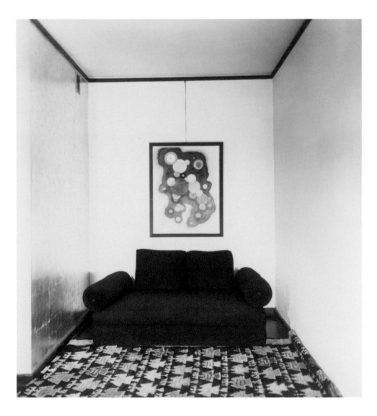

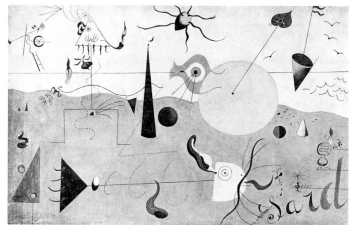

26 **Clematis blossom.** Illustration, rotated to right, taken from *Point and Line to Plane*, fig. 74, not paginated. Photo: Katt Both, Bauhaus

27 **Joan Miró,** *The Hunter* **(Catalan Landscape)** *(Paysage catalan [Le Chasseur])*, **1923–24.** Illustration in *Cahiers d'Art* 8 (October 1926), p. 213

very clearly expressed in the second painting, called *Each for Itself* (*Chacun pour soi*), as embryonic structures, each enclosed in a kind of color plasma and mixed with tiny geometric shapes. In *Blue World* (*Monde bleu*, plate 74), of the following month, the figures, looking like embryos, amoebas, and submarine creatures, have gelled into bodies freely floating in space with geometric, colorful internal structures such as frequently occurred in the late work from then onward into the 1940s. As with other pictures of this period, Kandinsky here added sand to the paint, a trick undoubtedly learned from the works of his Parisian colleagues such as Georges Braque, Delaunay, André Masson, or Pablo Picasso, though in his own case he used it less for relief effects than for a subtle alternation between the figure and background.[102] Literature on Kandinsky has come up with specific pictorial sources for the kind of biological microorganic motifs surfacing unexpectedly in Kandinsky's late work, for example, the depiction of human embryos in the book on cytology and histology (*Zellen- und Gewebelehre. Morphologie und Entwicklungsgeschichte. II. Zoologischer Teil* [Study of Cells and Tissues: Morphology and Evolution. II. Zoology], 1913) found among the other volumes of an extensive series on contemporary culture (*Die Kultur der Gegenwart* [Contemporary Culture]) left in Kandinsky's estate. Strips of paper inscribed in his own hand are still there, flagging the relevant illustrations.[103]

Generally, not much attention is paid to the fact that Kandinsky himself reproduced examples of illustrations from these volumes in his book *Point and Line to Plane*, for example, cross sections of tissue or "plants swimming by means of their 'tails'" [flagella] (fig. 26). In his scientific approach, he even provided them with precise "proofs."[104] We might wonder what Kandinsky's actual objective was in including such biological structures and how this fits in with the particular character of his late work in the environment of contemporary art. The first thing to note is that, even in this period, despite its specifically spiritual approach, his painting was of its time, and the influence of his fellow artists in Paris, for example Léger or particularly Joan Miró, is unmistakable. How closely Kandinsky kept an eye on their output even during his later Bauhaus years, particularly through reproductions in the *Cahiers d'Art*, is evident from his correspondence with Zervos.[105] Miró's *The Hunter* (*Catalan Landscape*) (*Le Chasseur* [*Paysage catalan*], 1923–24) in Robert Desnos's essay about the new Surrealist movement in the October 1926 issue must have been the first painting by the Catalan artist that Kandinsky had seen (fig. 27). Individual, enigmatic, defamiliarized phenomena floating in space, in a pictorial cosmos of their own, reappear in similar form in Kandinsky's late work. It was no longer the macrocosm of Russian Constructivism, whose spatial system prevailed until well into the mid-Bauhaus years, but more of a

microcosm in which figures busily whizz about, generally against a monochrome (usually sky blue, rusty red, or lime green) background. An example is Kandinsky's *Relations* of July 1934, where the floating reference system of the figurations gave the picture its name (fig. 28). Even more striking here than in the previously mentioned painting is the artificial, variegated coloration of the semi-organisms with their internal structures that are no longer just geometric but also decoratively woven, such as appear in *Sky Blue* (*Bleu de ciel*, 1940, plate 90), *Balancing* (*Balancement*, 1942, plate 94), and *Reciprocal Accord* (*Accord réciproque*, 1942, plate 93). The latter two pictures, from the late phase of the Paris years, show a tendency in which the individual parts of the amoeba-like structures seem to be sucked up into larger anthropomorphic figures or delicate geometrical structures likewise acting as living beings, generally in antithetical conformations.

The enamel-like coloration—mauve, turquoise, scarlet, pink, violet, brown, and delicate yellow—has prompted many interpreters to refer to the Russian or Far Eastern nature of Kandinsky's late work. His pictures were repeatedly referred to as "chinoiseries,"[106] whose gaily ornate organic shapes looked like echoes of "the oldest, most private layers of consciousness."[107] Though this was certainly pertinent, other influences should also be taken into account, such as the

28 *Relations*, 1934. Mixed media on canvas, 89 x 116 cm. Private collection

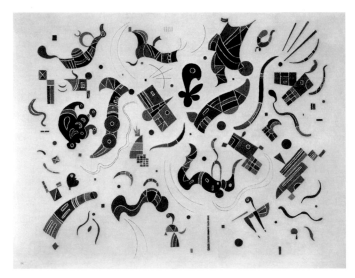

newly discovered colors he saw in France. Nina Kandinsky, for example, mentioned several times her husband's intense experiences of color during holidays by the Mediterranean or even in Calvados on the Normandy coast: "Kandinsky was always intoxicated by the fluctuating play of colors. 'There were fantastic, indescribably beautiful colors in the sky and particularly in the water,' he would enthuse, 'it was hardly ever calm for a moment, and often you saw at the same moment pure white, emerald green, and deep violet on the sea. Then there was the dry sand in delicate yellow, and the wet sand in various shades of brown, pink, and green . . . and the sky too, where various colored clouds were chased by the wind across delicate blue. And then in the next minute the whole picture would completely change. I have no desire to paint seascapes, but I drank in impressions greedily. And then the countryside! Normandy is indeed *le jardin de la France.*'"[108] In her memoir, Nina also reports that, in Paris, Kandinsky hardly ever used pure prefabricated colors, but "always mixed his own palette from various shades. With powdered colors he used a mortar. . . . The colors are different from picture to picture and sometimes even in the same picture."[109] He mixed new colors for every picture and, on completing the work, threw away the paint he had left. Together with the absolute, "always perfectly conceived precision of shapes"—the "clarté toujours parfaite de la forme conçue," as his artist friend Alberto Magnelli put it[110]—this habit may contribute occasionally to the impression of a certain mannerism in Kandinsky's late work. Possibly one might occasionally get the impression of the influence of Egyptian art in some of the exotic-looking coloration. Kandinsky is known to have liked Egyptian art, as he made clear in an interview with Julien in Russia in 1921. Certainly the way he interweaves strips of color ornately on the bodies and "necks" of his figures suggests it (fig. 29).[111]

Kandinsky's esteem for Egyptian wall painting is also evident in his handwritten remarks on a manuscript by his nephew, Alexandre Kojève, on "Les Peintures concrètes de Kandinsky" (Kandinsky's Concrete Paintings) of 1936.[112] Here a term appears in the manuscript's title that Kandinsky used for his painting of the Paris period instead of "abstract" or "absolute"—"concrete." At this point, we may briefly summarize the discussion of those years so as to clarify the term. At the

29 Reproduction paintings of Egyptian wall paintings (ca. 1450–1250 B.C.E.), ca. 1930

time, the term "abstract" was used to describe a work abstracted from nature, that is, it still had visible remnants of natural objects in it, whereas "concrete" represented the abandonment of "abstraction in favor of nonrepresentational art (without reference to natural forms or objects)."[113] In 1930, a short-lived group and periodical called *Cercle et Carré* (Circle and Square) and had been set up at the initiative of Michel Seuphor, and its single major exhibition had featured Kandinsky alongside Carl Buchheister, Mondrian, Antoine Pevsner, Kurt Schwitters, Georges Vantongerloo, and Friedrich Vordemberge-Gildewart. This was followed by an equally short-lived association called Art Concret (Concrete Art), led by Van Doesburg, whose presence in France—after his furnishing of the Café Aubette in Strasbourg in 1927—had, together with that of Mondrian, meant a breakthrough for abstract art in Paris. Even then, there were discussions whether the term "concrete art," used for the first time by Max Burchartz in a review of an exhibition dedicated to Van Doesburg, could be used solely in reference to him. This has recently been shown to be definitely not the case.[114] In February 1931, the remains of the two groups were incorporated into a new association called Abstraction-Création (Abstraction-Creation), whose title—like the name of its periodical first published in 1936, *abstraction–création–art non-figuratif*—indicated a more open-ended framework for the nonrepresentational avant-garde. It explained the title in its manifesto, for example, without using the specific term "concrete":

"Abstraction, since some artists have come to nonrepresentational art through a progressive abstraction of natural forms; Création, because other artists went straight to nonrepresentation via a purely geometrical approach or through the exclusive use of elements that are generally called abstract, such as circles, planes, bars, lines, etc."[115] The group, formed on the initiative of Auguste Herbin and Vantongerloo, included Max Bill, Delaunay, Naum Gabo, Albert Gleizes, Jean Hélion, Kandinsky, Kupka, and Mondrian, as well as other artists like Jean Arp, who, with their biomorphic/organic forms, stood somewhere between abstraction and Surrealism.

During the 1930s, when he was in Paris, probably particularly in discussions with his nephew Kojève, the term "concrete" established itself as a possibility for Kandinsky to describe appropriately the vision he had nurtured, even in his early work, of painting with purely painterly means. This view is also supported by his numerous theoretical writings in the late period, published from 1931 onward in Parisian and international periodicals and exhibition catalogues, starting with "Réflexions sur l'art abstrait" ("Reflections on Abstract Art," 1931) for Zervos's "Enquête de l'art abstrait" (Inquiry into Abstract Art) in his *Cahiers d'Art*, "Abstract of concreet?" ("Abstract or Concrete?") for the Stedelijk Museum, Amsterdam, 1938 exhibition catalogue *Tentoonstelling abstracte kunst*, through to "L'Art concret" ("Concrete Art," 1938) and "The Value of a Concrete Work" (1939) for Gualtieri di San Lazzaro's

periodical *XXe Siècle*.[116] In 1941, he wrote to the young investigative judge and art lover Pierre Bruguière, who in summer 1939 had provided critical assistance in getting the Kandinskys French citizenship: "The absence of precise terminology for what we call abstract art, which you call 'real' and I call 'concrete,' this absence is proof of the great vitality of the art that is still in development and has infinite perspectives. A definitive terminology is in my view altogether proof of the end of a development—that it's a 'museum,' and is classifiable as 'closed.' Our opponents have been claiming for thirty years that the resources of 'abstract' art are too limited for a possible development in the future. That may be true for the blind."[117]

But unlike, for example, Mondrian, with his universal language of the right angle and primary colors ("le plan rectangulaire de couleur primaire"[118]), or Van Doesburg's demand that the forms of nature be eliminated and replaced by art forms such as lines, colors, and surfaces,[119] in his late work, Kandinsky sought a middle way between his own nonrepresentation and a new definition of nature. Even in 1931, in his long response to Zervos's "enquête" (inquest) into abstract art, he had described geometric form as only one among many nonrepresentational vocabularies, and in a much quoted observation, also stressed their emotional content: "The contact between the acute angle of a triangle and a circle has no less effect than that of God's finger touching Adam's in Michelangelo." But the next sentence is at least as conclusive: "And if fingers are not only anatomy or physiology, but more—namely, pictorial means—the triangle and the circle are not only geometry, but more—pictorial means."[120]

If these remarks once again throw light on the apparently cool objectivity of his Bauhaus designs, the organic, morphological looking figures in Kandinsky's late Parisian works apparently populate a realm of pure art that should be equated with the universe of nature as a principal category.

In this context, a little regarded article, "Sachlich–Romantisch" (Objective–Romantic), written by Kandinsky for the *L'Intransigeant* periodical in June 1930 and not subsequently reprinted is extremely interesting. There were, said Kandinsky, three trends in modern art: "'absolute' (= 'abstract') painting, that would be destroyed or

succeeded by 'New Objectivity,' and the latter in turn by the more recent trend of 'Surrealist painting.' . . . All three styles are 'fantastic'—each in its own way." The difference lay solely in the means that were to serve the purpose of depicting fantastic reality. Then follows a sentence that, in view of his frequently discussed polemic against the Surrealists (for example in his letters to Albers and Zervos around 1934/35), may seem astonishing: "Seen from this point of view, abstract and Surrealist painting are natural siblings." The subsequent analysis shows, once again, that for all his progressive withdrawal into his painterly cosmos, Kandinsky was wholly aware of his position in the age and, as assumed above regarding his works from the Bauhaus period, likewise adopted contemporary visual elements characteristic of technology and science. At the same time, he explains the special three-dimensionality of his late pictures and their remarkable analogies to nature: "Both (abstract and Surrealist painting) destroy the material plane. Or they shape the material plane into an 'illusory' space—the painterly process happens somewhere in the 'cosmos.' And this is achieved with purely material means, which demands a particularly profound knowledge of the material. Thus materiality is used for the purposes of immateriality—a matter of going up and down at the same time. Both destroy 'gravity,' the law of gravity, which is why there is often the impression that the law has been turned on its head. But 'above' and 'below' remain extant— they are just raised to the same level."

Abstract painting and Surrealism were not different in purpose or idea, "but in the density of the 'naturalness' of the elements. . . . It is perhaps strange how little and rarely it is noticed that nature stands above 'nature,' and that 'nature' is only a tiny part of nature. People enthuse about the pod and stick loyally to the shell, taking it for the nut. The nut is the spirit. . . . Not for nothing has it only recently become possible to lift a heavier and heavier object higher and higher in the air. Not for nothing is the pace of life constantly speeding up. Likewise not for nothing has it only recently become possible to support heavy buildings on slender stilts and push weights in the air. Floating excites not only painters but also technologists, who these days want to be technologists and not artists at any price. Here too 'above' is weighted down

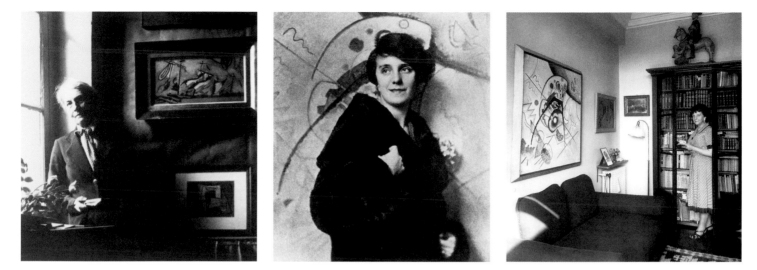

30 Left: **Jeanne Bucher, Paris, ca. 1940**

31 Middle: **Nina Kandinsky in front of** *Backward Glance* (*Rückblick*), **1924.**
Illustration in Hugo Erfurth's book *Bildnisse* (1926)

32 Right: **Nina Kandinsky in her living room, Neuilly-sur-Seine, France, ca. 1960**

as much as possible toward 'below' and the building turned on its head. Here, too, the almost boundless use of glass destroys the distinction of the material and dematerializes the material building." The "link with NATURE" would be "forbidden as a fruitless (i.e. harmful) phantasticism." But artists should take heart: "They are building a new world that is so deeply bound up with NATURE such as mankind has not seen for millennia. And thus the phantasticism will become REALITY."[121]

These statements read like a manifesto for his late oeuvre, which also presented the categories "biological–cosmic" wholly in their contemporary context based on new scientific discoveries.[122] This comes across in his works despite all the hermetic coding and the persistence of the personal iconography of old Russian visions and the motif of the clash of contrasts. Thus interpreters from Grohmann to Georgia Illetschko have, for example, tracked the motif of Saint George fighting the dragon right down to last works such as *Isolation* (1944, fig. 47) and *Tempered Elan* (*L'Élan tempéré*, 1944) with admirable consistency.[123] Likewise, the regular box-shaped arrangement in which Kandinsky sometimes enclosed his repertory of forms in his late

pictures might evoke the screens of Orthodox iconostases with their strict arrangement of saints' images. On the other hand, many of his colorful structures look as if they have been seen in cross section through a microscope, and also the effects of the cinema should be taken into account for Kandinsky's later pictures.[124]

This is not the place to go into the external circumstances of the Kandinskys' life in Paris, the artist's rather isolated position in the arts scene, which was due, to some extent, to his political aloofness, and his growing isolation during the war years under the German occupation when almost all his important colleagues had left the city. Nor can we explore his extremely regular daily life, which Nina Kandinsky has graphically described. Overall, a degree of bourgeois rigidity inserted itself into the Kandinskys' way of life and habits even in the Bauhaus years, and left traces in Vasily's physical appearance in portrait photos and numerous, rather inconsequential, holiday photographs.[125] Kandinsky's letters during his Paris years, whether to Albers, Bruguière, Hilla Rebay, or the collector Rupf, Galka Scheyer, or Zervos, are tiring to read, as they focus on possible exhibitions and sales, as well as his

admired, and his own painting from the Dessau house, *Backward Glance* (*Rückblick*, 1924) above the sofa. (In *Backward Glance*, which he gave to Nina and in front of which she posed for the photograph that appeared on Hugo Erfurth's 1926 book *Bildnisse* [Portraits], he had taken interim stock of his artistic development [figs. 31, 32]. In the work, the formal vocabulary of the Bauhaus period is still clearly featured—mountains, Russian church spires, boats, and horseback riders—but the composition is also closely based on the earlier *Small Pleasures* [*Kleine Freuden*, plate 36] of 1913 or even *Moscow I*.) Finally, above Kandinsky's meticulously arranged paints shelf, hung two of his own Hinterglasbilder from the Blaue Reiter years (fig. 33).

This is not the place to speculate how far and to what degree the artist felt that his own importance had not been sufficiently appreciated in his lifetime, given that he had emigrated three times and been defamed as "degenerate" in Germany. At any rate, with the organic-looking figurations of his late works, he sought to comply with his own demand for the independence of painting that he had earlier formulated at the Bauhaus with his notion of synthesis: "synthetic creation and work and recognition of creative principle in nature, and inner affinity of same to art."[126] Or, as Kojève put it in 1936: "Inference: In contrast to 'representational' art, which in all its four varieties—'Symbolism,' 'Realism,' 'Impressionism,' and 'Expressionism'—is abstract and sub-jective, the 'nonrepresentational' or ' total' paintings of Kandinsky are concrete and objective because they require no subjective contribu-tion by the painter or the viewer. They are concrete, because they are not abstractions of anything that exists outside them. Each of them is a complete and real universe, of itself, through itself, and for itself, in the same way as the real, nonartistic universe."[127]

Though this definition undoubtedly describes the textbook case, it does nonetheless sum up something of the universalism of Kandinsky's late formal idiom, which, to judge from its reception, can still make his work easy to understand, even today. The fact that Kandinsky's belief in the spiritual in art has in the meantime shown itself to be one of the last major utopistic approaches in the history of twentieth-century ideas yet again reverberates in the unswerving fascination exerted by his works.

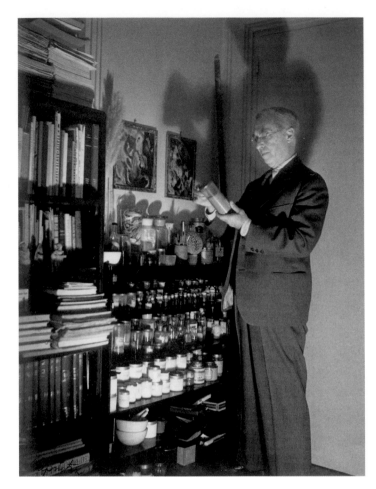

33 **Kandinsky in his studio, Neuilly-sur-Seine, 1936.** Photo: Bernard Lipnitzki

unquenchable hope of being able to champion the cause of abstract art with every new exhibition project and every newly founded periodical. Even in Paris, the great breakthrough and recognition never came.

After his relationship with Zervos cooled, Parisian gallery owner Jeanne Bucher put on several Kandinsky exhibitions from 1936 onward, loyally supporting the artist, even in 1942, with a clandestine exhibition during the Nazi occupation (fig. 30). In the war years, Kandinsky remained almost exclusively within his apartment, surrounded by things from various phases of his life, such as a large wooden sculpture of Saint Martin from his Munich days (which still survives in his Paris estate), a small picture of a chicken-run by painter Henri Rousseau, whom he

Notes

Unless otherwise attributed, all translations of original French or German quotations are based on service translations provided by the Städtische Galerie im Lenbachhaus, Munich.

1 See Jelena Hahl-Koch, *Kandinsky* (New York: Rizzoli, 1993), pp. 27–29; Noemi Smolik, "Auferstehung und kulturelle Erneuerung," in Hartwig Fischer and Sean Rainbird, eds., *Kandinsky: The Path to Abstraction*, exh. cat. (London: Tate, 2006), pp. 137–56; Noemi Smolik, "Russian Beginnings: Modernism's Prophet or its Adversary?" in Annegret Hoberg and Helmut Friedel, eds., *Vasily Kandinsky* (Munich: Prestel, 2008), pp. 29–53; Valery Turchin, *Kandinsky in Russia: Biographical Studies, Iconological Digressions, Documents* (Moscow and Prague: Society of Admirers of the Art of Wassily Kandinsky 2005), p. 39; and the articles by Dmitry Sarabianov and Natalia Adaskina in Lidia I. Romanchkova, ed., *Kandinsky et la Russie*, exh. cat. (Martigny, Switzerland: Fondation Pierre Gianadda, 2000), pp. 19–48.

2 See also Igor Aronov, *Kandinsky's Quest: A Study in the Artist's Personal Symbolism, 1866–1907* (New York: Peter Lang, 2006), pp. 9–14, and especially Valery Turchin, "The Professor Chuprov Circle," in Turchin, *Kandinsky in Russia*, pp. 46–56. Kandinsky's letter of March 20, 1908, to his uncle Ivan Sheiman on the occasion of Chuprov's death is probably erroneously dated; Chuprov was still alive in spring 1908 and even visited Kandinsky in Ainmillerstraße in Munich and in Murnau.

3 Turchin, *Kandinsky in Russia*, p. 39; see also Hahl-Koch, *Kandinsky*, p. 30.

4 Vasily Kandinsky, "Rückblicke," in *Kandinsky 1901–1913 Album* (Berlin: Verlag Der Sturm, 1913), reproduced as "Reminiscences," in Vasily Kandinsky, *Kandinsky: Complete Writings on Art*, ed. Kenneth C. Lindsay and Peter Vergo (1982; repr, New York: Da Capo Press, 1994), p. 368.

5 The Vologda diary and all the essays have recently been published in the original Russian versions with German translations in Vasily Kandinsky, *Wassily Kandinsky. Gesammelte Schriften 1889–1916. Farbensprache, Kompositionslehre und andere unveröffentlichte Texte*, ed. Helmut Friedel (Munich: Prestel, 2007), pp. 30–77, 78–90.

6 Kandinsky's foreword to the Galerie Hans Goltz catalogue of *Kandinsky. Kollektiv-Ausstellung 1902–1912* (*Kandinsky Retrospective 1902–1912*) (Munich: Verlag "Neue Kunst," 1912), quoted in Kandinsky, *Gesammelte Schriften*, p. 21.

7 Kandinsky, "Reminiscences," p. 360.

8 Bruno Haas, "Syntax," in *Kandinsky: The Path to Abstraction*, p. 198.

9 Igor Grabar wrote: "Then comes a gentleman with a box of paints, takes a seat and settles down to work. His appearance is typically Russian, indeed, there's a hint of Moscow University and something of the graduate about him. . . . In short, that's exactly how we immediately saw the gentleman who arrived today—as a Moscow graduate. And just imagine my astonishment when I heard his noticeable Russian accent. . . . So that was Kandinsky." Letter first published for Western readers by Natalia Avtonomova in "Die Briefe Wassily Kandinskys an Dmitrij Kardovskij," in *Wassily Kandinsky: Die erste sowjetische Retrospektive. Gemälde, Zeichnungen und Graphik aus sowjetischen und westlichen Museen*, exh. cat. (Frankfurt: Schirn Kunsthalle, Moscow: State Tretyakov Gallery; St. Petersburg: State Russian Museum, 1989), p. 47.

10 Rudolf H. Wackernagel, *Jawlensky und seine Weggefährten in neuem Licht*, ed. Bernd Fäthke (Munich: Hirmer, 2004), p. 41 and note 290. See most recently: Brigitte Salmen and Annegret Hoberg, "Um 1908–Kandinsky, Münter, Jawlensky und Werefkin in Murnau," in *1908–2008. Vor 100 Jahren. Kandinsky, Münter, Jawlensky, Werefkin in Murnau*, exh. cat. (Murnau, Germany: Schloßmuseum Murnau, 2008).

11 In Kandinsky's Paris papers, there are a number of smaller pages with excerpts from Eugène Delacroix's diary equating painting with music and noting the similarity of their compositional rules in terms of melody, chords, lines, and composition, in addition to a copy of Max Klinger's *Malerei und Zeichnung*, 3rd edition (Leipzig: Georgi, 1899), with notes in Kandinsky's own hand. Bibliothèque Kandinsky, Centre Pompidou, Paris.

12 On October 31, 1903, Kandinsky told Gabriele Münter about his visits to museums in Munich: "Took my hat off to [Arnold] Böcklin again and kept looking and admiring. If anyone wants to know a master before our day, it's this artist, painter, draughtsman, musician, and poet. I also admired old Rembrandt again and again." Gabriele Münter- und Johannes Eichner-Stiftung, Munich.

13 Kandinsky mentions Maurice Maeterlinck in this context not only in *Über das Geistige in der Kunst. Insbesondere in der Malerei* (*On the Spiritual in Art: And Painting in Particular*, 1912), but also in a manuscript from his time in Munich called "Farbensprache" (The Language of Color) (only recently published): "Wholly emancipated music does not need to borrow forms for its language anywhere at all. Literature, especially since M.[aeterlinck], is working on the development of its own resources (verbal euphony, inner meaning of words, combination of word sounds, etc.), whereas in painting this task still lies ahead." Vasily Kandinsky, *Gesammelte Schriften*, p. 303.

14 See, for example, the essays by Wilhelm Michel, "Das Erwachen des Geistigen," *Deutsche Kunst und Dekoration* XXXII (April–September 1913), p. 9; and Ludwig Volkmann, "Das Geistreiche im Kunstwerk," *Die Kunst für Alle* 16 (1903), pp. 153–61.

15 Vasily Kandinsky, "Kandinsky über seine Entwicklung" ("Cologne Lecture"), written in January 1914 for a lecture at his exhibition at the Kreis für Kunst, Cologne, Germany, and read in his absence. Kandinsky, *Complete Writings on Art*, p. 395. First published in parts in Johannes Eichner, *Kandinsky und Gabriele Münter. Von Ursprüngen moderner Kunst* (Munich: F. Bruckmann, 1957), pp. 109–16, 124–25.

16 Ibid.

17 Vasily Kandinsky, quoted in Vivian Endicott Barnett, *Kandinsky Watercolours: Catalogue Raisonné, Volume One, 1900–1921* (Ithaca, N.Y.: Cornell University Press, 1992), p. 87. See also Hahl-Koch, *Kandinsky*, p. 47.

18 Regarding Gabriele Münter, see *Gabriele Münter 1877–1962. Retrospektive*, ed. Helmut Friedel and Annegret Hoberg, Städtische Galerie im Lenbachhaus, Munich; Schirn Kunsthalle, Frankfurt, exh. cat. (Munich: Prestel, 1992).

19 See also Vasily Kandinsky and Gabriele Münter, *Wassily Kandinsky und Gabriele Münter in Murnau und Kochel 1902 bis 1914. Briefe und Erinnerungen*, ed. Annegret Hoberg (Munich: Prestel, 1994), and Gisela Kleine, *Gabriele Münter und Wassily Kandinsky. Biographie eines Paares* (Frankfurt: Insel Verlag, 1990).

20 Vasily Kandinsky to Gabriele Münter, April 25, 1904, Gabriele Münter- und Johannes Eichner-Stiftung, Munich.

21 Vasily Kandinsky to Gabriele Münter, November 16, 1904, Gabriele Münter- und Johannes Eichner-Stiftung, Munich. His often mentioned devotion, particularly to his native city of Moscow, sometimes took on almost amusing traits: "I absolutely will not be called a son of Odessa!! That would profoundly offend the whole family and particularly my father. Please don't do it again! The devil on it—son of Odessa indeed! No, that I am not, thank God. Born in Clear Pond Street, Moscow." Kandinsky to Münter, October 31, 1904, Gabriele Münter- und Johannes Eichner-Stiftung, Munich.

22 Turchin's assumption that Kandinsky did not speak German very well and wrote most of his manuscripts in Russian, which were in turn translated by "his wives," is wrong. Turchin, *Kandinsky in Russia*, p. 24. Münter could not speak Russian, and Nina Kandinsky, upon her arrival in Paris, had a poor command of French.

23 See also Kandinsky, "Cologne Lecture," pp. 394–95.

24 For the history, ideas, and members of the Neue Künstlervereinigung München (NKVM) (New Artists' Association of Munich) in detail, see Helmut Friedel and Annegret Hoberg, eds., *Der Blaue Reiter und das neue Bild. Von der "Neuen Künstlervereinigung München" zum Blauen Reiter 1909–1912*, Städtische Galerie im Lenbachhaus, exh. cat. (Munich: Prestel, 1999).

25 For *Der Blaue Reiter* almanac, see the outline in Klaus Lankheit, ed., *Der Blaue Reiter: Dokumentarische Neuausgabe* (Munich: Piper, 1965), and for more detail see Vasily Kandinsky and Franz Marc, *Der Blaue Reiter* (1912; Munich: R. Piper und Co., Verlag, 2008) and Annegret Hoberg, "The Blue Rider: Painting Alone Was Not Enough for Us," in Hoberg and Friedel, eds., *Vasily Kandinsky*, pp. 81–141. Even today, it is amazing to note the degree of insight Kandinsky and Marc had in choosing the pioneering representatives of the avant-garde for their Blaue Reiter project: artists such as Pablo Picasso and Georges Braque for France, the brothers David and Vladimir Burliuk, as well as Natalia Goncharova for Russia, or several artists from Die Brücke

(The Bridge) for Germany. Equally astonishing is their deep conviction apropos being representatives of a particular spiritual art that tended toward the abstract.

26 Kandinsky, *Über das Geistige in der Kunst. Insbesondere in der Malerei* (*On the Spiritual in Art: And Painting in Particular*) (Munich: R. Piper and Co., Verlag, 1912), in Kandinsky, *Complete Writings on Art*, p. 218.

27 Kandinsky, "Cologne Lecture," p. 396.

28 See also Annegret Hoberg, "Kandinsky und Schoenberg: I Saw all my Colours in my Mind," in Hoberg and Friedel, eds., *Vasily Kandinsky*. The analogies between music and abstract/absolute art also extend to Kandinsky's titles (*Improvisations* and *Compositions*).

29 Kandinsky, "Cologne Lecture," p. 393.

30 Ibid., p. 397.

31 Ibid., p. 398.

32 Vasily Kandinsky, "Abstrakt. Absolut," in "Entwicklung der Kunstformen" (1912–13), in Kandinsky, *Gesammelte Schriften*, pp. 477–79.

33 Kandinsky, *On the Spiritual in Art*, p. 219.

34 Kandinsky, in a memorial essay to Franz Marc in 1936, called this period heroic: "I can't remember all the precise dates anymore, although the intensity of those 'heroic' times will probably never lose their force in my memory." Kandinsky, in Lankheit, ed., *Franz Marc im Urteil seiner Zeit* (Cologne, Germany: DuMont Schauberg, 1961), p. 43.

35 Maria Marc, quoted in *Maria Marc. Leben und Werk, 1876–1955*, ed. Annegret Hoberg, exh. cat. (Munich: Städtische Galerie im Lenbachhaus, 1996), p. 104.

36 Vasily Kandinsky to Gabriele Münter, December 25, 1914, quoted in Hoberg, *Wassily Kandinsky und Gabriele Münter*, pp. 27–28.

37 Evelyn Benesch, "In Moscow 1915–1921: I Would Really Like to Paint a Large Moscow Landscape," in Hoberg and Friedel, *Vasily Kandinsky*, p. 172.

38 Peg Weiss, *Kandinsky and Old Russia: The Artist as Ethnographer and Shaman* (New Haven: Yale University Press, 1995), pp. 52–54.

39 Eichner, *Kandinsky und Gabriele Münter*, pp. 175–76.

40 For a summary of Kandinsky's stay in Sweden, see Vivian Endicott Barnett, "Kandinsky in Sweden, Malmö 1914, Stockholm 1916," in *Kandinsky and Sweden*,

ed. Barnett, exh. cat. (Malmö: Konsthall; Stockholm: Moderna Museet, 1989).

41 See John E. Bowlt, *Russian Art of the Avant-Garde: Theory and Criticism, 1902–1934* (New York: Viking Press, 1976); John E. Bowlt and Rose-Carol Washton Long, *The Life of Vasilii Kandinsky in Russian Art: A Study of "On the Spiritual in Art"* (1980; repr., Newtonville, Mass.: Oriental Research Partners, 1984); as well as *Die erste sowjetische Retrospektive* and Christoph Vitali, ed., *Die Große Utopie: Die russische Avantgarde 1915–1932*, exh. cat. (Frankfurt: Schirn Kunsthalle, 1992).

42 "Malenkie stateiki po bolshim voprosam: O tochke; O linii" ("Little Articles on Big Questions: On Point, On Line"), *Iskusstvo* (Moscow) no. 3 (February 1, 1919), p. 2, and no. 4 (February 22, 1919), p. 2; see also Kandinsky, *Complete Writings on Art*, pp. 421–27.

43 Kazimir Malevich, "Suprematismus," in El Lissitzky and Hans Arp, *Die Kunstismen: Les Ismes de l'art. The Isms of Art* (Erlenbach-Zurich: Eugen Rentsch, 1925), p. X.

44 Regarding the (self-)definition of Constructivism: "Artists see the world through the prism of technology. They do not wish to produce illusions with paint on canvas, and work directly in iron, wood, and glass. The blinkered see only the machine in that. Constructivism proves that a line cannot be drawn between mathematics and art, or a work of art and a technical invention." Ibid., p. XI.

45 Vasily Kandinsky, "Interview par C. A. Julien, 10 Juillet 1921," in *Kandinsky: Trente peintures des musées soviétiques*, ed. Christian Derouet, exh. cat. (Paris: Musée national d'art moderne, Centre Pompidou, 1979), pp. 26–27; first published in Vasily Kandinsky, *Kandinsky: "Regards sur le passé" et autres textes 1912–1922*, ed. Jean Boullion (Paris: Hermann, 1974), pp. 233–35. See also Vasily Kandinsky, "L'Art aujourd'hui est plus vivant que jamais," *Cahiers d'Art* 1–4 (1935), reproduced as "Art Today," in Kandinsky, *Complete Writings on Art*, pp. 764–71, or his letter to Max Huggler, February 3, 1937, in *Kandinsky nelle collezioni svizzere/in den Schweizer Sammlungen/dans les collection suisses*, ed. Manuela Kahn-Rossi, exh. cat. (Lugano, Switzerland: Museo cantonale d'arte; Milan: Skira, 1995), p. 271.

46 Vasily Kandinsky, quoted in Helmut Friedel

and Annegret Hoberg, *Der Blaue Reiter im Lenbachhaus München* (Munich: Prestel, 2000), cat. no. 35.

47 See for example Clark V. Poling, *Kandinsky in Russland und am Bauhaus, 1915–1933*, exh. cat. (Zurich: Kunsthaus Zurich, 1984), pp. 24–27; John E. Bowlt, "Wassily Kandinsky: Verbindungen zu Russland," in *Die erste sowjetische Retrospektive*, pp. 59–78.

48 Konstantin Umansky, *Neue Kunst in Rußland, 1914–1919* (Potsdam: Gustav Kiepenheuer Verlag, 1920), p. 20.

49 Umansky also says: "A certain passivity places him in the last ranks of the fighting artists to whom Russia today owes the most daring—and yet brilliantly executed—cultural reforms. . . . In the summer of 1919, I had an opportunity to talk to Kandinsky a number of times. The impression was always the same: Kandinsky cooperated, as he was impressed by the eagerness of the government in all aspects of art, but he could not agree with the overall artistic policy and its Marxist coloring. It is a point of view that will be comprehensible to any Kandinsky connoisseur, and the news will delight his friends, who have often been disappointed by false reports about Kandinsky's administrative activity and the 'popularization' and 'monumentalization' of his art." Umansky, quoted in Eberhard Steneberg, *Russische Kunst in Berlin, 1919–1932* (Berlin: Mann, 1969), pp. 30–31.

50 Incidentally, in the 1920s, it was the same Ludwig Baer who told Münter, after Herwarth Walden had stubbornly kept quiet, that Kandinsky had not been killed in the war years or during the Russian Revolution (as she had assumed), but was still alive, had married, and had returned to Germany to work at the Bauhaus.

51 On this subject see the instructive "administrative diagram" of the college of arts of the People's Commissariat for Enlightenment (Narkompros), point 7 in the appendix of Umansky, *Neue Kunst in Rußland*, p. 64.

52 See also the equally instructive, but rarely mentioned, essay by Troels Andersen, in Vasily Kandinsky, "Some Unpublished Letters by Kandinsky," ed. Anderson, *Artes. Periodical of the Fine Arts* (Copenhagen) 2 (October 1966), p. 101.

53 Ibid., p. 103.

54 After their return to the "West," neither of

the Kandinskys ever mentioned a single word about the existence of this son, either in the Bauhaus or Paris years, to the day they died.

55 Kandinsky, quoted in Vasily Kandinsky, *Kandinsky. Die gesammelten Schriften*, vol. 1, ed. Hans K. Roethel and Jelena Hahl-Koch (Bern: Benteli, 1980), p. 62.

56 Typed manuscript, in German, June–August 1921, Bibliothèque Kandinsky, Centre Pompidou, Paris.

57 Nina Kandinsky, *Kandinsky und ich* (Munich: Kindler, 1976), p. 94.

58 Marc Chagall, quoted in Steneberg, *Russische Kunst in Berlin*, p. 10.

59 See also Nina Kandinsky's interview with Eckhard Neumann regarding various enquiries on the sequence of events: Neumann, ed., *Bauhaus und Bauhäusler. Bekenntnisse und Erinnerungen* (Cologne, Germany: DuMont, 1985), pp. 233–35. For a different view, see most recently Christian Wolsdorff, "Bauhaus 1922–1933: The Inner Quality of the Nut," in Hoberg and Friedel, eds., *Vasily Kandinsky*, pp. 201–37.

60 See also Hans M. Wingler, "Foreword," in Clark V. Poling, *Kandinsky's Teaching at the Bauhaus: Color Theory and Analytical Drawing* (New York: Rizzoli, 1986), pp. 8–9.

61 Staatliches Bauhaus in Weimar and Karl Nierendorf, eds., *Staatliches Bauhaus, Weimar, 1919–1923*. With a note in the reprinted edition by Hans Wingler (Weimar and Munich: Bauhaus Verlag, 1980), pp. 102–3.

62 Kandinsky, "Farbkurs und Seminar," in *Staatliches Bauhaus, Weimar, 1919–1923*, reproduced as "Color Course and Seminar, in Kandinsky, *Complete Writings on Art*, p. 503.

63 For example, Kandinsky set out his view on wall painting, at the Bauhaus, in a memo dated April 4, 1924: "Unilaterally focusing on production would make the continued existence of the workshops mentioned impossible, which would be ominous for the ultimate objective of the Bauhaus—the development of the synthetic art concept." In conclusion, he stresses once again that the focus should not be on production. Instead, the "Bauhaus should constitute a community, one of developing the synthetic concept—apart from the ongoing works with immediate direct application—and should set as its highest objective the preparation of students to adopt this idea."

Quoted in Hans Wingler, *Das Bauhaus, 1919–1933: Weimar, Dessau, Berlin* (Bramsche, Germany: Rasch, 1962), p. 94. See also Vasily Kandinsky, "Die kahle Wand," *Der Kunstnarr* (Dessau) 1 (April 1929), reproduced as "Bare Wall," in Kandinsky, *Complete Writings on Art*, pp. 731–34.

64 Both the Bauhaus Archives in Berlin and the Bibliothèque Kandinsky, Centre Pompidou, Paris, preserve a number of questionnaires on this subject, filled out by the Bauhaus students, in color, using Kandinsky's correlation of blue with circles, red with squares, and yellow with triangles. This system was characteristic of his early teaching at the Bauhaus and made fun of by colleagues such as Oskar Schlemmer.

65 See Clark V. Poling, *Kandinsky: Russian and Bauhaus Years, 1915–1933*, exh. cat. (New York: Solomon R. Guggenheim Foundation, 1983); Poling, *Kandinsky's Teaching at the Bauhaus*; as well as various publications of the Bauhaus Archives by Peter Hahn and Christian Wolsdorff. For students' recollections, consult Eberhard Roters, *Maler am Bauhaus* (Berlin: Rembrandt Verlag, 1965); Ré Soupault-Niemeyer, "Du cheval au cercle," in *Hommage à Wassily Kandinsky*, ed. Gualtieri di San Lazzaro (Paris: Société internationale d'art XXe siècle; Secaucus, N.J.: Amiel Book Distributors Corp., 1974), pp. 41–49; Nina Kandinsky, *Kandinsky und ich*, pp. 11–12; Ursula Schuh, in *Bauhaus und Bauhäusler*; Rudolf Ortner, "Ein Lebensbericht über das Bauhaus," in Monika Ortner-Bach, et al., *Rudolf Ortner* (Munich: Holzapfel, 2007), not paginated.

66 Later, Kandinsky parted ways with László Moholy-Nagy, both artistically and socially, as becomes clear from his correspondence with Josef Albers. See Vasily Kandinsky and Josef Albers, *Kandinsky–Albers. Une correspondance des années trente. Ein Briefwechsel aus den dreißiger Jahren*, ed. Jessica Boissel (Paris: Centre Pompidou, 1998).

67 The series eventually totaled fourteen books, including Paul Klee's *Pädagogisches Skizzenbuch* (1925), Schlemmer's *Die Bühne im Bauhaus* (1925), and Malevich's *Die gegenstandslose Welt* (1927). The technical illustrations in Vasily Kandinsky's *Punkt und Linie zu Fläche. Beitrag zur Analyse der malerischen Elemente* (Point and Line to Plane: A Contribution to the

Analysis of Pictorial Elements) are briefly mentioned in Poling, *Kandinsky in Russland und am Bauhaus*, pp. 40–41.

68 Felix Auerbach, *Physik in graphischen Darstellungen* (1912; Leipzig: Teubner, 1925), pp. 81, 110. See also other textbooks on physics, geometry, astrology, planetary curves, or even the magic of numbers at the Bibliothèque Kandinsky, Centre Pompidou, Paris.

69 Typed manuscript, Bibliothèque Kandinsky, Centre Pompidou, Paris.

70 After the move to Dessau, the following former Bauhaus students became part of the staff as young masters (*Jungmeister*): Albers, Herbert Bayer, Marcel Breuer, Hinnerk Scheper, Josef Schmidt, and Gunta Stölzl.

71 For the reconstruction of the decoration of Kandinsky's semidetached house (originally left plain by Gropius) see Gilbert Lupfert, *Architektur und Kunst. Das Meisterhaus Kandinsky-Klee in Dessau* (Berlin: Seemann Verlag, 2000), particularly the essay by Norbert Michels, pp. 35–63.

72 Typed manuscript, January 14, 1927, Bibliothèque Kandinsky, Centre Pompidou, Paris.

73 Kandinsky must have seen Fernand Léger's work by 1924 at the latest, when he went to the *Internationale Kunstausstellung* (*International Art Exhibition*), in Vienna, at which Léger was also exhibiting (although it was mainly Léger's voluminous female nudes that were on view).

74 Vasily Kandinsky, *Punkt und Linie zu Fläche. Beitrag zur Analyse der malerischen Elemente*. Bauhaus Bücher 9 (Munich: Albert Langen, 1926), reproduced as *Point and Line to Plane: A Contribution to the Analysis of Pictorial Elements*, in Kandinsky, *Complete Writings on Art*, pp. 527–699.

75 Kandinsky, "Und. Einiges über synthetische Kunst," *i10* (Amsterdam) 1, no. 1 (January 1927); reproduced as "And, Some Remarks on Synthetic Art," in Kandinsky, *Complete Writings on Art*, pp. 706–18. The comment on *Point and Line to Plane* is a footnote to the paragraph: "The analysis of the external element of form should act as a pointer to its internal element." Ibid., p. 711.

76 In 1920, Fannina Halle published a book about Old Russian art, *Alt-russische Kunst/ Orbis Pictus, Weltkunstbücherei*, ed. Paul Westheim (Berlin: Ernst Wamuth, 1920),

and one year later, a study entitled *Kandinsky, Archipenko, Chagall* (Vienna: Die Bildenden Kunste, 1921).

77 Fannina Halle, "Dessau: Burgkühnauer Allee 6–7 (Kandinsky und Klee)," *Das Kunstblatt* (July 1926), pp. 203–10; reprinted in Wingler, *Das Bauhaus, 1919–1933*, p. 158.

78 Fannina Halle, *Kandinsky. Jubiläums-Ausstellung zum 60. Geburtstage*, exh. cat. (Dresden: Galerie Arnold, 1926), pp. 10–18, in which she also quotes from Kandinsky's "Reminiscences." Klee's contribution to the catalogue ends with the words often quoted in later literature: "And today I say Good morning, and make a slight movement toward him from the west! He takes a step toward me, and our hands meet. Germany, 1926."

79 For the relationship between the two artists, see Magdalena Droste, ed., *Klee und Kandinsky. Erinnerung an eine Künstlerfreundschaft anlässlich Klees 100. Geburtstag*, exh. cat. (Stuttgart, Germany: Staatsgalerie, 1979); Beeke Sell Tower, *Klee and Kandinsky in Munich and at the Bauhaus*, Ph.D. diss., Brown University, 1979 (Ann Arbor, Mich.: UMI Research Press, 1981); Osama Okuda, "Verwandlungskraft und Mut zum Neuen. Klees Verhältnis zu Kandinsky," in *Kandinsky. Hauptwerke aus dem Centre Georges Pompidou Paris*, Kunsthalle Tübingen, Germany, exh. cat. (Cologne, Germany: DuMont, 1999), pp. 112–19.

80 See Hans K. Roethel, with Jean K. Benjamin, *Kandinsky* (Munich: Piper, 1982), pp. 140–42; Felix Thürleman, "Launelinien und schwarze Flecken. Kandinskys künstlerische Entwicklung im Spiegel der Bildtitel," in *Kandinsky nelle collezioni svizzere*, pp. 115–37.

81 In the small collection of "pictorial sources" in the Fonds Kandinsky, Centre Pompidou, Paris, there are, among those images pasted on card or cut out of magazines, aerial views of the pattern of fields in the Nördlinger Ries, a natural circular depression in the Bavarian plain.

82 Paul Klee, quoted in Christian Geelhaar, *Paul Klee und das Bauhaus* (Cologne, Germany: DuMont, 1972), p. 120.

83 Vasily Kandinsky, "Ohne Titel [Paul Klee gewidmet]," *bauhaus* (Dessau) 3 (1931), not paginated, reproduced as "Untitled statement [Tribute to Paul Klee]," in Kandinsky, *Complete Writings on Art*, p. 753.

84 For a detailed account see: *Bauhaus Berlin. Auflösung Dessau 1932, Schließung Berlin 1933, Bauhäusler und Drittes Reich. Eine Dokumentation, zusammengestellt vom Bauhaus-Archiv Berlin*, ed. Peter Hahn, with the collaboration of Christian Wolsdorff (Weingarten, Germany: Kunstverlag Weingarten, 1985). The publication includes numerous documents, records, flyers, and letters.

85 The "Offener Brief. Mein Hinauswurf aus dem Bauhaus" (Open letter. My Expulsion from the Bauhaus) that Hannes Meyer wrote in August 1930 to the Mayor of Dessau is often quoted, but not usually the political swipe at the "painter individualists" Klee and Kandinsky: "The Bauhaus condor Gropius stoops from the Eiffel Tower and pecks at my directorial corpse, and by the Adriatic W. Kandinsky stretches relieved on the sand: It is finished. . . . The clover field [Klee field] of young Bauhaus artists, bred by the oddest painter-individualist, will lie fallow in our age of the utmost social restructuring and collective scarcity. It is really a crime that young people, who will have to take on creative roles for tomorrow's society, should be fed stale artistic theories of the day before yesterday." Meyer, quoted in Wingler, *Das Bauhaus, 1919–1933*, p. 171.

86 *bauhaus* appeared in various formats: the 1926 and 1927 issues appeared as inserts on high-quality paper; from 1928, it consisted of high-quality brochures; in 1930 it was not published at all; and in 1931 it appeared as three slender issues. See also *Bauhaus Dessau, 1926–1931*, facsimile produced in collaboration with the Bauhaus Archives, Berlin, Kraus Reprint Nendeln, 1977.

87 Vasily Kandinsky, "kunstpädagogik," *bauhaus* (Dessau) 2, no. 2–3, (1928), p. 8; reproduced as "Art Pedagogy," in Kandinsky, *Complete Writings on Art*, p. 724.

88 "It may be regarded as more or less proven that in the old Russian *church* all the arts served, with equal prominence and to the same extent, a *single goal*— architecture, painting, sculpture, music, poetry, and dance (movement of the clergy). Here, the aim was purely internal—prayer." In Kandinsky, "And, Some Remarks on Synthetic Art," p. 712.

89 Ibid., p. 711. In the single-page typewritten manuscript also called "Und. Einiges über synthetische Kunst," which was

obviously intended for a lecture, Kandinsky summed up these ideas in a concise and clearer form: "20th century—walls fall. Consequence—chaos. Confusion, despair associated therewith. The new basis approaches—*And*. . . . Arts getting closer to each other and relationships with wider areas. Painting fertilises other arts, combines art with science, technology, etc. Art and life. Preparatory run-up to the synthetic opus." Bibliothèque Kandinsky, Centre Pompidou, Paris.

90 See Christian Derouet and Fabrice Hergott, eds., *Vassily Kandinsky. Le Salon de musique de 1931 et ses trois maquettes originales*, exh. cat. (Strasbourg, France: Musées de Strasbourg, 2006).

91 Otto Nebel's diary, quoted in *Kandinsky nelle collezioni svizzere*, p. 267.

92 Vasily Kandinsky to Josef Albers, January 9, 1934, in Kandinsky and Albers, *Kandinsky–Albers*, p. 21.

93 Vasily Kandinsky to Alfred Barr, Jr., July 16, 1936, quoted in Georgia Illetschko, *Kandinsky und Paris. Die Geschichte einer Beziehung* (Munich: Prestel, 1997), p. 117.

94 E. Tériade (Stratis Eleftheriades), in *Exposition d'aquarelles de Wassily Kandinsky*, exh. cat. (Paris: Galerie Zak, 1929), not paginated.

95 This is developed at some length in Illetschko, *Kandinsky und Paris*, p. 26.

96 Will Grohmann, *Wassily Kandinsky* (Paris: Editions Cahiers d'Art, 1930).

97 Vasily Kandinsky to Christian Zervos, February 7, 1931, Vasily Kandinsky, *Correspondances avec Zervos et Kojève*, ed. Christian Derouet, trans. N. Ivanoff, Hors Série/Archives, *Les Cahiers du musée national d'art moderne* (Paris: Centre Pompidou, 1992), p. 70.

98 "2. Do you and M. Zervos find this little article by Mme Halle useful for my catalogue? Would it be possible to include it in the catalogue, behind the preface by M. Tériade?" Ibid., p. 57. The German manuscript by Halle is among the original Kandinsky–Zervos correspondence at the Bibliothèque Kandinsky, Centre Pompidou, Paris.

99 Typed manuscript signed "Fannina Halle/ Vienna/January 1930." Bibliothèque Kandinsky, Centre Pompidou, Paris. In another sentence, she says each work is "a living miracle in itself, whose diversity and 'secret soul' are only revealed in the context of the whole."

100 "Whenever we went to the Kandinskys,"

recalled Felix Klee, "we always said, we're now arriving in an East Asian museum." Nina Kandinsky, *Kandinsky und ich*, p. 147.

101 For the decoration of the master houses, see note 71 and Poling, *Kandinsky in Russland und am Bauhaus*, p. 40.

102 For the nature of the "sand paintings–wall paintings–room paintings," and other technical terms, see the enlightening explanations of Illetschko, *Kandinsky und Paris*, p. 127.

103 Eduard Strasburger and Wilhelm Benecke, *Zellen- und Gewebelehre. Morphologie und Entwicklungsgeschichte. II. Zoologischer Teil*, ed. Paul Hinneberg (Berlin: Teubner, 1913), p. 388. In this publication there is, for example, a bookmark by Kandinsky on p. 25 for an illustration of the division of unicellular organisms. See also Vivian Endicott Barnett, "Kandinsky and Science: The Introduction of Biological Images in the Paris Period," in *Kandinsky in Paris, 1934–1944*, exh. cat. (New York: Solomon R. Guggenheim Foundation, 1985), pp. 61–87.

104 Kandinsky also had the volumes on chemistry, physics, and jurisprudence in this series, but obviously used Part I of "Botany" on cytology and histology (in *Zellen- und Gewebelehre*) frequently during the Bauhaus period. Note, in particular, his flagged bookmark inscribed "Kreis" ["circle"] (p. 138). There is also a cross section of a root that resembles the many small circular shapes within large forms that one finds in his Bauhaus works.

105 On June 18, 1929, for example, Kandinsky expressed thanks for the latest issue, "which [he] thought very interesting, especially the works by Léger!" Kandinsky, *Correspondances avec Zervos et Kojève*, p. 44, and asks several times for illustrations for his collection of examples to use in his Bauhaus lessons, for example, works by Arp, Marcel Duchamp, Francis Picabia, and Piet Mondrian. See the essay by Christian Derouet in this catalogue.

106 Jean Cassou, *Interférences: Aquarelles et dessins de Wassily Kandinsky* (Paris: Delpire, 1960), p. 21.

107 Tom M. Messer, in *Wassily Kandinsky, 1866–1944*, ed. Messer, exh. cat. (Munich: Haus der Kunst, 1976/77), pp. 106–7. The "Eastern" character, coloration, and fantasy of Kandinsky's pictures were already emphasized post–Will Grohman by Otto Nebel in his diary in February 1937. Nebel

saw works from the Paris period at the exhibition in Bern in 1937, and also met Kandinsky himself: "Paris made him airier. In addition, a touch of sweetness came into things that look neither Russian nor German. All in all, his output has remained admirably consistent. It has remained 'Eastern' in a spiritual sense, which means to say that this 'East' is not to be understood in a geographical sense. Remarkably, there is nothing in the least bit reminiscent of Africa. The primeval in K. is blooming and dreamlike, at once unbridled and tamed." Nebel, quoted in *Kandinsky nelle collezioni svizzere*, p. 277.

108 Nina Kandinsky, *Kandinsky und ich*, p. 211.

109 Ibid., p. 169.

110 Alberto Magnelli, quoted in Max Bill, *Wassily Kandinsky* (Paris: Maeght, 1951), p. 18.

111 "I studied antique art, the ancient Egyptian, which I love very much, the Italian Renaissance painters from Venice and Florence, and Russian Icon paintings." Kandinsky, "Interview par C. A. Julien, 10 Juillet 1921," p. 26.

112 Here Kandinsky noted "our liking for this kind of art" on a passage about ancient Egyptian painting and its mixture of frontal and profile representation. Kandinsky, quoted in Alexandre Kojève, *Die konkrete Malerei Kandinskys*, trans. and ed. Hans Jörg Glattfelder (Bern: Gachnang und Springer, 2005), p. 35. For information about Kojève, the son of Kandinsky's half-brother Alexei Kojevnikov, see ibid., p. 75. See also the French version of the manuscript, unpublished in Kandinsky's lifetime, in Kandinsky, *Correspondances avec Zervos et Kojève*, pp. 177–93.

113 Gladys C. Fabre, *Abstraction Création, 1931–1936*, ed. Norbert Nobis and Hagen Röhrig, exh. cat. (Paris: Musée d'art moderne de la ville de Paris, Centre Pompidou; Munster: Westfälisches Landesmuseum für Kunst und Kulturgeschichte, 1978), p. 19.

114 See ibid., p. 9; and Kojève, *Die konkrete Malerei Kandinskys*, pp. 80–81, especially with reference to the important term "elementarism" relative to Theo van Doesburg's late Parisian period.

115 Fabre, *Abstraction Création, 1931–1936*, pp. 11–12. Kandinsky's pupil Bill and Arp would still be defining the term in 1944 in the catalogue of the major exhibition *Konkrete Kunst* (*Concrete Art*) at the

Kunsthalle in Basel: "We call concrete art works that were generated on the basis of their own means and laws without external reference to natural appearances, i.e. not through 'abstraction.'" Ibid., p. 9.

116 This article was also published in French as "La Valeur d'une oeuvre concrète," *XXe Siècle* (Paris) 1, nos. 5–6 (I) and nos. 1–2 (II) (1938–1939). The English version is reproduced in Kandinsky, *Complete Writings on Art*, pp. 820–28. The original manuscripts, written in German, are now in the Bibliothèque Kandinsky, Centre Pompidou, Paris; the original texts are published in Kandinsky, *Essays über Kunst und Künstler*, ed. Max Bill (Stuttgart, Germany: G. Hatje, 1955), p. 134.

117 Vasily Kandinsky to Pierre Bruguière, February 2, 1941, quoted in *Kandinsky. Hauptwerke aus dem Centre Georges Pompidou Paris*, pp. 179–80.

118 Piet Mondrian, "L'Expression plastique nouvelle dans la peinture," *Cahiers d'Art 7* (September 1926), p. 181. In other sources, for example in a letter to Hilla Rebay, Kandinsky also considered using the term "art non-figuratif" to define his art. At the time, this term was much discussed in Paris and officially "baptized" with the exhibition *Origines et développement de l'art international indépendant* (*Origins and Development of International Independent Art*) of 1937. In it, the last two rooms, displaying works by Kandinsky, among others, were classified under the term "Art non-figuratif." See the essay by Christian Derouet in this catalogue.

119 "Artists striving for purity were forced to abstract natural forms which tended to cover up three-dimensional elements; to eliminate the 'natural' forms and replace them with 'artistic' forms." Van Doesburg, quoted in *Art concret*, exh. cat. (Paris: Galerie René Drouin, 1945), not paginated.

120 Vasily Kandinsky, "Réflexions sur l'art abstrait," *Cahiers d'Art 7–8* (1931), reproduced as "Reflections on Abstract Art," in Kandinsky, *Complete Writings on Art*, pp. 759; 759–60.

121 Vasily Kandinsky, "Sachlich–Romantisch," Dessau, June 1930. Quoted from the typed German manuscript, Bibliothèque Kandinsky, Centre Pompidou, Paris.

122 "Biologisch-kosmisch" ("Biological-cosmic") is one of many pairs of concepts that Kandinsky noted in a one-page unpublished manuscript entitled "thema für einen

vortrag: *inhalt und form*" (Topic for a
Lecture on Content and Form), presumably
written during the late Bauhaus years.
Toward the end, Kandinsky summarizes
using the term "Klingende Welt"
(Resounding World). Bibliothèque
Kandinsky, Centre Pompidou, Paris.

123 See the summary in Illetschko, *Kandinsky
und Paris*, pp. 153–72.

124 Nina Kandinsky mentions, several times in
her memoir, their joint fondness for visits
to the cinema. She writes, for example,
about their secluded life in the six months
they spent in Berlin, in 1921, after moving
from Russia: "And we indulged thoroughly
our passion for going to the cinema." Nina
Kandinsky, *Kandinsky und ich*, p. 96. The
same applied to their time in Weimar, and
later. The Kandinskys obviously saw some
films several times, see pp. 114, 236. Only
Illetschko has hitherto considered this fact
worth mentioning. (*Kandinsky und Paris*).
In note 61, p. 193, she announced a study
of her own on cinematographic aspects in
Kandinsky, which is unfortunately not
yet published.

125 The Kandinskys' annual holiday trips from
the Bauhaus period onward are listed not
only in the chronology of the present cata-
logue, but in even more detail in Hoberg
and Friedel, eds., *Vasily Kandinsky*,
pp. 280–99.

126 Vasily Kandinsky, "der wert des theoretischen
unterrichts in der malerei," *bauhaus*
(Dessau) 1, no. 1 (December 4, 1926),
reproduced as "The Value of Theoretical
Instruction in Painting," in Kandinsky,
Complete Writings on Art, p. 705.

127 Kojève, *Die konkrete Malerei Kandinskys*,
p. 49.

THE ARTIST REINVENTS HIMSELF: CHANGES, CRISES, TURNING POINTS

The seventy-eight years of Vasily Kandinsky's life resemble a zigzag line with various angles and gaps rather than a continuous, fluid line. Although his artistic career is usually divided into four periods based primarily on the countries in which he lived, the biographical information revealed in his letters and recollections emphasizes many stages and turning points throughout his lifetime. This essay focuses on the crucial junctures, breaks, crises, and changes in Kandinsky's life in order to accentuate its nuances and shifts and to present an overview of the transformations in his art.

Although the paintings in this exhibition date from 1907 to 1942, Kandinsky's artistic career covered a broader time span, from 1896 to 1944. Before he decided to become an artist in 1895,[1] he had studied law, economics, and statistics at the law faculty of the University of Moscow. Through friends studying in the law faculty, he became active in the Tsarist Society for Natural Science, Ethnography, and Anthropology.[2] In the summer of 1889, Kandinsky traveled to the distant Vologda province for a month to do research sponsored by the society.[3] He completed his law degree in 1893 after writing his dissertation on the legality of laborers' wages.[4] In 1896, he declined a teaching position that he had been offered at the University of Dorpat (now Tartu, Estonia) and, in December of that year, he moved to Munich to study painting. He had not previously enrolled in art classes but as a child had bought himself a paint box.[5]

At the age of thirty, Kandinsky completely changed his career and moved from his native Russia to Germany. He had visited Munich as well as Vienna, Milan, and Paris, in 1891–92, during a six-month wedding trip after his marriage to his cousin Anja Shemiakina.[6] Significantly,

VIVIAN ENDICOTT BARNETT

he chose Munich rather than Moscow or Paris to study art. In early 1897, he began studies there in the private art academy of Anton Azhbe that was frequented by other Russians, including Dmitry Kardovsky, Nikolai Seddeler, Igor Grabar, Alexei Jawlensky, and Marianne von Werefkin. Years later, in a short biographical note, Kandinsky wrote: "At the age of thirty he threw overboard the results of his scholarly work and traveled to Munich to study painting."[7]

As early as 1898, Kandinsky began to exhibit his paintings in Odessa, Russia (now Ukraine); however, it is not known what they looked like. In August 1901, the first exhibition of the Munich artists' association Phalanx presented *Trysting-Place I* (*Stelldichein I*, 1901, fig. 34) and *Winter* (1901), as well as four more paintings and ten small oil studies. The Romantic theme of a couple in medieval dress seen against dark trees and a moonlit walled city appeared frequently in Kandinsky's early work; it stands in marked contrast to the contemporary scene of a woman, child, and dog found in *Winter*.[8] Kandinsky was not only one of the founders of the Phalanx association but also of the Phalanx-Schule (Phalanx School), where he taught painting and drawing.[9] In August 1903, after seeing Kandinsky's painting *Mounted Warrior* (*Reisiger Ritter*, 1902–03, fig. 35), Peter Behrens offered him a professorship at the Kunstgewerbeschule (School of Arts and Crafts) in Düsseldorf.[10]

When Kandinsky painted the first works in the present exhibition, he was already forty years old. He had totally changed his profession, declined teaching positions in law and decorative painting, relocated from one country to another, and developed and changed his style of painting, yet he had not found his artistic direction. It was a time of crisis both professionally and personally for Kandinsky. On the eve of his fortieth birthday, he wrote from Sèvres, a suburb of Paris, to his companion Gabriele Münter, who was at that time living separately from him in Paris: "I am working on the study for the silent couple on the horse and am enjoying it. I incorporated many of my dreams [in it]: it really resembles an organ. There is music in it. It gives me new courage for other things and twice already I have felt that peculiar palpitation of my heart, which I often had in earlier times, when I was much more of a painter-poet. I also understand more of the theory

34 *Trysting-Place I* (*Stelldichein I*), 1901. Oil and tempera on canvas, 100 x 75 cm. Private collection

35 *Mounted Warrior* (*Reisiger Ritter*), 1902–03. Oil and tempera on burlap, 108 x 160 cm. Städtische Galerie im Lenbachhaus, Munich

Page 58: detail of *Red Oval* (*Krasny Oval*), 1920 (plate 51)

now. But will my life and strength be enough to put this theory into practice? Tomorrow 40."[11] The final canvas, *Riding Couple* (*Reitendes Paar*, plate 1), of early 1907, portrays a fanciful, romantic scene of a maiden and young rider embracing on horseback with birch trees and domed towers along a river in the background. Evoking memories of Russia and situated far from the reality of Paris, the couple may express a personal longing, a symbolic meaning for the artist. In Paris, Kandinsky often turned to Russian fairy tales and folklore in his art. During his year there, he was in frequent contact with Russian relatives and friends.[12]

In 1906–07, Kandinsky's relationship with Münter was strained, and he wanted to be alone in the apartment they had rented in Sèvres.[13] During the periods of separation, Kandinsky wrote frequent letters to Münter that reveal his depressed and tormented state of mind. On February 20, 1907, after she had left, he wrote about losing control and sobbing: "Suddenly my heart was so full, that I quite unexpectedly broke into tears. It's been ages since I cried like that. I sat on the floor by the sofa and could not contain myself. My entire life passed before my eyes. . . . Without exaggerating, at that moment I would have been happy to die." Then, on February 22, Kandinsky asked Münter to order canvas for two stretchers, one of them corresponding to the dimensions of *Colorful Life* (*Motley Life*) (*Das bunte Leben*, 1907, plate 2) and, by early March, he wrote to her: "I have worked with two long breaks, yet quite determinedly: two canvases are blackened and much of 'Colorful Life' is drawn in. I'm fairly happy with the drawings. I hope to get more from the painting and expect more of it."[14]

Although Kandinsky mentioned his hopes and anxieties in his letters, the reasons for his self-doubt and depression remain unclear. It was not the first time that Kandinsky had been depressed. As a child, he was often sad and longed for something: "I was looking for something, something was missing, I was craving for something . . . 'the feeling of lost paradise' is what I called this mental state at the time."[15] In 1901, he described in a letter to his friend Kardovsky, the Russian artist, the depression he suffered after the death of his uncle Alexander Silvestrovich Kandinsky.[16] He grieved the death of his half-brother

Vladimir Kojevnikov in May 1905 and, later that autumn, felt guilt and remorse when he initiated divorce proceedings against his first wife Anja. At various times he wrote about the difficulties he had experienced in Paris.[17]

Not only Kandinsky's personal life but also his struggle to find his own artistic direction created tensions and doubts. He had taught and traveled; he had exhibited extensively in Russia, Germany, and France; he had not, however, found his own style of painting. Certainly the works he created in early 1907 stood in sharp contrast to those of Pablo Picasso and Henri Matisse: *Riding Couple* and *Colorful Life* were done at the same time that Picasso began work on *Les Demoiselles d'Avignon* (1907). When Kandinsky showed his tempera paintings with old Russian themes at the Salon des Indépendants in the spring of 1907,[18] Matisse exhibited *Blue Nude: Memory of Biskra* (*Nu bleu [Souvenir de Biskra]*, 1907), which was soon purchased by the American collectors Gertrude and Leo Stein. Kandinsky and Münter knew them, as well as Michael and Sarah Stein, who lived in an apartment at the same address as Münter. There Kandinsky could have seen Matisse's *Portrait of Mme Matisse (The Green Line)* (*Portrait de Mme Matisse [La Raie verte]*, 1905), *Sketch for "The Joy of Life"* (*Esquisse pour "La Joie de vivre,"* 1905–06), *Pink Onions* (*Les Oignons roses*, 1906), and many other paintings.[19] Gertrude and Leo Stein lived around the corner in rue de Fleurus; they owned Matisse's *Woman with the Hat* (*Femme au chapeau*, 1905), several Rose Period works by Picasso, as well as his recent *Portrait of Gertrude Stein* (1906).[20] In her diary, Münter referred to "the Stein family with their collection of modern French artists."[21] Later, she recalled that Kandinsky "only got to know the Stein family, with their modern gallery. Gertrude Stein once came to see him in his studio, saw his tempera paintings and smiled."[22] Münter's American friend Annette Rosenshine also remembered visiting Münter and Kandinsky in the spring of 1907 in Sèvres, where they had a large studio. She wrote about his large representational canvases in drab colors and noted: "I felt quite superior in recognizing how far removed his work was from the avant-garde art I was seeing at the Steins."[23]

After leaving Paris in June 1907, Kandinsky continued to be depressed and he stayed, in June and July, for several weeks of

36 *Upper Palatinate–Landscape with Yellow Field* (*Oberpfalz–Landschaft mit gelbem Feld*), 1903. Oil on cardboard, 29.8 x 44.5 cm. Städtische Galerie im Lenbachhaus, Munich

37 *Painting with Houses* (*Bild mit Häusern*), 1909. Oil on canvas, 97 x 131 cm. Stedelijk Museum, Amsterdam

treatment, at a sanatorium in Bad Reichenhall not far from Salzburg, Austria. He described his difficulty sleeping, his loneliness, and absent-mindedness: "I had actually expected my cure would help. I don't think that I will recover entirely. But I will gain some strength. All in all, I am already much better than I was in France."[24] He did not paint at all from June to September, and made only a few works when he and Münter lived in Berlin from September until May 1908.

Suddenly, in the late summer of 1908, Kandinsky began to paint bold, colorful landscapes inspired by the town of Murnau, Germany, and the surrounding countryside in Upper Bavaria. The transformation from a year earlier is astonishing: doubt and anxiety are replaced by confidence and enthusiasm. The change in palette, brushwork, technique, dimensions, and subject matter marks a major turning point in Kandinsky's art. He painted *Murnau–Landscape with Tower* (*Murnau–Landschaft mit Turm*, plate 3) with broad strokes of oil paint on heavy tan cardboard. The buildings and tower of an old brewery merge with the dark green and black foliage. The deep blue sky punctuated by patterns of white clouds contrasts with the deep red and gold of the field in the foreground. Kandinsky had, of course, painted landscapes before—often working with the palette knife on small canvasboards in Kochel am See, near Munich, as early as 1900, and in Kallmünz, in

Bavaria, three years later (fig. 36). In Paris, during 1906–07, he had painted the park at Saint-Cloud near Sèvres. Nevertheless, the abruptness and pervasiveness of the change in 1908, and the immediacy and intensity with which Kandinsky captured his surroundings, constitute a major turning point in his art.

After four years of constant travel, Kandinsky and Münter decided to settle in Munich and, by mid-August, they were staying at the Griesbräu Inn in Murnau. They were joined by their friends, Jawlensky and Werefkin, and painted out-of-doors.[25] Jawlensky had also been in Paris and was more familiar than Kandinsky with the art of Paul Gauguin and Vincent van Gogh, as well as the recent works of Matisse, André Derain, Maurice de Vlaminck, and other Fauve painters. Earlier, in 1905, Jawlensky had painted landscapes in Brittany and the south of France. Not only the impact of the Murnau country-side, but also his and his friends' reflections on the Fauve paintings that they had seen in Paris, inspired Kandinsky's prolific outpouring of works that began in August 1908.

In the summer of 1909, Kandinsky and Münter returned to Murnau. *Landscape near Murnau with Locomotive* (*Landschaft bei Murnau mit Lokomotive*, plate 4) shows the train going through the village and passing close to the house that Münter purchased that summer.

38 *Deluge (for Composition VI)* (*Sintflut [zu Komposition VI]*), 1911. Glass painting, dimensions unknown. Location unknown

39 *Composition VI* (*Komposition VI*), 1913. Oil on canvas, 195 x 300 cm. State Hermitage Museum, St. Petersburg

The shift from Murnau landscapes to pictures abstracted from the landscape can be seen in *Blue Mountain* (*Der blaue Berg*, 1908–09, plate 5), *Painting with Houses* (*Bild mit Häusern*, 1909, fig. 37), and in the many *Improvisations*, which date from 1909 to 1914. The significance of place—specifically, the landscape near Murnau—may seem surprising, even contradictory, in the work of an abstract artist.

In *Romantic Landscape* (*Romantische Landschaft*, plate 20), which Kandinsky painted on January 3, 1911, the same day that he made *Impression III (Concert)* (*Impression III [Konzert]*, plate 18), he moved beyond the specifics of place in his expression of the image of three horses racing down a snow-covered hillside. Years later, at the Bauhaus, he recalled that the landscape had nothing to do with the earlier romantic works. "I intend to use such a term again. So far I called some works 'Lyrical Triangle'—for which I had to endure incredible criticism in the press—or 'Lyrical Structure,' etc. The old gulf between these two concepts no longer exists: where is the border between lyrical and romantic?"[26] With its expressionist brushwork and color, *Romantic Landscape* is far removed from Kandinsky's earlier romantic paintings such as *Trysting-Place I* or *Riding Couple*.

Probably in the late summer of 1911, Kandinsky painted a glass painting, *Deluge (for Composition VI)* (*Sintflut [zu Komposition VI]*, fig. 38), which became the starting point for *Composition VI*

(*Komposition VI*, fig. 39). Eighteen months later, after many unsuccessful attempts, much reflection and searching, Kandinsky realized: "Under normal circumstances I would be able to paint the picture. No sooner had I received the canvas I had ordered than I began the laying-in. It advanced quickly, and nearly everything was right the first time. In two or three days the main body of the picture was complete. The great battle, the conquest of the canvas, was accomplished."[27] *Composition VI* was completed on March 5, 1913, and two months later, the artist wrote a text about the evolution of the large painting.

The sense of struggle and of fighting with the canvas occurs repeatedly in Kandinsky's writing about his painting. In September 1905, he wrote a letter to Münter about working for two hours on a painting, *The Rivals* (*Die Rivalen*), and having "the feeling of satisfaction and victory. . . . It was really a struggle and each movement I did was directed and sure."[28] In his essay "Rückblicke" ("Reminiscences"), written in 1913, he reflected upon his early childhood experiences with oil paint: "Fresh colors emerge from the tube, like in a battle, young forces replacing old."[29] Later, Kandinsky realized that the opposite of the adage "when painting, one look at the canvas, half at the palette, and ten at the model" was true for himself: "Ten looks at the canvas, one at the palette, and half at nature. In this way, I learned to struggle with the canvas."[30]

In May 1913, he wrote a text about *Painting with White Border (Moscow)* (*Bild mit weißem Rand [Moskau]*, plate 35), completed the same month. The first sketch was made soon after his return from Moscow in December 1912, and was followed by many studies. He described it as follows: "At the bottom left, there is a battle in black and white." After months of indecision, "I was sitting looking in the twilight at the second large-scale study, when it suddenly dawned on me what was missing—the white edge. . . . I treated this white edge itself in the same capricious way it had treated me: in the lower left a chasm, out of which rises a white wave that suddenly subsides, only to flow around the right-hand side of the picture in lazy coils, forming in the upper right a lake (where the black bubbling comes about), disappearing toward the upper left-hand corner, where it makes its last, definitive appearance in the picture in the form of a white zigzag. Since this white edge proved the solution to the picture, I named the whole picture after it."[31]

Painting did not come easily to Kandinsky. Months of searching and thinking were finally resolved with a burst of creative energy. The fact that he painted the monumental canvas *Composition VII* (*Komposition VII*, fig. 51) within four days in late November 1913 does not negate the many months and dozens of studies that preceded it.[32] In early December 1913, he was inspired to paint two of his most radically abstract canvases, *Light Picture* (*Helles Bild*, plate 38) and *Black Lines* (*Schwarze Linien*, plate 39). Kandinsky and Münter stayed in Murnau during the summer of 1914, as they had in previous years. Kandinsky painted *Improvisation Gorge* (*Improvisation Klamm*, 1914, plate 44) after visiting the Höllentalklamm near Garmisch-Partenkirchen and making several sketches of the sunset, dusk, a couple in Bavarian dress, and a rider on horseback. Landscape elements—such as houses, boats, a viaduct, waterfall, and dock—can be discerned, although the picture cannot be considered a landscape.

The period of great creativity that began in 1908 ended abruptly with the outbreak of the World War I on August 1, 1914. Within days, Kandinsky, who was a Russian citizen and thus an enemy alien, had to leave Germany. After staying in Switzerland for several months, he returned to Russia in December 1914. From August 1914 until January 1916, Kandinsky was unable to paint any oils. He did, however, make many watercolors and drawings. He wrote to Münter in November 1915: "I am working a lot in watercolor. It's very precise work and I have, so to speak, to learn the silversmith's art. They prepare me for the large paintings, which are slowly taking shape in my soul. I would like to make a large painting with enormous depth and achieve an effect of great distance with subtle means, which one discovers only by coming close to the canvas—an idea which I have already explored in the paintings, which you have seen—but now I understand it in a broader and more practical sense, which is the result of the many watercolors done recently."[33] Unlike the crisis of seven years earlier, the rupture in 1914 began with external political events beyond his control but resulted in personal difficulties affecting his ability to paint, the possibility of earning money from sales of works in Germany, and the possibility to travel freely or live with Münter.

At the end of 1915, Kandinsky went to Stockholm to meet Münter, who had been waiting for him in neutral Sweden. At the beginning of 1916, during his short stay in Stockholm, he painted three canvases. Only one of them survives, *Painting on Light Ground* (*Na Svetlom Fone*, plate 46). Here the oval composition set against a tan border suggests paintings such as *Gray Oval* (*Graues Oval*), of 1917,[34] and *White Oval* (*Bely Oval*, plate 49), of 1919, that he would create in Russia. Kandinsky promised Münter that he would come back to see her after his fiftieth birthday: "You have to understand that I *cannot* leave before December 5. It is even probable that being fifty will not give me freedom to travel. It is possible that I might have duties even here in *Moscow*. In any case, these duties will *not* be at all disagreeable."[35] He did not travel to Sweden after his birthday, nor did he ever see Münter again.

A few months before his fiftieth birthday, Kandinsky had met a beautiful, very young Russian woman, Nina Andreevskaya, whom he married in February 1917. The February Revolution took place during their honeymoon. He had sold his old house and had made plans to purchase land on which he would build a large house and studio, but because of the October Revolution, the plans could not be realized.[36] The artist experienced the Revolution "from his window."[37] From late October 1917 until June 1919, he did not paint any canvases. He did, however, continue to make glass paintings in a figurative, fanciful style

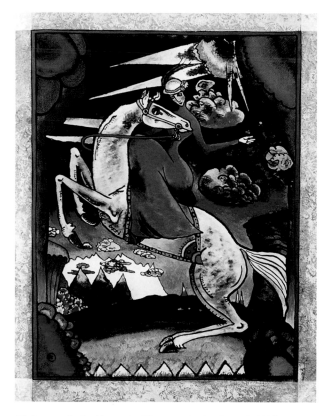

40 *Amazon in the Mountains (Amazone in den Bergen)*, 1918.
Glass painting, 31 x 25 cm. State Russian Museum, St. Petersburg

(fig. 40), as he had during the previous two years. Nina Kandinsky recalled that after the Revolution their life in Moscow became "unbearable" and that they endured cold, hunger, and extreme hardship for years.[38] After the Bolshevik Revolution, Kandinsky and his family lost all their assets and their properties were expropriated. For the first time, he did not have a regular income, and he experienced financial difficulties. He had grown up in a wealthy merchant family[39] with landholdings and income that permitted him to devote himself to his art and to travel. Although his personal life was happy with his marriage to Nina and the birth of their son Vsevolod in September 1917, the political upheaval within Russia caused drastic changes to his financial circumstances.

Not surprisingly, Kandinsky resumed teaching fifteen years after he had last held classes at the Phalanx School in Munich. In 1918, he became head of a studio at the Moscow Free State Art Studios

(SVOMAS) and also assumed an active role in the administration of the Department of Visual Arts of the People's Commissariat for Enlightenment (IZO NKP). In 1919, he became the first director of the State Museum of Painterly Culture in Moscow, which acquired works—including his own—by avant-garde artists for museums in distant provinces, as well as for the Moscow museum. In May 1920, he was instrumental in organizing the Institute of Artistic Culture (INKhuk) in Moscow, and was appointed head of the Department of Monumental Art. However, after his pedagogical program for the institute was rejected at the end of the year, Kandinsky resigned from INKhuk. In 1921, together with Pyotr Kogan, he founded the Russian Academy of Artistic Sciences (RAKhN) and served as vice-president. Although his numerous administrative duties within the state institutions took most of his time, Kandinsky painted abstract canvases and works on paper in 1919–20. He exhibited some of them at the *XIX Exhibition of the All-Russian Central Exhibition Bureau* in Moscow in the fall of 1920. In later years he recalled that, in 1921, "I was only able to paint seven pictures because during that difficult revolutionary period I had very little time and energy to paint," and that of these, *Red Spot II* (*Krasnoe Pyatno II*, plate 54) is "one of my best."[40]

Clearly Kandinsky adapted to the official organizations of the Bolshevik state. Through his role in the International Bureau of Narkompros, he promoted joint projects with German artists, and he initiated contact with influential people in Germany. In particular, his contacts with Walter Gropius, the director of the Bauhaus in Weimar, were significant: Kandinsky proposed an exhibition of recent Russian art in March 1921, and that fall he received an invitation from Gropius, through intermediaries, to visit the school. In October 1921, the RAKhN appointed Kandinsky its representative to travel to Berlin to study the feasibility of setting up a branch there and of expanding cultural exchanges between the two countries.[41]

Soon after his fifty-fifth birthday in December 1921, Kandinsky left Moscow for Berlin, accompanied by his wife Nina, who worked as a secretary for Narkompros. Initially, they did not intend to stay, but their official visit became a permanent residency. The warm welcome in Germany[42] and the formal invitation from Gropius in March 1922 to

join the faculty of the Bauhaus in Weimar were decisive factors. Moreover, Kandinsky's ideas of synthesis between the arts and his interest in the psychological effects of modern art had been increasingly met with resistance from younger generations of Russian artists. Not only professional factors but also personal circumstances may have contributed to the Kandinskys' decision. Their only child had died in September 1920—a loss that Nina never mentioned to her friends.

When Kandinsky left Russia, he was able to ship twelve paintings dating from 1919 to 1921 to Berlin.[43] In 1922, soon after his arrival, he sold *Points* (*Spitzen*, 1920),[44] and exhibited *In Gray* (*V Serom*, 1919, plate 50), *White Line* (*Bely Shtrikh*, 1920, plate 52), and *Blue Segment* (*Siny Segment*, 1921, plate 55), among other recent works, at the Galerie Goldschmidt-Wallerstein in Berlin, and then at art galleries in Munich and Stockholm. He participated in the *Erste russische Kunstausstellung* (*First Russian Art Exhibition*), at the Galerie van Diemen in Berlin, that he and his Soviet colleagues had helped to organize. Obviously enormous changes had taken place during the seven years he had lived in Russia.

However, there does not appear to be a significant stylistic difference between the last canvas painted in Russia, *Circles on Black* (*Krugi na Chyornom,* 1921, plate 58), and the first one done in Berlin, *Blue Circle* (*Blauer Kreis*, 1922, plate 59). From January to June 1922, Kandinsky painted *White Cross* (*Weißes Kreuz*, plate 60) in Berlin and Weimar, followed by *White Zigzags* (*Weiße Zickzacks*), the first picture to which he assigned a German title after his return. Although his Russian pictures contained circles, ovals, and checkerboards, the emphasis on geometric forms became more pronounced in the Bauhaus works. Circles were made with a compass and lines were drawn with precision. Straight lines contrast with curved lines in *On White II* (*Auf Weiß II*, 1923) and *Through-going Line* (*Durchgehender Strich*, 1923). Semicircles contrast with circles as well as triangles in *One Center* (*Ein Zentrum*, 1924, plate 65) and *Three Sounds* (*Drei Klänge*, 1926, plate 69). Triangles, trapezoids, and grids became familiar forms in Kandinsky's Bauhaus work. Spatial relationships shifted from the enormous distance sought in paintings done in Russia to a more compressed space and flatter

background in such Bauhaus pictures as *Yellow–Red–Blue* (*Gelb–Rot–Blau*, 1925, plate 66), *Several Circles* (*Einige Kreise*, 1926, plate 67), and *Accent in Pink* (*Akzent in Rosa*, 1926, plate 68).

At the Weimar Bauhaus, Kandinsky was appointed Master of the Wall Painting Workshop, and he taught theory of form in the Preliminary Course. In his teaching he emphasized forms and colors, especially the physiological and psychological properties of colors. His theory of correspondences between color and form—the yellow triangle, red square, and blue circle—are found in a questionnaire he prepared for Bauhaus students.[45] The three primary colors became the subject of *Yellow–Red–Blue* and are arranged in the same sequence as in his color scale, but the correspondence of the colors and forms differs. In 1924, Kandinsky titled canvases *Yellow Point* (*Gelbe Spitze*), *Yellow Accompaniment* (*Gelbe Begleitung*, plate 64), and *Black Accompaniment* (*Schwarze Begleitung*, fig. 41), and, the following year, *Black Triangle* (*Schwarzes Dreieck*, fig. 42).

In Weimar, Kandinsky immersed himself in the activities of the Bauhaus. He enjoyed being part of a community of artists. He was happy to be reunited with his old friend Paul Klee and he met Lyonel Feininger, Josef Albers, Johannes Itten, Georg Muche, Oskar Schlemmer, and later, László Moholy-Nagy. In addition to teaching, he wrote essays for Bauhaus publications and participated in Bauhaus exhibitions. Kandinsky had to create new works for the many one-person and group shows in which he exhibited since he had left most of his pictures behind in Russia in 1921, and he was still trying to recover the numerous works of art he had left with Münter in 1914. Kandinsky, who had exhibited extensively and was well known in Germany before World War I, was eager to present his recent paintings and to reestablish himself as a leading artist. The transformations in his art were immediately apparent to colleagues and critics.

When the Bauhaus relocated from Weimar, in Thüringen, to Dessau, not far away in Sachsen-Anhalt, the Kandinskys also moved. Kandinsky did not paint any canvases from April 1925, when the Bauhaus was closed in Weimar, until January 1926; he did, however, continue to make watercolors. The hiatus stands in contrast to the relatively smooth transition from Moscow to Berlin in late 1921; it

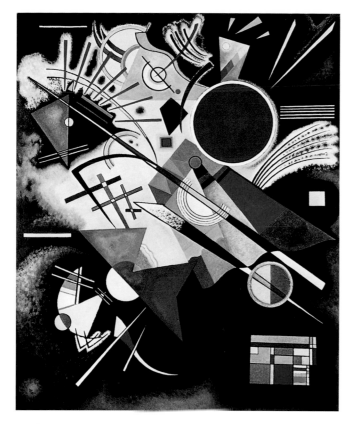

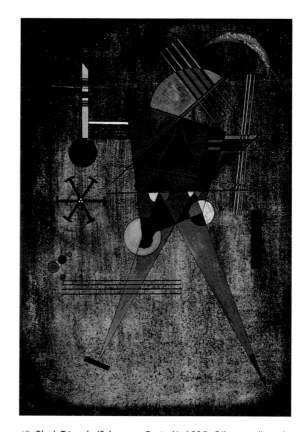

41 *Black Accompaniment (Schwarze Begleitung)*, 1924. Oil on canvas, 166 x 135 cm. Private collection, Switzerland

42 *Black Triangle (Schwarzes Dreieck)*, 1925. Oil on cardboard, 78.5 x 54 cm. Museum Boijmans Van Beuningen, Rotterdam, Netherlands

can be attributed to the fact that he spent most of his time working on the manuscript for *Punkt und Linie zu Fläche. Beitrag zur Analyse der malerischen Elemente (Point and Line to Plane: A Contribution to the Analysis of Pictorial Elements)*. The book, for which Kandinsky had begun to make notes in the fall of 1914, was published in the fall of 1926, soon before his sixtieth birthday.

In late 1925, Kandinsky was also busy preparing exhibitions marking his sixtieth birthday the following year. The Gesellschaft der Freunde junger Kunst (Society for the Friends of Young Art) in Brunswick organized an exhibition celebrating his "sixtieth birthday, thirty years in Germany." The exhibition included only oils and watercolors from 1921 to 1926. Among the most recent works shown were *Yellow–Red–Blue* and *Accent in Pink*. Later that year, however, the Galerie Arnold in

Dresden presented works from 1908 to 1926 in a *Jubiläums-Ausstellung zum 60. Geburtstage* (Jubilee exhibition on the occasion of his sixtieth birthday), which traveled to Berlin, Munich, and other German cities. Among the works from 1908 to 1926 included were *Murnau–Landscape with Tower*, *Improvisation 14* (1910, plate 15), *Composition IV (Komposition IV*, 1911), *Painting on Light Ground*, *White Line*, *White Zigzags*, *On White II*, *Through-going Line*, *Composition 8 (Komposition 8,* 1923, plate 63), and *Yellow–Red–Blue*—a few of which had been returned by Münter after lengthy negotiations by lawyers.[46]

The move from Weimar to Dessau did not result in significant changes in Kandinsky's painting or teaching. He continued to teach wall painting and analytical drawing, and, in 1927, he began to give classes in free (easel) painting. In January 1928, Kandinsky painted *Lyrical*

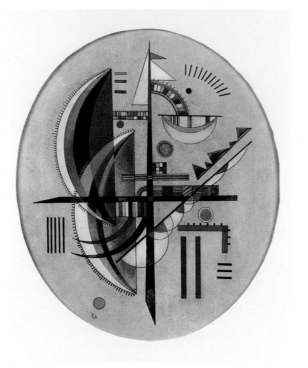

43 *Lyrical Oval (Lyrisches Oval)*, 1928. Oil on cardboard, 34 x 29 cm.
Private collection, Switzerland

Squares (*Quadratlyrik*) and *Lyrical Oval* (*Lyrisches Oval*, fig. 43); he
designed the stage sets for a production of Modest Mussorgsky's *Bilder
einer Ausstellung* (*Kartinki s vystavki* [*Pictures at an Exhibition*], 1874),
and not long afterwards made *On Points* (*Auf Spitzen*, plate 70).
There is a sense of continuity, fluency in composition, meticulous han-
dling of paint, and often a rigidity of structure in the pictures made
from 1926 to 1929. Kandinsky's earlier struggles seem to have dis-
appeared and been replaced by a remarkable effortlessness. In the
words of Will Grohmann, "he has mastered his craft so completely
that he can paint at any time of day, he can break off work and
resume it at the next occasion."[47] In spite of the fact that he took an
active role in the administration of the Bauhaus, Kandinsky created
more paintings and watercolors in Dessau than he did in Weimar.

In March 1928, Kandinsky became a German citizen and only in
December 1929 was he expelled from the RAKhN "as an emigrant."[48]
Consequently, many of the most important paintings from 1909 to 1921

that he had left behind in Russia—some of which belonged to the
artist and others that were on deposit in a museum in Moscow—were
nationalized by the Soviet museums.[49] With their German passports,
Vasily and Nina began to travel to France, Italy, and even the eastern
Mediterranean. Kandinsky was eager to exhibit outside Germany,
especially in France, Belgium, and the United States. Ironically, the
German passport permitted him not only to travel but also to focus
his attention outside Germany.

The years from 1929 to 1933 can be viewed as Kandinsky's
transition from the Bauhaus to his subsequent relocation to Paris. In con-
trast to the restraint and structure found in preceding years, Kandinsky
created a group of unusual, experimental works from about 1929 to
1932 that were characterized by intentionally messy surfaces, textured
effects from combining media, and discordant shades of nonprimary
colors, for example: *Variegated Accompaniment* (*Bunter Mitklang*,
1928), *Fluttering* (*Flatternd*, 1930, fig. 44), *Flutter-like* (*Flatterhaft*,
1931), *Slowly Out* (*Langsam heraus*, 1931), and *Cool Distance* (*Kühle
Entfernung*, 1932).[50] Moreover, his work began to reflect an aware-
ness of Surrealism on the one hand and an essentially Constructivist
tendency toward abstraction on the other.

The Bauhaus closed for good in July 1933 and that fall the
Kandinskys began to search for a place to live. As in August 1914, exter-
nal political events made it necessary for the artist to leave Germany,
but this time his departure was gradual rather than abrupt.[51] On his
sixty-seventh birthday, Kandinsky wrote to Grohmann: "We considered
for a very long time: where to? Switzerland? Italy? America? Paris?
Since the situation in the art market today is far from favorable every-
where, we decided on Paris; after all, it is the art center of the world
and offers the most opportunities to make a living by selling paintings.
We do not wish to leave Germany forever, something I wouldn't be
able to do since my roots are too deep in German soil. Also we rented
the apartment for only one year and I think that afterward we will go
back."[52] A few weeks later, Vasily and Nina settled in an apartment in
Neuilly-sur-Seine near the Bois de Boulogne, on the outskirts of Paris.

Kandinsky did not paint any pictures from August 1933, when he
made *Development in Brown* (*Entwicklung in Braun*, plate 73), until

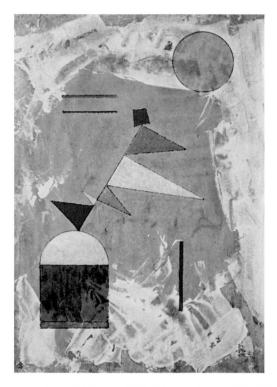

44 *Fluttering (Flatternd)*, 1930. Oil on cardboard, 34.5 x 24.5 cm.
Kunstmuseum Bern, Gift of Nina Kandinsky

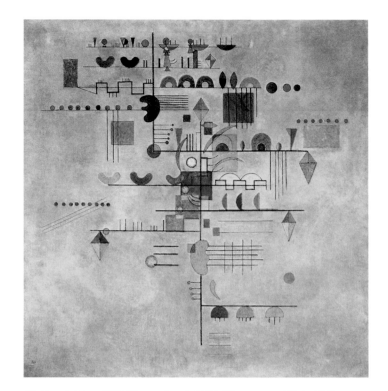

45 *Graceful Ascent (Montée gracieuse)*, 1934. Oil on canvas, 80.4 x 80.7 cm.
Solomon R. Guggenheim Museum, New York, Solomon R. Guggenheim
Founding Collection 45.970

February 1934, when he painted *Start*, in Paris.[53] One of his first oil paintings, *Graceful Ascent (Montée gracieuse*, 1934, fig. 45), was painted on a canvas he had probably brought with him from Germany. Under the pale gray and pastel colors, he had sketched in an earlier composition that has forms compatible with his Bauhaus work and whose hierarchical organization recalls *Levels (Etagen*, plate 71) of 1929.

When Kandinsky resumed painting, he introduced new hues in his palette, favoring lighter and more delicate color harmonies, and he selected new imagery derived from biomorphic as well as biological forms.[54] He incorporated embryological forms in *Blue World (Monde bleu*, 1934, plate 74) and *Capricious Forms (Formes capricieuses*, 1937, plate 84); images seen under the microscope in *Succession* (1935, plate 79); and insect forms in *Grouping (Groupement*, 1937, plate 85). In 1934–35, he added precisely defined areas of sand to numerous canvases, for example, *Blue World*, *Striped (Rayé*, 1934,

plate 75), *Two Surroundings (Deux entourages*, 1934, plate 76), and *Accompanied Contrast (Contraste accompagné*, 1935, plate 78). After he moved to Paris, Kandinsky began to assign titles in French to his work, even though he had stated that he only planned to stay there for a year.

Not long after his arrival, Kandinsky exhibited some of his most recent paintings, together with a selection of Bauhaus pictures, at the Galerie Cahiers d'Art in Paris in May 1934. The enormous difference between *Blue World*, painted in May, and *Development in Brown*, which was painted nine months earlier, would have come as a great surprise to his colleagues and collectors. Within months Kandinsky had completely changed his style of painting. A year later, during the summer of 1935, he showed, at the same gallery, ten paintings created in 1934–35, as well as a variety of watercolors and gouaches. He selected recent pictures for his Parisian audience so as to leave no doubt

that he had reinvented himself. In Paris, freed from teaching and administrative responsibilities, he devoted himself entirely to his art.

In March 1935, Kandinsky turned down an invitation from Black Mountain College in North Carolina to be artist-in-residence. He thanked Albers but explained: "I have been in Paris much too short a time to risk a lengthy absence. It would be ill-advised to loosen these weak, thin little roots that are beginning to connect me to the local soil here, worse even to pull them out, even if only for a relatively short period of time. In the coming spring I must exhibit here and of course be present in Paris."[55] At the beginning of 1931, after he had declined a teaching position at the Art Students League in New York, he corresponded with Galka Scheyer about a possible visit to the United States in the fall, and he even renewed his efforts to learn some English.[56] Again, in July 1933, after the Bauhaus closed, Kandinsky wrote to Scheyer: "Sometimes we both think about traveling to California, but it wouldn't be very easy financially."[57] Yet, in the fall of 1935, Kandinsky wrote to Grohmann: "I have become a true Parisian."[58]

A year later, he related to Alfred Barr, the director of the Museum of Modern Art in New York: "When I moved to Paris, I was so deeply moved by the light and by the nature there that I did not want to look at any unfamiliar pictures and, for almost two months, I could not paint. . . . Paris with its wonderful (intense soft) light had relaxed my palette—there were other colors, other entirely new forms, and some that I had used years earlier. Naturally I did all this unconsciously."[59] Thirty years earlier he had complained about the coldness and noise of Paris in comparison to the silence of Sèvres when he wrote to his former professor in Moscow and later friend Alexander Chuprov: "I like Paris less and less, as well as France (what I have seen) as a whole. It is so cold here, as maybe nowhere else. And impersonal."[60]

Paris had not changed; it was Kandinsky who had done so as he approached his seventieth birthday. In 1936, he created large, calm, majestic canvases such as *Composition IX* (1936, plate 82) and *Dominant Curve* (*Courbe dominante*, 1936, plate 83), and he titled other pictures *Environment* (*Environnement*, 1936) and *Stability* (*Stabilité*, 1936).[61] On the eve of his seventieth birthday, Kandinsky wrote to Grohmann, whose birthday was the same day: "Tomorrow we will each

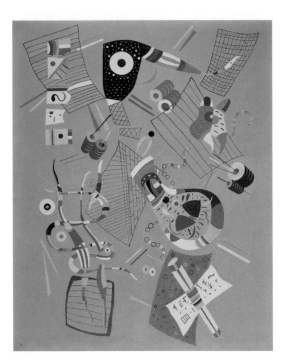

46 *Serenity* (*Sérénité*), 1938. Oil on canvas, 146 x 114 cm. Private collection, Switzerland

have a 0 at the end of our age, won't we? I am not very happy about my 0 accompanying a 7, although in fact I cannot bring myself to believe the mathematical proof of 1936–1866=70. Will you turn 50 tomorrow? . . . How often we spent December 4 together, and what happy occasions they were."[62]

In 1938, Kandinsky explained to the Swiss collector Hermann Rupf: "I sense that the 'Paris air' is favorable to me. In spite of my 'abstraction,' I depend to some extent upon my 'surroundings.' . . . Of all the various large cities that I know, I feel myself deeply rooted only in Moscow and Paris."[63] His paintings, such as *Serenity* (*Sérénité*, fig. 46), of 1938, and *Sky Blue* (*Bleu de ciel*, plate 90), of 1940, express the inventiveness, cheerfulness, and humor of an elderly artist working peacefully in his studio at home. In spite of the rapidly deteriorating political and economic situation,[64] he was happy to be in Paris "and to be able to work in [his] studio behind closed doors." He wrote: "My wife pampers me as usual so I can work without being distracted. I know this is very selfish but, at the end of the day, it is my duty."[65]

When Varian Fry, President of the American Emergency Rescue Committee (Centre américain de secours) in Marseille, wrote to the artist in 1941, at the request of Barr, to offer him and his wife free passage to New York and assured him that they would have no worries there, Kandinsky did not accept. Fry had mentioned: "Mr. Barr would like you to bring all your canvases with you, especially your early works."[66] At age seventy-five, Kandinsky did not want to relocate as he had done so many times before, nor did he want his recent canvases to be overlooked.

During the war and occupation, Kandinsky continued to paint and even to exhibit his work in Paris.[67] World War II did not affect either his personal life or his ability to paint, as had World War I. A month after his seventy-fifth birthday, he created *Balancing* (*Balancement*, 1942, plate 94) and *Reciprocal Accord* (*Accord réciproque*, 1942, plate 93). Kandinsky's last large-format canvas, *Delicate Tensions* (*Tensions délicates*, plate 95), was painted in June to July 1942; after its completion, he did not, however, stop working. Because of the war, it was difficult to obtain canvas and to heat the apartment in Neuilly. Nevertheless, Kandinsky continued to paint in oil on cardboard. At age seventy-seven, he created small pictures entitled *Dusk* (*Crépuscule*, 1943), *Darkness* (*Ténèbres*, 1943), and *Isolation* (1944, fig. 47), whose titles reflect his age and his surroundings.[68]

Within Kandinsky's long life, changes resulted from external events as well as from personal, internal needs. Wars and revolutions are obviously beyond anyone's control. However, the ways in which Kandinsky responded to his own situation in 1914, 1917, 1933, and 1941, are most revealing. Certainly, his efforts to adapt to the new Russian state when he was in his fifties, or to Paris at age sixty-seven, signal an ability to change. Subsequent significant changes in his paintings can be related to these dislocations and relocations. We may not expect an abstract artist to have been so strongly affected by the landscape near Murnau in 1908 or the light of Paris in 1934. Often we overlook the difficult moments or transitions in Kandinsky's life and focus only on the high points and breakthroughs in his art. It is, however, a mistake to ignore biographical elements and the impact of his personal life on his work.

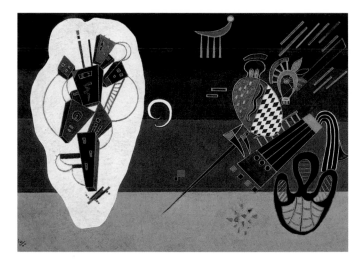

47 *Isolation*, 1944. Oil and tempera on cardboard, 42 x 58 cm. Private collection

This brief survey of the turning points in Kandinsky's life reveals remarkable coincidences with ages when most people reflect on their lives—thirty, forty, fifty, fifty-five, sixty, sixty-seven, seventy-five. By focusing on these junctures and referring to the artist's own words, a more accurate and balanced view of his self-awareness emerges. Even in 1901, before his career was launched, Kandinsky remarked to Kardovsky: "I wish I were only 20 years old! I keep thinking it's too late for everything and then I get all feverish."[69] Over the following decades, as his artistic direction gained strength, shifted, and rebounded, Kandinsky was keenly aware of where he stood and what his options were. He referred repeatedly to milestones—birthdays with round numbers. Over the years, the paths he did not take are telling: he could have accepted numerous teaching positions; he could have relocated to various places but chose not to go; and he could have stayed where he was, as he was, without changing.[70] Yet Kandinsky did transform himself and his art; he changed probably more often and with greater agility than many people born in the nineteenth century. This ability, to reinvent one's self, is an essentially modern phenomenon, more familiar to the late twentieth or twenty-first century than to the nineteenth.

Notes

Unless otherwise attributed, all translations of original French or German quotations are service translations provided by the Städtische Galerie im Lenbachhaus, Munich.

1 Igor Aronov, *Kandinsky's Quest: A Study in the Artist's Personal Symbolism, 1866–1907* (New York: Peter Lang, 2006), p. 13.

2 Ibid., pp. 10–14.

3 Boris P. Chichlo, "Wassily Kandinskys Erfahrungen in der Ethnographie: Ansichten eines Ethnologen," in Vasily Kandinsky, *Wassily Kandinsky. Gesammelte Schriften 1889–1916. Farbensprache, Kompositionslehre und andere unveröffentlichte Texte*, ed. Helmut Friedel (Munich: Prestel, 2007), pp. 653–62.

4 See Reinhard Richardi, "Kandinsky und das Recht der Arbeit," and Jean-Claude Marcadé, "Kandinskys universitäre Tätigkeit (1885–1895)," in Kandinsky, *Gesammelte Schriften*, pp. 665–69.

5 Kandinsky wrote: "As a thirteen or fourteen-year-old boy, I gradually saved up enough money to buy myself a paintbox containing oil paints." See Vasily Kandinsky, "Reminiscences" (1913), in Vasily Kandinsky, *Kandinsky: Complete Writings on Art*, ed. Kenneth C. Lindsay and Peter Vergo (1982; repr., New York: Da Capo Press, 1994), p. 371.

6 Aronov, *Kandinsky's Quest*, p. 9.

7 Vasily Kandinsky, "Self-Characterization" (1919), in Kandinsky, *Complete Writings on Art*, p. 431.

8 Vivian Endicott Barnett, *Kandinsky Watercolours: Catalogue Raisonné, Volume One, 1900–1921* (Ithaca, N.Y.: Cornell University Press, 1992), color ills. p. 64, no. 39, and p. 77, no. 42.

9 One of the students in his still-life class, in 1902, was Gabriele Münter. See Peg Weiss, *Kandinsky in Munich: The Formative Jugendstil Years* (Princeton, N.J.: Princeton University Press, 1979), pp. 63–65.

10 Ibid., p. 121, and Hans K. Roethel and Jean K. Benjamin, *Kandinsky: Catalogue Raisonné of the Oil Paintings, Volume One, 1900–1915* (Ithaca, N.Y.: Cornell University Press, 1982), p. 108.

11 Vasily Kandinsky to Gabriele Münter, December 4, 1906, Gabriele Münter- und Johannes Eichner-Stiftung in Munich. English translation is found in Vivian Endicott Barnett, *A Colorful Life: The Collection of the Lenbachhaus, Munich*, ed. Helmut Friedel, exh. cat. (Cologne, Germany: DuMont, 1995), p. 160.

12 His half-brother Alexei Kojevnikov was staying in Paris and his father Vasily Silvestrovich Kandinsky came to visit. In addition, he saw Elisabeth Epstein, Olga Meerson, and Nikolai Seddeler.

13 Münter lived separately at 58, rue Madame, in Paris from November 17 to December 18, 1906, and again from February 13 to March 19, 1907.

14 Vasily Kandinsky to Gabriele Münter, February 20–21 and 22, 1907, Gabriele Münter- und Johannes Eichner-Stiftung.

15 Vasily Kandinsky to Gabriele Münter, October 11, 1903, Gabriele Münter- und Johannes Eichner-Stiftung.

16 Vasily Kandinsky to Dmitry Kardovsky, March 13, 1901, published in German translation in: Kandinsky, "Die Briefe Wassily Kandinskys an Dmitrij Kardovskij," ed. Natalia Avtonomova, in *Wassily Kandinsky. Die erste sowjetische Retrospektive. Gemälde, Zeichnungen und Graphik aus sowjetischen und westlichen Museen*, exh. cat. (Frankfurt: Schirn Kunsthalle; Moscow: State Tretyakov Gallery; St. Petersburg: State Russian Museum, 1989), p. 49. The original Russian letter is preserved in the Manuscript Department of the State Tretyakov Gallery, Moscow.

17 For example, on August 18, 1932, he wrote to Will Grohmann: "At that time I had some very difficult years spiritually, perhaps especially in Sèvres; many severe doubts artistically and also purely private matters." Letter, in German, is preserved in the Archiv Will Grohmann, Staatsgalerie Stuttgart, Germany.

18 Barnett, *Kandinsky Watercolours: Catalogue Raisonné, Volume One*, p. 183, no. 203; p. 191, no. 214; p. 193, nos. 216, 217; and p. 194, no. 218.

19 Hillary Spurling, *The Unknown Matisse: A Life of Henri Matisse, The Early Years, 1869–1908* (New York: Alfred A. Knopf, 1998), pp. 347–48, 375, 383.

20 See John Richardson, *A Life of Picasso. 1881–1906, Volume One* (New York: Random House, 1991), p. 419, for an installation photograph of 27, rue de Fleurus, in 1907.

21 The diary, which Münter began in 1904 and continued on May 17, 1911, is preserved in the Gabriele Münter- und Johannes Eichner-Stiftung. Although she did not number the pages, the specific reference is found on p. 44.

22 Johannes Eichner, *Kandinsky und Gabriele Münter. Von Ursprüngen moderner Kunst* (Munich: F. Bruckmann, 1957), p. 52.

23 Spurling, *The Unknown Matisse*, p. 386. Annette Rosenshine met Sarah and Michael Stein when they visited San Francisco in 1906; she went to Paris to live with them and take care of their son Allan in 1907. Her unpublished memoir *Life's not a Paragraph* is preserved in the Bancroft Library, University of California at Berkeley.

24 Vasily Kandinsky to Gabriele Münter, July 7, 1907, Gabriele Münter- und Johannes Eichner-Stiftung.

25 Alexei Jawlensky and Marianne von Werefkin arrived in Munich in November 1896 and lived at 23 Giselastraße for eighteen years. Both Kandinsky and Jawlensky studied with Anton Azhbe in Munich.

26 Vasily Kandinsky to Will Grohmann, November 21, 1925, Archiv Will Grohmann. In November 1924, he painted a watercolor entitled *Lyrical Triangle* (*Lyrische Dreiecke*).

27 Kandinsky, "Reminiscences," p. 386.

28 Vasily Kandinsky to Gabriele Münter, September 15, 1905, Gabriele Münter- und Johannes Eichner-Stiftung. See Barnett, *Kandinsky Watercolours: Catalogue Raisonné, Volume One*, p. 181, for English translation and information about this lost picture (no. 195).

29 Kandinsky, "Reminiscences," p. 372.

30 Ibid.

31 Ibid., p. 391.

32 Barnett, *A Colorful Life*, pp. 445–48.

33 Vasily Kandinky to Gabriele Münter, November 16, 1915, Gabriele Münter- und Johannes Eichner-Stiftung. English translation by Lars Håkan Svensson found in Barnett, *Kandinsky Watercolours: Catalogue Raisonné, Volume One*, p. 33.

34 Hans K. Roethel and Jean K. Benjamin, *Kandinsky: Catalogue Raisonné of the Oil Paintings, Volume Two, 1916–1944* (Ithaca, N.Y.: Cornell University Press, 1984), p. 592, no. 621.

35 Kandinsky to Münter, October 16, 1916, Gabriele Münter- und Johannes Eichner-Stiftung. Emphasis original.

36 Nina Kandinsky, *Kandinsky und ich*, (Munich: Kindler, 1976), p. 41.

37 Dmitry Sarabianov and Natalia Avtonomova, *Vasilii Kandinskii. put khudozhnika, khudozhik i vrenia* (Moscow: Moskva Galart, 1994), p. 142.

38 Nina Kandinsky, *Kandinsky und ich*, p. 82.

39 His father was a tea merchant. On December 3, 1922, however, Kandinsky wrote to ask Katherine Dreier to send money to his eighty-year-old father: "My father in Odessa has great financial problems." Katherine S. Dreier Papers/Société Anonyme Archive, Beinecke Rare Book and Manuscript Library, Yale University, New Haven. Again, in 1924, Kandinsky wrote to Dreier about how many relatives in Russia he had to support and how difficult his financial situation was.

40 Vasily Kandinsky to Galka Scheyer, July 30, 1932, Blue Four Galka Scheyer Collection Archives, Norton Simon Museum, Pasadena, Calif.

41 See Nicoletta Misler, "Kandinsky e la scienza. Fra Mosca e Occidente," in *Wassily Kandinsky tra Oriente e Occidente: capolavori dei musei russi*, Palazzo Strozzi, Florence, exh. cat. (Florence: Artificio, 1993), pp. 48–51, and Margarita Tupitsyn, ed., *Gegen Kandinsky/Against Kandinsky*, Museum Villa Stuck, Munich, exh. cat. (Ostfildern, Germany: Hatje Cantz, 2006), pp. 145–46.

42 Nina Kandinsky, *Kandinsky und ich*, pp. 92–94.

43 Ibid., p. 90. She regretted that they had brought only twelve pictures and had left the rest in the depot of the Morozov Museum in Moscow.

44 See Roethel and Benjamin, *Kandinsky: Catalogue Raisonné of the Oil Paintings, Volume Two*, p. 626, no. 672, *Points* (*Spitzen*), which Nina Kandinsky identified as "Mit spitzen Formen" (with pointed forms).

45 The forms are reminiscent of "elementary life of the primary color and its dependence on the simplest locale." Vasily Kandinsky, "O dukhovnom v iskusstve" (*On the Spiritual in Art*), in *Trudy Vserossiiskago sezda khudozhnikov*, vol. I (Petrograd: Golike and Vilborg, October 1914). Later, in 1920, Kandinsky had prepared a questionnaire for INKhuk.

46 In a letter dated July 4, 1926, to Grohmann, Kandinsky stated: "Twenty-six boxes have arrived from Munich with my things from before the war; astonishingly after twelve years they are still in good condition." Archiv Will Grohmann.

47 Will Grohmann, *Wassily Kandinsky: Life*

and Work, trans. Norbert Guterman (New York: Harry N. Abrams, 1958), p. 210.

48 Tupitsyn, *Gegen Kandinsky/Against Kandinsky*, p. 169.

49 In a letter dated November 21, 1925, to Grohmann, Kandinsky wrote: "I have pictures there (you've got the list) that do not belong to the Russian museums but to me—they are simply being stored in one of the museums." Archiv Will Grohmann.

50 Roethel and Benjamin, *Kandinsky: Catalogue Raisonné of the Oil Paintings, Volume Two*, p. 803, no. 871; p. 857, no. 939; p. 911, no. 1010; p. 912, no. 1011; and p. 924, no. 1025. Many of these experimental works remained in the artist's estate.

51 In August, the Kandinskys vacationed in France and visited Paris, where they returned again in October. Marcel Duchamp assisted them in finding a place to live.

52 Vasily Kandinsky to Will Grohmann, December 4, 1933, Archiv Will Grohmann.

53 Vivian Endicott Barnett, *Kandinsky Watercolours: Catalogue Raisonné, Volume Two, 1922–1944* (Ithaca, N.Y.: Cornell University Press, 1994), p. 379, no. 1146.

54 Vivian Endicott Barnett, "Kandinsky and Science: The Introduction of Biological Images in the Paris Period," in *Kandinsky in Paris, 1934–1944,* exh. cat. (New York: Solomon R. Guggenheim Foundation, 1985), pp. 61–87.

55 Vasily Kandinsky to Josef and Anni Albers, March 15, 1935, Sterling Memorial Library, Manuscript and Archives, Yale University, New Haven.

56 Vasily Kandinsky to Galka Scheyer, May 9, 1931, Blue Four Galka Scheyer Collection Archives. In 1924, Kandinsky had written to Dreier that he was studying English. Later, in January 1940, he wrote several sentences in English in a letter to Albers.

57 Vasily Kandinsky to Galka Scheyer, July 15, 1933, Blue Four Galka Scheyer Collection Archives.

58 Vasily Kandinsky to Will Grohmann, October 22, 1935, Archiv Will Grohmann.

59 Vasily Kandinsky to Alfred Barr, Jr., July 16, 1936, Archives of the Museum of Modern Art, New York. A copy is located in the Bibliothèque Kandinsky, Centre Pompidou, Paris. English translation found in Vivian Endicott Barnett, *Kandinsky Drawings: Catalogue Raisonné, Volume Two, Sketchbooks* (London: Philip Wilson, 2007), pp. 17–18.

60 Vasily Kandinsky to Alexander Chuprov, January 27, 1907, cited in Aronov, *Kandinsky's Quest*, p. 126. Originally published in Sergei Shumikhin, "Pisma V. V. Kandinskovo. Kandinsky A. I. Chuprovu," in *Pamyatniki kultury* (Leningrad: Nouaka, 1983), p. 342.

61 Roethel and Benjamin, *Kandinsky: Catalogue Raisonné of the Oil Paintings, Volume Two*, p. 963, no. 1071, and p. 964, no. 1073.

62 Vasily Kandinsky to Will Grohmann, December 3, 1936, Archiv Will Grohmann.

63 Vasily Kandinsky to Hermann Rupf, December 5, 1938, Archiv Rupf in the Kunstmuseum, Bern. English translation is found in Barnett, *Kandinsky Drawings: Catalogue Raisonné, Volume Two*, p. 18.

64 In July 1939, the Kandinskys were granted French citizenship after their German passports expired and were not renewed. In her memoir, Nina Kandinsky stated that since 1934 they had wanted to be French citizens. Nina Kandinsky, *Kandinsky und ich*, p. 188.

65 Vasily Kandinsky to Hermann Rupf, May 14, 1940, Archiv Rupf.

66 Varian Fry to Vasily Kandinsky, May 7, 1941, Bibliothèque Kandinsky, Centre Pompidou.

67 See Georgia Illetschko, *Kandinsky und Paris. Die Geschichte einer Beziehung* (Munich: Prestel, 1997), pp. 143–46, 201–8.

68 Roethel and Benjamin, *Kandinsky: Catalogue Raisonné of the Oil Paintings, Volume Two*, p. 1048, no. 1157; p. 1049, no. 1158; and p. 1061, no. 1170.

69 Kandinsky, "Die Briefe Wassily Kandinskys an Dmitrij Kardovskij," p. 50.

70 For example: University of Dorpat (now Tartu, Estonia), 1896; Kunstgewerbeschule, Düsseldorf, 1903; University of Moscow, 1920; possibility to return to Russia, 1922; Art Academy, Tokyo, 1922; Art Students League, New York, 1931; stay in Germany, 1933; Black Mountain College, North Carolina, 1935; possibility to emigrate to the United States, 1941.

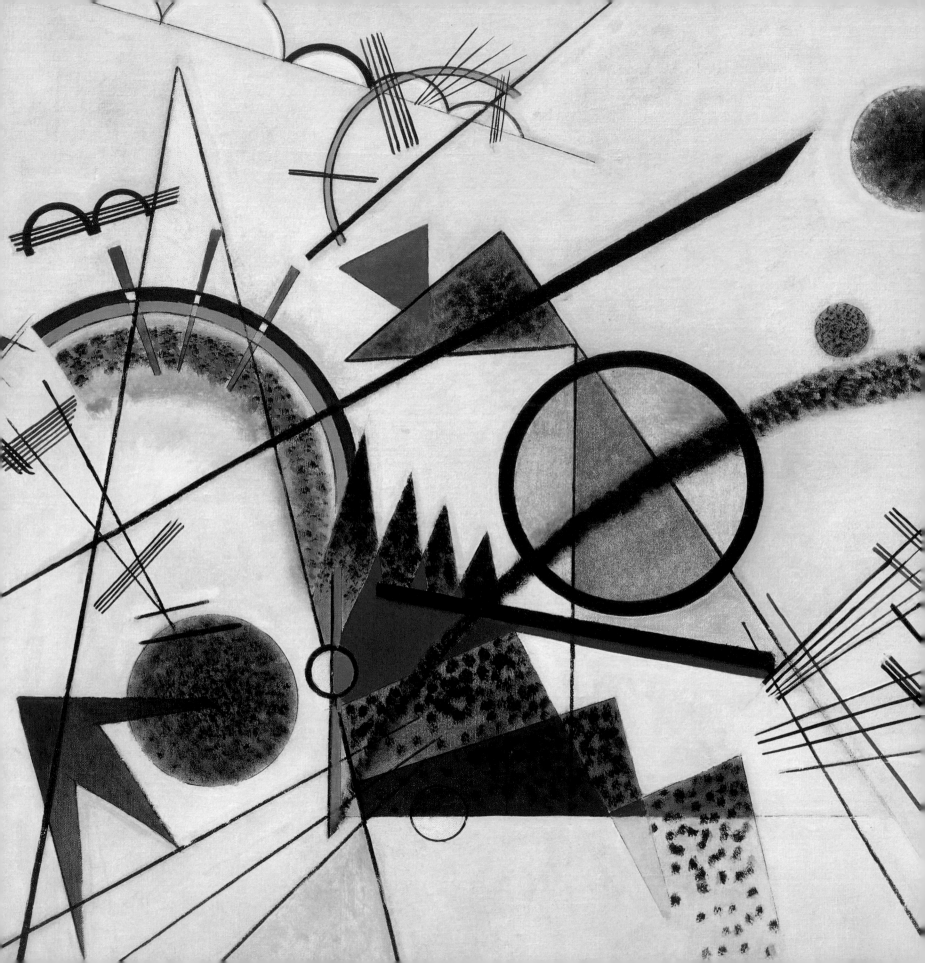

THE THEATER OF PICTURES: KANDINSKY'S ABSTRACTION OF ABSTRACTION

THINKING IN IMAGES

MATTHIAS HALDEMANN

"You are a European and you think logically I do too, but I think in images as well."[1] Vasily Kandinsky's statement to his biographer Will Grohmann is, apart from its overt Russophile significance, interesting in that it distinguishes between two kinds of thought—logical thinking and thinking in images. Do images have no logic or a logic of their own? Kandinsky allocated them a place in thought, thus separating mental and material images. What did thinking in images mean to him? How much does his abstraction have to do with the concept of an image? How is thinking in images connected with the spiritual in art?

Our questions assume that this concept of images has a particular relevance to his paintings. Can the iconic turn, a significant concept for modernism, also be found in Kandinsky's work, possibly in this thinking in images?

Initially, it is easy to see that this idea, along with abstraction, became important for him post-1908. The principle not only occurs frequently in his work; Kandinsky's own theories about his painting can be directly associated with thinking in images. In fact, his literary autobiography "Rückblicke" ("Reminiscences," 1913) reads like a history of remembered images and encounters with works of art. Two key passages serve as examples: the first describes Kandinsky's experience of one of Claude Monet's *Haystacks* paintings. The indistinctness of what he deemed to be an unidentifiable subject and the unsuspected "power of the palette" had a momentous effect on his later painting: "And suddenly, for the first time, I saw a picture."[2] Despite what he described as the discredited object, the picture as a whole burned itself deep into his memory.[3]

The second passage relates the memory of a sunset over the Kremlin in Moscow. He wrote not about the natural event as such but its imaginative transformation of a sensory experience. An abstract image of colors and lines opened up in his gaze as the urban landscape finally dissolved into a single spot.[4] Thus Kandinsky's paintings were based on the material picture and the mental image.

THE ROLE OF GEOMETRY

Kandinsky's statement to Grohmann dates from the Bauhaus period, a time when the artist was especially absorbed in a geometric, constructive formal idiom. But shouldn't we regard this approach as an effort to rationalize and objectify his artistic resources in a manner closer to logical thinking than thinking in images? Aren't Kandinsky's subjective/expressive and objective/constructive phases contradictory? The artist seems to confirm this assessment in speaking of leaps "from one 'extravagance' to another" and confronting the "warm" with a "'cold' period."[5]

The first thing to note is that geometry is not a suitable criterion for distinguishing different periods[6]—it was already a topic in his book *Über das Geistige in der Kunst. Insbesondere in der Malerei* (*On the Spiritual in Art: And Painting in Particular*, 1912). Likewise, Euclid's model of point and line, which is the basis of Kandinsky's Bauhaus-period book *Punkt und Linie zu Fläche. Beitrag zur Analyse der malerischen Elemente* (*Point and Line to Plane: A Contribution to the Analysis of Pictorial Elements*, 1926), is mentioned for the first time in "Reminiscences."[7] It can be traced without difficulty in works of the time as well, particularly *Composition VII* (*Komposition VII*, 1913, fig. 51). The circle pictures of the Bauhaus period follow from that. Moreover, Kandinsky's pre-1914 draft of a book on the theory of composition (only recently published)[8] proves that he had already done the basic thinking for *Point and Line to Plane*.

However, his view of geometry has to do with neither a particular mathematical interest nor an attempt to link painting to technology. It was certainly not a case of his borrowing ideas but of the self-reflective justification of autonomous resources. He took a hierarchical approach. As far as he was concerned, a work starts

48 **Philipp Otto Runge,** *Der Tag*, 1805. Copper engraving, 71.2 x 47.5 cm

Page 74: Detail of *In the Black Square (Im schwarzen Viereck)*, 1923 (plate 62)

with a point as the smallest form, developing via lines into planes, and thence into increasingly complex configurations. He therefore defined the point in the center of the square as the "primal image of pictorial expression."[9] Every configuration in each place on the basic plane can be traced back to it. The primary surface or plane is ground zero for everything that appears on it, and which, because of its origin in the point, ultimately borders on invisibility, the void: "Canvas is a void—the world before the Creation, before chaos.

49 Eugen Napoleon Neureuther, *Die Tageszeiten*, 1826. Lithograph

solved the problem of the dual invisible-visible nature of the point as a geometrically intelligible dimension and smallest starting point for a painterly action not logically but visually. He assumed a "sharp eye" ("geistvolles Auge" in German),[13] in which, in a way, mathematical, logical thought and vivid thinking in images were combined. His concept of a moving, temporal point also sets up a visual connection with the line. Accordingly, the work as a whole is, for him, not a sum of parts, as it had been for Alberti, but a dynamic continuum.

What is theoretically formulated in Leonardo but cannot be directly manifested in figurative painting is exemplified by *Composition VII*.[14] Everything visible can be traced back to the pithy point because, thanks to its clarity, only it is distinct from the wealth of "imperfect" and diversely interwoven color forms. In relating back to the point, the perspective of time unexpectedly doubles. It is unclear whether the point embodies the beginning or end of a development, so it can therefore be interpreted equally as the construction and deconstruction of form. The elements are transitory—"pre- or post-historical."[15] Geometry is accordingly a component of an unobjectifiable, dynamic concept of form.

As his work became increasingly abstract during his time in Murnau, Germany, Kandinsky did everything he could to destabilize the picture so as to deprive it of all physical appearance. Using boundless contrasts of color and form, he transformed it into a visual field of effects that eluded any permanent fixation, especially that of linguistic description. Following the music model, this unsettling involves the aesthetics of process taken to the extreme in order to transform painting from a spatial into a temporal art, best seen in the work *Impression III (Concert)* (*Impression III [Konzert]*, 1911, plate 18).[16] The splashes of color and black pattern of lines come across not as coherent abstract objects but instead seem to emerge from the immaterial white *in statu nascendi*. The exuberant sweeps of yellow contrast with the small yellow point on the center vertical, and below is a circle with a red point beside partly open splashes of color. Thus amorphous configurations and geometric shapes are not mutually exclusive but bound together in a common process. The impression seems to paint itself from intersecting points, lines, splashes, and planes. As a self-referential picture,

The first sign of life is a *point*—the moment of the first contact with the charcoal, pencil, or brush. The point is the germ of corporeality, the embryo of creation. Boundless possibilities are latent in it. Potentially, the first future *line* from it can go in any direction. . . . The line is the first definition of the *plane*, the first development of the cosmos or the embryo."[10] For Kandinsky, chromatic colors also develop from the void of white canvas and end in black.[11]

The geometric visual model can be traced back to discussions on the point topos in the treatises of Renaissance writers such as Leon Battista Alberti, Piero della Francesca, and especially Leonardo da Vinci, whose work was of particular interest to Kandinsky.[12] Leonardo

it becomes the model of an undepictable, unbounded dynamic reality. Unlike with Leonardo, for Kandinsky there is no longer any mimetic similarity between the real world and painting.

The Romantic pictures of Eugen Napoleon Neureuther and Philipp Otto Runge incarnate an interim stage between those of Leonardo and Kandinsky (figs. 48, 49). Complex weaves of lines embody allegories of day and times of day. But how can a temporal process be illustrated in a single figurative representation? The answer is by uprating arabesques from ornamental motifs to tools of meaning. In a halfway position between object and abstract configuration, they translate one motif into another, steering the eye along a meandering tissue of lines from morning to evening.

Art historian Werner Busch has demonstrated that complex arabesque structures have a hidden origin in the shape of a fish's mouth or the node of a spider's web—that is, the point.[17] In Neureuther, this marks the transition from the invisibility of a whole, represented by the light background, to the visibility of the motifs designated by the lines. In the case of Runge, it produces a three-dimensional connection with the cave at the back as a "spring" element. Water emerges from the darkness into daylight through the black hole of a fish's mouth, thereby setting in motion the compositional interplay of arabesques.

Before we take a closer look at the role of arabesques in Kandinsky's work, let us return to the Renaissance point topos, this time in the work of Alberti. For him, the point as a sign is a component of the linguistic sequence of letters, syllables, and words.[18] Kandinsky likewise saw the sequencing of points, lines, and planes analogously, as a genuine formal alphabet. But what is the meaning of abstract formal signs? In the Renaissance, iconographic source texts and the rhetoric of representation linked picture and language. Kandinsky's orientation on the other hand is to a linguistic model with vocabulary and grammar. He failed when he attributed definite meanings derived from physio-psychological experiences to basic colors and shapes, in order to set up a uniform system, for this monism has basically little to do with the question of pictures. But Kandinsky separated the absolute definition of individual elements—and this is critical—from their relative effects in a work of art.[19] Abstract pictures are meaningless at the level of their individual parts, but, in the syntactical context of the whole, surface semantic qualities come into play thanks to "eloquent" contrasts, through which the work finally became a model of reality.[20] More will be said on this point later.

Though in the 1912 essay "Über die Formfrage" ("On the Question of Form"), Kandinsky derived point and line from language like Alberti, showing how signs lose their meaning as signs through minor infringements of the rules, whereby reading becomes seeing and writing becomes image in its iconic turn. The graphic quality of signs as indecipherable, hieroglyphic, enigmatic pictorial language is something that Kandinsky thematized time and again, especially in his late oeuvre.

ARABESQUES AS PURE PAINTING

In the expressive work from 1908 to 1914, Kandinsky's use of arabesques emerges from the abstraction of figurative objects as hived-off contours. Even thereafter, the organic and occasionally tendril-shaped configurations belong to his vocabulary—the term "arabesque" even serving as a work title.[21] But what does their semantic function consist of after the real-world references drop away? Let us first have a look at Kandinsky's concept of abstract form. He stated, in fact, that the dissolution of real-life motifs went hand-in-hand with making things out of abstract shapes. (This statement is surprising because, as we will see, a link to the visual world remains, but in a new way.) In "On the Question of Form," he talked about "things,"[22] which he equated with objects, even though there was no real-life counterpart for them. Contemporaneously, an arabesque-like linear thing features for the first time as the protagonist in *Composition V* (*Komposition V*, 1911, fig. 50). But why did Kandinsky attribute qualities such as weight, surface, and movement to abstract things?[23]

We know today that even the most formless, highly contrasted work remains bound by real-world experience. Why so? Our perception replicates what we see not simply isomorphically but always as an act of interpretation and construction. A process unconsciously gets underway whereby the brain compares incoming signals with the models of the world it stores and then seeks the most likely solutions. The

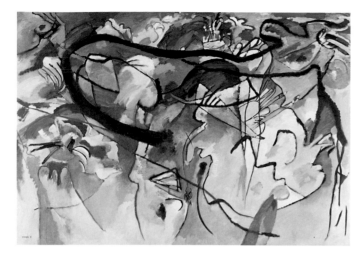

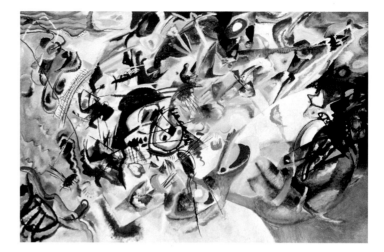

50 *Composition V (Komposition V)*, 1911. Oil on canvas, 190 x 275 cm.
Private collection

51 *Composition VII (Komposition VII)*, 1913. Oil on canvas, 200 x 300 cm.
The State Tretyakov Gallery, Moscow

visual information is grouped into figures in accordance with innate and acquired criteria, that is, gestalt processes.[24] What we see is always an interpretation, a sketch of the world. Not even abstraction can switch off this unconscious process of deciphering. Kandinsky even counted on it when he used vague, incomplete, or ambiguous formal elements—the "not-saying-the-ultimate" as a "space free for the operation of fantasy."[25] The viewer supplements the visual potential offered by the artist; decodes the ambiguity in front of him or her in a particular direction; and screens out information that doesn't fit, which he or she can thereupon extrapolate in a different way. Kandinsky intentionally left various developmental possibilities in all elements. Their indefiniteness makes them a "place for queries" for the viewer's imagination, which is supposed to exploit creatively the content-related free play in interpreting the elements as an expression of their vitality.[26]

We still look for objects in Kandinsky's work, or from 1912 on, for formal shapes of things to which we attribute virtual physical qualities and three-dimensionality, knowing full well that we are dealing with abstract painting. Color makes its contribution—the structuring eye notes any contrasts even if the elements are far apart.[27] This can look relatively large or then again very small, close or remote, or busy or calm. Varying perspectives depend on the environment. In addition,

the brain can associate meaningful-looking things (like those that feature in the Bauhaus works) with objects—stars, cells, embryos, cities, puppets, creatures, riders, boats, weapons, plants, books, pictures, et cetera. Kandinsky experimented with such things at first discreetly, but then in Moscow; Dessau, Germany; and Paris, with obvious allusions. In his works the forms take the role of what previously were only latent objects. The visual world thus crosses over into an imagined cosmic dimension.[28] Virtual motifs and optically completed formal shapes remain suspended before the inner eye and soon dissolve. New interpretations follow, one after the other.[29] The boundary between material and mental image blurs, and seeing is doubly determined: the imagination is also active in the sensory process. Kandinsky's works deliberately require this active looking. We see in them more than is actually present—we see ourselves seeing.

Which brings us back to arabesques, a new kind of link in Kandinsky between abstract, formal visibility and imagined invisibility that constitutes a radicalization of Runge's view of arabesques.[30] But in contrast to their function in Romantic works, arabesques here do not represent an ideal, invisibly absent whole, but, thanks to their high forming-potential, produce designs that allow all sorts of possibilities: "A line can say everything," Kandinsky said.[31] Combined with

52 **Victor Hugo, *Bateau dans une tempête (Tache)*, ca. 1875.** Ink and watercolor on paper. Bibliothèque nationale de France, Paris

color and form, Kandinsky's autonomous arabesques are the visual essence of sensual, imaginative reality accessible to the sharp eye.

Let us now turn to spots and splashes, specific examples of arabesques. We are familiar with Leonardo's advice to his pupils to train their imaginations by trying to see possible figures and shapes in marks on masonry walls. Victor Hugo consistently followed this advice with the bold pictures marked by spots and splashes he began painting in 1849.[32] In Symbolist drawings of oceans, skies, and ruins, all subjects visually develop from an amorphous, largely shapeless structure of splashes (fig. 52). They constantly regroup into new shapes as the products and stimuli of our imagination, then dissolve again and literally submerge into the watery, oceanic paint matter. In Hugo's work, Leonardo's exercise of the imagination becomes the reality metaphor of a metamorphosing, catastrophic world. Kandinsky's spots and splashes, as open formal elements, can be interpreted in different ways: as dots, as geometrical planes, or via associations with existing objects. Thoroughly indeterminate, these formless, transitional shapes can be made from basically anything. Kandinsky used them to refer to Leonardo's advice[33] as much as to connecting the painting *Backward Glance (Rückblick)* of 1924 with the earlier-mentioned Kremlin experience.

Even more radically than Hugo, Kandinsky left the task of putting specific imaginative shapes into the pictures entirely to the viewer's

sharp eye, which is thus creatively involved in the metamorphosis of the painting's ever-shifting meaning. His autonomous patterns of lines, splashes, and other configurations are arabesques in a new sense, as a principle of transformation taking on form. In *Composition VI (Komposition VI*, 1913, fig. 39), a nonfigurative painting derived from the Flood theme, Hugo's metaphor of oceanic reality is taken to the extreme. In general, Kandinsky's eschatological themes of that period seem like metaphors of an eternally circulating, liquidized world that embraces the viewer. Its activity becomes a creative analogue of a *natura naturans*, an infinitely extendable quantity à la Hugo that is constantly "disintegrated and was reconstituted" and spread through "increasing and decreasing affinities" with "thrusts of force or even geometrical points."[34] The point topos, arabesque lines, and art of color splashes are conveyed in Kandinsky's "compositional painting" and, with the inclusion of the real-world motifs alluded to, create a visibly imagined, universally metamorphosing continuum—in Friedrich von Schlegel's words, "painting as a pure picture, not as arabesques."[35]

THE PUPPET PRINCIPLE

In the wake of abstraction, Kandinsky was interested in not only music but also theater and dance. Starting in 1908, he developed innovative stage ideas and expounded his thoughts in several essays. I single out the puppet principle as a particularly helpful model for understanding his Bauhaus period.

Kandinsky was familiar with the new theater of Edward Gordon Craig, Maurice Maeterlinck, Vsevolod Meyerhold, and Oskar Schlemmer.[36] Common to these anti-illusionists was the rejection of the psychologizing actor, in whose place came elements of pantomime, commedia dell'arte, the circus, puppet theater, and technology. Rather than affected naturalness, the very artificiality achieved by detachment now expressed "pure content." Craig demanded that the actor transform his body into a machine or a piece of dead material—unless, better still, an über-puppet could replace him. Meyerhold even preferred machines, while Schlemmer with his *Triadic Ballet* (1923) developed a mechanical body dance. These radical innovations, which had had a marked effect on Kandinsky's stage works and paintings with puppet

53 Kandinsky, Point in the center, in Kandinsky, *Punkt und Linie zu Fläche* (*Point and Line to Plane*) Bauhaus Bücher 9 (Munich: Albert Langen, 1926), p. 30, fig. 4

and doll-like figures beginning in 1908 with works such as *Blue Mountain* (*Der blaue Berg*, 1908–09, plate 5), can ultimately be traced back to Heinrich von Kleist's 1810 essay "Über das Marionettentheater" ("On the Puppet Theater"). Kleist asserted that a mechanical puppet paradoxically has more charm and grace than a dancer because the dead object comes to life with the movement of a single joint, resulting in a dancelike movement. Kleist called it "anti-grav," that is, movement independent of the gravitation that keeps man bound to earth. An exponentiated vitality unfolds in the lifeless puppet on a string. Kleist opined that, like real form, it sets the spirit free, whereas bad form binds it.[37] For Craig as well, the strength of anti-grav lies in its going beyond life instead of competing with it.[38] Movement as an expression of vitality became the common criterion of the new theatrical concepts. At the same time, the aim was to provide iconicity, whether through the deliberate deceleration of dance movements into "instantaneous photography,"[39] the abandonment of the peepbox stage in favor of relieflike planar effects, autonomous lighting, the stylization of implied actions, or the independent movement of stage sets and props. As deliberately created theatrical artificiality, these

techniques serve to activate the audience, who are directly involved in the events, without a forestage to set them apart.

To return to Kandinsky's works from the Bauhaus period, let us compare his "Urbild" ("archetypal picture") of the square and the point in the center (fig. 53) with the puppet principle. Is the archetypal picture really a picture? It certainly was for Kandinsky because the apparently trite configuration already harbored an irresolvable tension between the part and the whole. He showed that we unconsciously introduce our physical experience in looking at an empty, symmetrically rectangular basic field and can never see it as neutral. Our relationship with above and below (gravitation) turns it into "a kind of reflection."[40] In other words, the painting functions like a mirror that shows the relationship of one's body to up and down. That is why planimetrically placed elements appear as frontally viewed virtual bodies, which we see in *Levels* (*Etagen*, 1929, plate 71).[41] Particularly in the Dessau period, Kandinsky worked with the principle of balance, which was based on the physical, three-dimensional view of nonrepresentational things placed in an upright position, as in *On Points* (*Auf Spitzen*, 1928, plate 70). He also commented that the edges of the basic field were unevenly resistant, and the four planar quadrants looked unequally heavy. Therefore, visually the geometrically unambiguous field is in an ambiguous state of tension and brings about an "inner pulsation."[42] The appearance of one element depends strongly on its relative position in the basic field. Its "optical proportions" differ markedly from its "mathematical proportions," as Kandinsky remarked.[43] A pictorial effect results from the reciprocal action of part and whole: "It is the summation of the component elements that establishes equilibrium by supplying the missing link. In this way, the elements are produced by the sum—lines by the plane—and vice versa."[44]

The material picture was, for Kandinsky, not a physical object but mainly something invisible per se, a network of relationships: "The structure of those parts that are independent, that relate to one another, and that united within the picture, constitute the structure of the whole."[45] With this idea he described a genuine visual logic defined by the interlocking of the work as a whole and its internal elements, which architect Gottfried Boehm defines as an iconic difference.[46]

54 **Kandinsky's notes in an untitled, pre-1914 manuscript.** Bibliothèque Kandinsky, Centre Pompidou, Paris

a logically indissoluble, dynamic constellation, whose complexity far exceeds the parts that generate it. The iconic difference describes this leap from the level of ordinary details to the ambiguous whole. As in the new theater, the aesthetic boundary between work and audience is abolished, finding itself "'somewhere' in 'illusory' space."[48]

Here the individually expressive form does not generate the expression or "sound" but rather the interaction of the now deliberately "cut back" and "inexpressive" parts with the whole[49]—the invisible tissue of relationships. It affects everything at once, just as, with a puppet, pushing one joint is enough to set the whole body in motion.

Whereas in "On the Question of Form" Kandinsky posited the representational "shells" of "great realism" as an alternative pole to "great abstraction," at the Bauhaus he implemented the principle of great realism with abstract formal shells within his abstraction. These shells—exterior shapes without content, the "outside" of the forms—show the material picture as something purely superficial and artificial. Movement and three-dimensionality unfold in it only in perception, and the work requires the visual stimulus of the eye and the network of relationships as a pictorial neural tract—just as with the puppet, the hidden hand of the puppet master pulls invisible strings.

Kandinsky was now using physical terms to characterize this immaterial quality of content in his works: "Thus, composition is nothing other than the logically precise organization of those living forces encapsulated within elements in the guise of tensions."[50] His objective was to turn facticity into effects: "The practiced eye must possess the ability to see that plane which is necessary for the work of art, partly as such, but partly to ignore it when it dons the guise of space. A straightforward complex of lines can, in the end, be treated in two ways—either it becomes one with the PP [picture plane], or it lies freely in space. The point that burrows its way into the surface is likewise capable of freeing itself from the surface and 'floating' in space."[51] The internal element is never hidden in Kandinsky's art—to some extent, it lies on the surface of the formal shells that the viewer sets loose in an anti-grav floating situation like puppets, liberating the spirit from the shape as the "life of the disembodied"[52] and "animating" the planar rigidity in the intentional act of seeing.[53]

Iconic difference can be demonstrated in *Red Spot II* (*Krasnoe Pyatno II*, 1921, plate 54). Though the discrete elements can be summed up as an overarching spiral, this interpretation transforms the emphatic planar character into a concentric-eccentric torque movement as well. The composition creates a new dimension, an iconic "plus," that is more than a sum of static planar parts. A suction effect appears to draw the latter objects downward, where they are flung out again. The large red spot floats as if in front of the picture in the viewer's real space. Kandinsky's works acquire a double virtual three-dimensionality, opening up behind and in front of the material surface (fig. 54). The picture stretches out in depth toward the viewer like an "accordion"[47]—

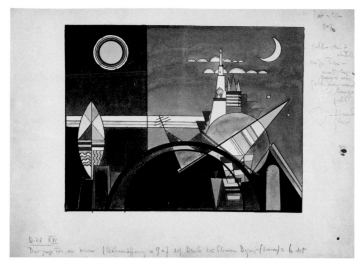

55 *Pictures at an Exhibition, picture XVI, The Great Gate of Kiev*, 1928.
Watercolor and India ink on paper, image: 21.3 x 27.1 cm, sheet: 30 x 40 cm.
Musée national d'art moderne, Centre Pompidou–Centre de création
industrielle, Paris

56 **Alexander Calder,** *Untitled*, ca. 1942. Horn, glass, wood, string, metal, and
paint, 66 x 71.1 cm. Private collection

Kandinsky's theatrical ideas, and in particular his production
Bilder einer Ausstellung of Modest Mussorgsky's 1874 piano suite
Kartinki s vystavki (*Pictures at an Exhibition*) in Dessau in 1928, can be
linked with this aesthetic (fig. 55). The stage sets move mechanically at
the end of ropes—the pictorial shells are puppets. Schlemmer summed
up this iconic difference with the idea: "Everything mechanizable is
mechanized. The result is the discovery of the unmechanizable."[54]
That direct connection of abstract work and puppet principle can also
be identified in Alexander Calder's works. He developed his sus-
pended mobiles from three-dimensional pictorial objects and sceno-
graphic, kinetic experiments—nonrepresentational arabesque puppets
floating in motion (fig. 56). They are similar to Kandinsky's contem-
poraneous late works, likewise done in Paris, for example the biomor-
phous configurations of *Composition IX* (1936, plate 82) and *Striped*
(*Rayé*, 1934, plate 75) that drift weightlessly across the background.
As oceanic arabesques, the latter are reminiscent of Paul Valéry's
"Grandes Médusès," jellyfish-like translucid "danseuses absolues,"
metamorphic embodiments of free-floating anti-grav motion.[55]

PICTURE-IN-PICTURE PRINCIPLE

Arabesques and the puppet principle refer to the picture's artificiality,
which in turn makes the painting self-referential, especially in com-
bination with the point topos. The material issue leaps to mind:
What is form? What is a picture? If the latter is more than the
sum of its forms, how do the two hang together? The principle of
point and line to plane establishes the basic plane as part of a
formal alphabet, which begins and ends in the point. Kandinsky
then systematically built a picture-in-picture principle out of it. We
can take the center configuration of *Composition VII* as the first
experiment in that direction.[56] *Painting with White Border (Moscow)*
(*Bild mit weißem Rand [Moskau]*, 1913, plate 35) has a distinct
internal frame marking off for the first time a picture within a picture.
He evolved the principle in Moscow and at the Bauhaus, creating
a multitude of encapsulated pictures in one, and the phrase also
figures as a work title.[57] In Paris, Kandinsky experimented with
striped and grid pictures. They represent "sums of pictures" that as

rhythmicized "picture corpuses" develop an additional vitality of their own, an iconic plus that cannot be accounted for by the number of "pictorial elements." The stage work *Pictures at an Exhibition*, however, was a real pictorial event—a theater of pictures.

The interweaving of material and mental images extends the picture-in-picture principle into the realm of perception and imagination. Painting, reality, and the sharp eye are thus conveyed through the image, which create continuity where mimetic similarity between art and reality no longer exists. So Kandinsky's abstract painting does not abandon visible reality, as is constantly claimed. As his Kremlin experience exemplifies, the recognizable world on the visual surface is itself abstracted into an autonomous image of color and shape.

Whereas in Weimar, Germany, Kandinsky linked his formal shells in color and shape in a variety of ways, in Dessau and Paris he parceled up elements that had been strongly reduced and individualized. The complementary approaches had the same objective: to anchor iconicity in shape, infuse the latter with a multiple charge, and in it set in motion the interplay of part and whole on a deeper level. Even the doll-like allusions of the late period in works such as *Sky Blue* (*Bleu de ciel*, 1940, plate 90) dissolve into an autonomous iconicity when looking at the details. Why so? As the eye focuses on them, it identifies every part as a possible space in which other smaller elements manifest themselves. But if one observes the same part in its environment, it conversely becomes a physical thing. Kandinsky used the paradoxical term "Raumkörperchen," referring equally to space and physical bodies.[58] Was that point, for example in *Several Circles* (*Einige Kreise*, 1926, plate 67), a thing or a black hole, a beginning or end? The approach he adopted was a calculated "taking things to the limit"[59] of his ambivalent elements, setting the eye a-bounding. For all the supposed formal clarity, no gestalt can be stabilized, always turning out to be a place for queries. Ultimately, iconicity is, in Kandinsky's work, not a question of form but a phenomenon of contrasts that facilitates the process of separating and combining in the sharp eye.[60] Image and shape are categorically not to be separated. The whole is consequently nothing but the part and vice versa. The microcosmic and macrocosmic elements are conveyed dynamically in Kandinsky's metaphorical visual

cosmogony as *Division–Unity* (*Division–Unité*, 1943),[61] an "all in all,"[62] a world of endless compositions.[63] Abolishing boundaries leads to invisibility, represented by the intelligible point, empty white canvas, and subjective viewer imagination inaccessible to others. The picture-in-picture principle makes itself known as a kind of reflection. It is generated and dissolved like visibility as an interaction from outside and inside, and with that, subject to iconicity.

PARADOX PICTURES

Kandinsky was aware that dissolving representational motifs and making autonomous color forms tangible did not dematerialize his paintings. The physical characteristics, the *faktura* of the work, penetrates to the "disillusioned" eye, and perception remains physical.

A formal scepticism characterized his artistic attitude right from the start. For one thing, the choice of shapes depended on their inner necessity and could therefore not be an external end in itself. Arabesques, the puppet principle, and picture-in-picture concept, on the other hand, show that Kandinsky was striving for something like a sublimation of nonrepresentational form—the abstraction of abstraction.[64] Contrasts intensify into antitheses to make tensions; visual forces; emotions; imagined three-dimensionalities; and an all-permeating, rhythmic movement accessible to experience going beyond hard form. No work can therefore be allowed to clam up into a uniform, aesthetic object. Kandinsky combined logically contradictory elements such as abstract and representational fragments. He sought discontinuities and used resistance to construct tensions and keep the externally heterogeneous work open to our perception and the imagination. Yet for all the objectivity, he removed the appearance of objectivity from the work and cast it as a metaphor of a fragmented world.

The split between consciousness and nature of the senses associated with modernism surfaces in Kandinsky's paintings through the broken unity of the picture and in Kleist's dancer as the loss of natural grace and charm. Both artists offset the loss by unshackling the reflected consciousness, using paradox to do it. Thus many of Kandinsky's statements about art are paradoxical—"harmony of disharmony" or "clearly expressing the unclear in clear language. The

irreproducible reproduced. Evaluating the unappraisable, measuring the immeasurable. Timelessness in temporality. That is the content. That is the objective."[65] Paradoxes also play an important part in his word-play and occasionally feature as titles: *Cool Energy* (*Kühle Energie*, 1926), *Mild Hardness* (*Milde Härte*, 1927), *Light in Heavy* (*Leicht im Schwer*, 1929), *One in Two* (*Eins in Zwei*, 1931), *Fixed Flight* (*Fixierter Flug*, 1932), or *Complex–Simple* (*Complexité simple*, 1939).

This brings us back to the beginning of our deliberations. Paradoxes have to do with the logic of an image, to a very particular extent. Unlike linear language, pictures contain "both . . . and" and are capable of displaying paradox as a meaningful tension: flat as floating, rigid as mobile, cold as warm, and so on. In contrast to propositional logic, the coherence of an image makes no distinction between subject and predicate. In the intermeshing of part and whole, all elements are made mutually relative, drawing their iconic semantic potential from this very indefiniteness. Pictures are basically always paradoxical—material and immaterial, real and unreal.

Kleist did not show paradox by itself, for example as a graceful puppet—he also subjected it to a process. Following the title of his famous essay "Über die allmähliche Verfertigung der Gedanken beim Reden" ("On the Gradual Production of Thoughts while Speaking," 1805), the narrator shows how the dancer and he himself constantly produce new contradictions in the conversation about the puppet. Paradox becomes the open form of the active consciousness, an infinite thought operation, a "fantastic construction of the as-yet-unthought" or a "new origin of the mind in the unconscious."[66] Kandinsky's paradox of the image is also subject to an infinite process. It is equally the product and origin of thinking in images, of a picture we've never previously seen crystallizing even as we perceive and imagine it, of the picture evolving from the void "on the surface of one's consciousness."[67] Kleist concluded with another conundrum that also applies to Kandinsky's conceptual work in Munich and Weimar: "Should, therefore, a notion be expressed confusedly, you can by no means conclude from this that the thinking was confused. It could easily be that the most confusing expressions were the most clearly thought."[68]

For the "open eye,"[69] the surprising transition from facticity to effect transforms the disenchanted, shattered, petrified, and frozen world of materialism and rationalism back into a "fairy tale," a causally indissoluble visual realm of animated matter.[70] Kandinsky's "new romanticism" was "a piece of ice in which a flame is burning."[71] Art was to practice not the "either . . . or" of matter and spirit but the "and."[72] For him, it linked object and subject as a relationship of matter and spirit, facticity and effect, outside and inside, physics and psychology, physiology and imagination—or, as his Bauhaus colleague and artist friend Josef Albers neatly put it, as a relationship between "factual fact" and "actual fact"—"objective" and "real facts (in our consciousness)."[73] Kandinsky's Weimar visual concept represents this paradox in its own way. It embodies materialism on the level of its emphatically physical, hard, and heterogeneous facticity in order to refer unexpectedly to the "and" in its effects.

For Albers, color—which all his life was at the heart of his work—became an actor on the pictorial surface: "Painting means getting color to act. . . . When color goes on stage, we never know what color it is."[74] Kandinsky's abstraction of abstraction likewise points to the theater of pictures. It is the place of "living facts,"[75] of the spiritual in art.

Notes

Unless otherwise attributed, all translations of original French or German quotations are service translations provided by the Städtische Galerie im Lenbachhaus, Munich.

1 Vasily Kandinsky, quoted in Will Grohmann, "Genius in Full Swing. 1910–1914," *Wassily Kandinsky: Life and Work*, trans. Norbert Guterman (New York: Harry N. Abrams, 1958), p. 158.

2 Vasily Kandinsky, "Reminiscences" (1913), in Kandinsky, *Kandinsky: Complete Writings on Art*, ed. Kenneth C. Lindsay and Peter Vergo (1982; repr., New York: Da Capo Press, 1994), p. 363. See also Matthias Haldemann, "Kandinsky sieht Monet. Zum Verhältnis von Abstraktion und Impressionismus," in *Logik der Bilder. Präsenz—Repräsentation—Erkenntnis*, ed. Richard Hoppe-Sailer, Claus Volkenandt, and Gundolf Winter (Berlin: Reimer, 2005), pp. 203–18.

3 Kandinsky, "Reminiscences," p. 363. See Haldemann, "Kandinsky sieht Monet," pp. 203–18.

4 Kandinsky, "Reminiscences," p. 360.

5 Vasily Kandinsky, "Empty Canvas, etc." (1935), in Kandinsky, *Complete Writings on Art*, pp. 781–82.

6 Matthias Haldemann, *Kandinskys Abstraktion. Die Entstehung und Transformation seines Bildkonzepts* (Munich: W. Fink, 2001), pp. 219–30, 236–38.

7 Kandinsky, "Reminiscences," p. 361.

8 Vasily Kandinsky, "Texte zur Kompositionslehre" (pre-1914), in Kandinsky, *Wassily Kandinsky. Gesammelte Schriften 1889–1916. Farbensprache, Kompositionslehre und andere unveröffentlichte Texte*, ed. Helmut Friedel (Munich: Prestel, 2007), pp. 549–622.

9 Vasily Kandinsky, *Point and Line to Plane* (1926), in Kandinsky, *Complete Writings on Art*, p. 552.

10 Vasily Kandinsky "Kompositionselemente" (ca. 1912–14), in Kandinsky, *Gesammelte Schriften 1889–1916*, p. 609.

11 Vasily Kandinsky, *On the Spiritual in Art* (1912), in Kandinsky, *Complete Writings on Art*, pp. 183–85. Kandinsky's emphasis. Kandinsky also relates color to light. See Vasily Kandinsky, "Inhalt und Form" (1910–11), in Kandinsky, *Gesammelte Schriften 1889–1916*, p. 403.

12 Kandinsky, *Über das Geistige in der Kunst* (1912; repr., Bern: Benteli Verlag, 1973),

p. 85. Leonardo's essay on painting is featured in a notebook of Kandinsky's in the Gabriele Münter- und Johannes Eichner-Stiftung in Munich. See Haldemann, *Kandinskys Abstraktion*, p. 45 n. 192, and Gottfried Boehm, "Der Topos des Anfangs. Geometrie und Rhetorik in der Malerei der Renaissance," in *Visuelle Topoi. Erfindung und tradiertes Wissen in den Künsten der italienischen Renaissance*, ed. Ulrich Pfisterer and Max Seidel (Munich: Deutscher Kunstverlag, 2003), pp. 49–59.

13 Boehm, "Der Topos des Anfangs," p. 56.

14 See the analysis of the work in Haldemann, *Kandinskys Abstraktion*, pp. 179–230.

15 Vasily Kandinsky, "Alle Formen sind eckig oder rund" (pre-1914), in Kandinsky, *Gesammelte Schriften 1889–1916*, p. 572. For Kandinsky, all forms are transformations of basic geometric shapes that in turn can be traced back to point and line. See pp. 571–73. The zigzag, for example, is not only a linear structure but also a "surface in the process of becoming." See Kandinsky, *Point and Line to Plane*, p. 585. His concept of form can also be seen as a divisionism of form, akin to Paul Signac's neo-Impressionist color divisionism. See Matthias Haldemann, "Das Sehen sehen. Neoimpressionismus und Moderne," in *Das Sehen sehen. Neoimpressionismus und Moderne. Signac bis Eliasson*, ed. Haldemann, exh. cat. (Zug, Switzerland: Kunsthaus Zug; Ostfildern, Germany: Hatje Cantz, 2008), pp. 116–18.

16 See Andreas Brenner, Matthias Haldemann, and Michael Roth, "Ut pictura musica. Ein interdisziplinäres Gespräch," in Haldemann, ed., *Harmonie und Dissonanz. Gerstl, Schönberg, Kandinsky. Malerei und Musik im Aufbruch*, exh. cat. (Zug, Switzerland: Kunsthaus Zug; Ostfildern, Germany: Hatje Cantz, 2006), pp. 253–73.

17 Werner Busch, *Die notwendige Arabeske. Wirklichkeitsaneignung und Stilisierung in der deutschen Kunst des 19. Jahrhunderts* (Berlin: Mann, 1985), p. 60.

18 Boehm, "Der Topos des Anfangs," p. 55.

19 Vasily Kandinsky, "Gegensatz" (ca. 1902–04), in Kandinsky, *Gesammelte Schriften 1889–1916*, p. 241; Vasily Kandinsky, "Gesetze der Komposition" (ca. 1912–14), in ibid., pp. 605, 607; Vasily Kandinsky, "Analyse der primären Elemente der Malerei" (1928), in Kandinsky, *Essays über Kunst und Künstler*, ed. Max Bill (1955; repr., Bern: Benteli

Verlag, 1973), p. 114. For Kandinsky's visual discourse, see Haldemann, *Kandinskys Abstraktion*, pp. 48–54.

20 "The dynamic moment starts with the juxtaposition of at least two emotions: elements, colors, lines, sounds, movements, etc. ('contrast'!). 'Two inner sounds.'" Vasily Kandinsky, "Art Today" (1935), in Kandinsky, *Complete Writings on Art*, p. 767.

21 *An Arabesque* (*Une Arabesque*, 1938), in Hans K. Roethel and Jean K. Benjamin, *Kandinsky: Catalogue Raisonné of the Oil Paintings, Volume Two, 1916–1944* (Ithaca, N.Y.: Cornell University Press, 1984), p. 978, no. 1085.

22 Vasily Kandinsky, "On the Question of Form" (1911–12), in Kandinsky, *Complete Writings on Art*, p. 247.

23 Vasily Kandinsky, "Elemente. Bewegung der Formen" (ca. 1912–14), in Kandinsky, *Gesammelte Schriften 1889–1916*, p. 560, and Vasily Kandinsky "Bild ist Kombination der Farbe und Linie . . ." (no date), in ibid., p. 555.

24 Wolf Singer, "Das Bild in uns—Vom Bild zur Wahrnehmung," in *Iconic Turn. Die neue Macht der Bilder*, ed. Christa Maar and Hubert Burda (Cologne, Germany: DuMont, 2004), pp. 56–76.

25 Vasily Kandinsky, "On Stage Composition" (1911–12), in Kandinsky, *Complete Writings on Art*, p. 258 n. 1. The artist has to provide the viewer's imagination with a starting point to prompt it into "discovering new countries and new life." Vasily Kandinsky, "Skizze war immer besser (interessanter) als fertiges Werk . . ." (1908–09), in Kandinsky, *Gesammelte Schriften 1889–1916*, p. 323. Kandinsky's introduction of the viewer's imagination is related to Maurice Maeterlinck's use of simple stage props, designed to make the viewer use his or her imagination to bring the scenario to life. See Kandinsky, *On the Spiritual in Art*, p. 147 n. 1.

26 Kandinsky, "Alle Formen sind eckig oder rund," pp. 576–77.

27 Kandinsky's course on color at the Bauhaus contained exercises to go with it. See Clark V. Poling, *Kandinsky—Unterricht am Bauhaus: Farbenseminar und analytisches Zeichnen, dargestellt am Beispiel der Sammlung des Bauhaus-Archivs Berlin* (Weingarten, Germany: Kunstverlag Weingarten, 1982), pp. 69–71.

28 "Abstract art, despite its emancipation, is subject here also to 'natural laws,' and is

obliged to proceed in the same way that nature did previously, when it started in a modest way with protoplasm and cells, progressing very gradually to increasingly complex organisms." Kandinsky, *Point and Line to Plane*, p. 62 n. 1. In the painting *Calm* (*Stilles*, 1926), he formulated the connection between geometry and real-world associations. Roethel and Benjamin, *Catalogue Raisonné of the Oil Paintings, Volume Two*, p. 743, no. 801.

29 For the tension between the recollection of motif and the autonomy of line, see Vasily Kandinsky, "Wie eine lockere Form eine grosse Präcisität bilden kann . . ." (ca. 1913), in Kandinsky, *Gesammelte Schriften 1889–1916*, p. 581.

30 "But don't confine yourself to these few lines, but in God's name indulge yourself, that's all right by me and I gladly grant it to you, whatever occurs to you in any mood and the variations you do of it in your mind, or however else you imagine that it could be." Philipp Otto Runge, quoted in Roger Fornoff, *Die Sehnsucht nach dem Gesamtkunstwerk. Studien zu einer ästhetischen Konzeption der Moderne* (Hildesheim, Switzerland: George Olms Verlag, 2004), p. 777.

31 Kandinsky, quoted in Grohmann, *Life and Work*, p. 144.

32 Georges Didi-Huberman, "Die ästhetische Immanenz," in *Bild und Einbildungskraft*, ed. Bernd Hüppauf and Christian Wulf (Munich: W. Fink, 2006), p. 75.

33 Vasily Kandinsky, "Wohin geht die 'Neue' Kunst?" (1911), in Kandinsky, *Gesammelte Schriften 1889–1916*, p. 428.

34 Victor Hugo, quoted in Didi-Huberman, "Die ästhetische Immanenz," p. 72.

35 Friedrich von Schlegel, quoted in Fornoff, *Die Sehnsucht nach dem Gesamtkunstwerk*, p. 60.

36 See Thomas Schober, *Das Theater der Maler. Studien zur Theatermoderne anhand dramatischer Werke von Kokoschka, Kandinsky, Barlach, Beckmann, Schwitters und Schlemmer* (Stuttgart, Germany: M & P Verlag für Wissenschaft und Forschung, 1994) and Jelena Hahl-Koch, *Kandinsky* (Stuttgart, Germany: Hatje Cantz, 1993), pp. 143–51.

37 Clemens Heselhaus, "Das Kleistsche Paradox," in *Kleists Aufsatz über das Marionettentheater. Studien und Interpretationen*, ed. Walter Müller-Seidel (Berlin: E. Schmidt, 1967), p. 112.

38 See Fornoff, *Die Sehnsucht nach dem Gesamtkunstwerk,* p. 271.

39 Vasily Kandinsky, "Dance Curves: The Dances of Palucca" (1926), in Kandinsky, *Complete Writings on Art,* p. 520.

40 Kandinsky, *Point and Line to Plane,* p. 643.

41 This observation occurs previously in the example of geometric forms. Kandinsky, "Alle Formen sind eckig oder rund," p. 575.

42 Kandinsky, *Point and Line to Plane,* p. 659.

43 Vasily Kandinsky, "Die materielle Fläche" (ca. 1912–14), in Kandinsky, *Gesammelte Schriften 1889–1916,* p. 592; Kandinsky, *Point and Line to Plane,* p. 662; Vasily Kandinsky, "The Value of a Concrete Work" (1938), in Kandinsky, *Complete Writings on Art,* p. 824.

44 Kandinsky, *Point and Line to Plane,* p. 593. Kandinsky concluded: "The sounds and characteristics of the component elements produce in individual instances a sum total of qualities not covered by the former." P. 591. Later he replaced the term "sum" with "multiplication." Kandinsky, "Art Today," p. 769.

45 Vasily Kandinsky, "Letters from Munich" (1910), in Kandinsky, *Complete Writings on Art,* p. 80.

46 See Gottfried Boehm, *Wie Bilder Sinn erzeugen. Die Macht des Zeigens* (Berlin: Berlin University Press, 2007).

47 Kandinsky, *Point and Line to Plane,* p. 648; Vasily Kandinsky, "Arabisches III (Zweikampf)" (ca. 1911), in Kandinsky, *Gesammelte Schriften 1889–1916,* p. 447; Vasily Kandinsky, "Richtung. Einzelne Formen" (ca. 1911), Kandinsky, *Gesammelte Schriften 1889–1916,* p. 565.

48 Kandinsky, "Empty Canvas, etc.," p. 783. Also involved in the aesthetic is the even contrastive, pastose, scumbled application of paint. Vasily Kandinsky, "Die Technik—das Auftragen der Farbe (Faktur)" (pre-1914), in Kandinsky, *Gesammelte Schriften 1889–1916,* p. 551.

49 Kandinsky, "Gesetze der Komposition," pp. 606–7; Kandinsky, "Mein Werdegang" (1914), in Hans K. Roethel and Jelena Hahl-Koch, eds., *Kandinsky. Die gesammelten Schriften,* vol. 1 (Bern: Benteli Verlag, 1980), p. 57.

50 Kandinsky, *Point and Line to Plane,* p. 611. See also Kandinsky, "Analyse der primären Elemente der Malerei," p. 116.

51 Kandinsky, *Point and Line to Plane,* p. 671.

52 Vasily Kandinsky, "Entwurf zu 'Bezeichnung der Mitglieder der NKVM'" (ca. 1909), in Kandinsky, *Gesammelte Schriften 1889–1916,* p. 327.

53 As Kandinsky said in 1910: "Nor should our work immediately empty out its whole being and whole content in front of people. The hot bit is often concealed coyly beneath the cold surface. . . . The shell is often indifferent, cold, and hard. The nut is inside. But, once its hiding place is discovered, the concealed bit has a never-to-be repeated force." Vasily Kandinsky, "In jedem Bild ist eine Hauptgewichtsform" (ca. 1909–10), in Kandinsky, *Gesammelte Schriften 1889–1916,* p. 382.

54 Oskar Schlemmer, "Mensch und Kunstfigur," in Oskar Schlemmer, László Moholy-Nagy, et al., *Die Bühne im Bauhaus,* Bauhaus Bücher 4 (Munich: Albert Langen, 1925), p. 7.

55 Paul Valéry, *De la Danse* (1935), quoted in Gregor Gumpert, *Die Rede vom Tanz. Körperästhetik in der Literatur der Jahrhundertwende* (Munich: Wilhelm Fink Verlag, 1994), pp. 217–19.

56 Kandinsky talks of a "large composition" made up from "self-contained smaller compositions" in *Über das Geistige in der Kunst,* p. 72.

57 *Picture within Picture (Bild im Bild,* 1929), in Roethel and Benjamin, *Catalogue Raisonné of the Oil Paintings, Volume Two,* p. 834, no. 911.

58 Kandinsky, *Point and Line to Plane,* p. 554. Kandinsky's term "Raumkörperchen" is translated as "tiny particles in space," but the German term has a double meaning: the particle can be a space, and the space can be a particle as well.

59 Ibid., p. 609.

60 Kandinsky, "Art Today," p. 767.

61 *Division–Unity (Division–Unité,* 1943), in Roethel and Benjamin, *Catalogue Raisonné of the Oil Paintings, Volume Two,* p. 1040, no. 1146.

62 Vasily Kandinsky, "Kleine Welt" (1914), in Kandinsky, *Gesammelte Schriften 1889–1916,* p. 543. Kandinsky borrowed this expression from Runge. See Fornoff, *Die Sehnsucht nach dem Gesamtkunstwerk,* p. 87.

63 Kandinsky, *Point and Line to Plane,* pp. 554, 617.

64 He distinguished "element" and "'element'" as "tension" and "form." For him, it was really tension that was abstract, not form. Ibid., p. 548.

65 Kandinsky, unpublished text (1920), quoted in Vasili Rakitin, "Zwischen Himmel und Erde, oder wie befreit man das Rationale vom trockenen Rationalismus," in *Wassily Kandinsky: Die erste sowjetische Retrospektive. Gemälde, Zeichnungen und Graphik aus sowjetischen und westlichen Museen,* exh. cat. (Frankfurt: Schirn Kunsthalle; Moscow: State Tretyakov Gallery; St. Petersburg: State Russian Museum, 1989), p. 79.

66 Heselhaus, "Das Kleistsche Paradox," p. 129.

67 Kandinsky, *Point and Line to Plane,* p. 532.

68 Heinrich von Kleist, "Über die allmähliche Verfertigung der Gedanken beim Reden," quoted in Hesselhaus, "Das Kleistsche Paradox," p. 130 n. 25.

69 Kandinsky, *Point and Line to Plane,* p. 540.

70 Kandinsky, "Empty Canvas, etc.," p. 783. For Kandinsky's abstraction as a pictured fairy tale, see Haldemann, *Kandinskys Abstraktion,* pp. 265–69.

71 Vasily Kandinsky to Will Grohmann, November 21, 1925, quoted in Grohmann, *Life and Work,* p. 180.

72 Vasily Kandinsky, "And, Some Remarks on Synthetic Art" (1927), in Kandinsky, *Complete Writings on Art,* pp. 706–18.

73 Josef Albers, *Interaction of Color. Grundlegung einer Didaktik des Sehens* (Cologne, Germany: DuMont, 1970), p. 117.

74 *Josef Albers,* exh. cat. (Cologne, Germany: Galerie Karsten Greve, 1989), p. 41.

75 Kandinsky, *Point and Line to Plane,* p. 672.

KANDINSKY AND THE CAHIERS D'ART, 1927–44

"A tiny little change of a single color—almost invisible—suddenly lends the work a boundless perfection." —VASILY KANDINSKY[1]

CHRISTIAN DEROUET

Vasily Kandinsky kept as close as he could to the international avant-garde, though a natural propensity to aloofness caused him to stay on the fringe of the artistic circles he frequented. He compensated for this isolation by publishing a series of writings through which he inflamed, stirred up, or tempered the controversy that surrounded his name. This desire to publish was the reason why, in December 1927, in Dessau, he was quite eager to see Christian Zervos, the owner and editor of the Parisian art periodical *Cahiers d'Art* (fig. 57). They immediately started a partnership that in itself accounted for Kandinsky and his wife Nina taking up residence in Neuilly-sur-Seine, France, in late 1933. Thus, in a way, his so-called Parisian period had already begun six years earlier, in Dessau.

Kandinsky, who was really looking for an art dealer, converted a publisher into an agent for his paintings (fig. 58). It should be borne in mind that, in the early part of the century, Kandinsky had already been directly (and to some extent financially) involved with another French periodical, *Les Tendances Nouvelles*, run from Paris by painter Alexis Mérodack-Jeaneau. Issue 26, published Christmas 1906, contained Kandinsky's article on the art of woodcuts (illustrated with some of his own examples) under the name of Gerôme-Maësse. Later, Kandinsky never spoke a word about this venture, which had turned out to be a failure. After his last submission to the Salon des Indépendants in 1912, no more negative reviews were written about him in the Parisian

press. In 1927, fifteen years later, the unexpected visit to 6 Burgkühnauer Allee, Dessau, by Zervos, a Gallicized Hellene, revived Kandinsky's old dream of making his mark in the Babylon of European art.

KANDINSKY AS GERMAN CORRESPONDENT FOR THE CAHIERS D'ART, 1928–33

Shrewdly, Zervos brought the most important dealer in Berlin along with him to Kandinsky's house. He wrote from the Hotel Central in Berlin in December 1927: "Monday, Dear Monsieur Kandinsky, I shall come and see you on January 28 or 31 with M. [Alfred] Flechtheim, and we will choose together the canvases he wants to buy from you. Everything is going well. Of course, M. Flechtheim is delighted with my idea of putting on an exhibition for you in Paris. That will give him more possibilities for doing things in Germany. My respects to Mme [Nina] Kandinsky, who delighted everyone. Sincere regards, Christian Zervos."[2] (fig. 59) To the day he died, Kandinsky would subsequently follow Zervos to the latter's successive addresses at the rue de Lisbonne in the eighth arrondissement in Paris to the Cahiers' office at 14, rue du Dragon in the sixth arrondissement, and so on. During World War II, Kandinsky added the two final addresses in pencil to his address book: 40, rue du Bac and the Zervos country retreat, La Goulotte, near Vézelay, France.

The two men had in common that they were both former academics and had remained outsiders in their adopted countries. Their recent naturalization barely checked the odor of xenophobia they encountered. What they offered each other was, above all, strategic. Kandinsky, the Bauhaus lecturer, introduced to Zervos's *Cahiers d'Art*: Will Grohmann, trusted critic; Dr. Ludwig Grote, curator at the Dessau Kunstverein; and Walter Peterhans, Bauhaus photographer. He explained to Zervos the workings of art lovers' societies that enabled artists to subsist in those years of crisis, such as the Gesellschaft zur Förderung der Jungen Kunst (Society for the Friends of Modern Art), run by Otto Ralfs in Brunswick. He joined forces with his colleague Paul Klee to represent German art to the Parisian public, though Klee already enjoyed a reputation in Paris that tended to ruffle Kandinsky's feathers. Kandinsky also made references to the *Cahiers d'Art* in the courses he

57 Top left: **Christian Zervos, photograph signed Dietz, Frankfurt, 1931.** Collection Yves de Fontbrune, Galerie Cahiers d'Art, Paris

58 Top right: **Vasily Kandinsky, 1934. Reproduced in *Cahiers d'Art* 5–8 (1934), p. 152.** Photo: Florence Henri

59 Above: **Facsimile of a letter from Zervos to Kandinsky, December 22, 1927, Berlin**

Page 88: Detail of *Sky Blue* (*Bleu de ciel*), 1940 (plate 90)

delivered to his Bauhaus students, and in 1932, he asked Zervos for some spare sheets to cut up, so that he could mount its reproductions of art on card (fig. 60).

In 1926, after learning the art of publishing for four years at art publishers Editions Albert Morancé, Zervos set up his own periodical. He immediately oriented it toward Berlin, even though he did not speak any German. He commissioned Flechtheim's assistant Curt Valentin to lease an office for him on the Spree River. By entrusting his "architectural" pages to Swiss architecture historian Sigfried Giedion from 1928 to 1934, Zervos spread the gospel of Kandinsky's paintings even as far as the Kunsthaus in Zurich. In Paris, Zervos had, in fact, little credit with the powerful galleries on the Rive Droite, where he was on familiar terms only with the Galerie Percier and Georges Bernheim galleries. But on the Rive Gauche, in Saint-Germain-des-Prés, he acted as artistic director for small gallery owners. From 1928 to 1932, he benefited from the acquaintance of Maurice Raynal and E. Tériade, who edited the arts page of the daily paper *L'Intransigeant*. They immediately invited Kandinsky to reply to its "enquêtes" ("inquests"), and even the smallest of his activities in Germany got a passing mention in the paper's diary. Moreover, as the circulation of the *Cahiers d'Art* increased in New York and London, Kandinsky's name became associated with the renowned masters of the School of Paris.

In January 1929, Zervos organized a modest exhibition of Kandinsky's watercolors at the Galerie Zak, Saint-Germain-des-Prés. He made an event of it in the *Cahiers d'Art*:

> I personally didn't know the work of Kandinsky except from reproductions in German periodicals and from his book *Punkt und Linie zu Fläche* [*Point and Line to Plane*, 1926], which is a resume of his theories he teaches students at the Bauhaus. So it was a real surprise even to me when, last winter, during my trip to Germany, I had the pleasure of seeing Kandinsky's works in Dessau. I had just paid a visit to his neighbor Paul Klee, who is likewise a professor at the Bauhaus in Dessau. I had seen some admirably painted canvases at Klee's that revealed to me the source of some aspects of Surrealism in France. In

60 **Jean Arp, *Relief*, 1918.** Reproduction from an article by Georges Hugnet, "L'Espirit Dada dans le peinture," *Cahiers d'Art* 7 (1st edition Zurich/New York) (1932), cut and pasted on card for Kandinsky's courses at the Bauhaus

> Kandinsky, I found the rest of these sources. So what is admired in France as an original creation was, when all is said and done, just a continuation of the work of Klee and Kandinsky.[3]

This rush to connect Kandinsky and Klee with the Surrealists was the source of an enduring misunderstanding. It is all the more comprehensible in that, among the buyers at the exhibition, was poet André Breton, who bought the watercolor *Small White* (*Kleines Weiß*, 1928). Not long after, Zervos published the first amply illustrated article, by Grohmann, on Kandinsky. He committed a blunder by reproducing *Painting with White Form* (*Bild mit weißer Form*, 1913), from Ralfs's collection in Brunswick, upside down—his first "bottom up."[4]

In March 1930, Zervos put on a more ambitious exhibition called *Kandinsky. Peintures récentes* (*Kandinsky: Recent Paintings*) at the Galerie de France, rue de l'Abbaye, near Saint-Germain-des-Prés.

61 Exhibition catalogue cover of *Exposition Kandinsky, peintures récentes* (*Kandinsky Exhibition: Recent Paintings*), Galerie de France, 2bis, rue de l'Abbaye, near Saint-Germain-des-Prés, Paris, 1930

He printed a fine catalogue and had plates made of four of the paintings exhibited (fig. 61). He ventured on a correction to his connection of Kandinsky with Surrealism by titling his foreword "Kandinsky et l'art abstrait" (Kandinsky and Abstract Art). In his analyses, he never attempted to place Kandinsky in an historical perspective; what he did was to rephrase the artist's statements:

The most precious aspect in the paintings of Kandinsky is the perfect arrangement of colors which, though often intense, are nonetheless perfectly logical. Kandinsky's color never aims at picturesqueness and effect. Indeed, by using the simplest of resources, it often leaves an impression of extreme sobriety and propriety. The fact is, the artist is concerned above all with the total harmony of the painting, and he knows better than anyone else the necessity for a basic color. Careful about the

surfaces of his canvases, Kandinsky avoids the danger of allowing the desired details to be mutually contradictory in the overall effect. The result is that his color never lacks melody.[5]

Then Kandinsky encouraged Editions Cahiers d'Art to publish a monograph like the one Zervos and Grohmann had done for Klee in 1929. It was agreed that the publication of this volume, financed by Kandinsky, would coincide with his exhibition of paintings and watercolors at the Galerie Alfred Flechtheim in Berlin (fig. 62). The publication was aimed more at German clients than Parisian collectors. Grohmann's original text, in German, was contained in a leaflet produced at the expense of the Kandinsky Gesellschaft in Brunswick. The plates—heliotyped—covered the painter's output from 1909 to 1929. Kandinsky tempted buyers by including, with every copy, a woodcut in three colors (fig. 63), and slipped watercolors, drawings, and etchings in the *tirages de tête* (the first issues of the monograph, which were printed on varying degrees of higher quality paper) (fig. 64). The *Compositions*, numbering eight at this time, were all included, one after the other. Grohmann wrote the introduction and drew up a table of concordance in German and French, in addition to a bibliography of Kandinsky's published writings. He also listed the positions Kandinsky had held from 1919 to 1921 in the Soviet Union. This was a succinct and concise reconstruction of the artist's career.

In 1931, the *Cahiers d'Art* launched a judicial-style "inquest" on abstract art, entitled "De l'art abstrait." Zervos drew up some real counts of indictment where, reading between the lines, we can see the misgivings of Henri Matisse and Pablo Picasso, the real patrons of *Cahiers d'Art*, about this German intrusion into the market. Abstract art was indicted on the following grounds:

That it was excessively cerebral and consequently in contradiction with the nature of art, which should be essentially of a sensual and emotional nature; that it had ousted emotion by deploying pure tones and geometrical drawings more or less skillfully and subtly but always objectively; that it had restrained the possibilities on offer to painting and sculpture to the point of

WILL GROHMANN

KANDINSKY

ÉDITIONS «CAHIERS D'ART»
14, RUE DU DRAGON, PARIS VI°

62 Cover of monograph by Will Grohmann, *Kandinsky* (Paris: Editions Cahiers d'Art, 1930). Printed January 15, 1931

63 Kandinsky, woodcut in three colors, 1930. Created for Grohmann, *Kandinsky*

64 Kandinsky, etching, 1930. Created for Grohmann, *Kandinsky*

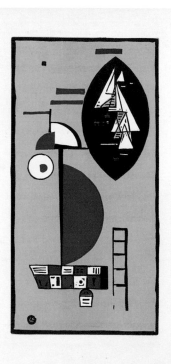

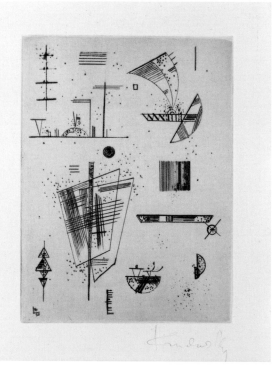

reducing the work of art to a simple game of colors and purely ornamental shapes that were more suited to posters and advertising catalogues; and that it had taken art down a blind alley and suppressed all its possibilities for evolution and development.[6]

Following Piet Mondrian, Kandinsky, who refused to be accused of Bolshevism, accepted the challenge: "abstract" painters were the accused and had to defend themselves to prove that "objectless" painting really was painting and had a right to exist alongside the other kind. He distinguished between abstract art and mathematics: "For example, I drew the image projected on a surface calculated in accordance with mathematical proportions, but the color already modified the proportions of the drawings so profoundly that it couldn't be left to mathematics alone—the painter would have to rely on his intuition." He contrasted the attitude of the "pure Constructivists" with intuition, "the voice of the deceased wife" of Henri Rousseau, and concluded with a bon mot: "The acute angle of a triangle touching a circle has no less effect than that of God's finger touching Adam's in Michelangelo."[7]

Such controversies were no obstacle to the continuation of the mutually unconditional relationship between Zervos and Kandinsky, with each man aiming to reinforce the position of the other. Zervos published Grohmann's review of an exhibition of Kandinsky's drawings at the Galerie Ferdinand Möller in Berlin (*Cahiers d'Art* 1–2, 1932), just as he announced the "closure of the Bauhaus by the National Socialist government of Anhalt" (*Cahiers d'Art* 6–7, 1932). This information was very remote from his readers, but it increased Kandinsky's authority with Ludwig Mies van der Rohe. When Zervos proposed the idea of creating a portfolio of engravings to reduce his arrears to his printers in 1932, he found in Kandinsky a friend who sent him a high-quality etching without grumbling.[8] Immediately after, Zervos asked both him and Klee for a voluntary offering of a *pochoir* in two colors, in the format (32 x 23 cm) of those done for the *Cahiers d'Art,* to enhance subscriber loyalty. The following month he made another proposal: "Despite all my problems, I have agreed with a printer to have six volumes printed, one each of the best poets of today, and here are their names: André Breton, [Paul] Éluard, Tristan Tzara, Benjamin Péret, [Hans]

Arp, [Georges] Hugnet. It will be a volume of 50 pages with three etchings. The first volume will be verses by Éluard: in my opinion the best French poet of the present day whose verses are in the same tradition as the art that I support. Éluard himself, when he saw the etching you did for the album, asked me if he could rely on you for the illustration of his book."[9] Kandinsky immediately set to work with zest, only to learn a little later that Zervos was postponing it because he really "didn't have a sou."[10] For the auction on April 12, 1933, that Zervos organized to save his periodical from bankruptcy, Kandinsky dispatched his nephew Alexandre Kojève with a painting in a respectable format, *Line-Spot* (*Linie-Fleck*, 1927), simply asking him not to let it go for nothing. The previous year, at the ardent request of Zervos, Kandinsky had gratified a backer of the periodical, Emil Friedrich of Zurich, by sending *Ladder Form* (*Leiterform [auf Flecken]*, 1929). In 1935, he gave away *Yellow Arc* (*Gelber Bogen*, 1930) for another Cahiers d'Art sale in New York.[11]

The situation was growing increasingly worse in Germany. Having left the Bauhaus, Klee was deposed from his chair at the Academy of Fine Arts in Düsseldorf. Then, on July 20, 1933, the professorial college of the Bauhaus voted to dissolve the Bauhaus in Berlin in the face of demands by the Nazis. Klee went to Paris to ask Zervos for help. Not finding him there, he concluded an agreement with dealer Daniel-Henry Kahnweiler. He then traveled to Bern, conceiving a grudge against Zervos. At the beginning of October, Kandinsky went back to Paris for a few days. Zervos still had not returned. Kandinsky met Breton, Éluard, and Tériade, who were publishing a new artistic and literary review called *Minotaure* (along with Albert Skira). He was invited to exhibit with the Surrealists at the end of October at the Salon des Surindépendants, at the Porte de Versailles. His presence acquired the status of a protest against the "réaction hitlérienne" ("Hitler reaction"), but this unnatural alliance with the Surrealists turned sour. In her book *Kandinsky und ich* (Kandinsky and I, 1976), Nina Kandinsky recalled: "Paul Éluard, whom we had met in 1933 at a reception at Tristan Tzara's . . . felt that we didn't have much sympathy for Communism, and so we had deceived him greatly. He interrupted the conversation abruptly."[12]

Zervos had been in Greece since August, collecting the required material for a subsequent issue of the *Cahiers d'Art* devoted exclusively to Greek art. He wrote to Kandinsky on November 20, 1933, to apologize: "Here we are back from Greece after being away for three months and a half. I very much regret having missed you."[13] He discovered the abyss into which everything he valued in Germany was slipping. Valentin was already sorting things out at the Galerie Alfred Flechtheim. Kandinsky told his confidant, Grohmann, that, on December 4, 1933, he had rented a fine apartment at 135, boulevard de la Seine in Neuilly-sur-Seine, near Paris.

KANDINSKY AT THE CAHIERS D'ART: THE HEYDAY OF A GERMAN IN EXILE, 1934–36

According to correspondence with Josef Albers, an old student and subsequent colleague of Kandinsky's from the Bauhaus who had recently emigrated to the United States and worked at Black Mountain College in North Carolina, the Kandinskys left Berlin on December 16, after trying days and harassments of all kinds. They spent five days in Bern before reaching Paris on December 21, 1933. On January 2, they settled into a building that was far from being finished. Their sixth-floor apartment was reminiscent of the location of the studio that Kandinsky had made for himself at the top of his investment property in Moscow in 1913, only here it was no longer the Kremlin he looked out upon. From the windows of the three interconnecting rooms, he could see the Seine flowing below, further off was an island liable to flooding, then, on the bank opposite, the industrial zone of Pûteaux, and finally, above Mont Valérien, an immense sky (fig. 65). This rental, taken initially for a year, was their last mooring. Kandinsky expired there eleven years later, in 1944, and Nina Kandinsky lived there until her death in 1980.

The Zervos did everything they could so that the Kandinskys would be absorbed into the artistic activity around Saint-Germain-des-Prés as quickly as possible. They visited them in Neuilly and set up a series of studio visits and meetings in the country, such as the excursion to Varengeville-sur-Mer, Normandy, in April (fig. 66). The offices of the Cahiers d'Art at 14, rue du Dragon were transformed into an exhibition gallery. Following an exhibition of Joan Miró's

65 Top: **View of the bridge of Pûteaux seen from 135, boulevard de la Seine, Neuilly-sur-Seine, 1938.** Photo: Joseph Breitenbach

66 **Varengeville-sur-Mer, Normandy, outside the house of American architect Paul Nelson and his wife, designer Francine Nelson, 1934.** Standing in the foreground: Zervos; seated: Yvonne Zervos; behind her, Francine Nelson and Nina Kandinsky; back right, wearing a hat: Kandinsky; to the right of him: Susi and Alberto Magnelli

large collages the space held its first Kandinsky exhibition entitled *Kandinsky. Peintures de toutes les époques, aquarelles, dessins* (*Kandinsky: Paintings of All Periods, Watercolors, Drawings*), in May–June 1934 (fig. 67). Yvonne Zervos gave Kandinsky a scaled drawing of the rooms so that the artist could prepare his hangings. Christian Zervos wrote to Giuseppe Ghiringhelli, director of the Galleria Il Milione in Milan, on May 19, 1934, that "the exhibition that Mme

KANDINSKY

PEINTURES DE TOUTES LES ÉPOQUES, AQUARELLES, DESSINS

Exposition organisée par Yvonne Zervos, dans les locaux de la revue „Cahiers d'Art", 14, rue du Dragon, du 23 Mai au 9 Juin 1934.

67 Invitation to the first Kandinsky exhibition at Galerie Cahiers d'Art, *Kandinsky: Peintures de toutes les époques, aquarelles, dessins* (*Kandinsky: Paintings of All Periods, Watercolors, Drawings*), May 23–June 9, 1934

Zervos has organized in the offices of the periodical is really splendid. The vernissage was yesterday. Every-one agreed unanimously in acknowledging the beauty of the works exhibited. We showed forty-five paintings in all, including a dozen very large canvases that gave a very strong impression of this marvelous artist."[14] Paul Westheim, the former publisher of the periodical *Das Kunstblatt*, wrote a review of it for a German newspaper published for refugees in Paris.[15]

Following the exhibition, Zervos wrote his "Notes sur Kandinsky, à propos de sa récente exposition à la Galerie des *Cahiers d'Art*" (Notes on Kandinsky: Regarding his Recent Exhibition at the Cahiers d'Art Gallery) in his periodical: "Vigor and nobility of thought, sobriety of form, and power of execution are unquestionably drawn from his life, the contours of which constantly enliven his works. . . . His recent paintings are perhaps distinct from the older ones in the maturity of age, [but] they are no less stamped with that hallmark of youth that makes his canvases vital, new, and sparkling with wit and imagination in all periods, like an unending series of debuts." He was in full denial that Kandinsky's work was abstract: "That's why Kandinsky's paintings are never abstract. On the contrary, they excel in breathing vitality into the artist's inventions, and bringing a universe or even the

most inert-looking things to life."[16] As was typical for him, he only reproduced unpublished canvases: *Development in Brown* (*Entwicklung in Braun*, 1933, plate 73), *Each for Itself* (*Chacun pour soi*, 1934), *Ensemble* (1934), *Black Forms on White* (*Formes noires sur blanc*, 1934, fig. 68), *In Between* (*Entre-deux*,1934), *Blue World* (*Monde bleu*, 1934, plate 74), and *Dominant Violet* (*Violet dominant*, 1934). Yvonne Zervos (fig. 69) complimented Kandinsky sincerely on June 13,1934: "I was anxious to tell you the moment I separated from your paintings how glad I was to have been in their company for two weeks and to have been able to show them to everyone who still likes good paintings."[17] In return, Kandinsky gave her the canvas with a paradoxical title, *Black Forms on White*, which he dedicated on the back: "à MADAME YVONNE ZERVOS/avec des sentiments vifs de respect et d'amitié/cordiale/Kandinsky/Paris 1934" (To Madame Yvonne Zervos, with strong feelings of respect and cordiality. Kandinsky. Paris 1934).

In this variation in black and white, Kandinsky examined the validity of his latest investigations into the contrasts between "hard" and "soft," the living and the geometrical, and optical illusions and actual biomorphic beings. Kandinsky wrote to Albers on June 19, 1934, congratulating himself on a real turnaround in his success: "I had paintings from 1921 to 1934 there [the Galerie Cahiers d'Art exhibition], i.e. including some painted in Paris. My wife instructs me to tell you that this event was considered a real event and was an extraordinary success. . . . The forthcoming group consists of artists who were formerly members of the Abstraction-Création (Abstraction-Creation) group and recently left, which had long been desirable since the A-C exhibitions were worse than feeble."[18] Subsequently, the Kandinskys came back to the gallery for an exhibition of (and in honor of) Max Ernst in May–June 1934, and later for an exhibition of the aforementioned group consisting of work by Arp, Nicholas Ghika, Jean Hélion, and Sophie Taeuber-Arp.[19]

Kandinsky's imprecations about the Surrealists pepper his letters to Albers. Referring to Ernst, on September 6,1934, though without mentioning him by name, he said: "Only the Sexuality Art is really bad, which is really very successful today. The word 'sexuality' could easily be translated as filth. Its admirers are mostly homosexuals or pure

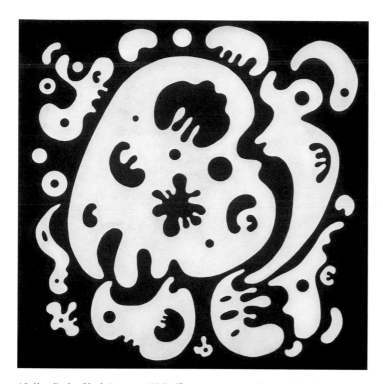

68 Kandinsky, *Black Forms on White* (*Formes noires sur blanc*), 1934. Oil on canvas, 70 x 70 cm. Musée Zervos, Vézelay, France (MZ. 133). Inscribed on reverse, top left: "K/n° 600/avril 1934." Dedicated on reverse, top right: "à MADAME YVONNE ZERVOS/avec des sentiments vifs de respect et d'amité/cordiale/Kandinsky/Paris 1934." Published in *Cahiers d'Art* 5–8 (1934), p. 153

69 Yvonne Zervos

snobs. To drag this aspect of existence from obscurity into the daylight is quite alright. But it's not alright to reduce life to that aspect."[20]

Kandinsky returned again to the Cahiers d'Art gallery to see the wrought-iron sculptures made by Julio González, which he found magnificent. In *Cahiers d'Art* 9–10, 1934, which went on sale in early 1935, Zervos published "two unpublished paintings by Henri Rousseau belonging to Mr. W. Kandinsky,"[21] (though without captioning them their names: *La Basse-cour* [*The Farmyard*] and *Le Peintre et son modèle* [*The Painter and His Model*].)[22] This was more than a simple addendum to the monograph he had written about Rousseau in 1927. Zervos was demonstrating his friendship for Kandinsky by publishing pictures authenticating the works in question and, moreover, awarding a "German" painter a Parisian cultural warrant.

As Albers was interested in showing his works in Paris, on December 15, 1934, Kandinsky advised him, praising the way exhibitions at the Cahiers d'Art were organized: "It is the best spot to exhibit, where the most interesting people go and the word is spread around." Unlike real art dealers who hired out their premises or simply refused to do anything at all because the crisis that had hit the art market was still going on and discouraged speculation, "the Zervos themselves only put on exhibitions out of conviction, without any personal profit from it."[23] However, an exhibition at the Cahiers d'Art could only have a social benefit—to show off the works and the artist. Of the practical matters of buying and selling, the Zervos knew nothing and provided no guidance.

In the *Art et décoration* (*Art and Decoration*) exhibition at the Grand Palais in May 1935, Yvonne Zervos and a firm of young architects, Barret and Buffetaut, improvised a confrontation between the two rival schools of abstract art in Paris—biomorphic and geometric.

On the walls of what purported to be the "drawing room of an intellectual's apartment," one of Kandinsky's most recent canvases, *Brown with Supplement* (*Brun supplémenté*, 1935), finished in March, faced off against a rhythmic composition of horizontals and verticals by Mondrian. Without even mentioning this confrontation, Kandinsky wrote to businessman Hermann Rupf on May 9, 1935: "There's a large exhibition on at the Grand Palais called *Art et décoration*. It's supposed to be incredibly bad, with the exception of one room fitted out by a young French architect and Mme Yvonne Zervos. That room is supposed to be terrific."[24]

A second Kandinsky exhibition at Galerie Cahiers d'Art occupied all three rooms, from June to September 1935, with ten new canvases, watercolors, gouaches, and drawings from all the artist's periods. It coincided with the appearance of Kandinsky's response to an enquiry about contemporary art in *Cahiers d'Art*. In his text, he repeated his claim to have liberated painting (or at least his) from objects. In Paris, the grapevine had just heard of the death of Kazimir Malevich, and Kandinsky planned to check the radicalism of the "Constructivists," most of whom maintained that an artist's external impressions and emotions were not only useless but had to be fought off, like the "rest of bourgeois sentimentality," and had to be replaced by the pure intentionality of mechanical process.[25] He denounced the sham of belief in pure color, which doesn't exist in reality. He recommended reintroducing "rich," complex compositions into painting instead. He lauded internal necessity, the subconscious, and subjectivity, which "always guided the hand." He praised artists who were capable of loving "shapes passionately, just as they love their instruments or the smell of turpentine, because these are powerful resources for expressing the content." Kandinsky also outlined a sure way of recognizing good painting from bad: "If the literary narrative gains the upper hand over the pictorial input, a reproduction in black-and-white does not make one grieve the lack of color. If, on the other hand, the content is purely pictorial, this lack becomes grievous."[26] He was able to apply this test to his own painting, as Zervos had already reproduced three of his exhibited canvases in black and white: *Fragile–Fixed* (*Fragile–Fixé*, 1934), *Striped* (*Rayé*, 1934, plate 75), and *Balancing Act* (*Voltige*, 1935).

The exhibition was given a very long review in *Il Lavoro Fascista* on July 28, entitled "Lettere da Parigi. Il pittore Kandinsky e le sue idee intorno all'arte" (Letters from Paris: The Painter Kandinsky and His Ideas about Art). At this time, the influence of Ben Nicholson and his English associates could be felt in Paris. Hélion and critic Anatole Jakovsky were visiting artists in Paris on behalf of a new English periodical, *Axis*. Published in London, this review had taken over the moribund publications of the Parisian Abstraction-Création group. Zervos did not like this competition, and cut off those, like Hélion, who responded to the British request for submissions. Kandinsky made further observations about painting in the next issue of *Cahiers d'Art* (5–6, 1935) under the heading "Toile vide, etc." ("Empty Canvas, etc."): "In appearance: truly empty, saying nothing, indifferent. Then it harmoniously picks up the contrasts: hard and soft; cool and hot, as in a Chinese spring roll; positive and negative; 'fairy tale' and 'reality.'" In the essay, Kandinsky shared a personal observation with the reader: "I look out of my window. Cold factories with several chimneys standing silent. They're rigid. Suddenly smoke rises from a single chimney. The wind catches it, and it immediately changes color. The whole world has changed."[27]

This issue of *Cahiers d'Art* was dedicated exclusively to the Surrealists (fig. 70), a fact that astonished Kandinsky, who wrote to Albers on December 19, 1935:

What I say to you must remain between ourselves. Zervos has always rejected the Surrealists; he found the artistic level pretty poor. To my great surprise, he has suddenly exhibited three of them—Max Ernst, Yves Tanguy, Man Ray. And the issue is full of people like that, as you can see for yourself. In my view, Zervos is "obliged" to "document" all artistic developments, and has to mention that 'such and such exists' in his *Cahiers*. I think he really ought to evaluate these phenomena. I am his friend. I appreciate his qualities, but I don't get involved with subjects of that kind, because that would get us into politics. And politically we don't see eye to eye at all, since he tends towards Communism even though he rejects materialism. Until yesterday

evening, all the Surrealists were Communists, which is very much the fashion among the "moderns" here.[28]

Kandinsky remained loyal to 14, rue du Dragon, but came more and more to doubt the sincerity of the chief editor of the *Cahiers d'Art* toward him. Zervos no longer needed him as a correspondent regarding German art. The conflict between abstract art and Surrealism forced Kandinsky to look elsewhere. On May 8, 1936, he confided to Albers:

> To some extent, the French have little inclination towards "abstraction," perhaps none at all. To some extent, in short, they confuse abstract art in general with Constructivism and its "mechanistic" approach in particular. I wrote something about that in the *Cahiers*, which certain artists took extremely amiss. I often hear it said by arty folk and people in the business that I am not an "abstract" painter. You know that what interests me in abstract art, and why I am attached to it, is its superior spirituality. Apart from that, the "question" hardly interests me. Incidentally, a different word is normally used here instead of "abstract"—"nonfigurative." Baroness [Hilla von] Rebay does much the same, using the English word "nonobjective."[29]

Kandinsky found a distributor capable of selling his work—a gallery reopened by Jeanne Bucher on the boulevard du Montparnasse (Galerie Jeanne Bucher). He was also approached by Arp and César Domela in connection with a new project for a journal called *Plastique*, financed by American patron of the arts A. E. Gallatin.

About this time, Kandinsky's beloved nephew Kojève, who had recently been commissioned to deliver courses on Georg Wilhelm Friedrich Hegel at the École pratique des hautes études, wrote an article on "Les peintures ~~objectives~~ concrètes de Kandinsky" (The ~~objective~~ [*word crossed out*] concrete paintings of Kandinsky), dated "Vanves, [France,] July 23–25, 1936," and subtitled in pencil, by Kandinsky, "Analyse de contenu!" (Analysis of the contents!) The manuscript—long but well crafted—remained unpublished. We may

70 **Cover of *Cahiers d'Art* 5–6, 1935.** Issue devoted to Surrealism in which Kandinsky published his essay "Toile vide, etc." ("Empty Canvas, etc.")

suppose that the author's uncle intended this "unpublished" material for the *Cahiers d'Art*. As for the term "concrete," which Kandinsky considered a more adequate word for his pictorial practice, it only compounded the confusion.

Still, Zervos provided Kandinsky with a final opportunity for a more political declaration.[30] A book published by Rembrandt Verlag in Berlin in 1936 arrived in Neuilly—a monograph on Franz Marc by Professor Alois J. Schardt. It had been immediately banned in Germany. Kandinsky reported on it in the *Cahiers d'Art* and called his article simply "Franz Marc."

In this issue (8–10, 1936), which focused on current events in Germany, Zervos warmly welcomed the *Kandinsky. Toiles récentes, aquarelles, graphiques de 1910–1935 (Kandinsky: Recent Canvases, Watercolors, Woodcuts, Etchings, 1910–1935)* exhibition put on by Bucher in December 1936, only to drive home his anti-abstract theme.

It is the first time that we have seen Kandinsky's graphic output collected together in one place: drawings, woodcuts, copper engravings, color engravings, etc. This exhibition has confirmed what we have always said about Kandinsky, namely that he is not only an amazing colorist, but also a master of line and arabesques. . . . When you look at this exhibition, you can see more clearly the gap that separates Kandinsky from the so-called abstract painters. All those who have no idea about the internal organization of a painting, who paint without being able to bring their work vividly alive, masquerade under the name "abstract," imagining that in this way they can make a few splashes of color pass for a painting whose dynamic appearance would never deceive an experienced eye. So this exhibition of Kandinsky's allows us to admire a great draughts-man, draw a lesson in art, and throw light on the ambiguities created by painters of no talent in order to mislead and to hide their artistic impotence.[31]

For Kandinsky, however, disillusions multiplied. In February, Zervos small-mindedly refused to send issue 5–6 of *Cahiers d'Art* to Max Huggler, who was preparing a Kandinsky retrospective at the Kunsthalle in Bern. Zervos, moreover, did not reply to Kandinsky's proposal to publish the photos of the hanging in Bern. Worse still, Zervos pledged (though fruitlessly) the canvas and watercolors offered by Kandinsky to Alphonse Bellier, auctioneer and financial guarantor of the *Cahiers d'Art*. In any case, to the great pleasure of his detractors, Kandinsky discredited himself with Zervos, from 1935 on, by paying great attention to the lecturers on Italian Futurism, welcomed at the École du Louvre, who were committed Benito Mussolini followers. Kandinsky kept a compromising letter, revealing a thought more or less shared, written to him on April 16, 1937, by Ghiringhelli, the Galleria Il Milione director, in which the latter deplored "a very unpleasant and dangerous situation between the various centers of European modernism. In Italy, there is never any question of politics getting mixed up in artistic affairs; but for many years there has been too much mingling of politics and art in Russia, in Germany, and now in France. A

situation like that in the last issue of the *Cahiers d'Art*, clearly paid for by the Komintern and the present neuroses of democratic and plutocratic countries, will surely justify all the stupidities done to art through the means of politics." He then added: "([Adolf] Hitler is an aggravation arising from French egoism and the immediate physical danger of Bolshevism by masses who have not had any preparation for spiritual resistance). In Italy, we understand that it is essential to defend our modernism from the Fascist point of view against the equivocations of a bourgeois and antirevolutionary modernism; and on the other hand, we shall defend our modernism from all reactions to our whole *Fascist* conception of modernism."[32] Kandinsky was also visited at home by Filippo Marinetti and then Carlo Belli, author of an essay entitled "Kn," where identical ideas were expounded.

ORIGINES ET DÉVELOPPEMENT DE L'ART INTERNATIONAL INDÉPENDANT: AN UNPREDICTABLE RIVALRY, 1937

Bucher and Marie Cuttoli put Kandinsky in direct contact with André Dézarrois, curator of the Écoles étrangères museum within the Jeu de Paume museum, with a view to preparing an exhibition of abstract art. For this exhibition, entitled *Origines et développement de l'art international indépendant (Origins and Development of International Independent Art)*, Dézarrois suggested borrowing "1. The large picture in his studio; 2. The brown picture, the last to be painted in Berlin; 3. A recent picture of the same dimensions as no. 2 in order to balance the panel," adding, "If my choice doesn't suit you, please would you give us the pictures of your own choosing, on condition that they do not exceed 6 meters of picture rail."[33] In his reply of July 15, 1937, Kandinsky concerned himself with getting 8 meters of hanging rail, to represent at least four periods of his "development": "*Painting with a Black Arch* [*Bild mit schwarzem Bogen*, plate 31], 1912, the so-called 'lyric' period (one of my first 'nonfig.[urative works]'); *On White II* [*Auf Weiß II*], 1923, 'cold'; *Development in Brown*, 1933, 'surfaces with greater depths'; *In Between*, 1934, and *Dominant Curve* [*Courbe dominante*, plate 83], 1936, a 'synthesis' of examples of my Parisian work." He indicated an order to be followed in the

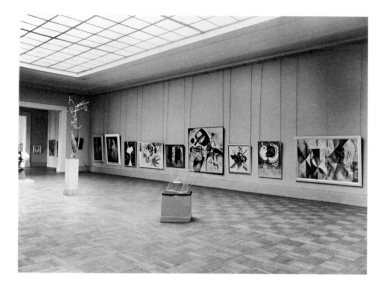

71 *Origines et développement de l'art international indépendant (Origins and Development of International Independent Art)*, Jeu de Paume, July 1937. View of Room XIV, Kandinsky installation. Left to right, on wall: two paintings by Theodor Werner; relief by Jean Arp; Kandinsky's *Dominant Curve (Courbe dominante*, 1936), *Development in Brown (Entwicklung in Braun*, 1933), *Painting with Black Arch (Bild mit schwarzem Bogen*, 1912), *On White II (Auf Weiß II*, 1923), *In Between (Entre-deux*, 1934); and a painting by Robert Delaunay. Left to right, on floor: sculptures by Antoine Pevsner, Julio González, and Naum Gabo

hanging, which was determined by the "range of colors in the canvases on show."[34] (fig. 71)

During the *Exposition internationale des sciences et techniques (International Exhibition of Science and Technology)* of 1937, the whole of European society surged from Les Invalides to the Concorde, from the Champs de Mars to the Palais de Chaillot. The Germans obtained travel permits more easily than usual, and they, too, came. The Kandinskys welcomed to Neuilly (or met up with among the pavilions) Herbert Bayer, Ida Bienert and her son Fritz, the Grotes and Grohmanns, Mies van der Rohe, Ralfs, Lilly Reich, and Peterhans. The radio and the German dailies in Paris—both opposition and propagandist—reproduced Hitler's speech at the opening of the *Große deutsche Kunstausstellung (Great German Art Exhibition)* at the Haus der Deutschen Kunst in Munich on July 18, 1937, and also reported on the counterpart exhibition on "degenerate" art (*Entartete Kunst*), where works by Kandinsky were exhibited.

The exhibition *Origines et développement de l'art international indépendant* opened on July 30 in the Jeu de Paume and closed on November 15. It presented a challenge to the official exhibition of *Les Maîtres de l'art indépendant, 1895–1937 (The Masters of Independent Art, 1895–1937)* at the Petit Palais. Zervos had managed to worm his way onto the Jeu de Paume committee as general secretary. He allocated the best places to Georges Braque, Matisse, and Picasso, having considered the fact that they had been relegated to the basements of the Petit Palais. He also transformed Kandinsky's initial concept for the exhibition into an anthology of Parisian art from Paul Cézanne to the present. Kandinsky's discontentment with Zervos became overt when the artist wrote him a letter, full of bitterness, on June 1, 1937.[35]

Later, on December 5, 1937, Kandinsky confided his tribulations to Albers: "Thanks to the 'collaboration' of M. Zervos, even these artists were given one of the large rooms (e.g., Picasso had one of the longest walls), and so the list had to be cut. . . . For my own part, I took part in the preliminary discussions at the start, but soon dropped out as I didn't like the way it was going. So, I only saw this exhibition when I went to the vernissage. I, myself, had a fine position that was not quite big enough, but was acceptable. And I only got so much good space because I was personally invited by the director of the museum and was given my place on his instructions."[36] In unsigned communiqués, Zervos downplayed the importance of Kandinsky's role in the discovery of pure art: "Nonfigurative Art. Under the influence of Cézanne and Matisse, Kandinsky, in 1911, broke up the representation of objects to use them as simple pretexts for developing forms and colors. In France, Francis Picabia (1909), [Alexander] Archipenko and [Robert] Delaunay had established the primary groundwork of what came to be called abstract art. In Russia, Vladimir Tatlin, Malevich, and [El] Lissitzky worked in the same way, but unfortunately, owing to lack of time, we were not able to get ahold of their works."[37] Kandinsky summed up the affair to Hélion, forgotten in faraway Virginia, on November 21, 1937: "This exhibition was important and interesting, and could have been even more important if the major project had been realized in a very pure way. But . . . as too often happens, several 'complications' brought about rather unfavorable changes,

though I grant that it was M. Zervos who wrote the foreword to the catalogue, where you and I play the principal role in the 'Abstract Art' section."[38]

The press did not say much about this alternative show, which, improvised and incomplete though it might have been, was nevertheless, retrospectively, one of the finest exhibitions of contemporary art mounted in Paris in the twentieth century. Kandinsky was chagrined to discover that "Klee was also represented because his works were available on the spot and because he is well known here."[39] He was, on the other hand, shocked at the way in which Arp had been treated.[40] He was in favor of making a protest, but definitely not in the form of an open letter like the one that appeared in the press and that he refused to sign.

KANDINSKY VERSUS THE *CAHIERS D'ART*, 1938

The break with Zervos came to a head with the postponed appearance of the *Histoire de l'art contemporain, de Cézanne à nos jours* (The History of Contemporary Art, from Cézanne to Today), which had been announced following the exhibition at the Jeu de Paume. Zervos classified Picabia, whom he scorned, and Kandinsky on the same page under the ironic title: "Au-delà du concret" ("Beyond the Concrete"). Zervos exaggerated: Kandinsky "will henceforth find poetry not only in engraved form on wood or painted on canvas, in the moon or flowers, but just as much in a cold cigarette stub lost in an ashtray, or a white button looking at you patiently, a puddle of water, or a little piece of bark dragged by the powerful jaws of an ant through thick grass, for reasons that escape us but that are extraordinarily important."[41] Of the eleven Kandinskys reproduced, two were upside down. Kandinsky shared with Albers his frustration with regard to this "thick volume with lots of reprod.[uctions] that costs 350 francs. Of course, we only got a brief look at the book, but had the impression that Picasso was, is, and will be, the beginning, continuation, and future of this new art. However, several important artists are missing. . . . People here are indignant about Zervos's book. Some of them even refuse to sell the book because they find it impossible to support such a book. . . . My wife asks me to tell you that recently Kurt Seligmann soundly boxed

72 **Cover of *XXe Siècle* 1 (March 1938)**

Zervos's ears in a large café. Of course, everyone knows about it in Paris, and many are very pleased."[42]

Thereafter, Kandinsky sent texts, cover designs, and poems to other journals such as Eugène Jolas's *Transition* and Tériade's *Verve*. He gave financial backing to Gualtieri di San Lazzaro, chief editor of Editions des Chroniques du Jour, to set up a new journal—*XXe Siècle*— to defend abstract art and "put a stop to *Cahiers d'Art*'s obsession with Picassos." This magazine, which "aim[ed] to be anything but trendy," featured artists (Kandinsky's friends) Max Bill, Alberto Magnelli, and Miró—and authors who had fallen out with Zervos, such as Pierre Guéguen and Hugnet. As he explained to Albers: "With these new publications, the *Cahiers d'Art* will sink to ever lower levels if Zervos doesn't pull his socks up. Unfortunately, he's too self-centered, by that I mean that personal relationships and material advantages of every kind play a key role with him. It has become intolerable of late."[43]

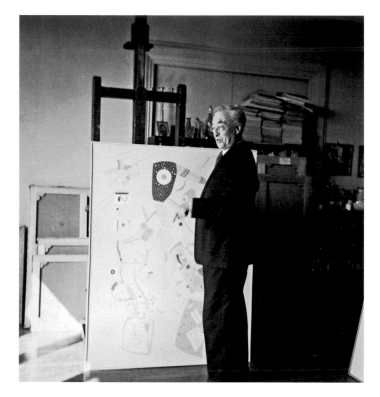

73 First page of Kandinsky's text "L'Art concret" ("Concrete Art"),
XXe Siècle 1 (March 1938), p. 9

74 Kandinsky in his studio in front of *Serenity* (*Sérénité*, 1938),
Neuilly-sur-Seine, August 1938

In Issue 1 of *XXe Siècle* (March 1, 1938, fig. 72), Kandinsky responded to Zervos with a manifesto dedicated to "L'Art concret" ("Concrete Art," fig. 73). "It will never be possible to make a painting without 'colors' and 'drawings,' but nonrepresentational painting has existed for more than twenty-five years this century. . . . I realize the enormous strength of 'habit,' and at the same time the enormous strength of what is called 'abstract' or 'nonfigurative' painting, for which I prefer the word 'concrete.' Concrete art is developing fast, especially in free countries, and the number of young artists committed to this movement is growing in those countries. The future!"[44] In 1939, he had his most recent theoretical text, "The Value of a Concrete Work," originally published in San Lazzaro's periodical, divided up into installments, since *XXe Siècle* had not been able to promote Concrete art in the manner Kandinsky had hoped.[45] These quarrels lasted until the outbreak of World War II, when *XXe Siècle*

disappeared. Two issues of *Cahiers d'Art* were distributed during the "Drôle de guerre" ("phony war").[46] Under the Occupation, only *Verve* survived the ins-and-outs of censorship. Kandinsky increasingly retreated to his studio (fig. 74).

KANDINSKY AND THE REVIVAL OF THE *CAHIERS D'ART,* 1944

In 1938, Kandinsky encountered difficulties in extending his German passport at the German consulate because he was unable to produce the papers of his paternal grandparents, who had been born in eastern Siberia, and thus were not Aryan. Through the help of Pierre Bruguière, a young judge who was an art collector and close to the circle of the Cahiers d'Art, he therefore became a French citizen. When war broke out, Kandinsky was vacationing on the French Riviera. He returned to Neuilly to put his paintings into safekeeping in

a house in the Aveyron. He equipped his cellar as the civil defence advised, and continued to paint in an empty studio.

Art dealers had left the capital. Yvonne Zervos rented premises in rue Bonaparte for her Galerie M. A. I. (Meubles, Architecture, Installation), and, to her credit, tried to shake up the artistic community with some splendid hangings. Kandinsky visited the gallery, telling Rupf on February 9, 1940: "Some time ago Mme Zervos opened a new art gallery, where she puts on some interesting exhibitions—Marc Chagall at the moment." But, as he made clear at the bottom of his letter, written by hand: "My personal relations with M. Zervos remain 'strained.' He has behaved very badly towards me. True, it's his custom to speak badly of everyone and [especially] to lie."[47] Kandinsky met Chagall at this exhibition, recounting to his old pupil Otto Nebel, on February 13, 1940: "We are going to the Champs-Elysées the day after tomorrow to have coffee with Marc Chagall and his wife."[48]

On June 11, 1940, Paris was declared an open city. German troops marched in through the Arc de Triomphe; the Kandinskys were then at Cauterets in the Pyrenees. At the end of August, they returned to Neuilly, where they shut themselves miserably away in the studio during the hard winter of 1941. On January 15, 1942, Kandinsky rather crowed when he wrote to Arp, settled in Grasse in the south: "Everything is white outside our windows and every so often great snowflakes fall slowly from the sky. Instead of the sun we have a good stove in my workroom so I can work normally and we take our meals in there, as well."[49] During his "exile" at home, he was totally absorbed in his drawings, not being able to paint due to a shortage of stretchers. He exhibited at Bucher's in July through August 1942. San Lazzaro wrote a review of this exhibition in *L'Italie nouvelle* on July 22, 1942. Kandinsky sold directly to German collectors like Helmut Beck, who visited him in Neuilly. Of the war he saw only what he noticed from his window. He described the bombing raids to Bruguière. On March 14, 1942, he wrote:

> From our windows we had a perfect view of the bombing on March 3 and were naive enough to imagine for some time that we were watching a marvelous firework display. My wife is

somewhat anxious, seeing the great number of chimneys opposite us at Pûteaux, but I am sure the English would not drop bombs on a town where dwelling houses surround on all sides and that are close to the factories of Pûteaux which are quite small, but after a great "interlude" we are again hearing the sound of the sirens, a strange, irritating music. None of that prevents my working a good deal, and I shall show you my new canvases with very great pleasure.

On April 7, 1943, he wrote in another letter:

> You have received my letter of 4.4, and so you knew already on the 5th or yesterday that the bombing spared us. In writing to you about theoretical matters, I completely forgot the event which had, for a moment, made a violent impression on us. We were just finishing lunch when we heard the noise of planes which were certainly not German—so must have been English or American. The warning siren was late when two violent explosions broke all our windows. The explosions were on the racecourse where they caused many injuries. A little later, we saw from our windows, an immense conflagration in the direction of Saint-Cloud. It was the Coti [*sic*] factory that was on fire. We were not able to hear the bombs exploding on Raynault [*sic*] we heard that they caused dreadful damage.[50]

The resumption of relations between Kandinsky and Zervos can be dated to the first bombing. During the war, Zervos spent a lot of time in Vézelay, where he put together and edited a two-volume catalogue of Picasso's paintings and drawings, meanwhile preparing an issue of *Cahiers d'Art* for when the war ended. Shortly after attending Kandinsky's funeral, he wrote on December 24, 1944, to his collaborator in New York, sculptress Mary Callery: "Here we are all still alive except Louis Marcoussis, Delaunay, and, since three days ago, Kandinsky." He returned to the subject on January 13, 1945:

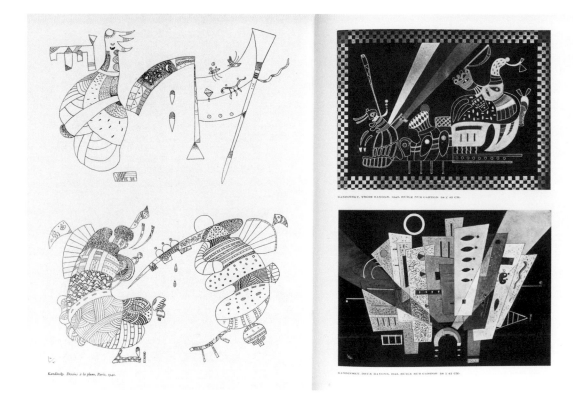

75 *Cahiers d'Art, 1940–1944* (1945), pp. 166–67. Left-hand page: two pen
drawings from Kandinsky's Sennelier-brand notebook, 1941. Right-hand page:
two paintings on board. Above right: *Three Rays* (*Trois Rayons*), September
1943; below right: *Two Rays* (*Deux Rayons*), June 1943

After a happy life of seventy-nine years [*sic*], Kandinsky died
on December 13, 1944, having been paralyzed for six months.
I say a happy life because Kandinsky had never known illness,
still less physical or moral suffering. He was a man who, in a
most bewildering way, seemed to have lived apart from daily
life. The war years and the Occupation in no way undermined
his happiness, as you'll see. One evening, the English and the
Americans carried out a terrifying raid aimed at the Renault
factories near his home. The next morning we phoned to see if
the Kandinskys were still alive. I asked him how they'd spent
the evening. "Splendidly," Kandinsky replied. How's that?
Imagine! "Yesterday evening the Germans in the camp oppo-
site our house gave us a great entertainment with . . . a superb

firework display, which lasted more than two hours. We were
on our balcony during the whole display and we didn't miss a
thing." I had to point out to him that it was a terrible air raid
and that there weren't many houses near his still standing, try-
ing to make him realize that he had been through one of the
worst bombings of Paris. And it didn't stop him painting a pic-
ture with "fireworks" as the subject. So at least, like that, he
knew nothing of life's atrocities and lived in a state of com-
plete beatitude.[51]

Cahiers d'Art, 1940–1944 was a large compendium published
in May 1945, reproducing works by painters and sculptors who had
in no way been compromised during the Occupation. Zervos used

drawings by Kandinsky from 1941 to illustrate two essays on musical aesthetics: René Leibowitz's "Introduction à la musique de douze sons" (Introduction to Twelve-tone Music) and Vladimir Jankélévich's "La fille aux cheveux de lin" (The Girl with the Flaxen Hair); then he published some plates without any commentary, four pen drawings of 1941, and twelve recent paintings on card that the painter had done between summer 1942 and March 1944 (fig. 75).

The even larger *Cahiers d'Art, 1945–1946* left the presses in November 1946. Zervos seized the opportunity for an exceptional obituary, "Wassily Kandinsky (1866–1944)":

> Kandinsky, who died at Neuilly-sur-Seine on December 13, 1944, played an important role in the evolution of contemporary aesthetics. In striking him down, death destroyed a remarkable personality, part artist, part scholar and philosopher; at the same time cutting short the flight of a mind whose imagination anticipated the future.... A few days before his illness destroyed his mental faculties, he wrote that a river never lets itself be stopped, even by locks or dams; slowed down for a moment by these, it leaps over the obstacle and pursues its course.... Until the moment when Kandinsky's hand, because of his illness, refused to guide his brush any longer, the colored matter that came out of a tube at the pressure of his finger was for him a source of endless intoxication.... And yet, having known so well the attitudes of Kandinsky's everyday soul, I am convinced that the latter was as much in touch with the little things of life as with the greater.[52]

EPILOGUE

After giving a whole wall to Kandinsky opposite Picasso during the extraordinary exhibition of contemporary art at the papal palace in Avignon in 1947 (*Exposition de peintures et sculptures contemporaines* [*Exhibition of Contemporary Paintings and Sculptures*]), Zervos and the

Cahiers d'Art promoted the rediscovery of the Kandinsky of the Blaue Reiter period, shortly after Gabriele Münter's 1957 donation of Kandinsky's work to the Städtische Galerie im Lenbachhaus, Munich. Kandinsky suddenly ceased to be a dilettante. Then, in 1959, his work's international dimension came to the fore with the long-awaited opening of the Solomon R. Guggenheim Museum in New York. Zervos commissioned Pierre Volboudt, a protégé of Nina Kandinsky, to cover the event. He himself repeated his now obsessive opposition to seeing Kandinsky's art as purely abstract in a simple "Editor's Note":

> We publish here an in-depth study of the work of Kandinsky, whose work as an artist consisted not solely of painting but of devising reasons so that his paintings came alive and were appropriate to the aspirations of his time. In what is called abstract art, Kandinsky represents reverie (whereas Mondrian represents precise facts), which enables him to dream as well. Kandinsky always knew how to compose with his nature and to give the work the sparkle of his original personality. At the same time, he knew exactly how to best preserve, of his own accord, the observation of shapes assumed by reality that made him cast aside everything that was not essential. The extreme rigor and high quality of his work are all the more appreciable today inasmuch as nonfigurative art is tending more and more toward going over into mannerism and arbitrariness.[53]

These laborious explanations bear witness to Zervos's undeniable loyalty to a creative artist who had much impressed him. *Black Forms on White* (the gift from Kandinsky to Yvonne Zervos) is one of the key works in the Musée Zervos in Vézelay. It acts as a link between Ernst's *Sauterelle* (1934, a gift from Ernst to Yvonne Zervos) and the abstract compositions of Hélion. These canvases of 1934 share a *Cahiers d'Art* familial air with the neighboring Alberto Giacomettis and Mirós, a place where Surrealists and Abstract artists are reconciled.

Acknowledgments

We owe a debt of thanks to Jessica Boissel, Emmanuelle Etchecopar, Christiane Rojouan, Isabelle Limousin, Angelika Weißbach, Yves de Fontbrune, and Adam Rzepka—our collaborators at the Bibliothèque Kandinsky, Centre Pompidou, Paris.

Notes

Unless otherwise attributed, all translations of original French or German quotations are service translations provided by the Städtische Galerie im Lenbachhaus, Munich.

1 Vasily Kandinsky to Pierre Bruguière, January 30, 1944, cited in Christian Derouet, "Notes et documents sur les dernières années du peintre Vassily Kandinsky. 25 lettres de Kandinsky à Pierre Bruguière," *Les Cahiers du musée national d'art moderne*, no. 9 (1982), p. 99.

2 Christian Zervos to Vasily Kandinsky, December 22, 1927, in Kandinsky, *Vassily Kandinsky. Correspondances avec Zervos et Kojève*, ed. Christian Derouet, Hors-Série Archives, *Les Cahiers du musée national d'art moderne*, trans. N. Ivanoff (Paris: Centre Pompidou, 1992), p. 25.

3 Christian Zervos, "Les expositions à Paris et ailleurs (Galerie Zak)," *Cahiers d'Art* 10 (1928), p. 451.

4 Will Grohmann, "Wassily Kandinsky," in *Cahiers d'Art* 7 (1929), pp. 322–29, ill. p. 325. See Hans K. Roethel and Jean K. Benjamin, *Kandinsky: Catalogue Raisonné of the Oil Paintings, Volume One, 1900–1915* (Ithaca, N.Y.: Cornell University Press, 1982), p. 450, no. 457.

5 Christian Zervos, "Les expositions. Kandinsky (Galerie de France)," *Cahiers d'Art* 2 (1930), p. 104.

6 Christian Zervos, "De l'Art abstrait," *Cahiers d'Art* 1 (1931), p. 41.

7 Vasily Kandinsky, "Réflexions sur l'art abstrait," *Cahiers d'Art* 7–8 (1931), pp. 350–53.

8 Hans Konrad Roethel, *Kandinsky: Das graphische Werk* (Cologne, Germany: DuMont Schauberg, 1970), p. 392, no. 196. Second etching for Editions Cahiers d'Art, 1932.

9 Christian Zervos to Vasily Kandinsky, November 8, 1932, in Kandinsky, *Correspondances avec Zervos et Kojève*, pp. 109–10.

10 Christian Zervos to Vasily Kandinsky, December 31, 1932, in ibid., p. 111.

11 Hans K. Roethel and Jean K. Benjamin, *Kandinsky: Catalogue Raisonné of the Oil Paintings, Volume Two, 1916–1944* (Ithaca, N.Y.: Cornell University Press, 1984), p. 788, no. 852; p. 821, no. 893; and p. 874, no. 960.

12 Nina Kandinsky, *Kandinsky und ich*, (Munich: Kindler, 1976), p. 175.

13 Christian Zervos to Vasily Kandinsky, November 20, 1933, in Kandinsky, *Correspondances avec Zervos et Kojève*, p. 129.

14 Christian Zervos to Giuseppe Ghiringhelli, May 19, 1934, Fonds Cahiers d'Art, Bibliothèque Kandinsky, Centre Pompidou, Paris.

15 Paul Westheim, document preserved in the press clippings of the Fonds Kandinsky with no indication of the source (*Pariser Tages Zeitung*), Bibliothèque Kandinsky, Centre Pompidou, Paris.

16 Christian Zervos, "Notes sur Kandinsky à propos de sa récente exposition à la Galerie des Cahiers d'Art," *Cahiers d'Art* 5–8 (1934), pp. 149–57. This essay, with a commentary, is included in Frederike Kitschen and Julia Drost, eds., *Deutsche Kunst–Französische Perspektiven 1870–1945. Quellen und Kommentare zur Kunstkritik* (Berlin: Akademie Verlag, 2007), pp. 277–86.

17 Yvonne Zervos to Vasily Kandinsky, June 13, 1934, in Kandinsky, *Correspondances avec Zervos et Kojève*, p. 129.

18 Vasily Kandinsky to Josef Albers, June 19, 1934, in Vasily Kandinsky and Josef Albers, *Kandinsky–Albers. Une correspondance des années trente. Ein Briefwechsel aus den dreißiger Jahren*, ed. Jessica Boissel (Paris: Centre Pompidou, 1998), p. 31.

19 *Les Quatre Noms. Hans Arp–Ghika–Jean Hélion–S. H. Tauber-Arp. A propos de leur exposition à la Galerie des Cahiers d'Art.*

20 Vasily Kandinsky to Josef Albers, September 6, 1934, in Kandinsky and Albers, *Kandinsky–Albers*, p. 39.

21 *Cahiers d'Art* 9–10 (1934), p. 269.

22 At the time, these two paintings were without dates, they are, however, known to have been purchased by Kandinsky in 1912.

23 Vasily Kandinsky to Josef Albers, December 15, 1934, in Kandinsky and Albers, *Kandinsky–Albers*, p. 43.

24 Vasily Kandinsky, "Kandinsky–Briefe an Hermann Rupf 1931–1943," ed. Sandor Kuthy, *Berner Kunstmitteilungen* 150/151 (May/July 1974), p. 6.

25 Vasily Kandinsky, "Réponse à l'enquête sur l'art d'aujourd'hui," *Cahiers d'Art* 1–4 (1935), pp. 53–56.

26 Ibid., p. 56.

27 Vasily Kandinsky, "Toile vide, etc.," *Cahiers d'Art* 5–6 (1935), pp. 117–19.

28 Vasily Kandinsky to Josef Albers, December 19, 1935, in Kandinsky and Albers, *Kandinsky–Albers*, p. 70.

29 Ibid., May 8, 1936, p. 75.

30 Vasily Kandinsky, "Franz Marc," *Cahiers d'Art*, 8–10 (1936), pp. 273–75. Zervos published the first part of his essay "Réflexions sur la tentative d'esthétique dirigée du IIIᵉ Reich" in the same issue, pp. 209–12.

31 Christian Zervos, "Les expositions 'Kandinsky (Galerie Jeanne Bucher)'–'Hélion (Galerie des Cahiers d'Art)'– 'Biedermann, Ferren, Gallatin, Morris, Shaw (Galerie Pierre),'" *Cahiers d'Art* 8–10 (1936), pp. 276–79.

32 Giuseppe Ghiringhelli to Vasily Kandinsky, April 16, 1937, Bibliothèque Kandinsky, Centre Pompidou, Paris, 9200–594.

33 André Dézarois to Vasily Kandinsky, Musée du Louvre, Archives des Musées nationaux, 2HH.1.

34 Vasily Kandinsky to André Dézarrois, July 15, 1937, Musée du Louvre, Archives des Musées nationaux, 2HH.1.

35 Vasily Kandinsky to Christian Zervos, June 1, 1937, in Kandinsky, *Correspondances avec Zervos et Kojève*, pp. 138–39. Fonds Kandinsky, Bibliothèque Kandinsky, Centre Pompidou, Paris, 9200–1540.

36 Vasily Kandinsky to Josef Albers, December 5, 1937, in Kandinsky and Albers, *Kandinsky–Albers*, p. 97.

37 Anonymous brochure produced for the *Origines et développement de l'art international indépendant* exhibition. See the announcement for this exhibition in *Cahiers d'Art* 1–3 (1937), p. 95, and a review of the exhibition in *Cahiers d'Art* 4–5 (1937), pp. 162–64.

38 Vasily Kandinsky to Pierre Bruguière, November 21, 1937, former Pierre Bruguière Archives.

39 Vasily Kandinsky to Josef Albers, November 18, 1937, in Kandinsky and Albers, *Kandinsky–Albers*, p. 95.

40 Arp was represented by just a single work already owned by Zervos, and no loans were requested from the artist for the exhibition.

41 Christian Zervos, "Au delà du concret," in Zervos, *Histoire de l'art contemporain, de Cézanne à nos jours* (Paris: Editions Cahiers d'Art, 1938), p. 311, plates pp. 314–20.

42 Vasily Kandinsky to Josef Albers, April 28, 1938, in Kandinsky and Albers, *Kandinsky–Albers*, p. 107.

43 Ibid., p. 106.

44 Vasily Kandinsky, "L'Art concret," *XXe Siècle* 1 (March 1, 1938), pp. 14–15.

45 Vasily Kandinsky, "La Valeur d'une oeuvre concrète" (November 1938), *XXe Siècle* 5–6 (February–March 1939), p. 48; previously unpublished drawings by Kandinsky, pp. 49, 51, 52; and woodcut in two colors, p. 53, *XXe Siècle* 1 (1940), supplement to *XXe Siècle* 5–6, p. 49.

46 The German army was expected to rush through the French border in September 1939, however, they did not arrive until May–June 1940, leading to the term "drôle de guerre."

47 Once war was declared, Kandinsky's correspondence with his German-speaking friends was written in French. Rupf Archive, Musée des Beaux-Arts, Bern.

48 Vasily Kandinsky, "Kandinsky–Briefe an Otto Nebel 1926–1940," ed. Therese Bhattacharya-Stettler, *Berner Kunstmitteilungen* 203 (January/February 1981), p. 19.

49 Vasily Kandinsky to Hans (Jean) Arp, January 15, 1942, Archives Arp, Fondation Jean Arp, Meudon, France.

50 Vasily Kandinsky to Pierre Bruguière, March 14, 1942, and April 7, 1943, cited in Derouet, "Notes et documents sur les dernières années du peintre Vassily Kandinsky," pp. 96, 97.

51 Anne-Laure Deburaux, *Mary Callery (1903–1977), sculpteur. Découverte des archives privées.* Unpublished memoir, University of Paris I, Pantheon-Sorbonne (2007), pp. 190–91.

52 Christian Zervos, "Wassily Kandinsky (1866–1944)," *Cahiers d'Art, 1945–1946* (Paris: Editions Cahiers d'Art, 1946), pp. 114–27.

53 Note signed N. D. L. R. (Note de la rédaction [Editor's Note]) and ascribed to Pierre Volboudt, "Wassily Kandinsky," in *Cahiers d'Art, 1956–1957* (Paris: Editions Cahiers d'Art, 1957), pp. 177–215.

Kandinsky's correspondence with Gualtieri di San Lazzaro is not included in the Fonds Kandinsky. Information on the relationship between the publisher of *Chroniques du Jour* and Kandinsky might be found among the papers of an intermediary, the painter Alberto Magnelli, if these papers could be accessed. For the moment, we must be content with the two essays by the Italian critic himself, published shortly after the war: *Parigi era morta* (Milan: Garzanti, 1947) and *Parigi era viva* (Milan: Garzanti, 1948). There are also comments in San Lazzaro's text *Painting in France: 1895–1949* (London: Harvill Press, 1949), especially in his chapter "At the Gates of the Absolute."

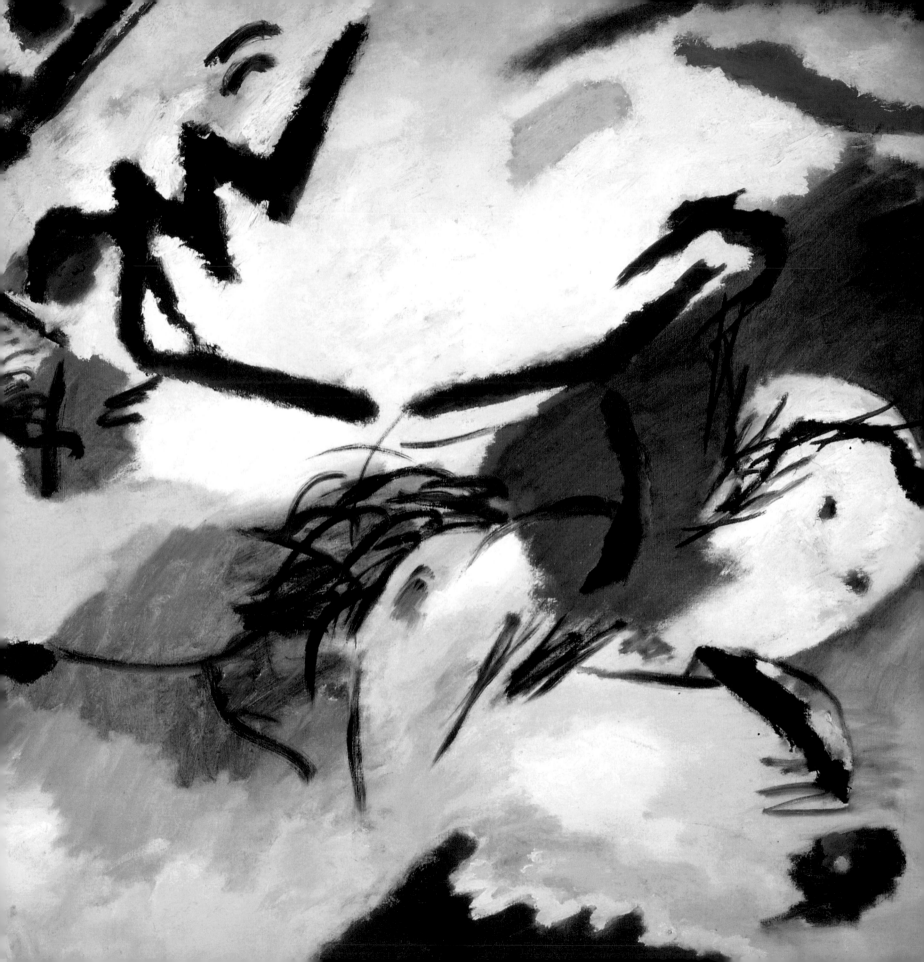

KANDINSKY AND "AMERICA IN GENERAL"

"The situation is very bad here in Germany and does not look as it it will improve. But we still have courage. The right-wingers are again trying to swallow up the Bauhaus, but without success. The last few months especially were really aggravating in this respect. But we continue to work calmly. . . . Would you advise me to hold an exhibition in New York in the near future, or in America in general?" —VASILY KANDINSKY TO HILLA REBAY[1]

TRACEY BASHKOFF

In a letter to Hilla Rebay, artist and art advisor to Solomon R. Guggenheim, Vasily Kandinsky spoke about the impact of the political climate on the Bauhaus in Dessau, Germany, in late January 1932. Later in the year, in August, the Dessau community council issued a decree to close the progressive school of integrated arts on October 1. Kandinsky, however, continued to teach there when it reopened for classes in Berlin in December. Adolf Hitler was appointed chancellor of Germany in January 1933, and the mounting anti-intellectual measures during the following months led to the final closing of the Bauhaus by a faculty vote on July 20. Within days Kandinsky painted *Gloomy Situation* (*Trübe Lage*, fig. 76), a composition of fused geometric and biomorphic forms isolated in a somber-toned haze of sprayed colors. The uncharacteristic directness of this work's title mimics the candor of Kandinsky's letters of this period, which capture a mixture of fear, frustration, optimistic determination, and practical reasoning.[2]

Kandinsky's artworks had been presented in the United States and drawn the attention of collectors, critics, artists, and the public since 1912 and especially after his inclusion in the 1913 *International Exhibition of Modern Art*, or the Armory Show, in New York.[3] His reputation in America

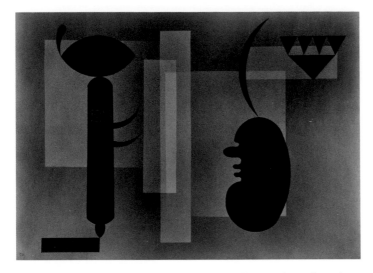

76 *Gloomy Situation (Trübe Lage)*, July 1933. Watercolor, gouache, and pencil on paper, 47.3 x 66.8 cm. Solomon R. Guggenheim Museum, New York, The Hilla Rebay Collection 71.1936

Page 108: Detail of *Improvisation 20*, April 1911 (plate 25)

of course was subject to shifts in opinion about abstraction in general as well as modern Russian and German art in particular. The individuals offering support to the artist after he left Germany included a number who shaped the course of American abstraction in the first half of the twentieth century. On October 7, 1933, Kandinsky reported to Galka Scheyer, who had been promoting his work in the United States since 1924, of Hitler's antagonistic position on modern artists, as had been expressed in the congress of the National Socialist party in Nuremberg, Germany, in September: "The Führer recently said the 'modern' artists are either swindlers (money!)—in that case they belong in prison—or overly convinced fanatics (ideal!)—in that case they belong in a mental asylum."[4] Although he was well aware of the increasingly uncomfortable situation for artists, he was reluctant to abandon faith in the German government and even advised artist Willi Baumeister to join the Kampfbund für deutsche Kultur (Combat League for German Culture), naively hoping the situation could improve from within. Nonetheless, Kandinsky and his wife Nina moved to Neuilly-sur-Seine, a suburb of Paris, in late December 1933. Writing from France in February 1934, he enumerated the reasons for leaving Germany:

After lengthy consideration I decided to move to Paris for a while. We will stay here at least a year. What will happen after that, one cannot say in view of the present unstable conditions. My situation in Germany became very uncertain because I have three full 'minuses': I am 1) not really German (am even a 'former Russian'), 2) a former Bauhaus teacher (which today, strangely enough, almost means one is a Marxist), 3) an abstract painter. I have, so to speak, three Achilles heels. Accordingly, I was attacked, or to make it plainer, I was 'given the cold shoulder.' The artist groups to which I belonged for years passed me over in their exhibitions. The museums placed my paintings in storage. The *Reichsverband*, an obligatory organization, has not yet admitted me, although I applied for admission. My contract with Dessau, according to which I am still entitled to half my salary until April 1, 1935, was violently broken. Exhibitions, even in private art galleries, became impossible for me. Therefore the art dealers also could no longer represent me energetically. In one word, I sat there with my hands tied. I left with a heavy heart, as I had lived in Germany since 1897 and had taken strong root there.[5]

Kandinsky thought the crisis in Germany would be temporary and end quickly. He reiterated his sense of connection to his adopted country to his friend, art historian Will Grohmann, shortly before leaving Berlin: "We are not leaving Germany for good—I couldn't do that; my roots are too deep in German soil."[6] Kandinsky claimed a separation between art and politics in his writing and actions, sometimes resulting in positions that appear unsympathetic to the causes of oppressed artists.[7] In summer 1935 he even went so far as to ask his nephew Alexandre Kojève, who was traveling in Germany, to approach the government and explain that "the reasons why [he had] not been in Germany for almost two years now have nothing to do with politics but only with art."[8] Although in 1937 and 1938 fourteen Kandinsky works were included in the *Entartete Kunst* (*Degenerate Art*) exhibition (fig. 77), and fifty-seven were confiscated from German museums, Kandinsky remained uninvolved in circles of artists who had left

Germany.[9] In France he did not associate with the Freie Künstlerbund (Free Artists' League), founded in September 1937, or exhibit in their 1938 *Freie deutsche Kunst* (*Free German Art*) exhibition that was organized in response to *Entartete Kunst*—although, after some hesitation, he did lend five paintings to the New Burlington Galleries in London for its 1938 response, *Exhibition of 20th Century German Art*. In addition, Kandinsky's support of the Italian Futurists—such as his sponsorship of Filippo Marinetti's 1935 Paris lecture and contact with the Fascist Galleria Il Milione in Milan—complicated his relationship with the Surrealists and other avant-garde artists working in Paris.[10]

The Nazi regime was not the first era of political conflict Kandinsky had lived and worked through.[11] His situation in Paris caused him to reflect on his past in a letter to Rebay on July 4, 1936:

I see in my 'house catalogue' that I only have one painting left, *In Gray* (*V Serom*, 1919, plate 50), from the period 1916–1920 (inclusive). That was the time of the war and the first years of the revolution which I spent in Moscow. I would not want to experience such years again.

Aside from 'moral' shocks I also experienced considerable financial shocks. Just before the revolution I was able to provide for myself financially for the rest of my life—I was not rich, but had enough in order to work without worrying, without having to think of making money. This condition lasted only a few months. Later I had to teach for 14 years, something which I did not dislike doing, but which was very disadvantageous to my own work. . . . However, I am happy that all these difficult conditions did not in the end prevent me from creating very important paintings. Self praise![12]

Kandinsky's attention to financial matters, while likely prompted by a question from Rebay concerning the availability of canvases, may also attest to the difficulties he encountered working in Paris. He felt a lack of public interest in and understanding of the abstraction he had pioneered, removed as it was from the legacy of Cubism so

championed in France. Kandinsky wrote to Rebay in March 1936 of his lack of acceptance in Paris: "I painted my first abstract painting roughly 25 years ago. After that I made some small excursions here and there but concentrated more and more on abstr.[act] form. I did not wish to rush anything nor force myself to anything. In Germany all this created much noise and slowly crossed various borders, though the least of these was the French border. Here abstr.[act] art is explained as derived from Cubism, which really is only true of Constructivism."[13]

André Dézarrois, curator of the Jeu de Paume, pointedly remarked on the artist's lack of supportive patrons in an exchange over a possible purchase for the museum in 1939: "I said last summer that I had failed in my attempt to find a patron who would donate this picture. But the kind of patron who would appreciate Kandinsky's work is rare, and I for my part do not know a single one in France."[14] Similarly, Kandinsky did not appreciate Surrealism. Although he was friends with André Breton and was attracted to the possibilities suggested by the abstract forms of Surrealist artists, he was not engaged in their methods or motivations. Thanks to his brief affiliation with the Abstraction-Création (Abstraction-Creation) group, he became friendly with Jean Arp, Hans Hartung, Jean Hélion, and Sophie Taeuber-Arp. Kandinsky also enjoyed the company of Fernand Léger, Alberto Magnelli, and Enrico Prampolini but increasingly favored working in isolation.

Even so, he was prolific in Neuilly-sur-Seine, intrepidly experimenting with mediums and style.[15] Indeed, Kandinsky wrote enthusiastically about the large scale of his early French works in April 1935: "Our life here has its rewards and we would be completely happy if financial problems were not always threatening. The main thing for me here is that I can work well. Of late I have mainly been painting rather large pictures, something which gives me much pleasure. I like the large format, but for many years had to deny myself this pleasure because the work at the Bauhaus took up too much of my time and constantly interrupted my painting."[16]

Kandinsky was granted French naturalization in 1939, before World War II began. In 1942 he abandoned large-format paintings, working on small boards due to lack of canvas. His letters frequently downplay wartime privations, as in a letter to Pierre Bruguière on

March 13,1942: "On the whole, we have no great reason to complain. We saw the bombardment on March 3 very well from our windows and were naive enough to think it was a marvellous fireworks display for quite some time. . . . All this does not stop me working hard."[17]

For Kandinsky, as an artist and theoretician, expanding his audience internationally was about promoting his works and disseminating his ideas. Though he never visited the United States, by the 1930s he was familiar with American attitudes about abstraction and his work. When Alfred Stieglitz purchased Kandinsky's *Improvisation 27 (Garden of Love II)* (*Improvisation 27 [Garten der Liebe II]*, 1912, plate 30) for $500 from the 1913 Armory Show in New York, he wrote to the artist to explain his indignation at the parochial response to the work: "I really had no moral right, nor even the money to buy your picture. I was so insenced [sic] at the stupidity of the people who visited the Exhibition, and also more than incen [sic] at the stupidity of most of those in charge of the Exhibition, in not realizing the importance of your picture that I decided to buy it. Thus I knew I might influence the people to look at the picture, which I thought of importance to themselves."[18] Kandinsky's reply showed his acceptance of the explanation and expressed his wishes that the work travel to the Chicago and Boston presentations.[19] They discussed the possibility of a solo show at Stieglitz's 291 gallery, but World War I derailed those plans.

American artist and collector Katherine Dreier also showed in the Armory Show but did not turn to abstraction until 1918. With artists Marcel Duchamp and Man Ray, she founded the Société Anonyme in 1920 as an "International Organization for the Promotion of the Study in America of the Progressive Art."[20] Having already purchased Kandinsky's work from the gallery Der Sturm in Berlin in 1920, Dreier met him at the Bauhaus in Weimar, Germany, in 1922, the first of many visits with the artist and his wife Nina (fig. 78). In 1923 Dreier arranged his first solo exhibition in New York and appointed him an honorary vice-president of the Société Anonyme, a post he held until his death. Through correspondence, Kandinsky advised Dreier on the group's exhibition program and informed her about the European art scene. Their shared interest in Theosophy and belief in the spiritual in art made them lifelong friends; Kandinsky's aesthetics also had a great impact on her paintings. In Dreier's numerous lectures and texts, she echoed his sentiments about the evils of American materialism. In his February 1927 letter to her from the Dessau Bauhaus, he wrote: "It is truly extraordinarily sad that the Americans have so little interest in new (and especially, apparently, abstract) art. They will buy our pictures later, once we are all dead and our pictures command tens of thousands. And it is very nice to see how despite all the difficulties you never lose your courage and your incredible energy, but keep working and never shy

77 Kandinsky's works in *Entartete Kunst* (*Degenerate Art*), Hofgarten-Arkaden, Munich, 1937; right: Installation view: *Entartete Kunst*

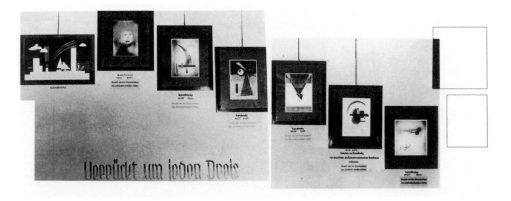
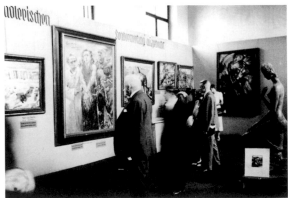

from any kind of work. . . . Hopefully your countrymen will one day learn to appreciate your merits."[21]

Dreier's last trip to Europe in 1937 included a visit with Kandinsky in Paris. Her plans to publish his *Punkt und Linie zu Fläche. Beitrag zur Analyse der malerischen Elemente* (1926) in English were eventually realized by Rebay, to whom she sold the rights, and Howard Dearstyne as *Point and Line to Plane: A Contribution to the Analysis of Pictorial Elements* in 1947.[22]

Another conduit to the United States began when Scheyer left Germany for New York, arriving in May 1924. Having befriended first Alexei Jawlensky, then, at the Weimar Bauhaus, Lyonel Feininger, Kandinsky, and Paul Klee, Scheyer dedicated herself to promoting their artworks in Europe and abroad.[23] In 1923, at painter Rajah von Rubio's invitation, Scheyer planned a trip to America, writing to Jawlensky in September: "I'll organize an exhibition of your work over there, and perhaps I'll be able to send you some dollars so you don't have to keep running to the bank."[24] Feininger, Jawlensky, Kandinsky, and Klee were enthusiastic about her proposal to represent them as a group, and Kandinsky wrote in January 1924, "Concerning our small group of friends, we—Feininger, Klee, and I—have spoken and suggest to you the name 'The Four,' i.e. 4 friends or 4 comrades—one can interpret it as one likes. But on the whole, it is characteristic and modest. And Feininger said that '4' is good for America. All 4 of us are very different, which I find to be especially advantageous."[25]

In March, Scheyer met with Feininger, Kandinsky, and Klee at the Bauhaus, and the name was altered to the Blue Four. A formal agreement was signed, joining these three artists and Jawlensky as "the free group of the blue Four" and granting Scheyer the right to act on their behalf, "for the dissemination of their artistic ideas abroad, especially through lectures and exhibitions." A financial agreement concerning the sale of work was also part of the contract.[26]

After the initial exhibition of the Blue Four, which was held at the Daniel Gallery in New York in February 1925, Scheyer decided to pursue exhibition and lecture opportunities in California. With the support of William Clapp at Oakland Art Gallery, Arthur B. Clark at Stanford University, and gallerist Paul Elder, and others, she made significant inroads in advancing modern art on the West Coast. For five years she traveled extensively, including time spent back in Germany (fig. 79). Encountering Germany's altered political climate in 1932, Scheyer acquired two hundred fifty works by the Blue Four and settled in Los Angeles in 1933. She proposed solo exhibitions in 1934 "since the museums don't have money to pay for my travel expenses and lecture fees nowadays."[27] Kandinsky accepted her decision, and his reply indicates his awareness of the pressures of the day: "The very idea to *also* show our works as *individual* collections appeals very much to me. Nowadays one is forced to have many irons in the fire."[28] The financial hardships of 1930s America made sales difficult, though she continued to sell works into the 1940s. In fall 1944, not long before Kandinsky died, the last Blue Four exhibition in Scheyer's lifetime took place at Curt Valentin's Buchholz Gallery in New York.

Born in Alsace, Germany, Baroness Hildegard Rebay von Ehrenwiesen entered the circle of artists at Der Sturm in Berlin in 1916. When she arrived in New York in January 1927, she expected America to have modern tastes. Disappointed, she noted in letters to artist Rudolf Bauer: "America has no style. I am too modern for this country. . . . In this country no cocks crow for non-objective art."[29] She also sensed a bias against German immigrants, advising him to change his name if he came to New York for "people with German names have *no* success here!!"[30] Rebay soon exhibited her collages in New York and came to the attention of Irene Guggenheim, Solomon's wife and initially the art collector in the family.

Rebay was hired to paint Solomon's portrait, and during his sittings at her Carnegie Hall studio in 1928, she promoted the art and artists she had associated with at Der Sturm. By 1929 she was guiding his purchases, which came to include, among others, works by Bauer, Marc Chagall, Robert Delaunay, Albert Gleizes, Kandinsky, Léger, and László Moholy-Nagy—most of which were secured during trips to Paris or through her connections in the European art world.

Rebay was acutely aware of the likely public reaction to the distinctly modern and experimental direction of Guggenheim's collection. She warned Bauer, who influenced the selections and secured many of the works, "Guggenheim will be attacked for his new collection, so it

78 **Katherine Dreier during her visit to Germany, 1924**

must be first quality."[31] In 1930 Rebay traveled with the Guggenheims to Europe to meet artists, purchase new works, and demonstrate that nonobjective painting had more acceptance there. Their tour included a visit with Kandinsky at the Dessau Bauhaus (fig. 80), which resulted in the purchase of *Composition 8* (*Komposition 8*, 1923, plate 63), among the first of the more than one hundred fifty works by the artist now in the collection of the Solomon R. Guggenheim Foundation. Beginning in late 1930 to early 1931, Guggenheim's collection was installed in his suite at the Plaza Hotel (fig. 81). Rebay continued to make purchases for him, such as two Kandinsky canvases from his 1932 exhibition at the Valentine Gallery in New York, but as the 1930s wore on, even Guggenheim stopped buying for a period.[32]

In addition to securing new works, Rebay focused on exhibitions, writing, and lecturing on nonobjective painting. Large-scale shows of the Guggenheim collection took place at the Gibbes Memorial Art Gallery in Charleston, South Carolina, in 1936 and 1938, the Philadelphia Art Alliance in 1937, and the Baltimore Museum of Art in 1939. Kandinsky was in favor of these presentations and catalogues and felt they were "strong propaganda" for

nonobjective art, rivaling the efforts of the Surrealists.[33] At this time Rebay began to quietly discuss plans for a museum in New York. Kandinsky, writing from Neuilly-sur-Seine, was moved by the prospect: "I do not need to tell you how interested I am in the plans for the museum. Do you and Mr. G[uggenheim] intend to show the collection in N.Y. (that is, to the greater public) as it looks today, or do you wish to wait until the museum is a reality? The latter would produce a handsome 'explosion!'"[34]

Kandinsky also offered opinions on who else might belong in the collection and suggested that the tiled music room he had designed for the Bauhaus might be built into the new museum (fig. 23).[35] In 1937 the Solomon R. Guggenheim Foundation was created. Under Rebay's direction the collection rapidly grew in size and widened in scope to fill in underdeveloped areas.[36]

By 1938 paintings that had been removed from German museums in the purges of so-called degenerate art became available to Americans. Sales to Germans were forbidden (but often occurred), and many works were sold abroad for foreign currency. Valentin tried to contact Rebay in Paris and wrote in September 1938 that "the German Government wants to sell most of the modern pictures belonging to German museums.... I thought you might be interested in some of the pictures by Klee, Kandinsky, and Franz Marc."[37] Rebay also learned of available works through artist Otto Nebel, who facilitated their purchase through the gallery Gutekunst und Klipstein in Bern in spring 1939.[38] Bauer continued to be an important source of paintings for Rebay until, financed by Guggenheim, he immigrated to the United States that same year. During this period, Guggenheim's aim to support innovative trends in painting became inseparable from his desire to rescue works from Europe. Artist Hans Richter wrote of Guggenheim's efforts after meeting him in 1939: "To evacuate from endangered Europe works from all important periods, especially those of the last generation, that are so important for the future; to bring them to America and plant the 'Seed of culture' directly into America's soil.... That is a great thought.... This man is making *history*."[39]

Letters between Kandinsky and Rebay or the Guggenheims ceased around 1938, primarily due to tension over Bauer's role.[40]

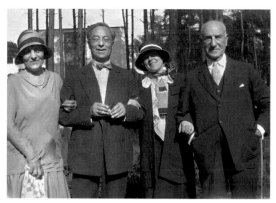

79 Galka Scheyer and Vasily Kandinsky, Berlin, 1933

80 Irene Guggenheim, Kandinsky, Hilla Rebay, and Solomon R. Guggenheim, Dessau, Germany, 1930

81 The Guggenheims' suite with paintings by Rudolf Bauer at the Plaza Hotel, New York, ca. 1937

Kandinsky's final letter, addressed to Solomon, is from April 18, 1938. In it, he extended his best wishes for the foundation's future and remarked on the public's resistance to the innovative: "It is incredible how slowly people adjust to something new. They always start with a sharp rejection (God, what insults one had to take during the first years), then they gradually begin to prick up their ears, and eventually (it will still take some time) there is understanding. This growing understanding will smooth the path for your Foundation."[41]

The Museum of Non-Objective Painting opened in June 1939 with *Art of Tomorrow*, an inaugural exhibition of Guggenheim's collection of nonobjective paintings. Half the works on view, 215 paintings, were by Bauer, and Rebay's catalogue essay "The Power of Spiritual Rhythm" extolled his canvases as the epitome of nonobjectivity. Kandinsky was represented by 104 paintings. The reviews varied in their praise of Rebay and Guggenheim's mission. The *New York Times* reported, "At first glance non-objective art bears a notable resemblance to some of the more painstaking doodles commonly found in a public telephone booth. The typical non-objective canvas is decorated with forms which resemble spheres, triangles, squares, and other familiar geometric patterns. Mme Rebay explained, however, that while the non-objective painting might appear as meaningless as a doodle, it was somehow endowed with a 'spiritual message,' which could be interpreted only by those with 'cosmic vision.'"[42] Kandinsky's work was

highlighted by Bauer's in Emily Genauer's review for the *New York World Telegram*: "Kandinsky's are complex, full of action, invested with a subtle, sensitively balanced counterpoint, variations in tone, shape, and texture, which are endlessly fascinating. They're like fireworks at the Fair or a sun-spangled fountain, or a passage of music, or a particularly brilliant length of fabric. Some of the Bauers have the same quality of excitement, though most are completely sterile, antiseptic creations with something of the appearance and about the same degrees of excitement as the bubble design on a package of Wonderbread, or a view through a child's kaleidoscope."[43]

While the 1930s brought growing institutional support for abstraction in the United States, with such exhibitions as the Museum of Modern Art's *Cubism and Abstract Art* (1936) and *Fantastic Art, Dada, and Surrealism* (1936–37), Rebay's emphasis on the connection between spirituality and nonobjectivity was often a source of confusion and criticism. The American Abstract Artists (AAA), founded in 1936 to promote abstract and nonobjective works, openly protested Rebay's narrow interpretation in a 1937 letter to *Art Front*:

[W]e cannot accept with approbation the opinions which Baroness Rebay seems to have that abstract art has 'no meaning,' that it is the 'prophet of spiritual life,' something 'unearthly'; that abstractions are 'worlds of their own'

82 **Karl Nierendorf in his gallery, New York, 1937**

achieved as their creators 'turn away from contemplation of the earth.' The meaning implied in these phrases is that abstract artists preclude from their works, and lives too (for after all, an artist must live some super-worldly existence in order to create super-worldly works of art), worldly realities, and devote themselves to making spiritual squares, and 'triangles, perhaps, less spiritual,' which will exalt certain few souls who have managed, or can afford, to put aside 'materialism.'[44]

AAA questioned Rebay's view but accepted Kandinsky's and Bauer's works, which inspired many American artists.[45] Still, the painters in this group were subject to criticism that found their work too derivative of European sources. In a review of AAA's 1938 exhibition, Jerome Klein wrote in the *New York Post*: "These are the artists who are above imitating nature. But too many of them are not above imitating other artists in the most slavish manner."[46]

When Kandinsky settled in France in 1934, he wrote to Rebay that he "just moved to a new apartment in Neuilly and that when considering moving had thought for a few months of going to America, but then decided against it, as it would have been too expensive a pleasure. Maybe another time!"[47] In 1931 he had been asked to teach at the Art Students League in New York and in 1935 invited to be an artist-in-residence at Black Mountain College in North Carolina.[48]

Kandinsky turned down both offers. In June 1940 the Emergency Rescue Committee (ERC) was established in New York. In August of that year, Varian Fry was sent by the ERC to the south of France with a list of artists furnished by Museum of Modern Art director Alfred Barr, Jr.[49] Fry wrote to Kandinsky: "Mr. Alfred Barr is very interested in you as I have tried to tell you a number of times. The crossing to New York for you and Mrs. Kandinsky and all the expenses of the voyage will be guaranteed by him. . . . All you have to do is come to Marseille as quickly as possible and take care of the formalities for your departure. Mr. Barr would particularly like you to take all your canvases with you, especially your earlier works."[50] Kandinsky, however, did not leave France.

Approximately 700 artists and 380 architects emigrated to the United States between 1933 and 1944.[51] The European influx made it more difficult for critics to dismiss abstract art. As the United States' entrance to the war approached, the opportunities for German artists diminished. From her earliest days in New York, Rebay had sensed that some resistance to the art she promoted was based on nationalist preferences: "*Mrs. G.*[uggenheim]'s friends are working against me and they say this isn't art, it won't last, it is geometry, it is worthless and comes from hateful tasteless Germany."[52] Modern French art, from the Armory Show forward, was preferred. Kandinsky first came to the attention of the American public as a Russian artist, in one mention as "Wassilli Kaudansky, the Russian artist who has caused a sensation in art circles," and his radical abstraction was seen as linked to anarchist politics.[53] In the 1920s, Dreier may have enjoyed this association in her lectures, such as "Revolution in Art" delivered in 1921 at the socialist League for Industrial Democracy. In the 1925 preface of the catalogue for the first Blue Four exhibition in New York, Charles Daniel of Daniel Gallery wrote that she "hopes that through [the exhibition] may come an exchange of spirit between the artists of the two continents."[54] By 1931, Barr included Kandinsky in his study on *German Painting and Sculpture* and in the 1938 *Bauhaus: 1919–1928* exhibition. When Guggenheim bought *Improvisation 28 (Second Version)* (*Improvisation 28* [*zweite Fassung*], 1912, plate 32) from the Museum Folkwang, Essen, Germany, for 9,000 reichsmarks, the museum's director, Klaus von Baudissin, announced in the press:

"The high price attained could benefit a type of art for which we really care. . . . A decent photograph is quite sufficient as a souvenir of this attempt to Russianize German art."[55] To promote the art that had put his Berlin gallery in peril, in 1937 Karl Nierendorf established a gallery in New York, whose purpose was announced in the February 1937 Art News (fig. 82). The gallery "[promised] to make America more familiar with the great figures in experimental Germany."[56] Kandinsky's work was shown by Nierendorf until the war and after, such as in his 1945 exhibition Forbidden Art in the Third Reich.

Kandinsky's death on December 13, 1944, was announced in an obituary in the New York Times, which highlighted his tribulations in wartime Paris: "His love for his work was demonstrated in Paris three years ago, under Nazi occupation, when he continued to paint although he had to wear gloves, a hat, and an overcoat because of the lack of heat due to the rigor of war."[57]

Kandinsky had written to Rebay about his desire for a retrospective in the United States, hoping also that it would help the cause of nonobjective artists: "If my anniversary [sixtieth birthday] would be utilized and an imposing exhibit would be held, which would be followed by a large exhibition of Bauer's work, our art would receive the proper light."[58] Although Nierendorf had helped organize a retrospective in 1937 for the Cleveland Museum of Art, Rebay saw it as her duty to put on a major showing at the Museum of Non-Objective Painting after Kandinsky had died. Drawn from several American collections, including the Art Institute of Chicago, Museum of Modern Art, Nierendorf Gallery, Société Anonyme, Solomon R. Guggenheim Foundation, and Yale University Art Gallery, as well as from Walter Arensberg, Dreier, Katherine Kuh, Duncan Phillips, and Rebay herself, the presentation filled three floors of the museum. Rebay published two catalogues, In Memory of Wassily Kandinsky: The Solomon R. Guggenheim Foundation Presents a Survey of the Artist's Paintings and Writings and Kandinsky, as well as a substantial brochure entitled Wassily Kandinsky 1866–1944. The critic for the New York Sun wrote:

The Wassily Kandinsky memorial exhibition is pre-eminently one of the things to be seen. Housed in the galleries of the Solomon

83 Installation view: *Kandinsky Memorial Exhibition*, Museum of Non-Objective Painting, New York, March 15–June 3, 1945

Guggenheim Museum of Non-Objective Art, 24 East 54th Street, it presents 227 paintings by the master who is credited with being the first artist to eliminate objects from his paintings. If only those American modernists who have profited by his example attend it should prove an impressive tribute. From the moment you enter the galleries you are under the master's spell. You don't know why and, if you are wise, perhaps you don't care. Perhaps some unsuspected depths have stirred some more profound understanding than accompanies our conscious thinking. Music from some hidden source follows you on your round of the galleries and furnishes an appropriate and perhaps only fitting accompaniment for art of this sort. And you are vaguely satisfied and thrilled as you pass before the array of canvases, brilliant or somber in color, according to the mood, and apparently limitless in invention. And, in spite of those who can find nothing in non-objective art, you realize that these are things you could live with and would be glad to, if they were only small enough to admit of their being hung on your modest apartment-house walls.[59]

Notes

Unless otherwise attributed, all translations of original French or German quotations are based on service translations provided by the Städtische Galerie im Lenbachhaus, Munich.

1 Vasily Kandinsky to Hilla Rebay, January 30, 1932, quoted in Joan M. Lukach, *Hilla Rebay: In Search of the Spirit in Art* (New York: George Braziller, 1983), p. 114.

2 Kandinsky denied the political interpretations of *Improvisation 30 (Cannons)* (*Improvisation 30 [Kanonen]*, 1913), claiming: "The presence of the cannons in the picture could probably be explained by the constant war talk that had been going on throughout the year. But I did not intend to give a representation of war; to do so would have required different pictorial means; besides, such tasks do not interest me—at least not just now." Vasily Kandinsky to Arthur Jerome Eddy, in Eddy, *Cubists and Post-Impressionism*, rev. ed. (1914; repr., Chicago: A. C. McClurg, 1919), pp. 125–26, as quoted in Gail Levin, "Kandinsky's Debut in America," in Levin and Marianne Lorenz, eds., *Theme and Improvisation: Kandinsky and the American Avant-garde, 1912–1950*, exh. cat., Dayton Art Institute, Ohio (Boston: Little, Brown, 1992), p. 15.

3 "Kandinsky's Debut in America" details the introduction and impact of Kandinsky's art in the United States. Before his controversial first major presentation in the 1913 *International Exhibition of Modern Art*, or the Armory Show, Kandinsky was included in an exhibition organized by Martin Birnbaum for the New York offices of the Berlin Photographic Company in December 1912. The presentation then traveled to the Albright Art Gallery in Buffalo, N.Y.; the City Art Museum in St. Louis, Mo.; the Carnegie Institute in Pittsburgh, Pa.; and other museums around the United States. Ibid., pp. 10–11.

4 Vasily Kandinsky to Galka Scheyer, October 7, 1933, by permission of Peg Weiss, in Stephanie Barron, ed., *"Degenerate Art": The Fate of the Avant-Garde in Nazi Germany*, exh. cat. (Los Angeles: Los Angeles County Museum of Art; New York: Harry N. Abrams, 1991), p. 263.

5 Vasily Kandinsky to Hilla Rebay, February 1, 1934, quoted in Lukach, *Hilla Rebay*, p. 115. Kandinsky uses similar wording in the earlier letter to Galka Scheyer on October 7, 1933: "In Germany my position is especially bad, because I have three qualities, of which each one alone is bad: 1) former Russian, 2) abstractionist, 3) former Bauhaus instructor until the last day of its existence." By permission of Peg Weiss, in Barron, *"Degenerate Art*," p. 263.

6 Vasily Kandinsky to Will Grohmann, December 4, 1933, in Grohmann, *Wassily Kandinsky: Life and Work*, trans. Norbert Guterman (New York: Harry N. Abrams, 1958), p. 221.

7 A discussion of the political implications of Kandinsky's denial of the intertwining of art and politics can be found in *Kandinsky in Paris: 1934–1944*, exh. cat. (New York: Solomon R. Guggenheim Foundation, 1985) and Keith Holz, "Scenes from Exile in Western Europe: The Politics of Individual and Collective Endeavor among German Artists," in Barron, *Exiles + Emigrés: The Flight of European Artists from Hitler*, exh. cat. (Los Angeles: Los Angeles County Museum of Art; New York: Harry N. Abrams, 1997), pp. 43–56.

8 Vasily Kandinsky to Alexandre Kojève, undated, quoted in *Kandinsky in Paris*, p. 20.

9 Barron, *"Degenerate Art*," p. 263 According to figures in Barron, *Exiles + Emigrés*, p. 391, twelve thousand prints and five thousand paintings and sculptures were removed from 101 German museums. Two million people saw the *Entartete Kunst (Degenerate Art)* exhibition in Munich, which then traveled to Berlin, Leipzig, Düsseldorf, and Frankfurt, among other German cities. Barron's excellent exhibition catalogues thoroughly document the exhibitions, related events, and aftermath.

10 Barbara Copeland Buenger, "Wassily Kandinsky in Paris, 1933–44," in Barron, *Exiles + Emigrés*, p. 70. Kandinsky's sympathies for Fascist Italy at this early stage of the conflict appear to be guided by his interest in the Italian government's sanctioning of new art: "Of course it is a matter of great regret to us, as 'modern' artists, that the new [German] government misunderstands the new art. In Italy it's all quite different. There the new architecture and the new art [Futurism] are recognized as Fascist art." Vasily Kandinsky to Werner Drewes, April 10, 1933, quoted in Peter Hahn, "Bauhaus and Exile: Bauhaus Architects and Designers between the Old World and New," in Barron, *Exiles + Emigrés*, p. 213.

11 Christian Derouet reviews the "continual state of cold-war or full-scale involvement in war" throughout Kandinsky's life, including the Russo-Japanese war, the Russian Revolution in 1905, World War I, the Russian Revolution and Civil War from 1917 to 1921, and the many associated hardships in "On War in General and Vasily Kandinsky in Particular," in Bengt Lärkner, Peter Vergo, et al., *Nya perspektiv på Kandinsky/New Perspectives on Kandinsky* (Malmö, Sweden: Malmö Konsthall/Sydsvenska Dagbladet, 1990), pp. 133–52.

12 Vasily Kandinsky to Hilla Rebay, July 4, 1936, quoted in Lukach, *Hilla Rebay*, p. 116.

13 Vasily Kandinsky to Hilla Rebay, March 30, 1936, quoted in ibid., p. 102.

14 André Dézarrois to Vasily Kandinsky, February 28, 1939, quoted in Derouet, "On War in General," p. 151. Derouet recounts the fascinating story of the disagreement over the selling price for *Composition IX* (1936, plate 82) and its entanglement with the assignment of Kandinsky's French naturalization.

15 In his seventies, while lacking the companionship of the Bauhaus and laboring under the limitation of war, Kandinsky was still very prolific, producing during this period just less than half the number of works done while at the Bauhaus. See Buenger, "Wassily Kandinsky in Paris," p. 68.

16 Vasily Kandinsky to Hilla Rebay, April 1, 1935, quoted in Lukach, *Hilla Rebay*, p. 116.

17 Vasily Kandinsky to Pierre Bruguière, March 13, 1942, quoted in Derouet, "On War in General," p. 139. New research has shown that this letter is from March 14, 1942. It is interesting to note that American obituaries for Kandinsky following his death on December 13, 1944, mention the suffering the artist endured during the war.

18 Alfred Stieglitz to Vasily Kandinsky, May 26, 1913, quoted in Levin, "Kandinsky's Debut in America," p. 12.

19 Ibid., p. 13.

20 Katherine S. Dreier and Marcel Duchamp, *Collection of the Société Anonyme: Museum of Modern Art 1920* (New Haven: Yale University Art Gallery, 1950), quoted in Levin, "Kandinsky and the First American Avant-Garde," in Levin and Lorenz, *Theme and Improvisation*, p. 29.

21 Vasily Kandinsky to Katherine Dreier, February 29, 1927, quoted in Jennifer R. Gross, "Believe Me, Faithfully Yours," in *The Société Anonyme: Modernism for America*, ed. Gross, exh. cat. (New Haven: Yale University Press in association with Yale University Art Gallery, 2006), p. 130.

22 Rebay greatly admired the elder Dreier; some of their correspondence, including their complicated collaborative efforts on Kandinsky's behalf, is published in Lukach, *Hilla Rebay*, pp. 226–33.

23 A vivid and thorough summation of Scheyer's life and work accompanies the catalogue by Vivian Endicott Barnett, "Galka Scheyer: The Transformation from E. E. S. to G. E. S.," in Barnett, *The Blue Four Collection at the Norton Simon Museum* (New Haven: Yale University Press in association with the Norton Simon Art Foundation, 2002), pp. 11–21.

24 Galka Scheyer to Alexei Jawlensky, September 5, 1923, quoted in ibid., p. 12.

25 Vasily Kandinsky to Galka Scheyer, January 17, 1924, quoted in ibid., p. 13. Lyonel Feininger, the American in the group, proposed that the word "four" would be familiar to Americans due to the Big Four Railroad, in operation at the time.

26 Ibid., p. 14. The artists received 50 percent, Scheyer received 30 percent, with the remaining 20 percent going to a fund for reimbursing Scheyer's expenses.

27 Galka Scheyer to Vasily Kandinsky, October 26, 1934, quoted in ibid., p. 17.

28 Vasily Kandinsky to Galka Scheyer, November 17, 1934, quoted in ibid., p. 17. Kandinsky's emphasis.

29 Hilla Rebay to Rudolf Bauer, January 28, 1927, and July 1927, quoted in Lukach, *Hilla Rebay*, p. 44.

30 Hilla Rebay to Rudolf Bauer, quoted in ibid., p. 46. Rebay's emphasis.

31 Hilla Rebay to Rudolf Bauer, December 16, 1929, quoted in ibid., p. 60.

32 Ibid., p. 81.

33 Vasily Kandinsky to Hilla Rebay, February 10, 1936, quoted in Lorenz, "Kandinsky and American Abstraction: New York and Europe in the 1930s and 1940s," in Levin and Lorenz, *Theme and Improvisation*, p. 175.

34 Vasily Kandinsky to Hilla Rebay, October 16, 1936, quoted in Lukach, *Hilla Rebay*, p. 104.

35 Vasily Kandinsky to Hilla Rebay, December 16, 1936, ibid., p. 105.

36 "Where can one get a Futurist picture? A Severini or a Balla? This is missing from the collection." Hilla Rebay to Rudolf Bauer, 1938, ibid., p. 105.

37 Curt Valentin to Hilla Rebay, September 19, 1938, quoted in Vivian Endicott Barnett, "Banned German Art: Reception and Institutional Support of Modern German Art in the United States, 1933–45," in Barron, *Exiles + Emigrés*, p. 276.

38 Ibid, p. 276. The entire letter from Otto Nebel, August 19, 1938, is reproduced in Lukach, *Hilla Rebay*, pp. 121–22.

39 Hans Richter to Hilla Rebay, July 20, 1939, quoted in Lukach, *Hilla Rebay*, p. 122. Richter's emphasis.

40 Vivian Endicott Barnett, "Rereading the Correspondence: Rebay and Kandinsky," in *Art of Tomorrow: Hilla Rebay and Solomon R. Guggenheim*, exh. cat. (New York: Solomon R. Guggenheim Museum, 2005), pp. 86–100. Lukach reports that Rebay wrote to Kandinsky within weeks of the liberation of Paris, but Kandinsky died before the letter reached him. Lukach, *Hilla Rebay*, p. 117.

41 Vasily Kandinsky to Solomon R. Guggenheim, April 18, 1938, quoted in ibid., p. 117.

42 "Exhibition is opened of Guggenheim Art, Paintings Shown in Special Building," *New York Times*, June 1, 1939.

43 Emily Genauer, "Art of Tomorrow in Colorful Design," *New York World Telegram*, June 3, 1939.

44 Hananiah Harari, Jan Matulka, Emanuel Herzl, Byron Browne, Leo Lances, Rosalind Bengelsdorf, and George McNeil, letter to the editor, *Art Front* 3, no. 7 (October 1937), pp. 20–21.

45 Levin and Lorenz document the many American artists who found inspiration from Kandinsky's work and writing in Levin and Lorenz, *Theme and Improvisation*.

46 "However sincere their pretensions, they are certainly not substantiated by the bulk of this work, which is generally shallow in design, rarely more than superficial decoration." Jerome Klein, quoted in Sandra Kraskin, *Pioneers of Abstract Art: American Abstract Artists, 1936–1996*, exh. cat. (New York: Sidney Mishkin Gallery, Baruch College, City University of New York, 1996), p. 9.

47 German manuscript in the Hilla von Rebay Foundation Archive, M0007, Solomon R. Guggenheim Museum Archives, New York.

48 Lorenz, "Kandinsky and American Abstraction," p. 173.

49 Elizabeth Kess, "Moral Triage or Cultural Salvage? The Agendas of Varian Fry and the Emergency Rescue Committee," in Barron, *Exiles + Emigrés*, pp. 99–112.

50 Varian Fry to Vasily Kandinsky, May 7, 1941, quoted in Derouet, "On War in General," p. 141.

51 Cynthia Jaffee McCabe, "A Century of Artist-Immigrants," in *The Golden Door: Artist-Immigrants of America, 1876–1976*, exh. cat. (Washington, D.C.: Hirshhorn Museum and Sculpture Garden, 1976), p. 31, as cited in Kraskin, *Pioneers of Abstract Art*, p. 18.

52 Hilla Rebay to Rudolf Bauer, December 25, 1929, quoted in Lukach, *Hilla Rebay*, p. 59. Rebay's emphasis.

53 See the thorough discussion of the connection as seen in contemporary press in Levin and Lorenz, *Theme and Improvisation*, pp. 11–12.

54 Barnett, *The Blue Four Collection*, p. 14.

55 Klaus von Baudissin, "Das Essener Folkwangmuseum stösst einen Fremdkörper ab," *National-Zeitung* (Essen, Germany), August 18, 1936, quoted in Andreas Hünecke, "On the Trail of Missing Masterpieces: Modern Art from German Galleries," in Barron, *"Degenerate Art,"* p. 122.

56 Barnett, "Banned German Art," p. 275 n. 37.

57 "Kandinsky, Leader in Modern Art, 78," *New York Times*, December 19, 1944, p. 21.

58 Vasily Kandinsky to Hilla Rebay, April 21, 1936. Hilla von Rebay Foundation Archive, M0007, Solomon R. Guggenheim Museum Archives, New York.

59 Melville Upton, "Kandinsky in Retrospect," *New York Sun*, March 24, 1945, scrapbook 6, Solomon R. Guggenheim Foundation records, A0033, Solomon R. Guggenheim Museum Archives, New York.

KANDINSKY'S MATERIALS AND TECHNIQUES: A PRELIMINARY STUDY OF FIVE PAINTINGS

GILLIAN MCMILLAN AND VANESSA KOWALSKI

A pioneer of Western abstract art, Vasily Kandinsky was intensely interested in the relationship between the visual arts and music and the expression of his "inner necessity," which he talks about many times in his extensive writings.[1] He conveyed his complex theories through paintings, drawings, writings, theatrical works, and teaching. Much research has focused on the themes and meanings in Kandinsky's oeuvre, though less attention has centered on the techniques he used to achieve his revolutionary work.[2] Conservators, art historians, and scientists use photographic and scientific techniques to gain insight into artworks as physical, composite objects as well as vehicles for artistic expression. In 2007 the Conservation Department at the Solomon R. Guggenheim Museum commenced a study to launch an exploration of Kandinsky's methods and materials. A small group of paintings were chosen from the Guggenheim Museum's collection of more than one hundred fifty works by Kandinsky, of which sixty-four are easel paintings. One goal of this project was to gain a deeper understanding of this complex artist that will allow us to develop well-informed future treatment plans for the Guggenheim Museum's works. This essay explains the most interesting aspects of five paintings, representing a range of dates and techniques.

Kandinsky's choices of materials changed with his painting style over the course of his career. Some examples of the diverse supports he used are canvas board, paper, colored paper, paper board, stretched canvas, glass, wood, plywood, and hardboard.[3] We found various canvas-weave patterns, though all the fibers we observed were linen.[4] The artist painted in oils, watercolors, gouache, and tempera.[5] He drew with pencil, drypoint, and inks, but the ways in

84 *Blue Mountain (Der blaue Berg)*, 1908–09 (plate 5)

85 **X-radiograph of** *Blue Mountain*

Page 120: Detail of *Light Picture (Helles Bild)*, 1913 (plate 38)

McMILLAN AND KOWALSKI

which he may have mixed, modified, or added to these basic materials remain a source of ambiguity.[6]

Kandinsky produced thousands of works, making it difficult to generalize to a great extent about his methods. Still, one can chart a hasty course through his career and, with a focused examination of some of his masterworks, surmise a sense of his technical development. Many of his paintings in Munich from around 1900 contain what seems to be gouache and tempera paint on black, gray, and other colored paper. The paint is opaque body color and appears very dry on matte paper or board. The visual effect is like that of his colored wood-cuts, with bright figurative forms on dark backgrounds. Kandinsky used this technique through approximately 1907. Other early works produced between about 1900 and 1909 are mostly small, brightly colored landscapes on compressed fiberboard or canvas board, some with and some without grounds. Those without grounds sometimes incorporated the color of the board into the compositions. He probably used these small, portable supports because he traveled widely during that

time and often painted out of doors. Relatively simple in construction and painted in a very direct technique, these works usually have texture, sometimes quite high impasto, and the paint appears to have been applied with a spatula as well as a brush. Later works on board from this period are less textured, and the paint is frequently thinner and usually put on using a brush.

When Kandinsky settled in Munich and began visiting nearby Murnau, Germany, to paint landscapes in 1908, he began to make breakthroughs in his theories. He also started painting larger, far more complex pictures, usually on canvas and, at that time, using brushes, but perhaps on occasion employing other tools. *Blue Mountain (Der blaue Berg*, 1908–09, fig. 84) demonstrates his complicated approach to color. This work on canvas has an off-white ground over which a second gray-colored ground or imprimatura layer can be seen on the edges. On top of this, Kandinsky employed robust, staccato brushwork over much of the picture, using what we estimate to have been a flat, hog's hair–type brush with rather stiff bristles about

86 Ultraviolet (UV) photograph of *Blue Mountain*

1 cm wide. The X-radiograph[7] (fig. 85) exposes the basket-weave structure of the canvas. It also shows the areas painted with pigments that contain heavy-metal elements, such as lead white in the white highlights. A very interesting feature of the X-ray is that we can see that Kandinsky changed the lead horse's legs from a rearing to a galloping position. Ultraviolet-light (UV) examination[8] indicates the characteristic fluorescence of certain pigments, including what appears to be rose madder as well as zinc white.[9] The UV photograph (fig. 86) shows the characteristic salmon pink fluorescence of the madder pigment in the foliage on the left and right sides. Since not all red-pink areas in the composition fluoresce, it is evident that the artist used other red pigments, perhaps vermilion, which is also suggested by the absorption on the X-ray. Zinc white, which appears in many of his works, can also be seen and is characterized by bright yellow fluorescence in UV.

Kandinsky painted many *Hinterglasbilder,* or reverse glass paintings, during this period and beyond, which, though interesting from a technical point of view, are not the focus of our study. Reverse glass painting is a technique that involves applying the paint to one side of a piece of glass and then turning it over to view the painting through the glass. It requires the artist to paint the final desired composition in reverse, something Kandinsky was accustomed to doing as he made many woodcuts and etchings, which require the desired design to be drawn in a similar manner.

In Murnau, as Kandinsky developed his theories of abstraction, he began to organize and arrange his compositions arduously, making detailed sketches, drawings, and watercolors to work out the forms, colors, and tones. His final paintings, some of which were created in just a few days, sometimes have the look of spontaneity. However, this impressively quick execution was often possible only after months of preparation.[10] Though *Composition II* (*Komposition II*, 1910) was destroyed during World War II, our examination of *Sketch for Composition II* (*Skizze für Komposition II*, 1909–10, fig. 87) has uncovered considerable information about his preparation for his final canvases. Among other preliminary works,[11] he made a pencil drawing for the right side entitled *Study for Section of Composition II* (*Entwurf zu Fragment zu Komposition II*) in a sketchbook in 1910.[12] This drawing has extensive color notations, though interestingly some colors do not correspond to the notes under the paint layers of *Sketch for Composition II* indicating a change of mind and refining of his ideas. The ground is off-white in color and extends over the tacking margins, suggesting that *Sketch for Composition II* is a proprietary canvas, a primed canvas prepared by an artist's colorman. We can clearly see the characteristic diagonal pattern of the twill-weave linen fabric beneath the thin paint. Over the ground he drew a grid on the canvas, presumably to help transfer the forms from his sketches to the much larger canvas (fig. 88). Kandinsky did sometimes create a pencil grid and/or write color notes on preparatory watercolors, for example in *Study for Composition IV* (*Entwurf zu Komposition IV,* 1911)[13] and *Study for Improvisation with Horses* (*Entwurf zu Improvisation mit Pferden,* 1911),[14] though these preparations for his easel paintings have not been previously published.

The paint layers consist of simple, fairly wide, dark blue lines around most of the forms, and the colors are painted in a direct manner within these lines using paint of a paste consistency. Some lines

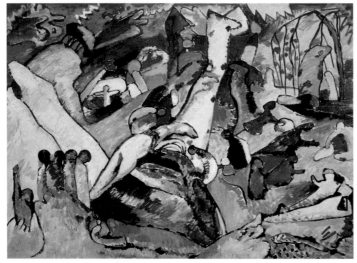

87

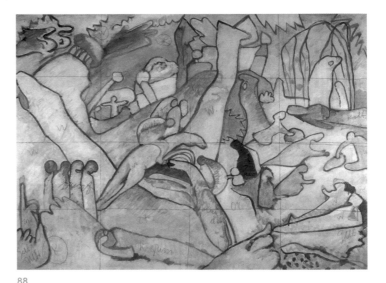

88

89

90

91

92

McMILLAN AND KOWALSKI

87 *Sketch for Composition II (Skizze für Komposition II)*, 1909–10 (plate 12)
88 Infrared (IR) photograph of *Sketch for Composition II*
89 Detail of *Sketch for Composition II*
90 IR photograph of detail of *Sketch for Composition II*
91 Detail of *Sketch for Composition II*
92 IR photograph of detail of *Sketch for Composition II*

that he drew in the composition can also been seen (figs. 88, 90, 92). In many places the dark painted lines that outline forms obscure other lines drawn in pencil. Beneath the thin paint layers, we can see a few faintly visible pencil notes. These notations could have slowly become more noticeable over the years since Kandinsky finished this sketch, as time sometimes renders paint more transparent.[15] When this painting was examined with infrared light, many more color notations and the entire grid, including Kandinsky's slip of the pencil

on the center-right edge, can be seen. The images (figs. 88, 90, 92) made using infrared reflectography (IR)[16] reveal more than twenty inscribed color notations in Old German.

Color was immensely important to Kandinsky, and his notes are particularly meaningful in light of his theories on the juxtaposition of colors, shade (relative darkness), and temperature (warm or cool). What is interesting about the pigment analysis is that Kandinsky has, in certain cases, used quite complex mixtures of individual pigments (for a summary of this analysis, see Canvas, Pigments, and Binding Mediums of Select Paintings on pages 130–31). While some inscriptions such as "Blau d" (dark blue) or "or" (orange) are straightforward, others are less certain. "Kalt" (cold or cool) surfaces in a purple area. "D" probably stands for "dunkel" (dark) and is a dark green area. "W," probably for "weiß" (white), is noted in several white areas

and interestingly, in one place that was subsequently painted green, showing that once again, Kandinsky was constantly amending his plans for the final work. Three less legible notations appearing to be "ro…[illegible]…a," perhaps "rosa," fall in a pinkish-purple area. "Mit," short for "mitte," meaning middle, below the "gelb" (yellow) notation in the lower left could indicate that Kandinsky meant to paint a yellow of middle tone. Finally he seems to have written the word "bunt," which, gratifyingly, means "colorful," across the four figures on the left—a marvelous description of the paint in that section.

X-ray fluorescence (XRF)[17] was first used to analyze the various elements in the paint structure. This method can sometimes suggest the pigments an artist used, particularly when they contain distinctive heavy-metal elements. For example, in this painting we found a red pigment that contained the element mercury, indicating that it is vermilion, or mercuric sulphide. In another area XRF revealed cadmium, indicating that yellow is cadmium yellow. Polarizing light microscopy (PLM)[18] was used to accurately identify the pigments Kandinsky used to paint this painting.

Light Picture (*Helles Bild*, 1913, fig. 93), another work in the Munich period and the original inspiration for the Guggenheim study, strongly exemplifies the spirit of the new, embodying a great deal of technical and aesthetic experimentation. It appears to be on a proprietary, plain-weave canvas, as the size (77.8 x 100.2 cm) is almost identical to several contemporaneous works, and the stretcher is the original one. The off-white ground extends over the tacking margins to the canvas's edge on all but one side, where it is dripped over the edge. The IR images display no visible drawing, which is not a surprise, as the composition was worked out in remarkable detail in *Study for Light Picture* (*Entwurf zu helles Bild*), an autumn 1913 watercolor. X-radiography reveals, stunningly, how Kandinsky added an underlying paint layer (fig. 94). It shows the gestural brushwork of a thick, lead-white imprimatura applied with a wide brush, using fluid, broad strokes. The X-ray clearly points out the direction of the brushstrokes as well as the flow and thickness of this underlayer, which was spread in a strong diagonal with two blocked-in square forms from the lower-left to the upper-right corner. This layer creates some texture and is also a brighter

white than the ground. Kandinsky may have laid it down to create a more luminous underlayer, over which he placed thin bright washes of transparent paint in a technique rather like watercolor (which uses the white paper as the highlights). These broad brushstrokes contrast remarkably with the fine details and delicate washes of the upper layers, where Kandinsky likely used softer brushes and, we suggest, other tools to apply the thin washes and lines. These upper layers are completely transparent to X-rays and therefore cannot be seen at all on the X-ray photograph, giving us a dramatic and seemingly incongruent X-ray image that bares little resemblance to the painting.

A few earlier watercolors, particularly *Watercolor with Red-Blue Stripes* (*Aquarell mit rotblauen Streifen,* 1913)[19] and the painting *Dreamy Improvisation* (*Träumerische Improvisation,* 1913),[20] resemble the work and indicate the genesis of the graphic black lines Kandinsky painted so dramatically in *Light Picture,* in which the deep black paint creates highly energetic marks that look rather like India ink.[21] They seem to be applied with a brush in some areas (fig. 95) and a pen (or similar tool) in others (fig. 96). Note the apparent opening of a nib and separation of a single line into two finer lines and the scratching and scribbling into the surface (fig. 97). The fluid and continuous lines indicate that a thin medium was used. Kandinsky also splattered the same black paint in, for him, a new and surprising way, relying on chance to a certain degree to deliver the spots and drips to where they lie (fig. 98). He then applied more thin, colored washes over the black lines to give a feeling of greater depth to the painting, presenting an almost celestial feeling (fig. 99).

It is intriguing to speculate about why these lines are flaking, particularly in light of their inklike appearance. To test the media, tiny samples were removed from the fine, scribbled lines where flaking exists and from the thicker painted lines. The results of Fourier Transform Infrared Spectroscopy (FTIR) and gas chromatography/mass spectometry (GC/MS)[22] indicate that the lines of both samples are pigmented with fine particles of charcoal black and the media is Pinaceae resin.[23] In the early twentieth century, pigments were commonly bound together in a drying oil like linseed oil. While Pinaceae resin is often found as an additive to linseed-oil paint, it is the only binding media

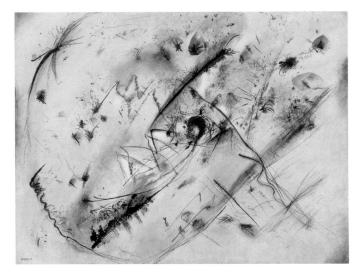

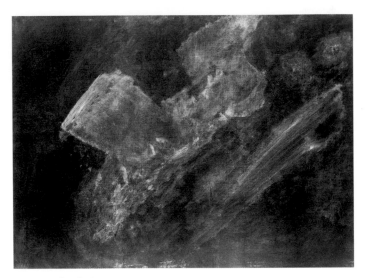

93 *Light Picture* (*Helles Bild*), 1913 (plate 38)

94 **X-ray of *Light Picture***

detected in these samples. It is possible that the Pinaceae resin's brittleness accounts for the cracking and flaking. Several other samples taken from colored areas of this painting and from *Black Lines* (*Schwarze Linien,* 1913, plate 39) have a linseed-oil and Pinaceae-resin medium or Pinaceae resin alone as the medium. Perhaps Kandinsky aimed to create a watercolor-like thin, transparent medium by adding the resin to his paint. The resin's presence helps greatly explain the paint's sensitivity to solvents when tiny areas were tested for possible cleaning.

Another interesting finding relates to the painting's signature and date. In early reproductions of the work, it is unsigned and undated,[24] and the earliest-known image of the painting signed is in a 1937 exhibition catalogue.[25] Kandinsky abruptly returned to Russia from Munich in 1914 at the start of World War I, and he later revisited, signed, and dated the work, perhaps between 1922 and 1929 when he was again living in Germany and it was owned by German art collector Franz Kluxen.[26] Kandinsky also made many delicate additions or retouchings to the black lines when he signed the work. The original black lines are very opaque and deep black in color while the signature, date, and the retouchings are both painted with a warmer, more transparent black paint. Some retouchings cover minor losses while others add tiny flourishes here and there (fig. 100). From these observations it appears that some black lines may have already been flaking when

he signed the work, and it is intriguing to see how Kandinsky found the smallest details significant.

Kandinsky made many drawings and watercolors from 1914 to 1916 but no easel paintings while he was in Russia at the start of World War I. After this two-year hiatus, he resumed painting. At the end of 1921, he returned to Germany and soon taught at the Bauhaus. During the Bauhaus period from 1922 to 1933, geometric forms began to predominate in his compositions, and the circle became an important and enduring motif, which very likely necessitated the use of mechanical tools. For example, we can plainly see tiny compass points in many paintings, such as *Several Circles* (*Einige Kreise,* 1926, fig. 101), where the points appear in all of the circles (fig. 103). The ground layer on this painting consists of an off-white layer, and the paint layers are very simple, thinly applied, and single layered for the most part. Where the circles overlap, Kandinsky has carefully painted in the separate colors in single layers (fig. 104). This cross section,[27] taken from near the bottom edge, shows the off-white ground layer with zinc-containing pigment particles, which exhibit a bright yellow fluorescence, and the single, thinly applied, black background layer.

Kandinsky appears to have selectively varnished some of his paintings or chosen a glossy medium for certain areas during this period.[28] Varnishing specific places enhances the depth of field and

95

96

97

99

98

95–100 Details of *Light Picture*

100

allows the forms to float in a composition. When *Several Circles* was examined in specular light,[29] we observed that while the overall surface is very matte, some areas look very glossy. The large black circle above and left of the center has a high level of gloss, compared to the other forms. Kandinsky may have applied a layer over the black paint or added a resinous medium to the paint to make it glossier than the surrounding layers. UV-light examination reveals a greenish fluorescent layer on the largest black circle, suggesting a natural-resin layer. The vigorous brushstrokes used to add this layer do not correspond to the brushstrokes of the black paint, leading us to suspect it is a discrete layer, rather than being an additive mixed with the paint (fig. 102). The layer certainly appears to be an original surface coating by Kandinsky since it was specifically applied to the large circle. Some of the smaller

black circles also have a glossy look; however, UV-light examination did not indicate a similar fluorescence, and he could have used a different medium to create a shiny layer. The excellent paint condition in these areas would have made it extremely difficult to remove a sample that could confirm whether this is a discrete layer. Perhaps in the future we may find the means to definitively say what this material is and how it was incorporated.

Kandinsky painted many works on cardboard and other various composite boards during the Bauhaus years, and he began to experiment with texture in his surfaces. In December 1933 Kandinsky moved for the last time, to Neuilly-sur-Seine, near Paris, where his style continued to evolve. During this period he included sand in many works and painted his more carefully delineated biomorphic[30] forms on prepared

127

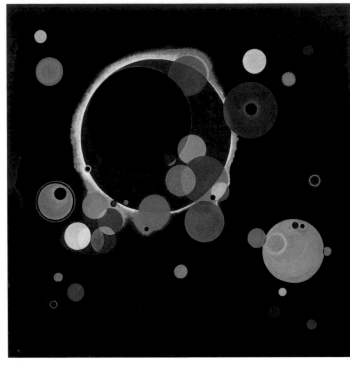

101

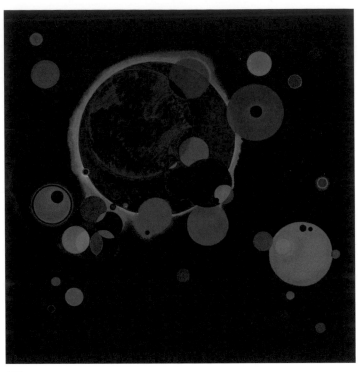

102

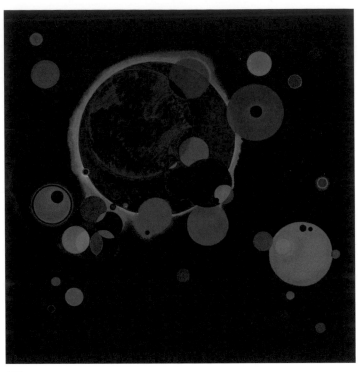

103

104

101 *Several Circles (Einige Kreise)*, 1926 (plate 67)
102 UV photograph of *Several Circles*
103 Detail of *Several Circles*
104 Cross section of *Several Circles* under UV light

canvases. *Blue World* (*Monde blue*, 1934, fig. 105) provides an interesting case in point. Using a plain-weave linen canvas commercially prepared by the art supplier Sennelier as evidenced by the manufacturer's stamp on the reverse,[31] he included sand over various areas with some particles as large as small pebbles (fig. 106). Kandinsky was not the first artist to add surface texture in this way. Several other artists, notably Georges Braque and Pablo Picasso, incorporated sand (and other materials) in their paintings much earlier in the century, but Kandinsky used it differently, making it more highly textured in very carefully defined areas. In many paintings it forms a key physical element, and he often chose rather coarse sand. From scientific testing and the appearance of *Blue World*, *Striped* (*Rayé*, 1934, plate 75), and *Accompanied Contrast* (*Contraste accompagné*, 1935, plate 78) under magnification, we presume he applied an extra, fairly thick off-white oil ground layer in the areas he intended to put the sand. He then pressed the sand into the paint, let it dry, and painted over the sand. No adhesive, other than the oil paint, was discovered when samples were analyzed (fig. 107).

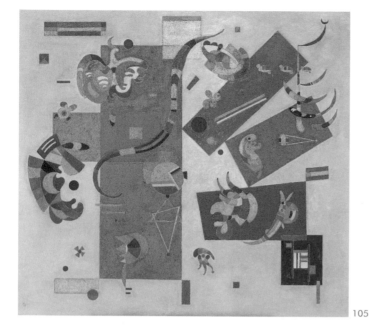

105

106 107

105 *Blue World (Monde bleu)*, 1934 (plate 74)
106, 107 Details of *Blue World*

Kandinsky kept meticulous records of his works and their where-abouts in what he called his *Hauskataloge*, or Handlists as they are known in English.[32] In these orderly notebooks he recorded and numbered each painting consecutively by date and often made a tiny sketch of the work along with notes about its size, location, and sometimes its medium as well as occasionally after 1931 its support. The notes on technique are usually found in the upper-right corner of the entry, in parentheses to the right of the work's title. In the entry for *Blue World*, he describes it as "huile sur sable," or oil on sand. We find it telling that he described the technique of the work as oil on sand, rather than oil and sand. It seems to describe the order of how the picture was painted and confirms our thesis that Kandinsky applied the sand to the canvas and then applied the paint over the top. Figure 107 illustrates a detail of an area where some small particles of sand have fallen off, revealing the off-white oil layer underneath.

Kandinsky stopped painting on canvas in 1942.[33] His last paintings are quite small in scale, painted on compressed wood panels, often without grounds and leaving the color of the board visible as part of his compositions. The paint in these works is generally thin and flat.

It is carefully confined to the various shapes, with very little texture. The medium has a tendency to be glossy.

The new scholarship on Kandinsky's working methods and materials in our study reveals important information about the underlying preparation of his canvas and details about his choice of colors. It also sheds light on the way he mixed his colors to achieve the effects he wanted to convey as well as the changes in his materials as he matured as an artist and developed his complicated artistic theories. Identifying these materials has far-reaching consequences for the conservation and future treatment of his works. For example, some paintings were varnished over the years after he no longer owned them. As we see in *Several Circles*, Kandinsky made conscious choices about which areas of the painting should be glossy and which should be matte, and an overall unifying varnish clearly interferes with his intended surface appearance. The possibility of removing these later varnishes and returning these paintings to close to their original condition, without affecting the sensitive paint, necessitates a full understanding of their compositions. This research into Kandinsky's techniques continues at the Guggenheim Museum, and this small study will be expanded in our larger ongoing project.

CANVAS, PIGMENTS, AND BINDING MEDIUMS OF SELECT PAINTINGS

Sketch for Composition II, 1910 (below, left)

CANVAS TYPE: Linen WEAVE: Twill weave FIBER: 20 μm GROUND TYPE: Extends to side edges of canvas; lead white, calcium carbonate with traces of zinc-containing pigment

SAMPLE DESCRIPTION	PIGMENTS	BINDING MEDIUMS
1 • Purple from area at center of right side; Kandinsky's notation: "kalt" ("cool")	Ultramarine blue, trace of red lake, black pigment (probably carbon black), zinc white	Drying oil, zinc soaps
2 • Yellow from bottom-right quadrant; Kandinsky's notation: "gelb" ("yellow")	Cadmium yellow, cadmium oxalate, strontium yellow	Drying oil
3 • Blue from bottom center; Kandinsky's notation: "blau d" ("dark blue")	Ultramarine blue, zinc white	Drying oil, zinc soaps
4 • Orange from area just right of bottom; Kandinsky's notation: "or" ("orange")	Cadmium yellow, cadmium carbonate, cadmium oxalate, strontium yellow, lead white	Drying oil, zinc soaps
• White layer under the orange	Lead white	Drying oil
5 • Red from lower-left quadrant; Kandinsky's notation: "rt" ("rot," or "red")	Vermilion (wet process), barium sulphate, lead white	Drying oil, zinc soaps
6 • Dark blue-green from upper-left quadrant; Kandinsky's notation: "D" ("dunkel," or "dark")	Prussian blue, goethite (yellow iron oxide), cadmium yellow, calcium carbonate, lead white, gypsum	Drying oil, zinc soaps
7 • Green-blue from near top edge to left of center; Kandinsky's notation: "K" ("kalt," or "cool")	Prussian blue, strontium yellow, lead white, calcium carbonate, zinc white	Drying oil, zinc soaps
8 • Green from upper-left quadrant; Kandinsky's notation: "W" ("weiß," or "white")	Prussian blue, goethite, cadmium yellow, cadmium oxalate, zinc white, lead white	Drying oil, zinc soaps
9 • Crimson from upper rider in center; Kandinsky's notation: "rt" ("red")	Red lake, trace bone black, zinc white	Drying oil, zinc soaps
10 • Green from bright green area near bottom edge and center; Kandinsky's notation: "h grun" ("hellgrün," or "light green")	Strontium yellow, zinc white, lead white	Drying oil, zinc soaps
11 • White from center of left edge; Kandinsky's notation: "W" ("weiß," or "white")	Lead white, calcium carbonate, zinc white	Drying oil
12 • Yellow from edge of area in bottom-left corner; Kandinsky's notation: "gelb mit" ("middle yellow")	Strontium yellow	Drying oil

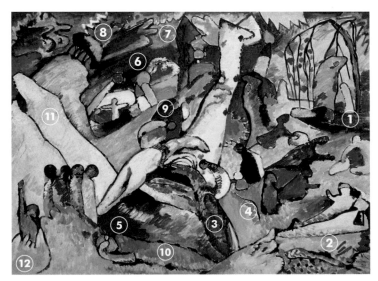

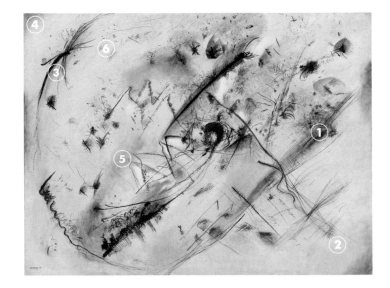

Light Picture, 1913 (opposite, right)

CANVAS TYPE: Linen WEAVE: Plain weave THREAD COUNT: 11 vertical, 13 horizontal FIBER: 15–25 μm GROUND TYPE: Extends to side edges of canvas; calcium carbonate with traces of zinc-containing pigment, natural earth pigments (yellow), natural ultramarine blue

	SAMPLE DESCRIPTION	PIGMENTS	BINDING MEDIUMS
1	• Black estimated to be pen-applied	Charcoal black	Unidentified (sample too small)
	• Ground beneath black	Lead white, lead carbonate, zinc white	Drying oil, zinc soaps
2	• Black from what looks like pen-applied line in lower-right quadrant	Charcoal black (10–15 μm), lead white, zinc white	Pinaceae resin, zinc palmitate, stearate
3	• Black paint that looks brush applied	Bone black (probably charcoal black, 5–15 μm)	Pinaceae resin, zinc palmitate, stearate
4	• Green from top left corner	Viridian; another green pigment, possibly emerald green; possibly a yellow chromate pigment	Drying oil
	• White under green	Lead white, zinc white	Linseed oil, Pinaceae resin, zinc soaps
5	• Pale pink-red from swath of pink to left of center	Probably a trace of vermilion, lead white, zinc white	Pinaceae resin, zinc soaps
6	• Yellow from the upper-left quadrant	Probably cadmium yellow, lead white, zinc white	Linseed oil, Pinaceae resin, zinc soaps

Several Circles, 1926 (below, left)

CANVAS TYPE: Linen WEAVE: Plain weave THREAD COUNT: 12 vertical, 12 horizontal FIBER: 15–30 μm GROUND TYPE: Extends to side edges of canvas; natural chalk with small amounts of lead white, zinc-containing pigment, kaolin, quartz

	SAMPLE DESCRIPTION	PIGMENTS	BINDING MEDIUMS
1	• Black	Charcoal (5–15 μm), trace quartz	Unidentified (sample too small)
2	• White ground from bottom edge	Kaolin, quartz	Linseed oil

Blue World, 1934 (below, right)

CANVAS TYPE: Linen WEAVE: Plain weave THREAD COUNT: 13 vertical, 11 horizontal FIBER: 15–30 μm GROUND TYPE: Commercially applied by Sennelier, extends to side edges; lead white, calcium carbonate

	SAMPLE DESCRIPTION	PIGMENTS	BINDING MEDIUMS
1	• Pale blue/white	Zinc white, calcium carbonate, trace charcoal black	Linseed oil, Pinaceae resin

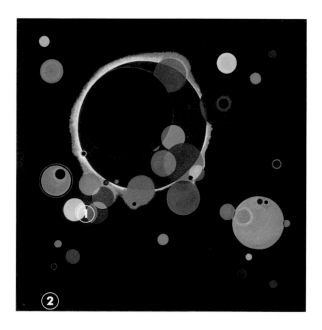

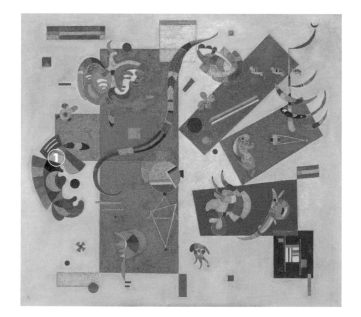

Acknowledgments

The Guggenheim Conservation Department would like to thank the Canadian Conservation Institute (CCI), in particular Elizabeth Moffatt, Senior Conservation Scientist, and Jennifer Poulin, Conservation Scientist, for undertaking the scientific analysis of the samples. CCI completed the Fourier Transform Infrared Spectroscopy (FTIR), gas chromatography/mass spectrometry (GC/MS), and high-magnification polarizing light microscopy (PLM) testing of the media and pigments.

Notes

1 Kenneth C. Lindsay and Peter Vergo, "Introduction," in Vasily Kandinsky, *Kandinsky: Complete Writings on Art*, ed. Lindsay and Vergo (1982; repr., New York: Da Capo Press, 1994), p. 32.

2 The materials Kandinsky left in his studio in Neuilly-sur-Seine, France, when he died are preserved at the Musée national d'art moderne, Centre Pompidou, and were thoroughly documented in 1998 by conservator Benoit Dagron in Dagron, "Inventaire du matériel de l'atelier de Vassily Kandinsky" in "Matériaux et techniques de l'art au XXe siècle," special issue, *Techne: la science au service de l'histoire de l'art et des civilisations* (Paris), no. 8 (1998), pp. 64–77, and Christian Derouet, "L'atelier Kandinsky à Neuilly," *Techne*, no. 8 (1998), pp. 60–64.

 Scientific testing has been conducted on two of Kandinsky's palettes, one preserved at the Gabriele Münter- und Johannes Eichner-Stiftung located in the Städtische Galerie im Lenbachhaus in Munich and the other preserved at the Centre Pompidou. Rudolph H. Wackernagel wrote a very informative article on Kandinsky's materials, entitled "'Watercolor with 'Oil' . . . , Oil with 'Watercolor,' and so on': On Kandinsky's Studio and His Painting Techniques" in *Vasily Kandinsky: A Colorful Life, The Collection of the Lenbachhaus, Munich*, ed. Vivian Endicott Barnett and Helmut Friedel (Cologne, Germany: DuMont, 1995), pp. 547–68.

3 A painting's support is usually a canvas or other fabric tacked to a wooden stretcher to keep it taut or to a solid like wood, plywood, or paper-board panel. A thin-size layer follows and is often, but not always, a dilute, water-soluble glue like rabbit-skin glue that helps preserve the support. Next there is usually a ground layer, which is most often an off-white chalky preparation applied to the support in a thin layer or sometimes in multiple layers. An artist's materials supplier or paint vendor often completes these steps though some artists prefer to do it themselves.

4 Various types of canvas have characteristic weave patterns. A plain- (or tabby-) weave canvas has a warp thread, which passes over one and under one weft thread. A basket-weave canvas has two or more warp threads passing over and under two or more weft threads. A twill-weave canvas has a warp thread, which passes over one and under three weft threads.

5 Kandinsky refers to tempera many times in his Handlists. According to *Painting Materials: A Short Encyclopedia*, "The meanings of the word, 'tempera,' as used to define a painting medium, have been many and have changed from time to time in the history of art. As late as the XV century this term probably included all mediums but, with the gradual prevalence of oil, its limits were narrowed until it has often meant only a medium prepared from egg. A broader definition, which allows it to include albuminous, gelatinous, and colloidal materials, is also in use. For specification this requires a second term, and the whole would be for example, 'glue tempera,' or 'gum tempera,' or 'egg tempera.'" Rutherford J. Gettens and George Leslie Stout, *Painting Materials: A Short Encyclopedia* (1942; repr., New York: Dover, 1966), pp. 69–70. See also Wackernagel, "Watercolor with 'Oil' . . . , Oil with 'Watercolor,' and so on," pp. 547–68.

6 Kandinsky himself said: "For your information. What I call 'watercolour' does not mean that it really is a watercolour, because I mix different techniques; for instance, several 'watercolours' are painted in oil only or in gouache, or in tempera, or in distemper (which I grind myself) or they are painted in several media at the same time on one and the same sheet of paper. (Equally, what I call 'oil' is also not always painted in oil but is mixed in the same way)." Vasily Kandinsky to J. B. Neumann, October 2, 1935, quoted in Hans K. Roethel and Jean K. Benjamin, *Kandinsky: Catalogue Raisonné of the Oil Paintings, Volume One, 1900–1915* (Ithaca, N.Y.: Cornell University Press, 1982), p. 24. He also wrote: "[As of this moment] I have listed 645 'oil-paintings' and 584 'watercolours.' The ' ' [quotation marks] indicate that this division is a conventional one because in the case of oil there are often other media at work (e.g., tempera, watercolours, gouache, indian ink [Tusche]) and equally so with watercolours." Vasily Kandinsky to Hans Thiemann, December 8, 1937, quoted in Roethel and Benjamin, *Catalogue Raisonné of the Oil Paintings, Volume One*, p. 24.

7 X-radiography is used to determine how an artist built up the composition. This noninvasive technique usually shows any changes the artist made and sometimes even earlier compositions that the artist painted over. X-rays have shorter wavelengths than those in the visible range. To make an X-ray image, the painting is placed between the X-ray source and a photographic film that is sensitive to the radiation. The X-rays pass through the painting, and depending on the materials present, will usually leave an image on the film. An image is created if pigments containing heavy metals, such as lead white and cadmium yellow, are in the paint. These pigments effectively shield the photographic emulsion by absorbing the radiation, leaving white areas on the film. Areas that contain no heavy-metal pigments allow the X-rays to pass through onto the film, creating dark areas and an image.

8 Ultraviolet-light (UV) examination identifies certain pigments and detects the presence of aged varnish layers and glazes as well as improves the legibility of faded inscriptions. UV is also a noninvasive means to disclose areas of previous restoration or later additions to an artwork as in-painting or retouching fluoresces differently than the surrounding original paint. Invisible to the human eye, UV light is radiation of a shorter wavelength than visible light. Certain materials including the minerals that comprise certain pigments and varnishes fluoresce, absorbing the short wavelength of UV light and releasing some of this absorbed energy as radiation.

9 A pigment hand-labeled "Krapplack 2 (rosa)" is listed in the inventory from Kandinsky's studio. See Dagron, "Inventaire du materiel de l'atelier de Vassily Kandinsky," p. 66. Zinc white, also known as Chinese white, is made from zinc oxide.

10 Vasily Kandinsky "Reminiscences" (1913), in Kandinsky, *Complete Writings on Art*, p. 386.

11 Angelica Zander Rudenstine, *The Guggenheim Museum Collection: Paintings 1880–1945*, vol. 1 (New York: Solomon R. Guggenheim Foundation, 1976), pp. 228–36.

12 Vivian Endicott Barnett, *Kandinsky Drawings: Catalogue Raisonné, Volume One, Individual Drawings* (London: Philip Wilson, 2006), p. 73, no. 124.

13 Vivian Endicott Barnett, *Kandinsky Watercolours: Catalogue Raisonné, Volume One, 1900–1921* (Ithaca, N.Y.: Cornell University Press, 1992), p. 235, no. 266.

14 Ibid., p. 242, no. 271.

15 Rudenstine illustrated this work and noted the grid lines and the six pencil color notations that were partially visible to the naked eye in Rudenstine, *Guggenheim Museum Collection*, p. 228.

16 Infrared reflectography (IR) is useful for understanding how the artist may have planned the design before applying paint. Infrared radiation has a longer wavelength than visible light. This noninvasive technique can reveal preparatory underdrawings, which are often executed in charcoal or a similar material beneath the paint layers. Black charcoal and graphite absorb infrared light and reflect back radiation in the visible range, while other materials such as some of the colors in the upper paint layers do not and are therefore not seen in an infrared image.

17 X-ray fluorescence (XRF) is quite different from a regular X-ray and helps identify certain pigments on a molecular level. The X-ray beam is focused on the area of interest, and when an X-ray of sufficient energy strikes the sample, each element emits its own fluorescent X-ray energy spectrum, revealing a unique pattern like a fingerprint. Thus tentative identification can sometimes be made quickly and easily without any need to take a sample.

18 High-magnification polarizing light microscopy (PLM) and UV-light microscopy are commonly used to identify pigments. Miniscule samples of 2–500 μm are examined through a microscope, and a pigment is identified through its individual crystal's visual and physical characteristics, such as size, color, shape, and fluorescence using known samples for comparison. Paint samples are often mixtures of more than one pigment (for example, orange may be a mixture of red and yellow pigments). Accurate pigment identification is a very specialized field.

19 Barnett, *Watercolors: Catalogue Raisonné, Volume One*, p. 336, no. 374.

20 Roethel and Benjamin, *Catalogue Raisonné of the Oil Paintings, Volume One*, p. 476, no. 478.

21 Conversations with Leni Potoff, then Associate Conservator at the Solomon R. Guggenheim Museum, in the mid-1980s first pointed Gillian McMillan toward the idea that India ink might have been used.

22 Fourier Transform Infrared Spectroscopy (FTIR) and gas chromatography/mass spectrometry (GC/MS) are two advanced methods most commonly used to analyze paint mediums or varnish layers, which are organic elements in paint samples. Both methods require standards for comparison. FTIR requires a smaller sample than GC/MS and points out a characteristic spectrum for specific elements, usually enabling identification. GC/MS combines two distinct analytical features to separate out a sample's molecular components. GC/MS is more accurate than FTIR because it is a separation technique that identifies specific chemical compounds and not general functional groups. Trace components can be detected and thus more specific information about an organic binder can be obtained. "In GC, a gas or a vaporized sample is introduced and carried along by an inert carrier gas though a long, thin column where the sample components are separated. The components are flushed in sequence from the column and through a detector and are identified by measuring the time from introduction to detection. The mass spectrometer breaks up constituents into molecular ions and other fragments, which then pass through an electric and/or magnetic field that separates them according to their mass-to-charge ratio. Thus, the GC separates the components within a compound while the MS identifies these components." Getty Conservation Institute, "Gas Chromatography (GC) and GC/Mass Spectrometry (GC/MS)," http://getty.edu/conservation/science/about/gcms.html (accessed April 7, 2009).

23 A Pinaceae resin is drawn from a tree of the pine family, such as pines, spruces, firs, and larches.

24 It appears unsigned and undated in Kandinsky, *Tekst Khudozhnika* (Moscow: Izdanie Otdela Izobrazitelnykh Iskusstv Narodnago Kommissariata po Prosveshcheniyu, 1918), p. 44; Will Grohmann, Wassily Kandinsky (Leipzig, Germany: Klinkhardt und Biermann, 1924), p. 27; and Will Grohmann, *Wassily Kandinsky* (Paris: Editions Cahiers d'Art, 1930), p. 14.

25 *Solomon R. Guggenheim Collection of Non-objective Paintings: Second Enlarged Catalogue*, exh. cat. (New York: Solomon R. Guggenheim Foundation, 1937), p. 77.

26 Vivian Endicott Barnett, e-mail to Gillian McMillan, August 13, 2008.

27 A cross section is a tiny sample of paint taken from a painting, set on its side in a transparent resin, and polished so that the layer structure of the ground and paint applications can be observed and studied under high magnification.

28 Varnish was often the painting's final layer, but especially since the advent of Impressionism, artists sometimes choose not to varnish. Departure from the typical way of painting is one way an artist can make his or her work unique.

29 Specular light is a noninvasive technique in which bright, frontal light is bounced off the painting's surface, showing the surface reflection, evidence of the surface's matte or glossy nature, and selective varnishing.

30 Vivian Endicott Barnett, "Kandinsky and Science: The Introduction of Biological Images in the Paris Period," in *Kandinsky in Paris: 1934–1944* (New York: Solomon R. Guggenheim Foundation, 1985), pp. 61–87.

31 Several stamps of Sennelier, a French artists' supplier, appear on the Paris-period paintings owned by the Guggenheim Museum.

32 Kandinsky, unpublished manuscript, Inv. 187a. Catalogue de Peintures, 1927–40, nos. 371–738. Handlist IV, Dessau/Paris, Fonds Kandinsky, Centre Pompidou.

33 Derouet, "L'atelier Kandinsky à Neuilly," p. 63.

PARIS

1906-07

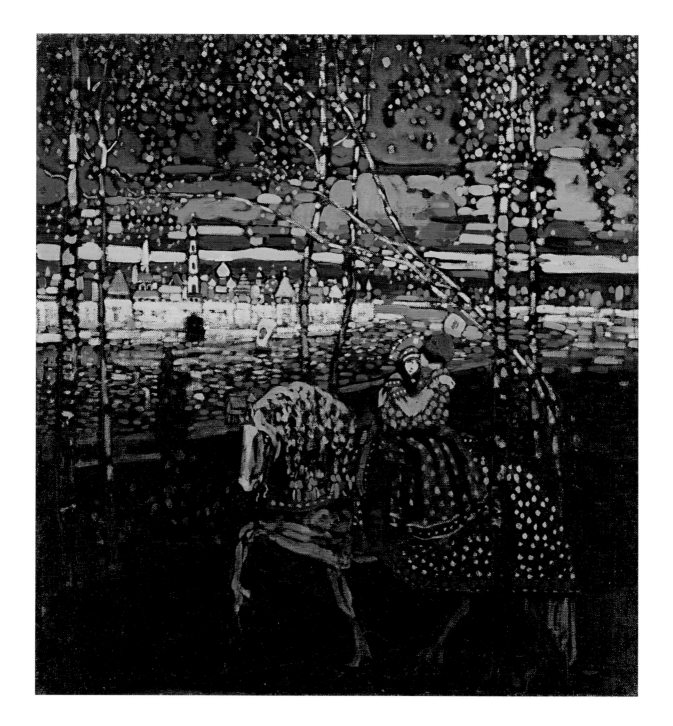

1 *Riding Couple* (*Reitendes Paar*), 1907
Oil on canvas, 55 x 50.5 cm
Städtische Galerie im Lenbachhaus, Munich, Gabriele Münter-Stiftung, 1957

• *Colorful Life (Motley Life)* (*Das bunte Leben*), along with *Riding Couple* (*Reitendes Paar*, plate 1, 1907) painted shortly before, forms the culmination of the large group of tempera pictures in Kandinsky's early work between 1902 and 1907. He called these works, which almost all depict nostalgic scenarios with old Russian, old German, or Biedermeier figures, "colored drawings," and they were usually executed on dark colored paper and sometimes on large canvases. In *Colorful Life*, the viewer's eye, observing from slightly above the picture plane, glides over a multifigure panorama of humanity from a freely imagined time in ancient Russian history, composed of dazzling colored spots on a dark background. The artist obviously used such scenes to investigate the fusion between the figure and ground from a nearly abstract perspective wherein the historical setting provided the liberty to venture away from realistic models. He wrote: "In [my picture] *Colorful Life*, where the task that charmed me most was that of creating a confusion of masses, patches, lines, I used a 'bird's eye view' to place the figures one above the other. To arrange the dividing-up of areas and the application of brushstrokes as I wished, on each occasion I had to find a perspective pretext or excuse."[1] The figures, such as the rider, the loving couple, the intertwined pair of saintly brothers in the center, and the rower on the peaceful river in the background, as well as the kremlin with its colorful towers and domes on the massive hill, all appear in later pictures as a great number of cryptic symbols and, with their remnants of the concrete, suggest an aura of mystery and vitality. – Annegret Hoberg

1 Vasily Kandinsky, "Cologne Lecture" (1914), in Kandinsky, *Kandinsky: Complete Writings on Art*, ed. Kenneth C. Lindsay and Peter Vergo (1982; repr., New York: Da Capo Press, 1994), p. 395.

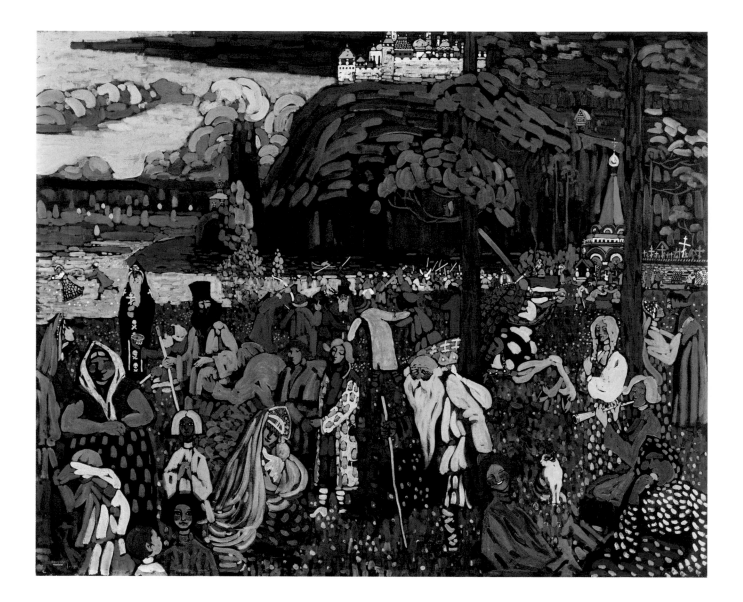

2 *Colorful Life* (*Motley Life*) (*Das bunte Leben*), 1907
Tempera on canvas, 130 x 162.5 cm
Bayerische Landesbank, on permanent loan to the Städtische Galerie im Lenbachhaus, Munich

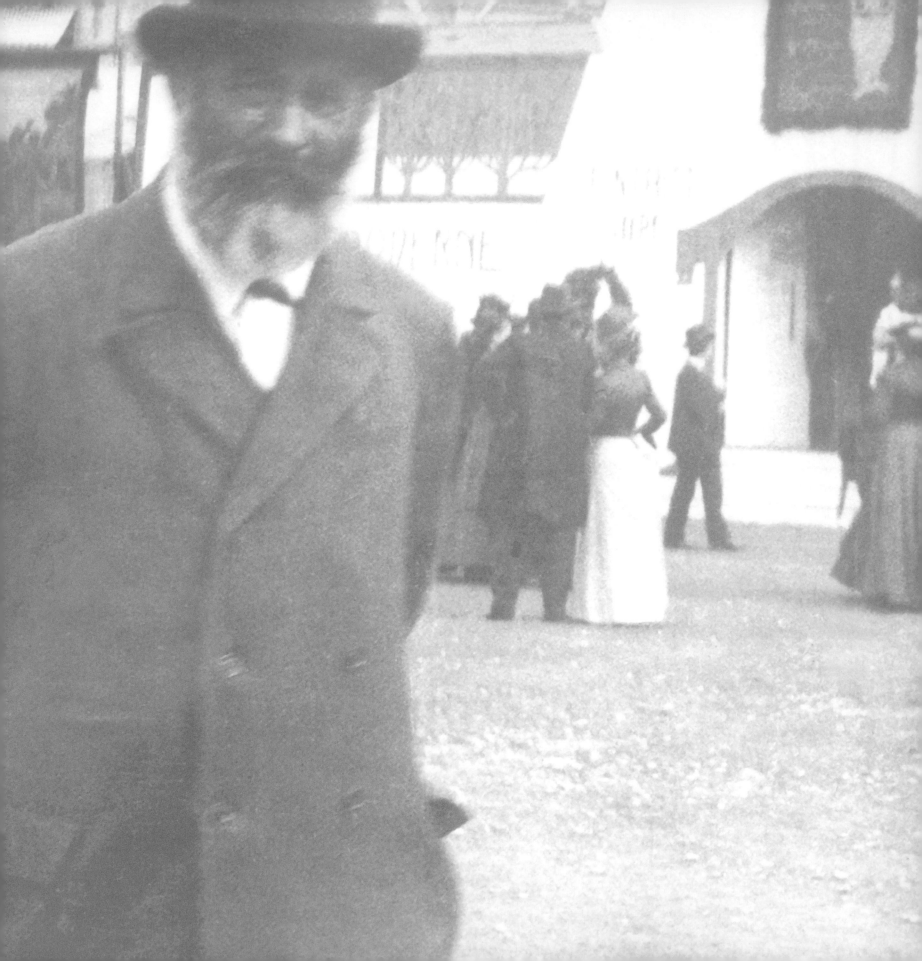

MUNICH AND MURNAU

1908–14

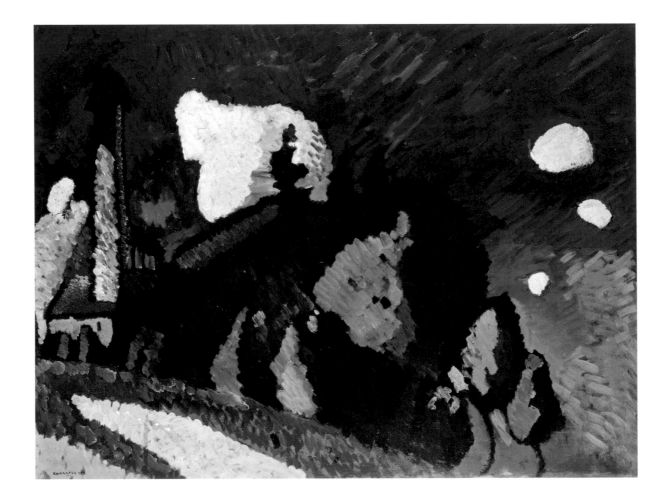

3 *Murnau–Landscape with Tower (Murnau–Landschaft mit Turm)*, 1908
Oil on cardboard, 74 x 98.5 cm
Musée national d'art moderne, Centre Pompidou, Paris, Gift of Nina Kandinsky, 1976

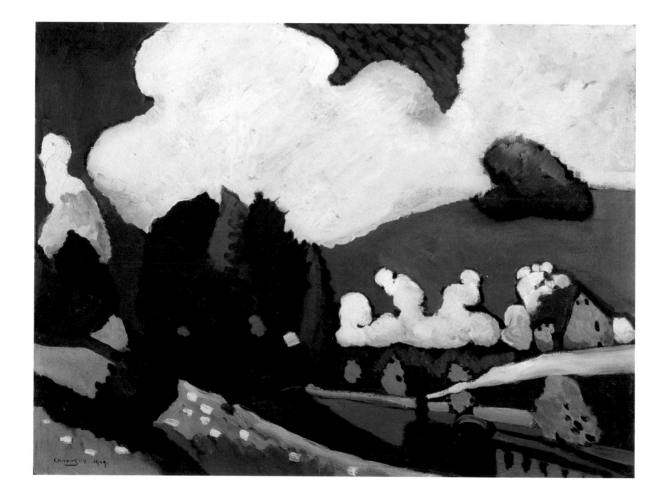

4 *Landscape near Murnau with Locomotive (Landschaft bei Murnau mit Lokomotive)*, 1909
Oil on cardboard, 50.5 x 65.1 cm
Solomon R. Guggenheim Museum, New York 50.1295

• In summer 1908, after several years of extensive travel throughout Europe and Tunisia, Kandinsky and his companion, the artist Gabriele Münter, settled in Murnau, a small picturesque market town south of Munich and much favored by writers and artists. Inspired by the Bavarian landscape, Kandinsky featured it prominently in his work. He also discovered Bavarian-style *Hinterglasbilder* (reverse glass painting), which was renowned for its colorful depictions of folksy scenes. *Blue Mountain* (*Der blaue Berg*), painted in winter 1908–09, typifies the notable shift in the artist's style evident in the bolder and brighter canvases that he produced after his stay in Paris in 1906–07, when he had become acquainted with the brilliant canvases of the Fauves—including those of Georges Braque, André Derain, and Henri Matisse—whose work he considered miraculous.

Kandinsky had been fond of horses since childhood, and *Blue Mountain* is one of many works that depict horses and riders, motifs that symbolize his unconventional aesthetic values and mission to bring about a new, more spiritual era through art. The outlines of the horses, mountain, and landscape—in a nod to his distinctive early graphic works, particularly the expressive woodcuts—are more schematic and underline the plane. In his quest toward abstraction, Kandinsky slowly detached his imagery from nature. Here he stripped the procession of riders and figures of any truly identifiable shapes, and the colors were intended to trigger emotional responses. The gradual dematerialization of forms and vivid colors play against each other as independent sensorial patterns that speak to his search for artistic freedom and his aim to present a new spiritual reality. – Karole Vail

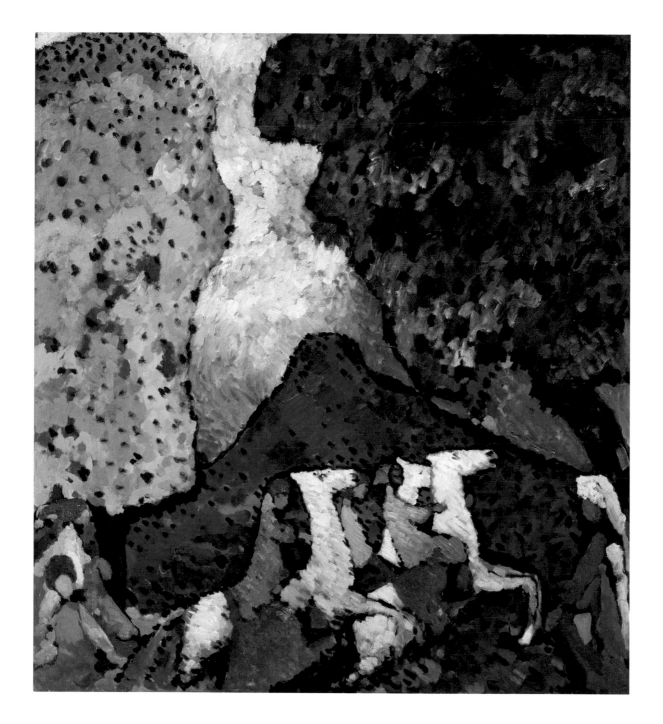

5 *Blue Mountain* (*Der blaue Berg*), 1908–09
Oil on canvas, 106 x 96.6 cm
Solomon R. Guggenheim Museum, New York, Solomon R. Guggenheim Founding Collection, By gift 41.505

• Kandinsky created the already broadly abstract painting with the lapidary title *Mountain* (*Berg*) as early as 1909; however, with its representational forms blurred to the point of unrecognizability and its emotional effect, it anticipates compositional elements used during Kandinsky's tempestuous phase of expressive abstraction, immediately preceding World War I. The viewer can just make out the bright outlines of two figures shot through with white in front of the colorful cone of a mountain. The green mountainside is torn open to expose a white interior; its cone is circumscribed by a dominant blue, which is further bounded by an energy zone of fiery red. On closer inspection the figurative ciphers are references to symbols introduced in Kandinsky's early work. Below, a rider on a white horse encounters a figure turned toward him, accompanied on the left picture edge by a zigzag line and on the right by a shadowy form. On the summit of the mountain, there is a formal echo of the brightly colored kremlin that looms above the landscape in *Colorful Life* (*Motley Life*) (*Das bunte Leben*, 1907, plate 2).

Even if the blue mountain may be traced back to a landscape in Murnau, Germany, in the Bavarian foothills of the Alps, landscape and figurative elements from Kandinsky's personal iconography fuse here in a new unified whole. Genres that until now had been treated separately in Kandinsky's oeuvre—the oil studies of nature and the mysterious figures of the colored drawings, as in the tempera paintings with predominantly old Russian motifs—now appear in large paintings. In terms of form, this shift broke through into the new, though to Kandinsky, already long anticipated, means of expression, which he would soon display in the many large works in his *Improvisations* series as "impressions of 'internal nature.'"[1] — A. H.

1 Vasily Kandinsky, *On the Spiritual in Art* (1912), in Kandinsky, *Kandinsky: Complete Writings on Art*, ed. Kenneth C. Lindsay and Peter Vergo (1982; repr., New York: Da Capo Press, 1994), p. 218.

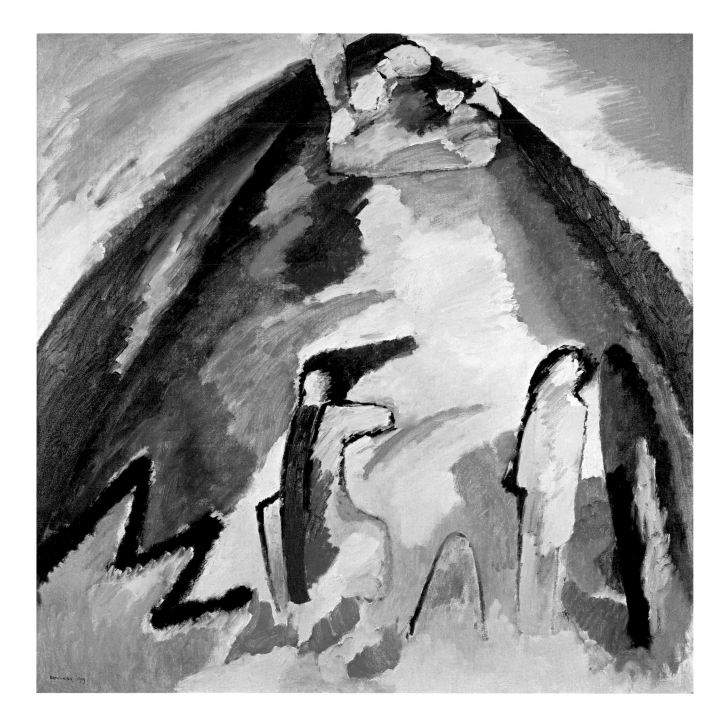

6 *Mountain* (*Berg*), 1909
Oil and tempera on canvas, 109 x 109 cm
Städtische Galerie im Lenbachhaus, Munich, Gabriele Münter-Stiftung, 1957

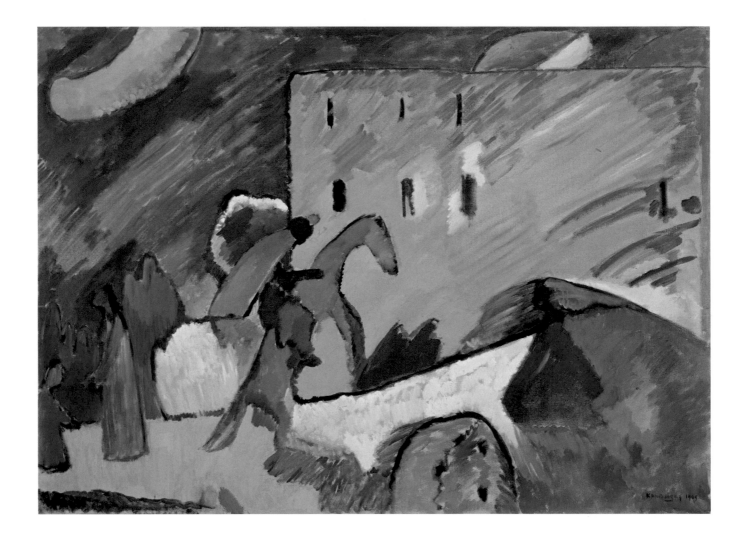

7 *Improvisation 3*, 1909
Oil on canvas, 94 x 130 cm
Musée national d'art moderne, Centre Pompidou, Paris, Gift of Nina Kandinsky, 1976

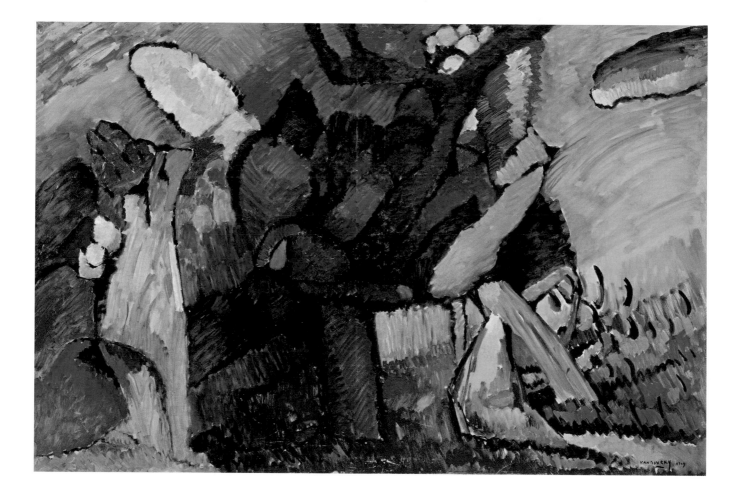

8 *Improvisation 4*, 1909
Oil on canvas, 108.5 x 159.7 cm
State Art Museum, Nizhny Novgorod, Russia

• *Picture with an Archer* (*Bild mit Bogenschützen*) shows a rider galloping hastily to the left—his bow aimed backward at an unknown target—through scenery of fairy-tale colorfulness that is abstracted to a large degree. The gorgeous shades of blue, green, red, and yellow solidify under a large menhir-like rock formation with black patches to create the inner "seething" of form that Kandinsky frequently mentioned in his writings of the period. Compared to the earlier colored wood-cut *Archer* (*Bogenschütze*, 1908–09) that was included in the 1912 version of *Der Blaue Reiter* (*The Blaue Reiter Almanac*) produced specifially for museums, the artist moved the color zones beyond the objects' borders. The colorful silhouettes in the lower-left foreground are probably old Russian figures, which also appear in *Improvisation 2 (Funeral March)* (*Improvisation 2 [Trauermarsch]*, 1909) and other works. Their activity and significance are made indecipherable through the cropping by the picture's edge, another means that Kandinsky often used to make a picture more puzzling. Still, the rider, in the figure of the archer, must definitively be interpreted as a "metaphor for liberation."[1] The élan, emotional pathos of the motif, and application of color make this picture one of the most important works from the period when the artist was making his way toward abstraction.

– A.H.

1 Armin Zweite, *Kandinsky und München: Begegnungen und Wandlungen 1896–1914*, ed. Zweite, exh. cat. Städtische Galerie im Lenbachhaus, Munich (Munich: Prestel, 1982), p. 151. Translated by Sarah Kane, Watford, England.

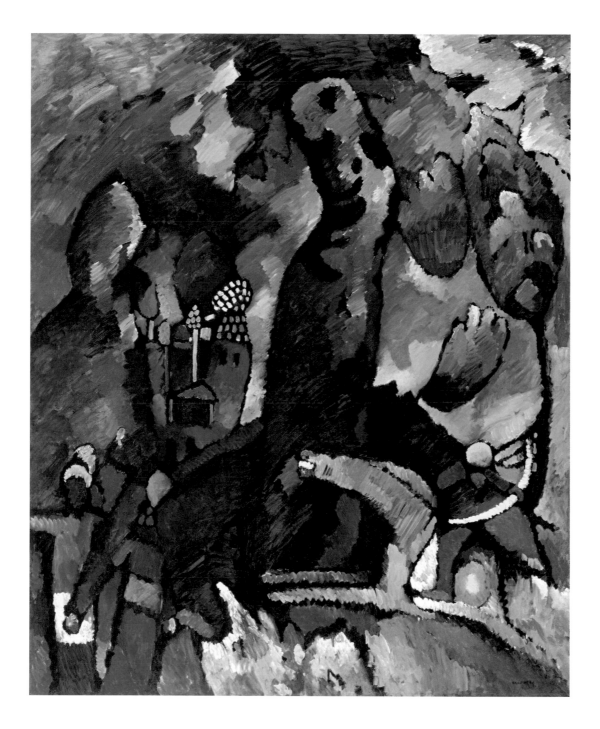

9 *Picture with an Archer* (*Bild mit Bogenschützen*), 1909
Oil on canvas, 177 x 147 cm
The Museum of Modern Art, New York, Gift and bequest of Louise Reinhardt Smith, 1959

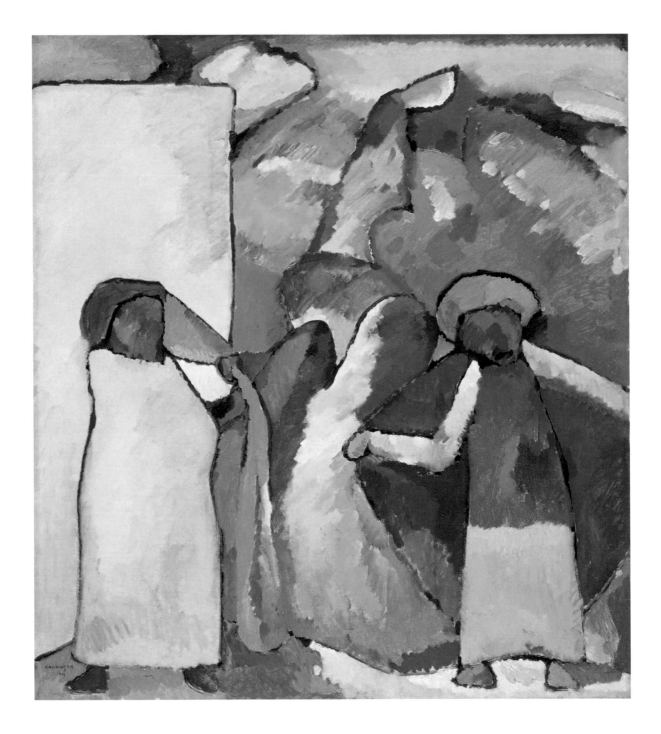

10 *Improvisation 6 (African)* (*Improvisation 6 [Afrikanisches]*), 1909
Oil and tempera on canvas, 107 x 99.5 cm
Städtische Galerie im Lenbachhaus, Munich, Gabriele Münter-Stiftung, 1957

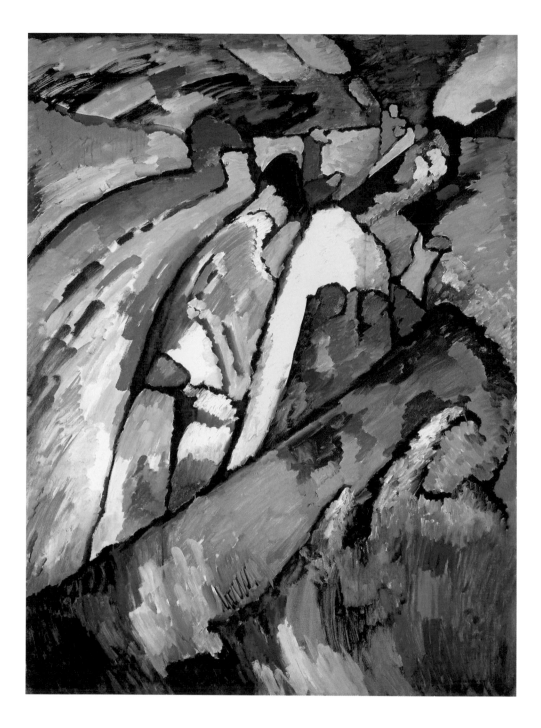

11 *Improvisation 7* (*Storm*) (*Improvisation 7* [*Sturm*]), 1910
Oil on canvas, 131 x 97 cm
The State Tretyakov Gallery, Moscow

• Throughout his career Kandinsky created series of paintings that he considered "examples of the new symphonic type of construction."[1] In an effort to synthesize the arts, he titled these works *Impressions*, *Improvisations*, and *Compositions*, all words that allude to music. The paintings are also works of spontaneous invention or intimations of his inner nature rather than material observations of the external world. During this period of intense activity, he accelerated his move toward abstraction.

About the *Compositions* Kandinsky stated: "The expressions of feelings that have been forming within me in a similar way [to the *Improvisations*] (but over a very long period of time), which, after the first preliminary sketches, I have slowly and almost pedantically examined and worked out. This kind of picture I call a 'Composition.' Here, reason, the conscious, the deliberate, and the purposeful play a preponderant role. Except that I always decide in favor of feeling rather than calculation."[2]

The last in a series of studies for a monumental oil painting now destroyed, *Sketch for Composition II* (*Skizze für Komposition II*) has an iconography that has often baffled scholars because of the presumed lack of thematic content claimed by Kandinsky in his writings. Nonetheless, it has been suggested that opposing forces are at work: a peaceful and idyllic scene, revealed by the glowing colors on the right, contrasts with a catastrophic disaster, perceived through the darker and somber color palette to the left. Appearing as simplified and spontaneous contours, the figures, rocks, riders, and horses are outlined in black, and the brilliant colors powerfully create an exuberant medley of shapes that is meant to elicit emotions and connect to the viewer's inner spirituality. – K. V.

1 Vasily Kandinsky, *On the Spiritual in Art* (1912), in Kandinsky, *Kandinsky: Complete Writings on Art*, ed. Kenneth C. Lindsay and Peter Vergo (1982; repr., New York: Da Capo Press, 1994), p. 218.
2 Ibid.

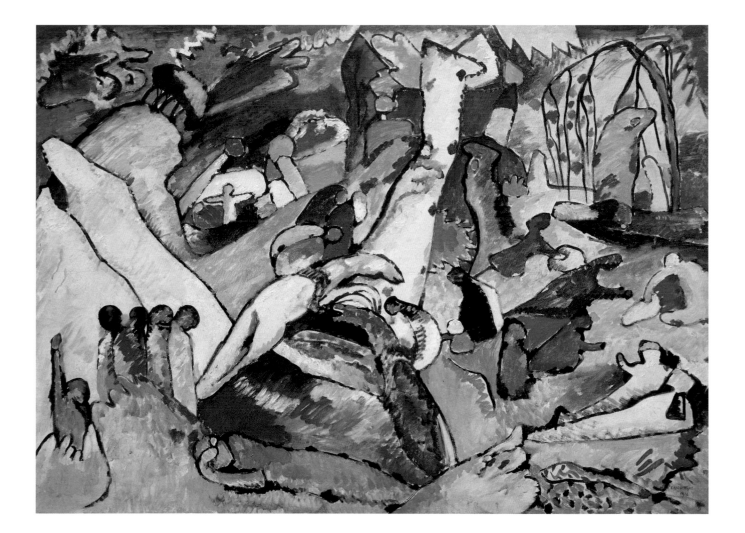

12 *Sketch for Composition II* (*Skizze für Komposition II*), 1909–10
Oil on canvas, 97.5 x 131.2 cm
Solomon R. Guggenheim Museum, New York, Solomon R. Guggenheim Founding Collection 45.961

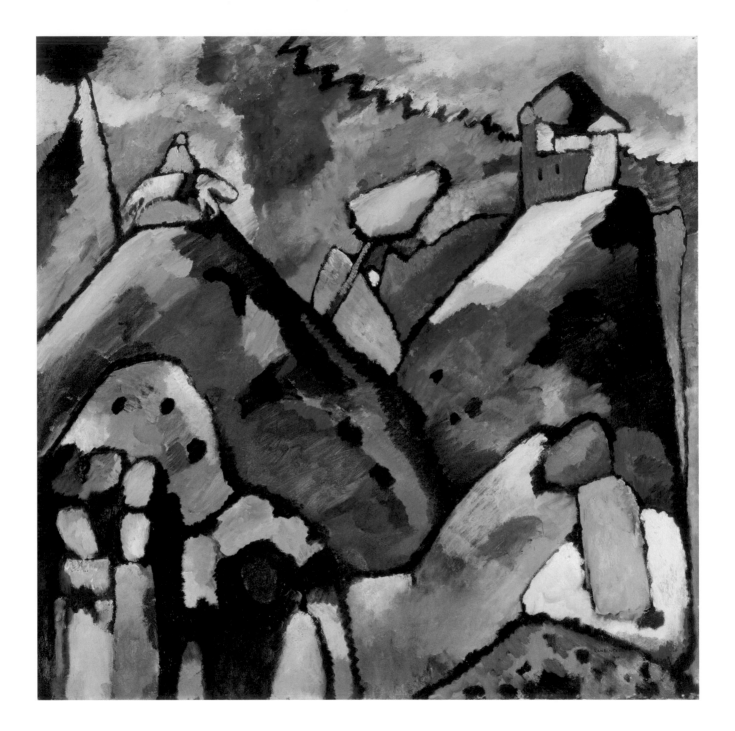

13 *Improvisation 9*, 1910
Oil on canvas, 110 x 110 cm
Staatsgalerie Stuttgart, Germany

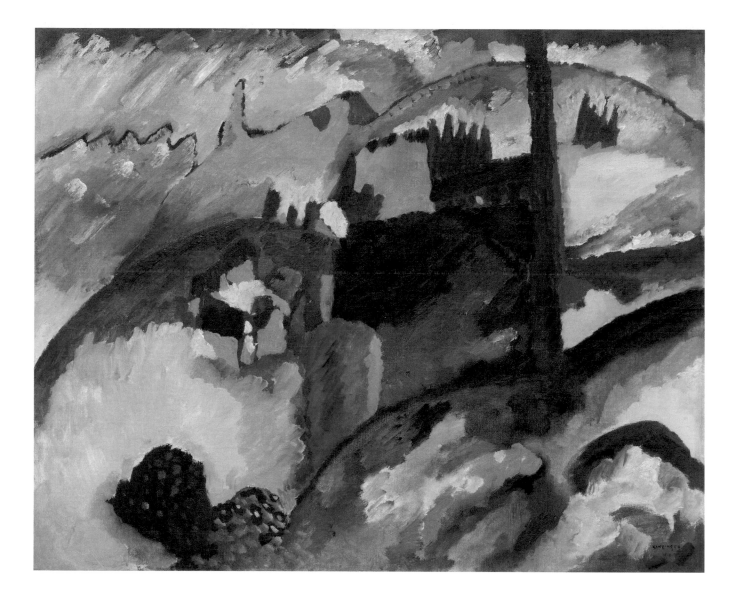

14 *Landscape with Factory Chimney* (*Landschaft mit Fabrikschornstein*), 1910
 Oil on canvas, 66.2 x 82 cm
 Solomon R. Guggenheim Museum, New York, Solomon R. Guggenheim Founding Collection, By gift 41.504

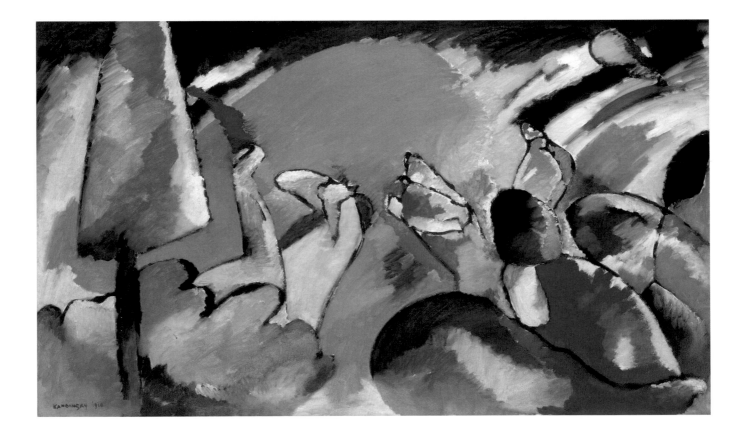

15 *Improvisation 14*, 1910
Oil on canvas, 73 x 125.5 cm
Musée national d'art moderne, Centre Pompidou, Paris, Gift of Nina Kandinsky, 1966

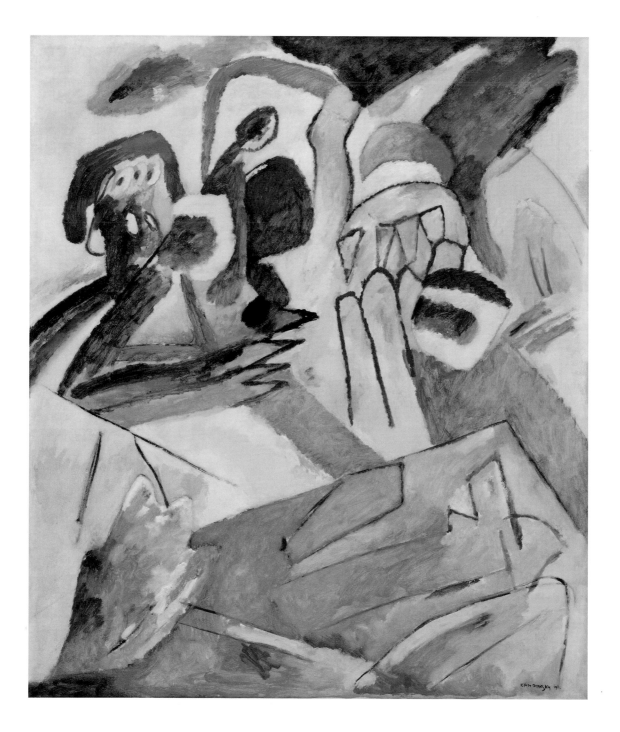

16 *Improvisation 18 (With Tombstone)* (*Improvisation 18 [mit Grabstein]*), March 1911
Oil and tempera on canvas, 141 x 121 cm
Städtische Galerie im Lenbachhaus, Munich, Gabriele Münter-Stiftung, 1957

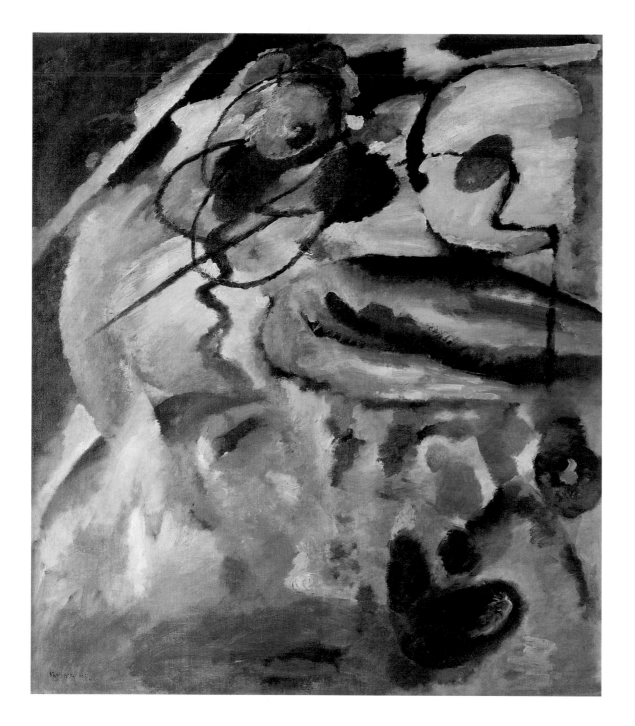

17 *Picture with a Circle* (*Bild mit Kreis*), 1911
Oil on canvas, 139 x 111 cm
Georgian National Museum, Tbilisi

• Kandinsky painted *Impression III (Concert)* (*Impression III [Konzert]*) the day after hearing a January 2, 1911, concert by Arnold Schönberg in Munich. This unique painting shows that the "impression[s] of 'external nature,'" which, according to him, form the basis of his *Impressions* series, could not only be visual, but also acoustic.[1] It is also one of modern art's most outstanding examples of synaesthesia, correspondences between music and painting that other early-twentieth-century artists sought. A dynamic wave of yellow paint flows across the painting from left to right like a great swell of sound that seemingly reverberates to and fro. Above it in the upper half of the painting is an energetic black in a diagonal position. In the preparatory pencil sketches one can clearly decipher the scene with the open, black grand piano as well as the curved backs of the seated listeners and those standing along the wall. The room is divided by two pillars, which in the largely abstract painting seem transposed into white pillars of sound.

In his book *Über das Geistige in der Kunst. Insbesondere in der Malerei* (*On the Spiritual in Art: And Painting in Particular*, 1912), Kandinsky wrote in detail about the correspondences between colors and certain sounds or instruments. Yet in a 1913 supplement for the exhibition catalogue *Kandinsky. Kollektiv-Ausstellung 1902–1912* (*Kandinsky: Retrospective 1902–1912*), he spoke out decisively against the claim by contemporary critics that he painted music: "And finally: I personally am unable to paint music, since I believe any such kind of painting to be basically impossible, basically unattainable."[2]

Still his explorations of these two art forms remain powerful. In *On the Spiritual in Art* he had already explained that, for him, the analogy between painterly art and music was based on the abstract laws of composition that the new, non-figurative painting strove for. In "Rückblicke" ("Reminiscences," 1913), he wrote: "In this respect, painting has caught up with music, and both assume an ever-increasing tendency to create 'absolute' works, i.e., completely 'objective' works that, like the works of nature, come into existence 'of their own accord' as the product of natural laws, as independent beings."[3] – A. H.

1 Vasily Kandinsky, *On the Spiritual in Art* (1912), in Kandinsky, *Kandinsky: Complete Writings on Art*, ed. Kenneth C. Lindsay and Peter Vergo (1982; repr., New York: Da Capo Press, 1994), p. 218.
2 Kandinsky, "Postscript" (1913), in ibid., p. 345.
3 Kandinsky, "Reminiscences" (1913), in ibid., p. 379 n.

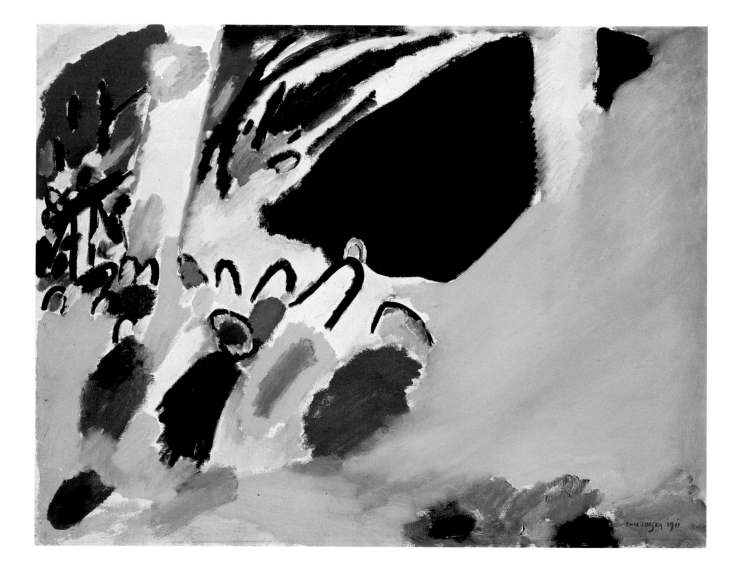

18 *Impression III (Concert)* (*Impression III [Konzert]*), January 1911
Oil and tempera on canvas, 77.5 x 100 cm
Städtische Galerie im Lenbachhaus, Munich, Gabriele Münter-Stiftung, 1957

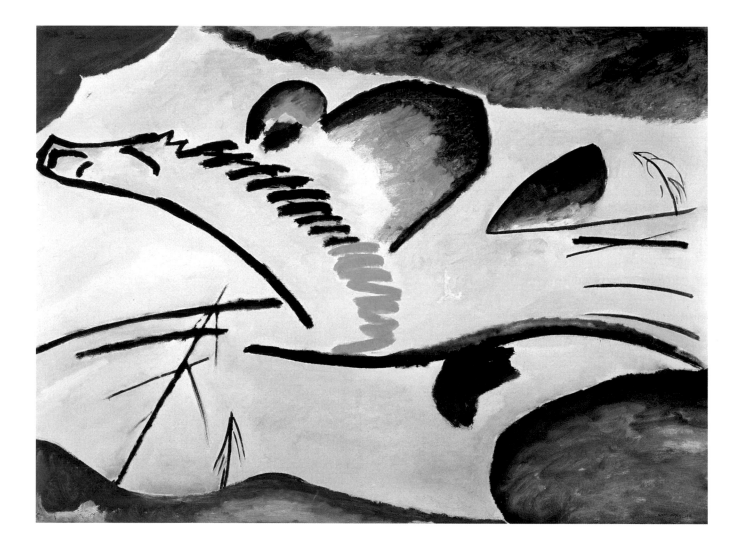

19 *Lyrical* (*Lyrisches*), January 1911
Oil on canvas, 94 x 130 cm
Museum Boijmans Van Beuningen, Rotterdam, Netherlands

• *Romantic Landscape* (*Romantische Landschaft*), designated by Kandinsky as neither part of the *Impressions* nor the *Improvisations* series, is not a straightforward landscape but rather an emotionally and symbolically transformed depiction that constitutes a category of its own. While the form exhibits an openness and spontaneity almost unknown in fine art at the time, the pictorial invention maintains a hermetic magic. Three riders bent over swiftly moving horses charge from right to left down an incline parallel to the picture plane; the tempo and direction of this charge is taken up by the other pictorial elements on the side of the hill and in the sky. The steep brown cliff formation seems like a latent threat, albeit one that the riders will surely storm past, and the dark form on the right that the group has left behind acts as a kind of counterpoint. By contrast, the sweeping, sketchily applied white areas gracefully disperse the elements of the landscape, and the graphic sparsity of means makes the painting an open cosmos full of potential.

Many years later in a letter to his friend, German art historian Will Grohmann, dated November 21, 1925, Kandinsky wrote about the particular idiosyncrasy of this work: "In 1910, if I am not mistaken. I painted a *Romantic Landscape* that had nothing in common with earlier Romanticism. I intend to use such a title again. . . . Where is the boundary line between Lyricism and Romanticism? The circle which I have been using so often of late is nothing if not Romantic. Actually the coming Romanticism is profound, beautiful (the obsolete term 'beautiful' should be restored to usage), meaningful, joy-giving—it is a block of ice with a burning flame inside. If people perceive only the ice and not the flame, that is just too bad. But a few are beginning to grasp."[1] In *Romantic Landscape* with its riders on blue and yellow horses, Kandinsky transposed the mysterious content of his *Improvisations* into the broad space of lyrical freedom. – A. H.

1 Vasily Kandinsky, quoted in Will Grohmann, *Wassily Kandinsky: Life and Work*, trans. Norbert Guterman (New York: Harry N. Abrams, 1958), p. 180.

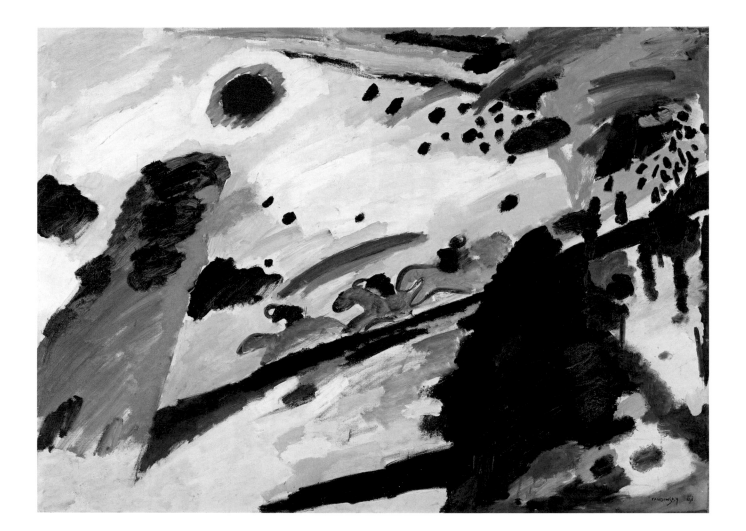

20 *Romantic Landscape* (*Romantische Landschaft*), January 1911
Oil and tempera on canvas, 94.3 x 129 cm
Städtische Galerie im Lenbachhaus, Munich, Gabriele Münter-Stiftung, 1957

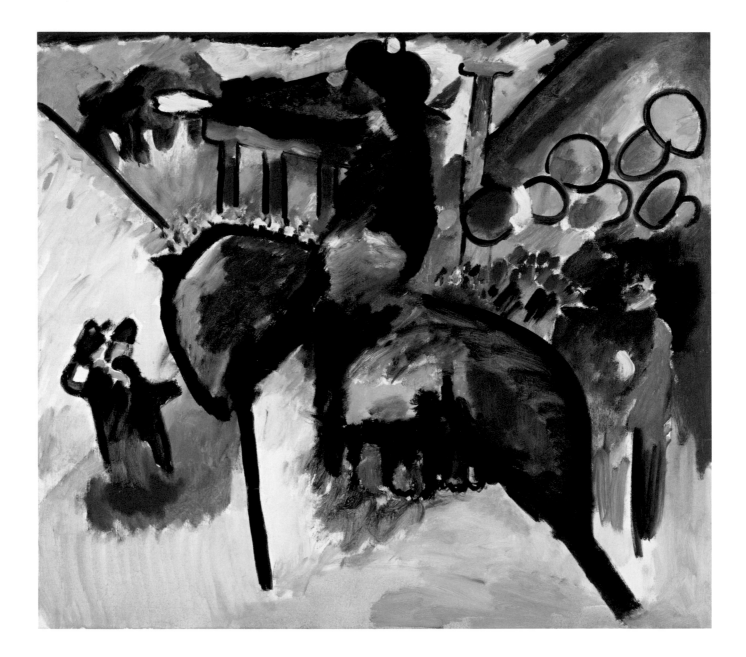

21 *Impression IV (Policeman)* (*Impression IV [Gendarme]*), March 1911
Oil and tempera on canvas, 95 x 107.5 cm
Städtische Galerie im Lenbachhaus, Munich, Gabriele Münter-Stiftung, 1957

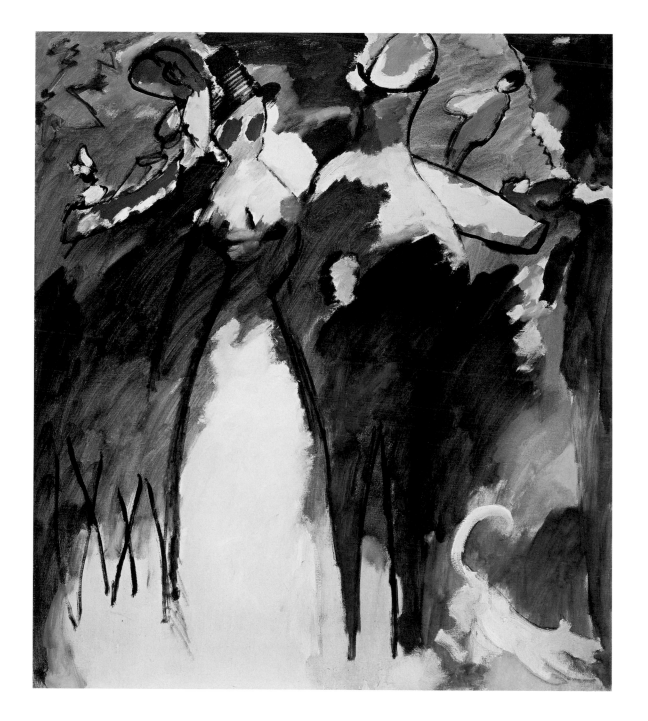

22 *Impression VI (Sunday)* (*Impression VI [Sonntag]*), March 1911
Oil and tempera on canvas, 107.5 x 95 cm
Städtische Galerie im Lenbachhaus, Munich, Gabriele Münter-Stiftung, 1957

• *Improvisation 19* clarifies an important aspect of Kandinsky's work. Sixten Ringbom and other researchers have shown that the artist was deeply involved with Theosophical and mystical ideas in the years before World War I. He knew the works of Helena Blavatsky and Edouard Schuré as well as Annie Besant and C. W. Leadbeater's classic book *Thought-Forms* (1905). He was also aware of Rudolf Steiner's lectures and was in contact with the circle around author Karl Wolfskehl and philosopher Ludwig Klages in Munich and with neurologist Albert von Schrenck-Notzing, who also focused on extrasensory perceptions and parapsychology. Kandinsky found in these writers' illustrated books inspiration for forms that suited his endeavor to express the immaterial.

It seems as if an unknown ritual occurs in *Improvisation 19*, a kind of initiation and enlightenment of figures who can be understood as novices. One sees translucent figures outlined only in black. On the left a procession of smaller forms presses forward to the front, followed by shades of color. The largest part of the painting, however, is filled with a wonderful, supernatural blue, which also shines through the group of figures shown in profile on the right, who seem to move toward a goal outside the painting. The spiritual impact of these long, totally incorporeal figures draws both on their uniformity (that is, they are all the same height, as in Byzantine pictures of saints) and on the fact that the deep blue, almost violet shade in their heads may symbolize extinction or transition. An elongated, rounded shape projects into the painting from above, its diaphanous colors surrounded by a strong black border. Like the other color phenomena in this work, it represents an aura of forms of thought and sense. This work underscores Kandinsky's almost messianic expectation of salvation through painting. — A. H.

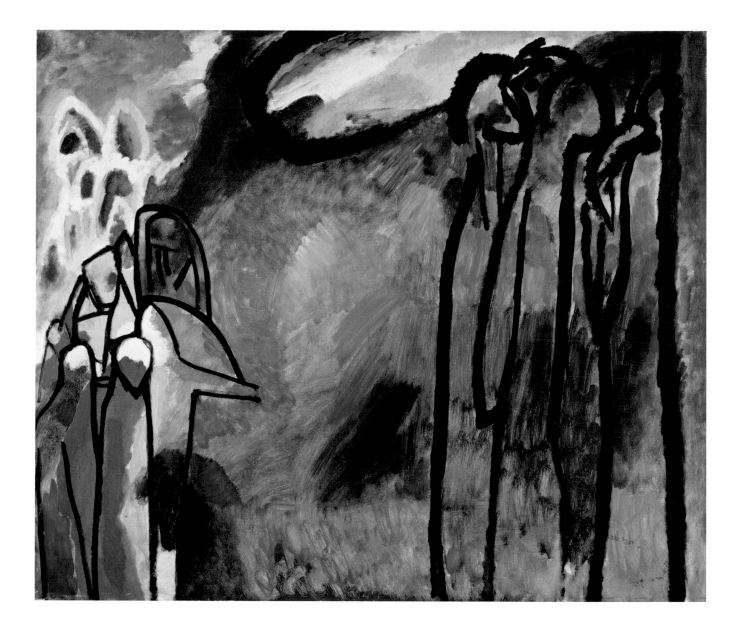

23 *Improvisation 19*, March 1911
 Oil and tempera on canvas, 120 x 141.5 cm
 Städtische Galerie im Lenbachhaus, Munich, Gabriele Münter-Stiftung, 1957

• In addition to the Christian motifs of All Saints' Day and the Last Judgment, which found their way into Kandinsky's symbolic vocabulary around 1911, the figure of Saint George also gained importance. Kandinsky heightened the dragon slayer into a universal, metaphoric figure: vanquisher of materialism and herald of a spiritual message. Alongside three glass paintings, one of which is almost identical with the famous woodblock print on the cover of *Der Blaue Reiter* (*The Blaue Reiter Almanac*, 1912), he painted three large oils on this theme, all of which have a hallucinatory quality. *St George I* (*St Georg I*, 1911) shows the saint in schematic form as he pierces the dragon in a numinous white mountain setting. *St George II* (*St Georg II*, 1911) transforms the horse and rider into an almost abstract pattern behind an expressive diagonal, formed by the lance. In *St George III* (*St Georg III*) the knight is hardly recognizable; forced to the painting's left edge, he drives a vertical lance into the snout of the dragon lying below him. Because of the bright, white-infused colors of its body—white is also dominant in the background despite the stronger colors—the dragon seems to merge into its surroundings, as if dissolving.

In his *book Über das Geistige in der Kunst. Insbesondere in der Malerei* (*On the Spiritual in Art: And Painting in Particular*, 1912), Kandinsky says that the color white does not occur in nature, and if used in art, it is to "represent nature" as an "inner impression."[1] There seems to be a secret relationship between the charisma of battle, downfall, and salvation, which his depictions of Saint George radiate, and the ecstatic zone of white. "White, which is often regarded as a noncolor, . . . is like the symbol of a world where all colors, as material qualities and substances, have disappeared. This world is so far above us that no sound from it can reach our ears. We hear only a great silence that, represented in material terms, appears to us like an insurmountable, cold indestructible wall, stretching away to infinity. For this reason, white also affects our psyche like a great silence. . . . It is a silence that is not dead, but full of possibilities. White has the sound as of a silence that suddenly becomes comprehensible."[2] – A. H.

1 Vasily Kandinsky, *On the Spiritual in Art* (1912), in Kandinsky, *Kandinsky: Complete Writings on Art*, ed. Kenneth C. Lindsay and Peter Vergo (1982; repr., New York: Da Capo Press, 1994), p. 185 n.
2 Ibid., pp. 183–85.

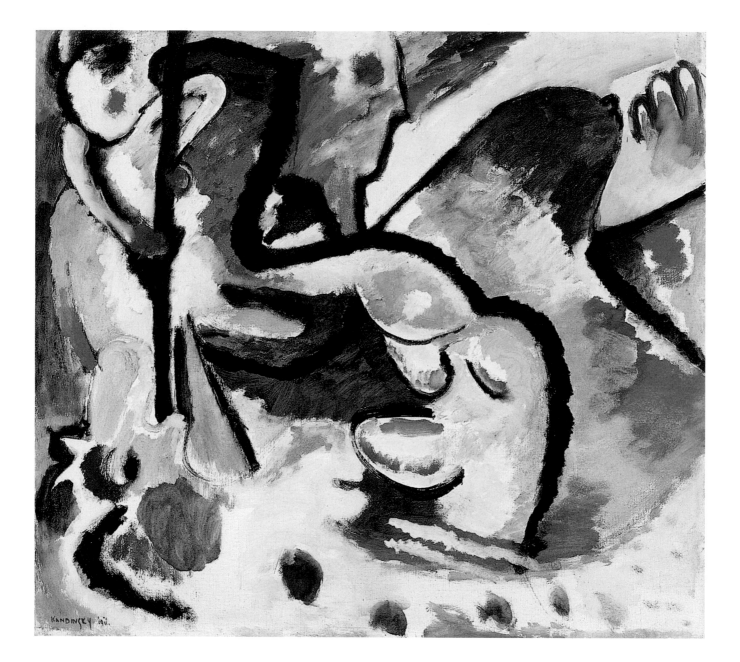

24 *St George III* (*St Georg III*), March 1911
 Oil and tempera on canvas, 97.5 x 107.5 cm
 Städtische Galerie im Lenbachhaus, Munich, Gabriele Münter-Stiftung, 1957

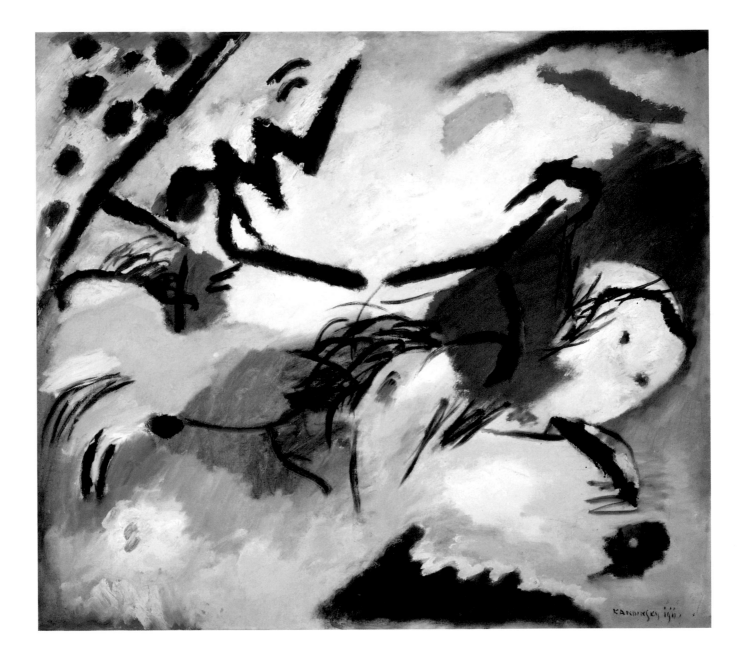

25 *Improvisation 20*, April 1911
Oil on canvas, 94.5 x 108 cm
The State Pushkin Museum of Fine Arts, Moscow

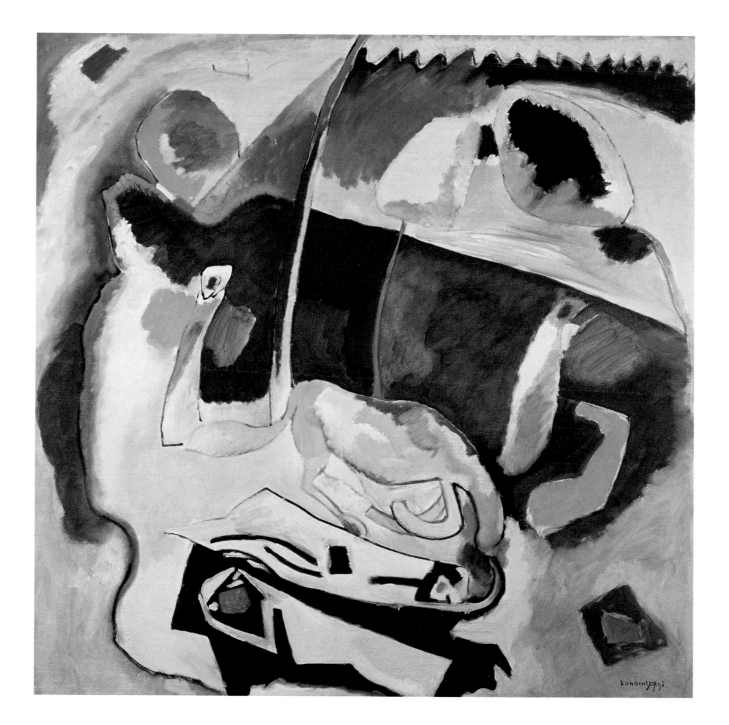

26 *Improvisation 21*, October 1911
 Oil and tempera on canvas, 108 x 108 cm
 Franz Marc Museum, Kochel am See, Germany, on permanent loan

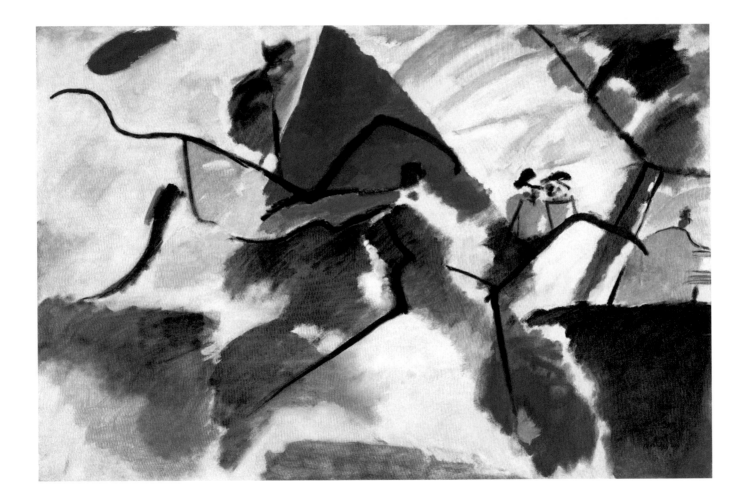

27 *Impression V (Park)*, March 1911
Oil on canvas, 106 x 157.5 cm
Musée national d'art moderne, Centre Pompidou, Paris, Gift of Nina Kandinsky, 1976

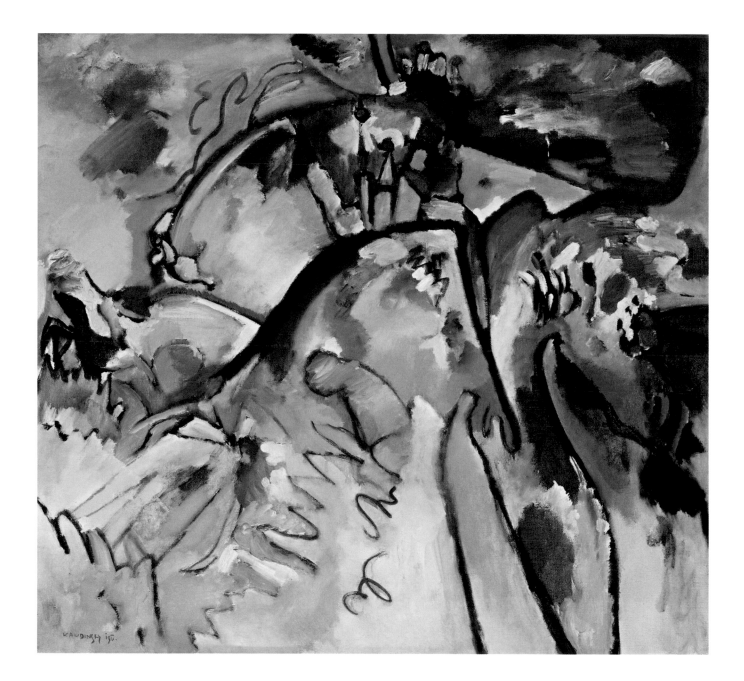

28 *Improvisation 21A*, 1911
 Oil and tempera on canvas, 96 x 105 cm
 Städtische Galerie im Lenbachhaus, Munich, Gabriele Münter-Stiftung, 1957

29 *Improvisation 26 (Rowing)* (*Improvisation 26 [Rudern]*), 1912
Oil and tempera on canvas, 97 x 107.5 cm
Städtische Galerie im Lenbachhaus, Munich, Gabriele Münter-Stiftung, 1957

30 *Improvisation 27 (Garden of Love II)* (*Improvisation 27 [Garten der Liebe II]*), 1912
 Oil on canvas, 120.3 x 140.3 cm
 The Metropolitan Museum of Art, New York, Alfred Stieglitz Collection, 1949

• The black arc is a symbol that relates to the *douga*, the Russian term for the part of a horse's harness made from elm wood that also signifies a yoke, or more generally, an arc. This same douga reappears in the corner of *In Gray* (*V Serom*, 1919, plate 50), which Kandinsky had initially titled *With the Black Arc*.

The work is surprising in two ways. When he painted his large-scale *Compositions* series, he preferred rectangular supports. While it was not uncommon in those years for Kandinsky to use an almost square canvas, he never used one so large as for *Painting with a Black Arch* (*Bild mit schwarzem Bogen*). It is also striking that the artist did not have it reproduced in *Kandinsky 1901–1913. Album*, produced by Der Sturm gallery in Berlin, for on September 20, 1912, he wrote to Herwarth Walden, the director of the gallery and affiliated magazine, to suggest that it be shown in that exhibition in place of *Improvisation 27 (Garden of Love II)* (*Improvisation 27 [Garten der Liebe II]*, 1912, plate 30). Furthermore, on September 27, he proposed the extremely modest selling price of 1,500 marks.

Later the painting disappeared, undoubtedly part of the transaction, which caused friction between Kandinsky and his then-companion, artist Gabriele Münter. It appears in the background of a photograph of Kandinsky and Paul Klee taken in 1926 in Dessau, Germany, at the local Kunsthalle (art gallery), which he was using as a temporary studio. In his inventory, Kandinsky notes that it was on loan to the König Albert Museum in Zwickau, Germany, in October 1926. It can be seen again in another photograph, this time in the house that Kandinsky and his wife Nina rented for a few months in 1932 on the southern outskirts of Berlin. It was then loaned to the 1933 Salon des Surindépendants at the Porte de Versailles in Paris, where it was included in the Surrealist section. It triumphed as the replacement for *Composition IV* (*Komposition IV*, 1911), which the Jeu de Paume curator André Dézarrois chose as the centerpiece of a major 1937 exhibition and was—despite the painter's wishes—reproduced as a full page for the first time in Christian Zervos's *Histoire de l'art contemporain, de Cézanne à nos jours* (The History of Contemporary Art, from Cézanne to Today) in 1938. After the war, it became the emblematic masterpiece of Nina Kandinsky's collection until she donated it in 1976 to the Centre Pompidou. – Christian Derouet

31 *Painting with a Black Arch* (*Bild mit schwarzem Bogen*), autumn 1912
Oil on canvas, 188 x 196 cm
Musée national d'art moderne, Centre Pompidou, Paris, Gift of Nina Kandinsky, 1976

• By 1911, a year of remarkably fecund activity, Kandinsky had written his seminal treatise *Über das Geistige in der Kunst. Insbesondere in der Malerei* (*On the Spiritual in Art: And Painting in Particular*, 1912), in which he proclaimed his philosophical, artistic, and spiritual ideas outlining a language of form, color, and their effects on one another. He had also painted several of his *Impressions*, among other important works. In 1912, a year no less creative thanks to the development of major themes in his art, Kandinsky edited, with Franz Marc, *Der Blaue Reiter* (*The Blaue Reiter Almanac*) and finished *Klänge* (*Sounds*), his volume of lyrical prose poems and woodcuts. The second exhibition of Der Blaue Reiter (The Blue Rider), the group he and Marc had founded, took place at Galerie Hans Goltz in Munich.

Kandinsky described his *Improvisations* series as manifestations of events of an inner spiritual character. With *Improvisation 28 (Second Version)* (*Improvisation 28 [zweite Fassung]*), a foremost painting from 1912 and possibly a version of an unlocated earlier work, the artist's style had become more abstract and nearly schematic in its spontaneity. In the years preceding World War I, Kandinsky and other artists investigated abstraction in part out of an interest in the soul and life after death. This painting's sweeping curves and forms, which dissolve significantly but remain vaguely recognizable, seem to reveal apocalyptic events on the left and symbols of hope and redemption on the right; the latter are exemplified by what appears to be a church or tower in the canvas's top-right corner. – K. V.

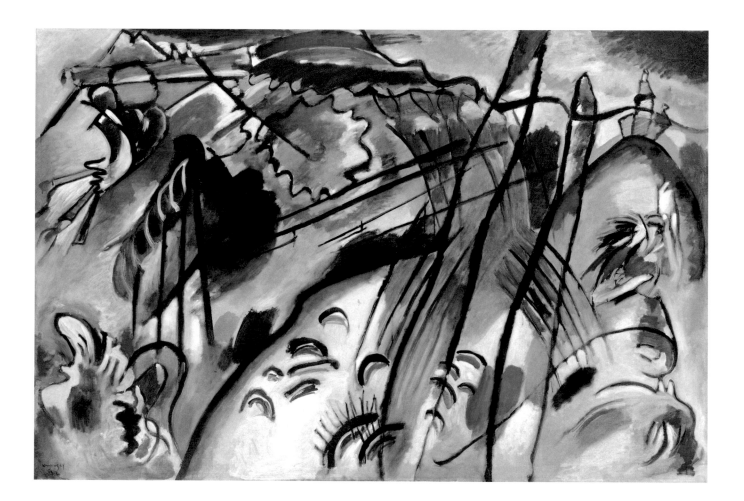

32 *Improvisation 28 (Second Version)* (*Improvisation 28 [zweite Fassung]*), 1912
Oil on canvas, 111.4 x 162.1 cm
Solomon R. Guggenheim Museum, New York, Solomon R. Guggenheim Founding Collection, By gift 37.239

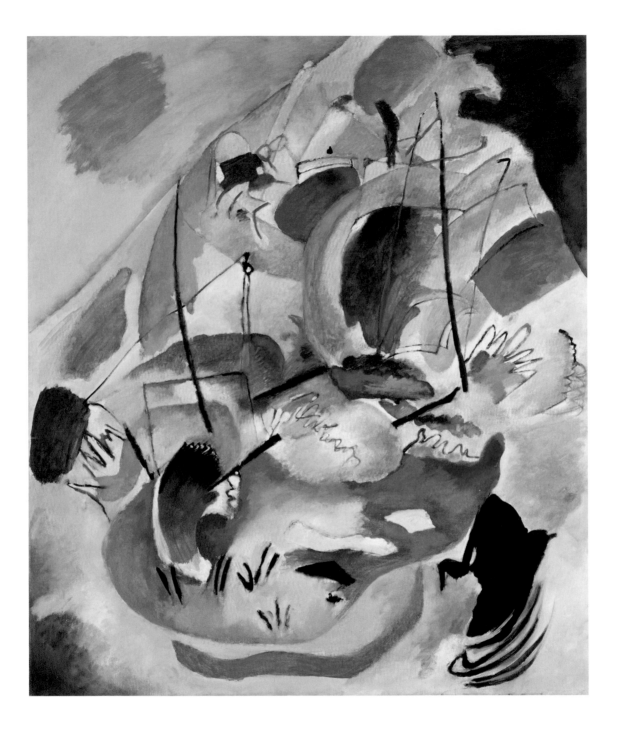

33 *Improvisation 31 (Sea Battle)* (*Improvisation 31 [Seeschlacht]*), 1913
 Oil on canvas, 140 x 120 cm
 National Gallery of Art, Washington, D.C., Ailsa Mellon Bruce Fund, 1978

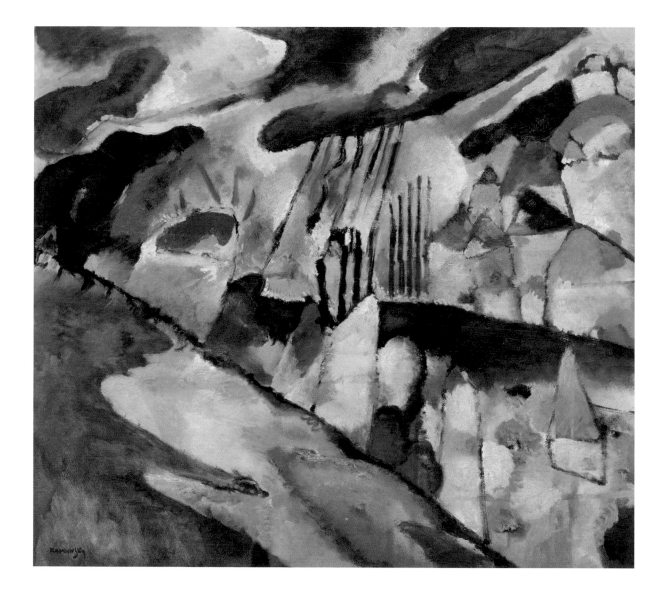

34 *Landscape with Rain* (*Landschaft mit Regen*), January 1913
Oil on canvas, 70.2 x 78.1 cm
Solomon R. Guggenheim Museum, New York, Solomon R. Guggenheim Founding Collection 45.962

• "For this picture, I made numerous designs, sketches, and drawings," Kandinsky wrote about *Painting with White Border (Moscow)* (*Bild mit weißem Rand [Moskau]*) in 1913, later making a surprising reference to the impression made by his hometown: "I made the first design immediately after my return from Moscow in December 1912. It was the outcome of those recent, as always extremely powerful, impressions I had experienced in Moscow—or more correctly, of Moscow itself. This first design was very concise and restricted. But already in the second design, I succeeded in 'dissolving' the colors and forms of the actions taking place in the lower right-hand corner. In the upper left remained the troika motif, which I had long since harbored within me and which I had already employed in various drawings."[1] Only the troika motif is explained in greater detail: "This is what I call the three lines, curved at the top, which, with different variations, run parallel to one another. The lines of the backs of the three horses in a Russian troika led me to adopt this form."[2] Just as important is the white curved form at the center with a white ray pointing to the left in a powerful diagonal. Kandinsky did not even mention it though he did a large number of individual studies for it. Many interpreters have read it as the Saint George figure, on horseback and crossing the composition with his white lance.

For the artist, formal references became increasingly important as carriers of meaning. He spoke of "clarity and simplicity in the upper left-hand corner, blurred dissolution, with smaller dissolved forms vaguely seen in the lower right. And as often with [him], two centers."[3] Kandinsky finally talked about the title: "Thus, it was not until after nearly five months that I was sitting looking in the twilight at the second large-scale study, when it suddenly dawned on me what was missing—the white edge. . . . I treated this white edge in the same capricious way it had treated me: in the lower left a chasm, out of which rises a white wave that suddenly subsides, only to flow around the right-hand side of the painting in lazy coils, forming in the upper right a lake (where the black bubbling comes about), disappearing toward the upper left-hand corner, where it makes its last, definitive appearance in the picture in the form of a white zigzag. Since this white edge proved the solution to the picture, I named the whole picture after it."[4] – A. H.

1 Vasily Kandinsky, "Reminiscences" (1913), in Kandinsky, *Kandinsky: Complete Writings on Art*, ed. Kenneth C. Lindsay and Peter Vergo (1982; repr., New York: Da Capo Press, 1994), p. 389.
2 Ibid., p. 389 n.
3 Ibid., p. 390.
4 Ibid., p. 391.

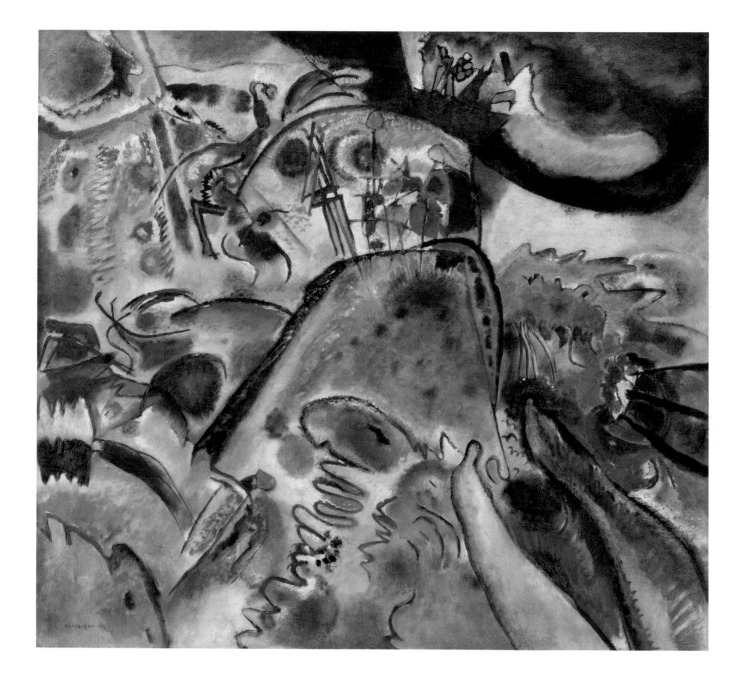

36 *Small Pleasures* (*Kleine Freuden*), June 1913
Oil on canvas, 109.8 x 119.7 cm
Solomon R. Guggenheim Museum, New York, Solomon R. Guggenheim Founding Collection 43.921

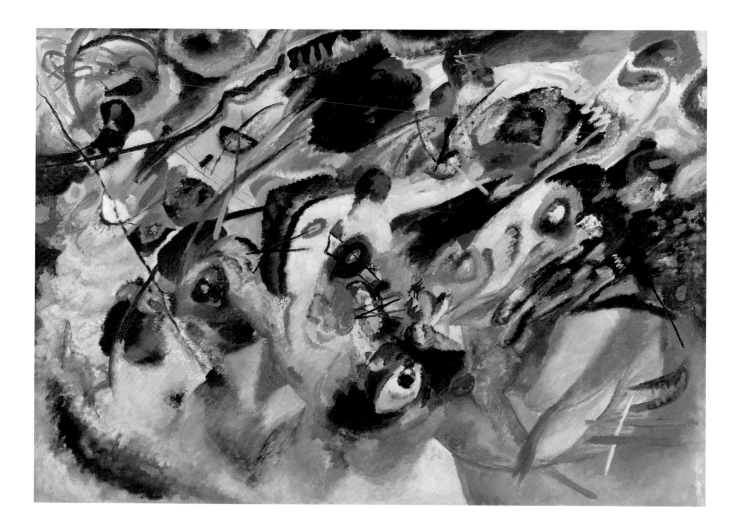

37 *Sketch 2 for Composition VII* (*Entwurf 2 zu Komposition VII*), 1913
 Oil and tempera on canvas, 100 x 140 cm
 Städtische Galerie im Lenbachhaus, Munich, Gabriele Münter-Stiftung, 1957

• Although *Light Picture* (*Helles Bild*) is one of the paintings of 1913 that Kandinsky described as having "nothing whatever to do with an object," it is tempting to find remnants of landscape references in this work.[1] In fact, he was not intent on discarding objects completely, particularly at this stage. Composed of hovering black lines and bright colors, *Light Picture* is a delicate and lyrical canvas. Looking more like a drawing or even a colored etching, it exudes an ethereal quality and a levity of spirit quite different from the artist's other works of this period when he was battling his way toward abstraction. This painting may represent a moment of joyful respite before his imminent departure from Germany to Russia and eventual changes in his personal circumstances. Moreover, 1913 was a productive and intense year. His works were exhibited at the *International Exhibition of Modern Art* (popularly known as the Armory Show) in New York, thereby gaining entry into American collections, including that of Edwin Campbell, who in 1914 commissioned four wall panels for his New York apartment. Kandinsky's work was shown regularly at Der Sturm, the Berlin gallery that published *Kandinsky 1901–1913. Album* containing his candid recollections of his early life in Russia titled "Rückblicke" ("Reminiscences," 1913) and short texts about several recent canvases in which he expounded on the difficulties of painting. – K.V.

1 Vasily Kandinsky to Hilla Rebay, December 16, 1936, quoted in Angelica Zander Rudenstine, *The Guggenheim Museum Collection: Paintings 1880–1945*, vol. 1 (New York: Solomon R. Guggenheim Foundation, 1976), p. 274.

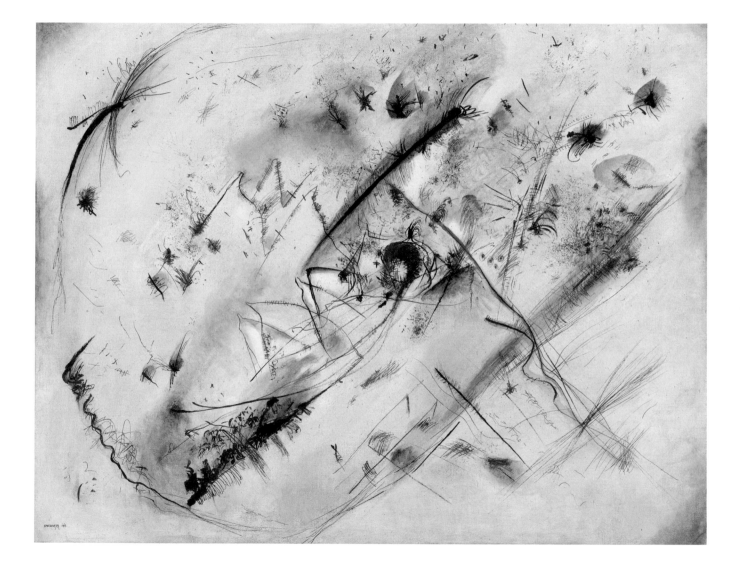

38 *Light Picture* (*Helles Bild*), December 1913
Oil on canvas, 77.8 x 100.2 cm
Solomon R. Guggenheim Museum, New York, Solomon R. Guggenheim Founding Collection, By gift 37.244

• One of the last works Kandinsky painted in Munich in 1913, *Black Lines* (*Schwarze Linien*) was also one of the earliest nonobjective works in his attempt to attain pure, lyrical abstraction or absolute painting. The artist expressed such concerns in a speech he prepared but never gave (later called "Kandinsky über seine Entwicklung" ["Cologne Lecture"]) for the opening of a solo exhibition in Cologne in January 1914, when the work was first shown. The composition, with its delicate filigree of intertwined lines, has no ties to the material world. The expressiveness and brilliance of the overlapping organic shapes of color and black graphic lines conjure a dynamic, floating puzzle or tapestry. Primary and complimentary splashes of color give the illusion of rapid movement, as if they strive to become circles, a feature that becomes prominent in the artist's work some ten years later. The year 1914 was a period of powerful creativity, but one that was soon marred by personal suffering and difficult political circumstances that eventually drove Kandinsky to return to Moscow from his base in Munich at the outbreak of World War I. During the years he remained in Russia, he produced very few paintings and was devoted largely to teaching and museum reform. – K. V.

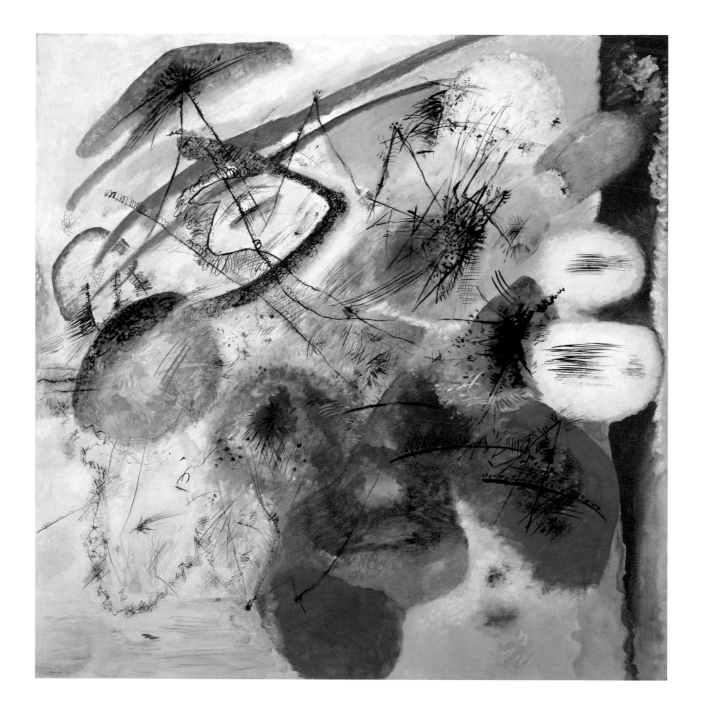

39 *Black Lines* (*Schwarze Linien*), December 1913
Oil on canvas, 129.4 x 131.1 cm
Solomon R. Guggenheim Museum, New York, Solomon R. Guggenheim Founding Collection, By gift 37.241

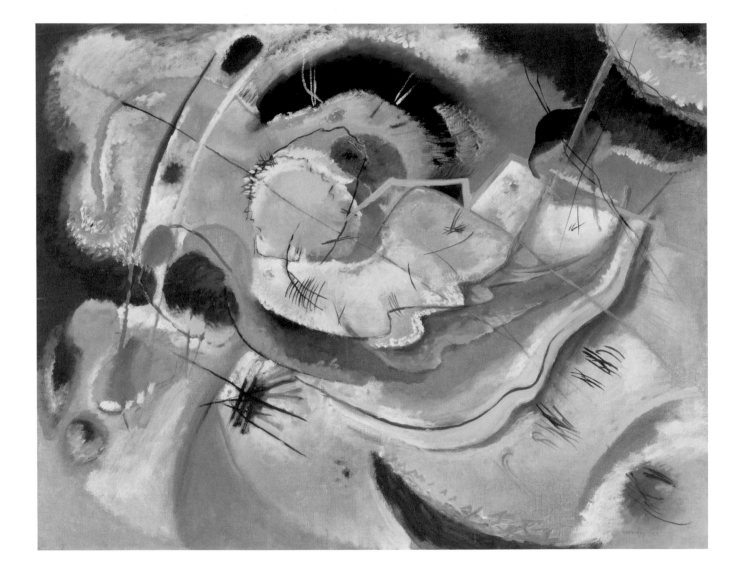

40 *Little Painting with Yellow* (*Kleines Bild mit Gelb*), February 1914
Oil on canvas, 78 x 100 cm
Philadelphia Museum of Art, The Louise and Walter Arensberg Collection, 1950

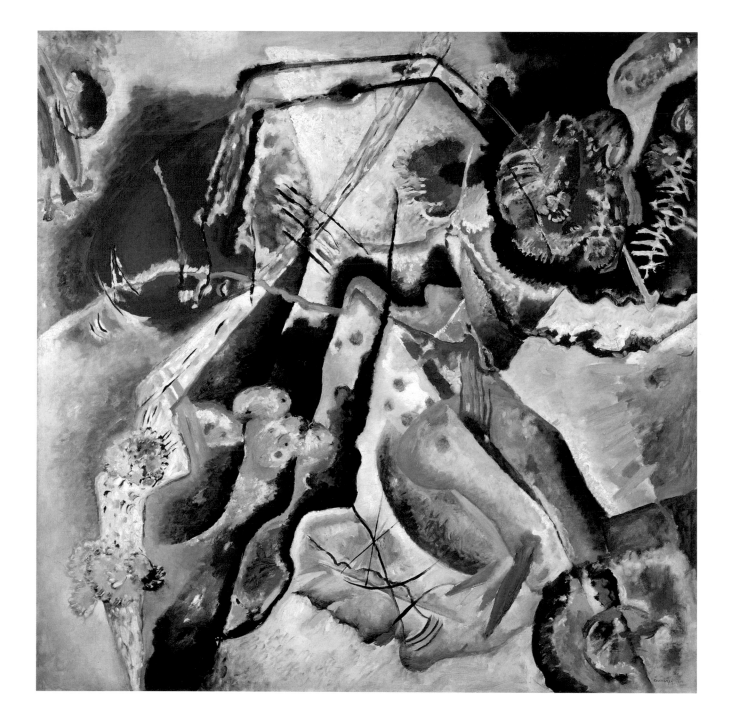

41 *Painting with Red Spot* (*Bild mit rotem Fleck*), February 1914
Oil on canvas, 130 x 130 cm
Musée national d'art moderne, Centre Pompidou, Paris, Gift of Nina Kandinsky, 1976

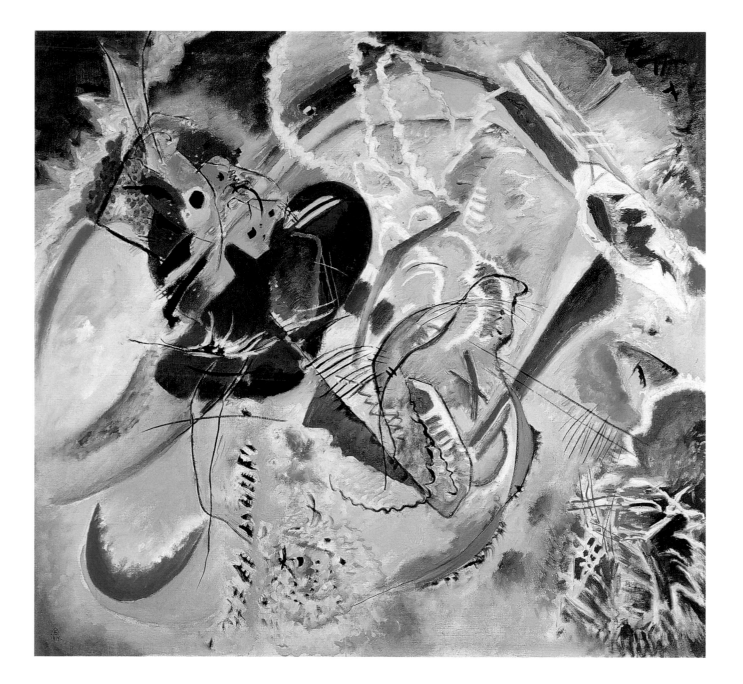

42 *Improvisation 35*, May 1914
Oil on canvas, 110 x 120 cm
Kunstmuseum und Museum für Gegenwartskunst, Basel

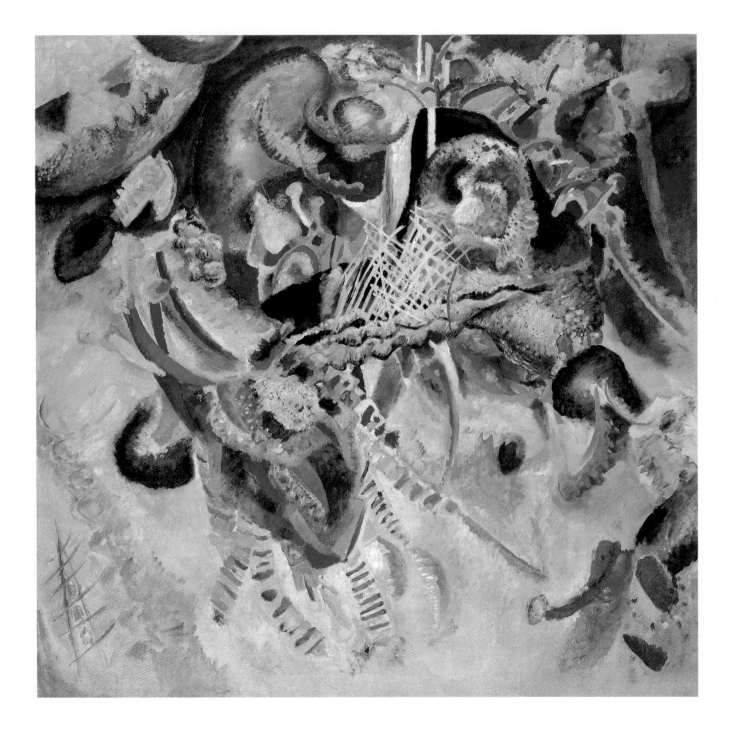

43 *Fugue* (*Fuga*), 1914
Oil on canvas, 129.5 x 129.5 cm
Fondation Beyeler, Riehen/Basel

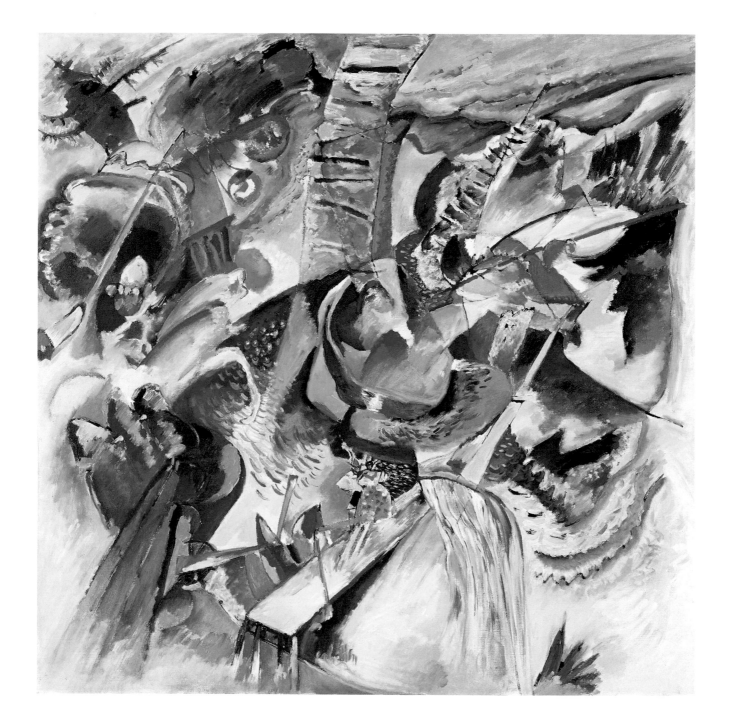

44 *Improvisation Gorge* (*Improvisation Klamm*), 1914
Oil and tempera on canvas, 110 x 110 cm
Städtische Galerie im Lenbachhaus, Munich, Gabriele Münter-Stiftung, 1957

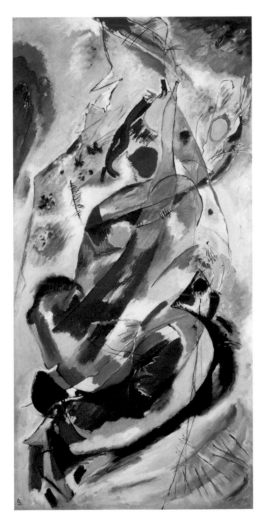

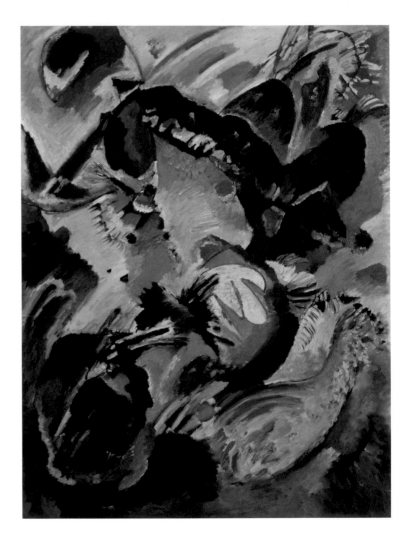

45a *Panel for Edwin R. Campbell, No. 1*, 1914
Oil on canvas, 162.5 x 80 cm
The Museum of Modern Art, New York,
Mrs. Simon Guggenheim Fund

45b *Panel for Edwin R. Campbell, No. 2*, 1914
Oil on canvas, 162.6 x 122.7 cm
The Museum of Modern Art, New York, Nelson A. Rockefeller Fund
(by exchange)

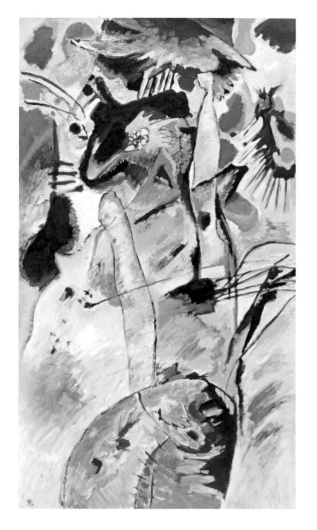

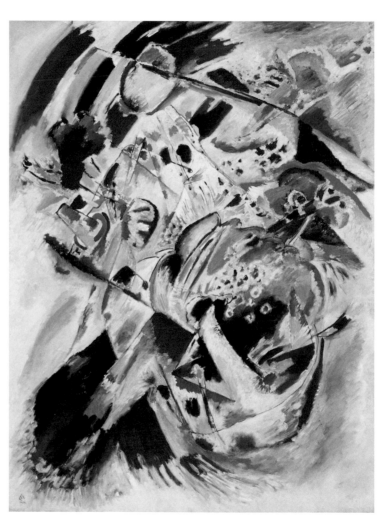

45c *Panel for Edwin R. Campbell, No. 3*, 1914
Oil on canvas, 162.5 x 92.1 cm
The Museum of Modern Art, New York,
Mrs. Simon Guggenheim Fund

45d *Panel for Edwin R. Campbell, No. 4*, 1914
Oil on canvas, 163 x 122.5 cm
The Museum of Modern Art, New York, Nelson A. Rockefeller Fund
(by exchange)

MOSCOW AND STOCKHOLM

1914-21

• *Painting on Light Ground (Na Svetlom Fone)* is one of three works that Kandinsky made during his stay in Sweden, having taken up his brush after a long break that had begun in August 1914. He arrived in Stockholm from Moscow in December 1915 and stayed there with his companion, the artist Gabriele Münter, for three months—the last time they would be together. The picture shows with unusual clarity Kandinsky's examination of the border motif that occupied him so intensely in those years. As if seen through a kaleidoscope and strangely pushed into the background, a configuration of quasi-landscape compositions appears in vivid but subdued colors as an inner zone on the light ground, which is surrounded by a brown border. The artist enclosed the colored forms in a type of cave, in which they appear to pivot on themselves, while a preparatory pencil sketch indicates two colliding and diverging upward movements and, on the right, a downward motion. Elements that once operated independently, such as the mysteriously alive, tentacle-like landscape motifs, are here carried off to the picture within a picture, as if in one's memory. Accordingly, this painting turns its back on Kandinsky's Munich years as it prefigures the encapsulation of different elements in the biomorphic forms that one finds in his later output. – A. H.

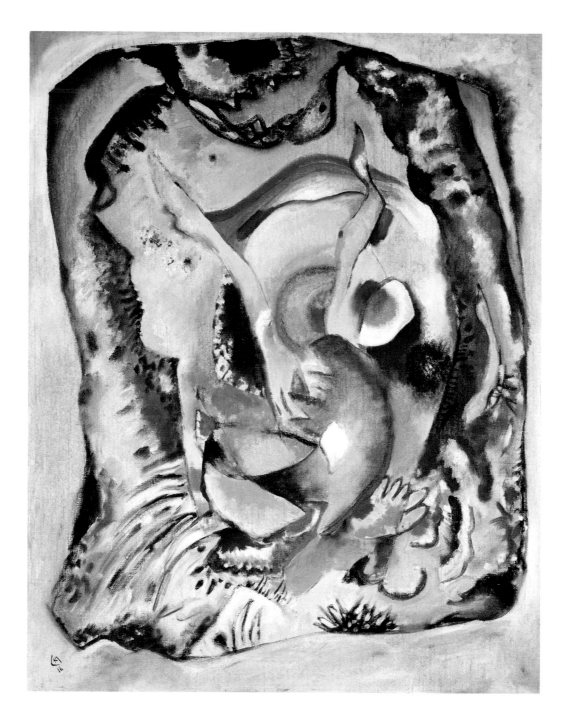

46 *Painting on Light Ground* (*Na Svetlom Fone*), 1916
Oil on canvas, 100 x 78 cm
Musée national d'art moderne, Centre Pompidou, Paris, Gift of Nina Kandinsky, 1976

• In a June 4, 1916, letter written from Moscow after an evening stroll to the Kremlin, Kandinsky told his former companion, artist Gabriele Münter, about his rewoken creative powers: "Finally, yesterday, I got them back again. I would like to do a big Moscow landscape—gather the parts from everywhere and unite them in a single picture, weak and strong elements, everything mixed together, just as the world itself is composed of varied parts. It must be like an orchestra. I feel the general idea, but the broad composition is not yet clear. At 8 in the evening I went to the Kremlin in order to see the churches from the viewpoint which I need for the picture. And new riches opened up before my eyes. Back in Sobovskaya I have so far done a painted sketch, which isn't bad."[1] However, for a few more months Kandinsky wrestled with this pictorial idea, especially with the effect of depth built up in different spatial layers. On September 4 he wrote: "I am working again on my painting 'Moscow.' It is slowly taking shape in my imagination. And what was in the realm of wishing is now assuming real forms. What I have been lacking with this idea was depth and richness of sound, very earnest, complex, and easy at the same time."[2] (The letters were originally written in French, the language that Kandinsky in Moscow and Münter in Sweden used in their correspondence during World War I to circumvent the censors.) In the final painting Moscow I (Mockba I), his vision is caught up in an eruptive pictorial happening: "He composes a shimmering whole, capturing the essence of a town in blue color formations. Kaleidoscope-like, a panorama radiates out from the central mountaintop, which is crowned by towers and aspiring buildings; one can see extensive clusters of houses, churches with onion domes, and in-between them big, wide surfaces. Somehow weightless and spaceless, the vision of Moscow hovers in the picture," which is spread out before a little couple in Bavarian costume on the summit in the center.[3] – A. H.

1 Vasily Kandinsky to Gabriele Münter, June 4, 1916, quoted in Hans K. Roethel and Jean K. Benjamin, *Kandinsky: Catalogue Raisonné of the Oil Paintings, Volume Two, 1916–1944* (Ithaca, N.Y.: Cornell University Press, 1984), p. 580.
2 Vasily Kandinsky to Gabriele Münter, September 4, 1916, quoted in ibid., p. 580.
3 *Wassily Kandinsky. Der Klang der Farbe, 1900–1921*, exh. cat. BA-CA Kunstforum, Vienna; Von-der-Heydt-Museum, Wuppertal, Germany (Bad Breisig, Germany: Palace Editions Europe, 2004), p. 112. Translated by Sarah Kane, Watford, England.

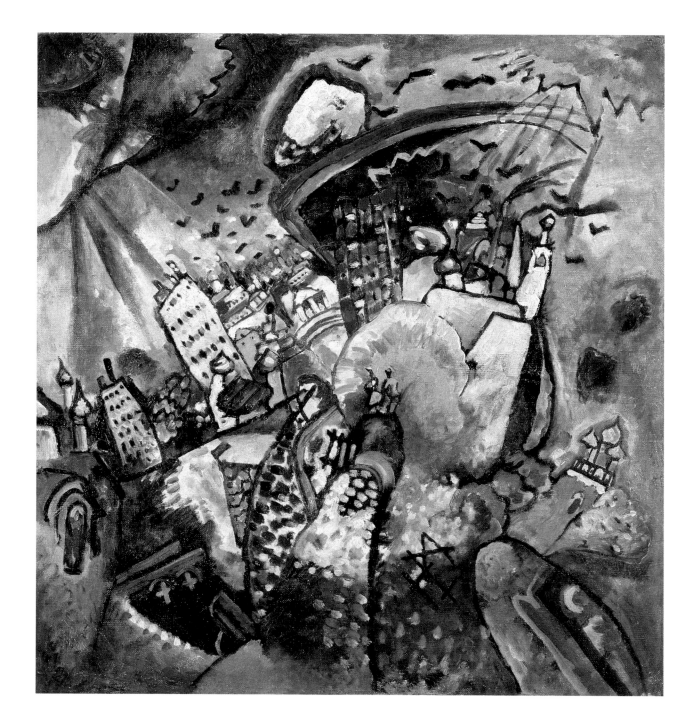

47 *Moscow I* (*Mockba I*), 1916
Oil on canvas, 51.5 x 49.5 cm
The State Tretyakov Gallery, Moscow

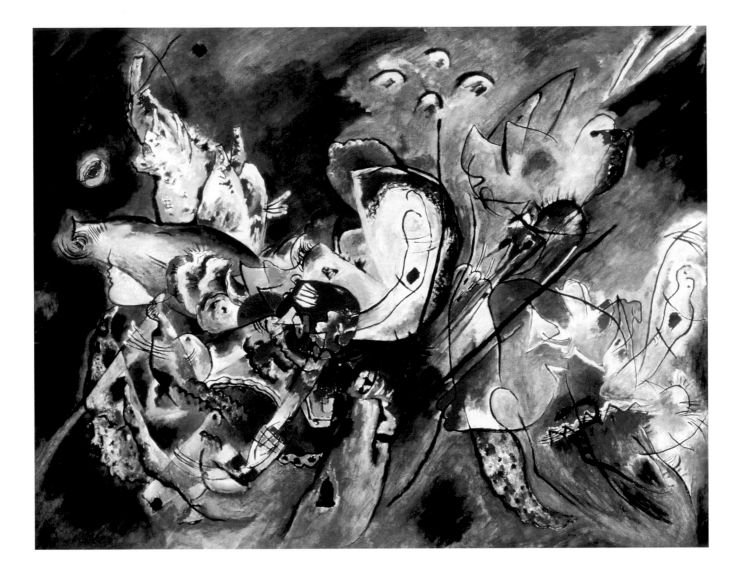

48 *Overcast* (*Smutnoe*), September 1917
Oil on canvas, 105 x 134 cm
The State Tretyakov Gallery, Moscow

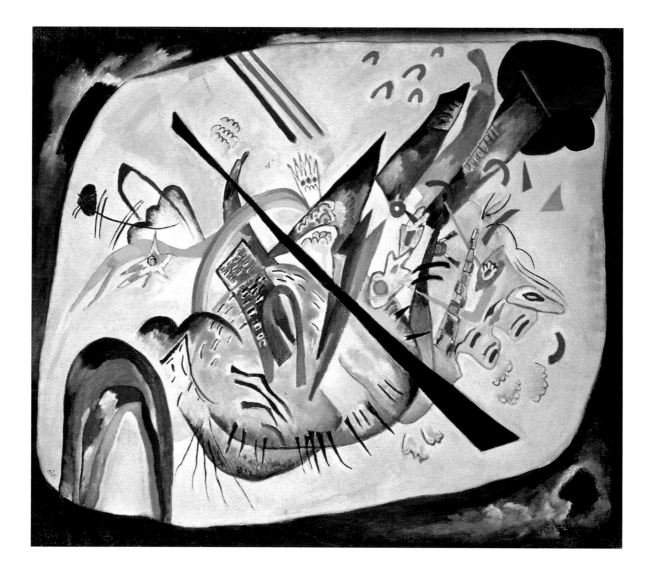

49 *White Oval* (*Bely Oval*), January 1919
Oil on canvas, 80 x 93 cm
The State Tretyakov Gallery, Moscow

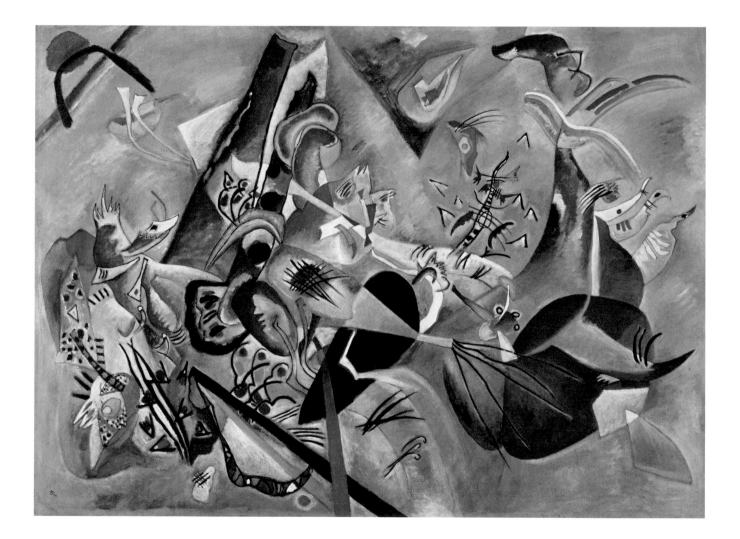

50 *In Gray* (*V Serom*), 1919
Oil on canvas, 129 x 176 cm
Musée national d'art moderne, Centre Pompidou, Paris, Bequest of Nina Kandinsky, 1981

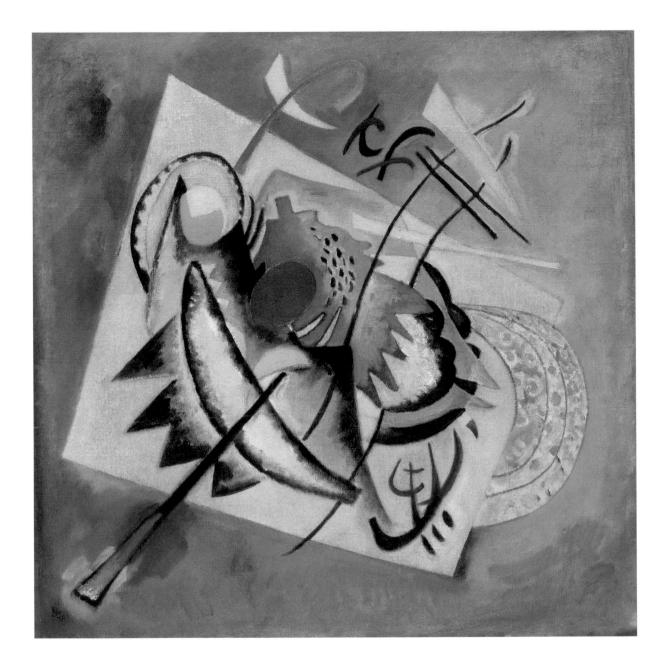

51 *Red Oval* (*Krasny Oval*), 1920
Oil on canvas, 71.5 x 71.2 cm
Solomon R. Guggenheim Museum, New York 51.1311

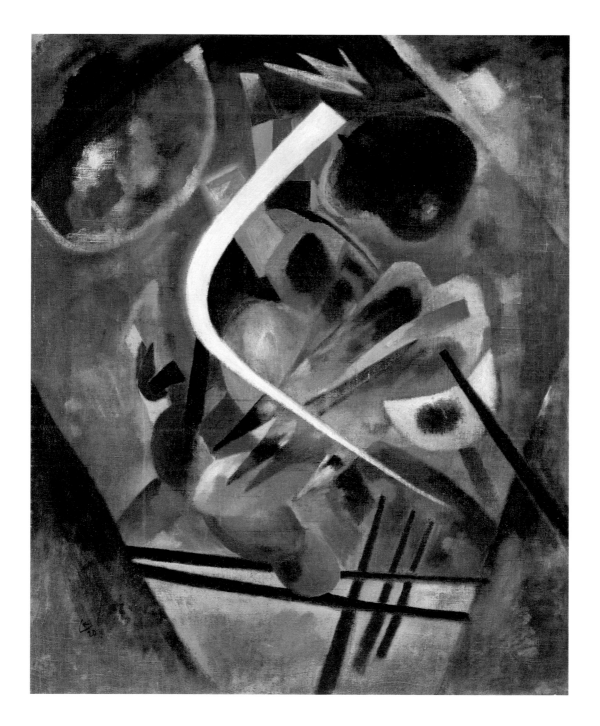

52 *White Line* (*Bely Shtrikh*), 1920
Oil on canvas, 98 x 80 cm
Museum Ludwig, Cologne

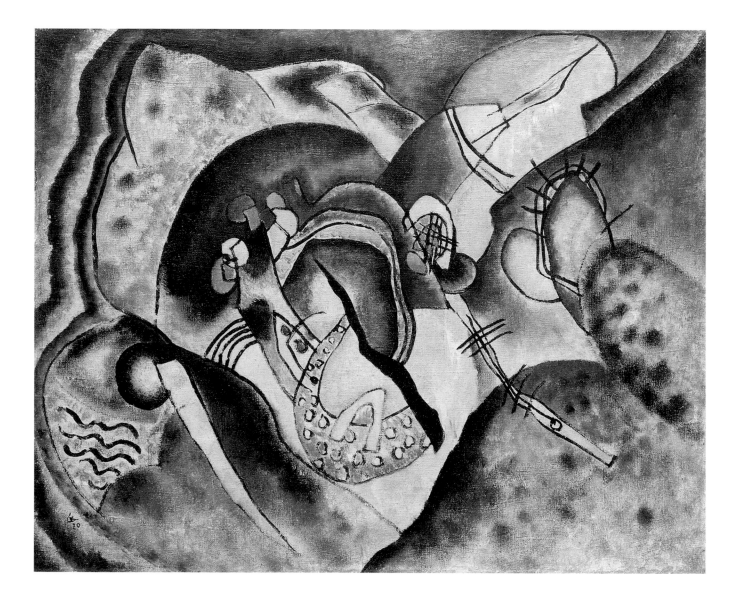

53 *Black Lines II* (*Chyorny Shtrikh II*), 1920
Oil on canvas, 57 x 71 cm
Georgian National Museum, Tbilisi

• *Red Spot II* (*Krasnoe Pyatno II*) is a major work from Kandinsky's Russian period, executed shortly before his departure for Germany and the Bauhaus, and of equal importance to the 1921 works *Blue Segment* (*Siny Segment*, plate 55), *Multicolored Circle* (*Pestry Krug*, plate 57), and *White Center* (*Bely Tsentr*, plate 56). The technique is quite different from that of his earlier work and marks the beginning of a new phase in his creative development. The influence of such Suprematist or Constructivist artists as Kazimir Malevich, Liubov Popova, and Vladimir Tatlin, with whom Kandinsky taught for a time in Moscow, is clearly evident in the clarity and precision of the work, the geometric arrangement of the individual elements, and the smoothness of the surface. The expressive vehemence of the prewar pictures has given way to a more detached, seemingly rational mode of composition, using pure, simple forms. Kandinsky, however, always distanced himself from the mechanical art of the Constructivists. He, too, began, especially from 1920 to 1921, to use geometric forms such as circles, triangles, and precisely elongated arcs and lines, but often with soft borders and in irregular combinations. Particularly striking here is the modeling of the large red spot, which pulsates like a slightly off-center "heart"[1] on the overt white trapezoid in front of a multicolored, equally sculptural-looking horn shape, accompanied by overlapping colored arcs and three circles floating independently in space. Among these forms the small green dot on the left has recently been identified as the painting's central point: "The only trace that remains is the 'central point,' which, admittedly, need not necessarily be at the geometric centre, but which is the last witness to what Kandinsky calls the 'prototype of pictorial expression,' the point lying in the centre of a surface which is square in shape."[2] Concentrated in this dot is the last vestige of the pictorial narrative whose disappearance, through a gradual process of disassembly, also demolished the notion of the viewer as a subject with a consistent standpoint. Once again the border design plays an important role; the trapezoid, which is intersected on all sides by the picture margin, is surrounded at the four corners by irregular triangular segments painted in violet, brown, mottled gray-white, and black, while on the black triangle two whitish ovals are adrift like cosmic stars in deep space. – A. H.

1 Matthias Haldemann, *Kandinskys Abstraktion. Die Entstehung und Transformation seines Bildkonzepts* (Munich: W. Fink, 2001), p. 237. Translated by Sarah Kane, Watford, England.
2 Bruno Haas, "Syntax," in *Kandinsky: The Path to Abstraction*, ed. Hartwig Fischer and Sean Rainbird, exh. cat. (London: Tate, 2006), p. 206.

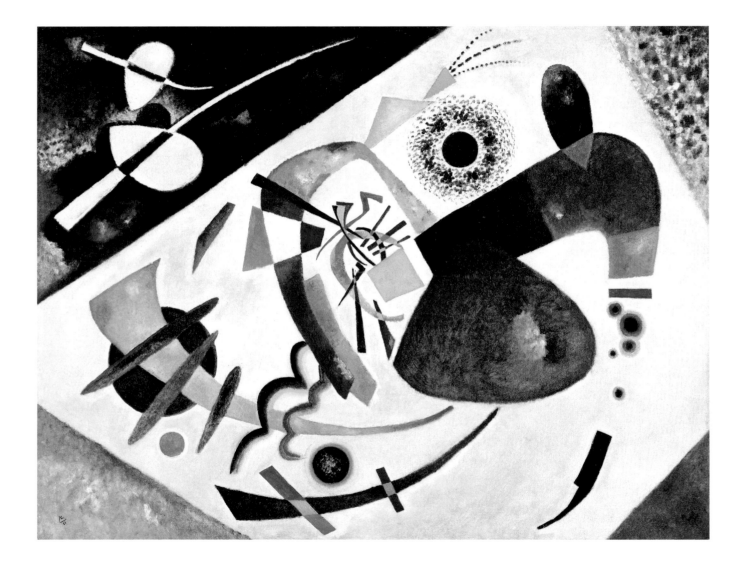

54 *Red Spot II* (*Krasnoe Pyatno II*), 1921
Oil on canvas, 137 x 181 cm
Städtische Galerie im Lenbachhaus, Munich

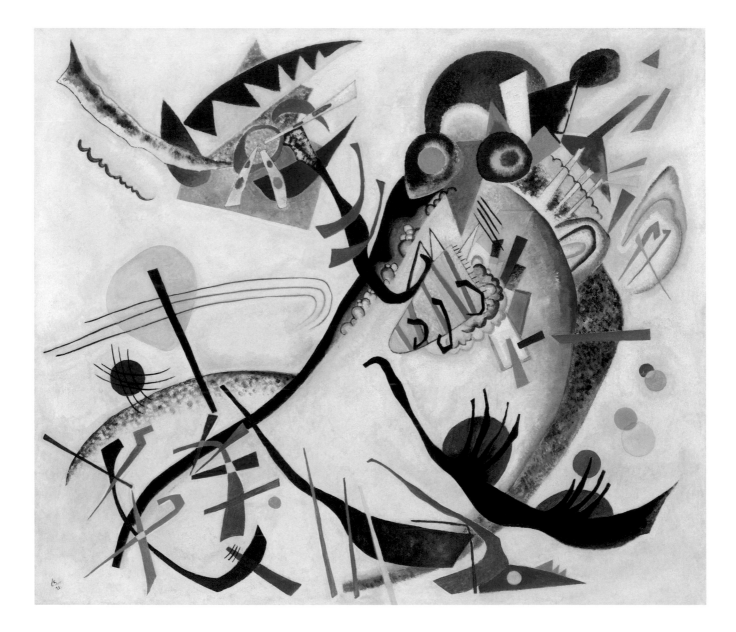

55 *Blue Segment* (*Siny Segment*), 1921
Oil on canvas, 120.6 x 140.1 cm
Solomon R. Guggenheim Museum, New York, Solomon R. Guggenheim Founding Collection 49.1181

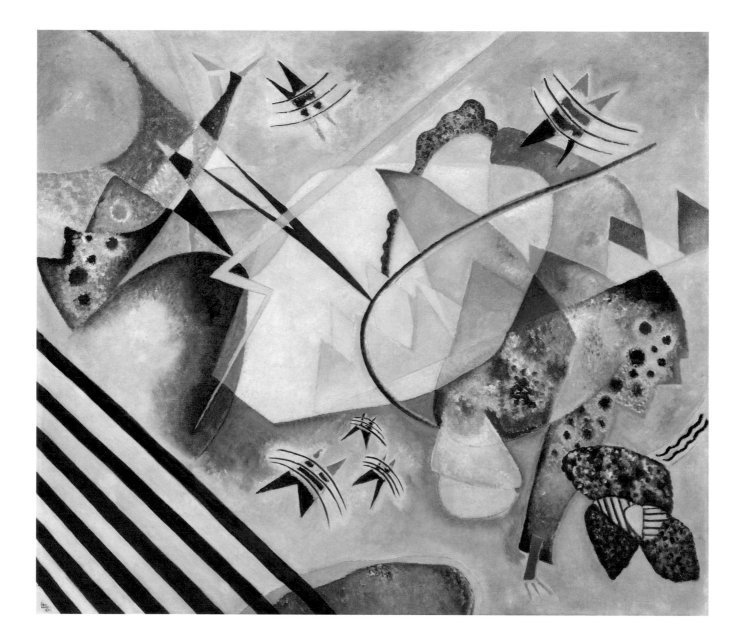

56 *White Center* (*Bely Tsentr*), 1921
Oil on canvas, 118.7 x 136.5 cm
Solomon R. Guggenheim Museum, New York, The Hilla Rebay Collection 71.1936.R98

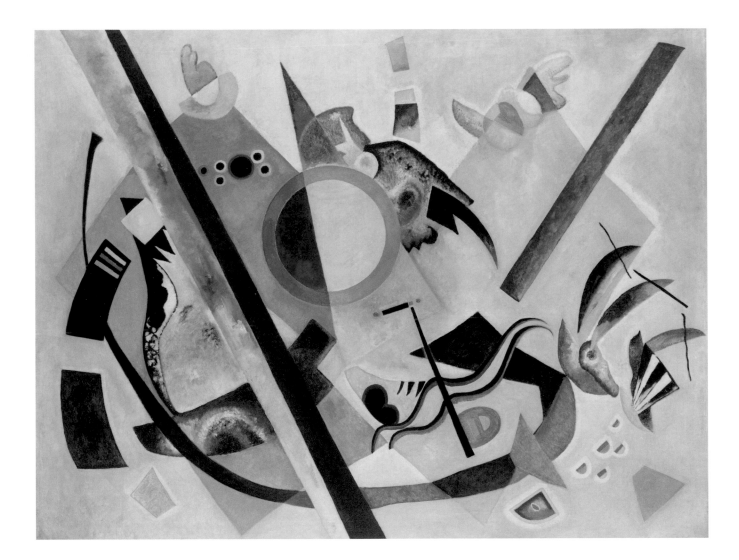

57 *Multicolored Circle* (*Pestry Krug*), 1921
Oil on canvas, 138 x 180 cm
Yale University Art Gallery, New Haven, Gift of Collection Société Anonyme

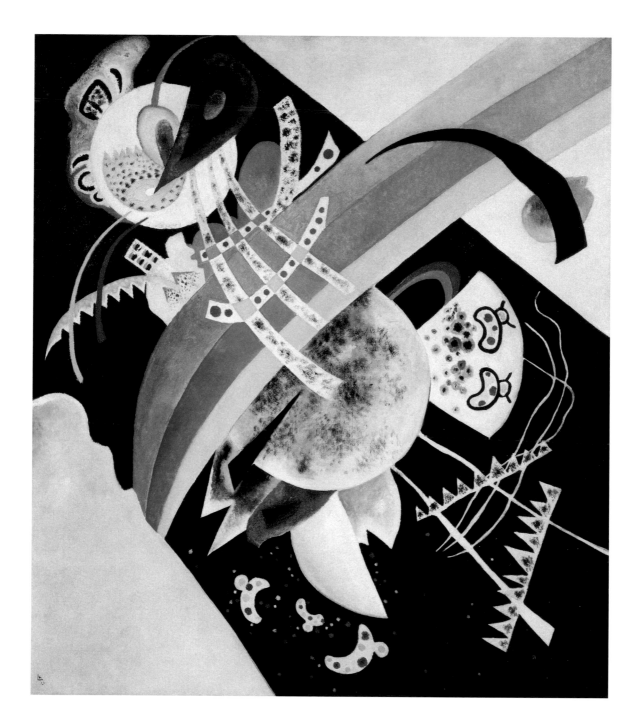

58 *Circles on Black* (*Krugi na Chyornom*), 1921
Oil on canvas, 136.5 x 120 cm
Solomon R. Guggenheim Museum, New York, Solomon R. Guggenheim Founding Collection 46.1050

BAUHAUS

WEIMAR DESSAU BERLIN

1922-33

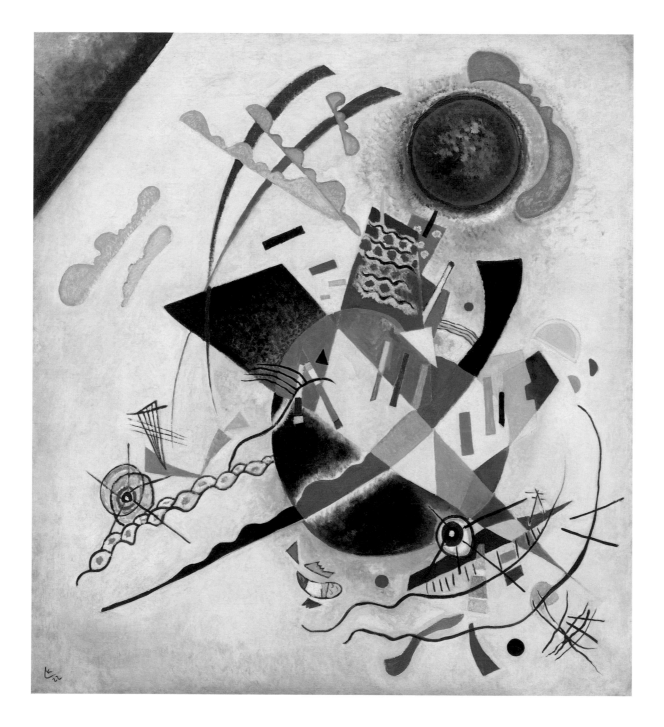

59 *Blue Circle* (*Blauer Kreis*), 1922
Oil on canvas, 109.2 x 99.2 cm
Solomon R. Guggenheim Museum, New York, Solomon R. Guggenheim Founding Collection 46.1051

In June 1922, still fresh from his recent experiences in Moscow and the influence of Russian avant-garde artists such as Kazimir Malevich and Alexander Rodchenko, Kandinsky moved to Weimar, Germany, to teach at the Bauhaus. Weimar was a literary and intellectual center in the eighteenth century, when it was home to Johann Wolfgang von Goethe and Friedrich Schiller, and Goethe's color theories continued to be influential in the twentieth century among artists, including Kandinsky. At the Bauhaus, where he was a committed and respected teacher, the artist gradually adopted a geometric vocabulary that emphasized his intuitive process. His involvement with the school, which encouraged all arts to move toward a more egalitarian society, proved to be fortuitous, thanks to its exhibitions, his teaching, and his theoretical writings on color, form, and their inherent relationship.

White Cross (*Weißes Kreuz*) marks a turning point in Kandinsky's work; the painting borrows elements from the artist's earlier Munich years as well as Russian Constructivist influences. Its floating organic crescents and soft shapes of color hark back to the Bavarian landscape—particularly to imagery such as horsemen and mountains—as well as to overlapping diagonal planes, circles, and the black-and-white grid that often recur in his later works. The white cross of the title blends seamlessly, almost imperceptibly, into the checkered pattern not only as pure geometry, in reference to Malevich's Suprematist forms, but also perhaps as an evocative religious motif. What appears to be an inverted number three, appearing twice on the left side, may allude to a humorous poem entitled "Anders" ("Different"), which is among the prose poems and woodcut illustrations published in Kandinsky's 1912 artist's book *Klänge* (*Sounds*). – K. V.

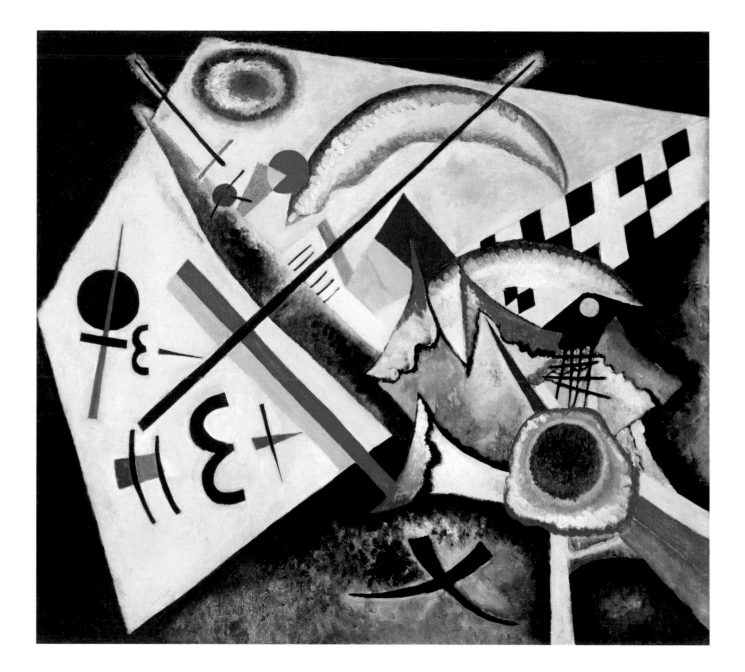

60 *White Cross* (*Weißes Kreuz*), January–June 1922
Oil on canvas, 100.5 x 110.6 cm
Solomon R. Guggenheim Foundation, New York, Peggy Guggenheim Collection, Venice 76.2553.34

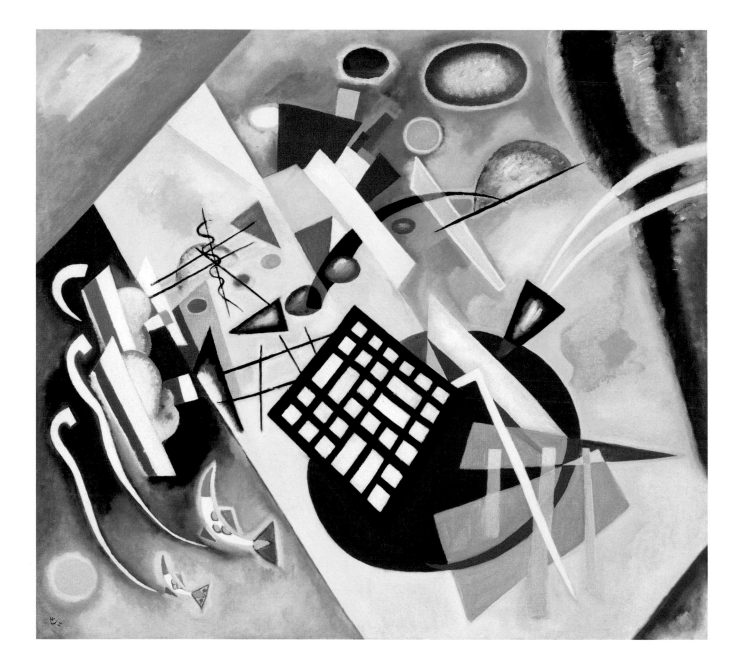

61 *Black Grid* (*Schwarzer Raster*), 1922
Oil on canvas, 96 x 106 cm
Musée national d'art moderne, Centre Pompidou, Paris, Bequest of Nina Kandinsky, 1981

• Having previously taught at and headed several cultural institutions in Munich and Russia, it seemed natural for Kandinsky to accept a post at the Bauhaus, where he worked alongside such colleagues as Johannes Itten, who taught the Preliminary Course on the ideas of the Bauhaus, and Paul Klee, who taught a design-theory class as an examination of formal means. Moreover, because of his estrangement from his Russian contemporaries who opposed his more intuitive ideas, the opportunity to instruct and paint in Germany once again must have appeared all the more congenial to Kandinsky, who never returned to Russia. He was also keenly interested, since his Munich days, in Richard Wagner's idea of the *Gesamtkunstwerk* or "complete artwork"—a unification of painting, music, dance, and theater. The Bauhaus, with its multiple disciplines, offered him an ideal environment in which to work. Less interested in the mechanical functionalism that many teachers at the Bauhaus emphasized, however, Kandinsky underscored spiritual and psychological values and concerns, stressing aesthetics in modern design. He taught a variety of classes and workshops—including Analytical Drawing, Abstract Elements of Form, Color Seminar, and Wall Painting Workshop—and wrote copious lecture notes in an effort to define visual laws and create a science or system of art. *In the Black Square (Im schwarzen Viereck)*, painted in Weimar, Germany, unites contemporary Russian influences, as depicted by the white trapezoid reminiscent of Kazimir Malevich's work, and graphic elements that temptingly recall landscape imagery. – K. V.

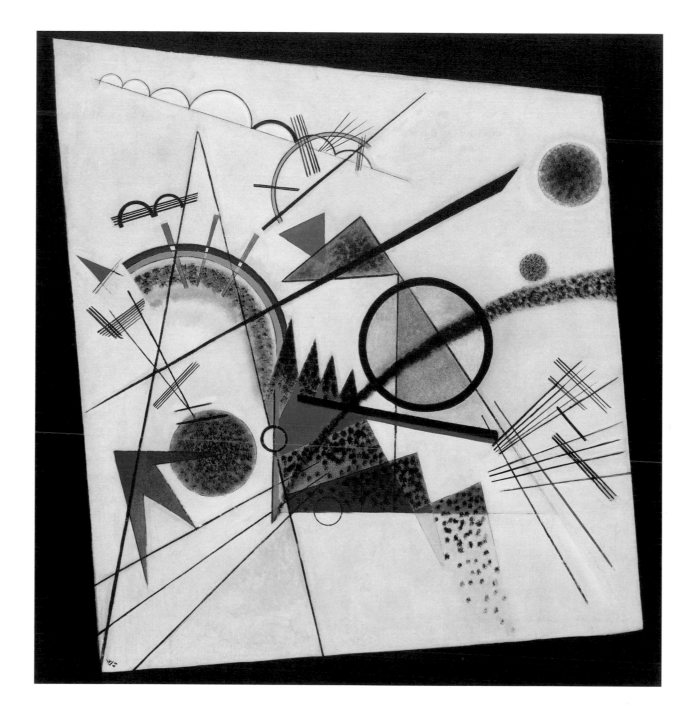

62 *In the Black Square* (*Im schwarzen Viereck*), June 1923
Oil on canvas, 97.5 x 93 cm
Solomon R. Guggenheim Museum, New York, Solomon R. Guggenheim Founding Collection, By gift 37.254

• After leaving Russia, Kandinsky taught at the Bauhaus from 1922 until 1933, first in Weimar, then Dessau, and finally Berlin, at which time it closed due to political pressure. The famed German school was a collegial milieu where Kandinsky also pursued his art and writing. When Solomon R. Guggenheim visited him at the Dessau Bauhaus on July 7, 1930, he purchased a number of works, including *Composition 8* (*Komposition 8*), the first major painting by the artist to enter Guggenheim's growing collection of modern art.

A masterpiece of the artist's Bauhaus years, this late *Composition* was painted nearly a decade after the previous painting in the series. Dominated by miscellaneous geometric and abstract elements as well as fine black lines, it is a commanding and highly organized canvas that Kandinsky considered a highlight of his post–World War I period.

Still quite discernible are the triangular shapes of what may be mountain peaks, lending a harmonious and cool compositional device to the picture. The work is dotted with colorful floating circles, which Kandinsky described as the "synthesis of the greatest oppositions. [The circle] combines the concentric and the excentric in a single form, and in equilibrium. Of the three primary forms [triangle, square, circle], it points most clearly to the fourth dimension."[1] In many respects, the circle replaced the horse as the artist's favorite motif and gained even more prominence in subsequent works, conveying, as he suggested, a variety of fascinating meanings. – K.V.

1 Vasily Kandinsky to Will Grohmann, October 12, 1930, quoted in Angelica Zander Rudenstine, *The Guggenheim Museum Collection: Paintings 1880–1945*, vol. 1 (New York: Solomon R. Guggenheim Foundation, 1976), p. 310.

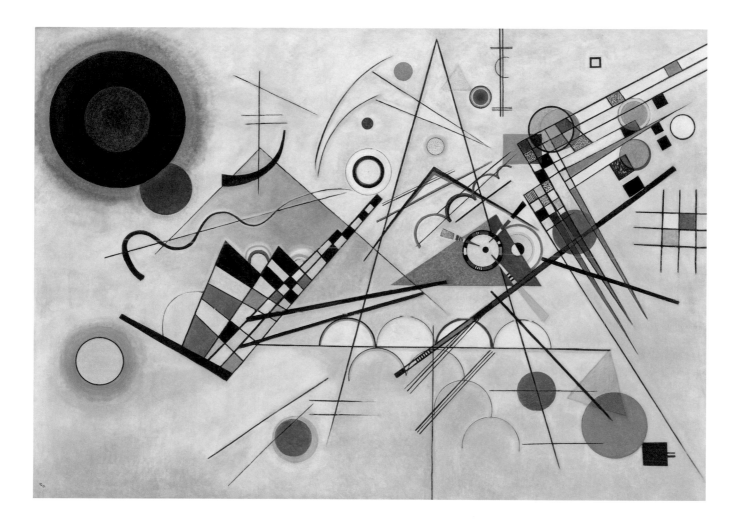

63 *Composition 8* (*Komposition 8*), July 1923
Oil on canvas, 140 x 201 cm
Solomon R. Guggenheim Museum, New York, Solomon R. Guggenheim Founding Collection, By gift 37.262

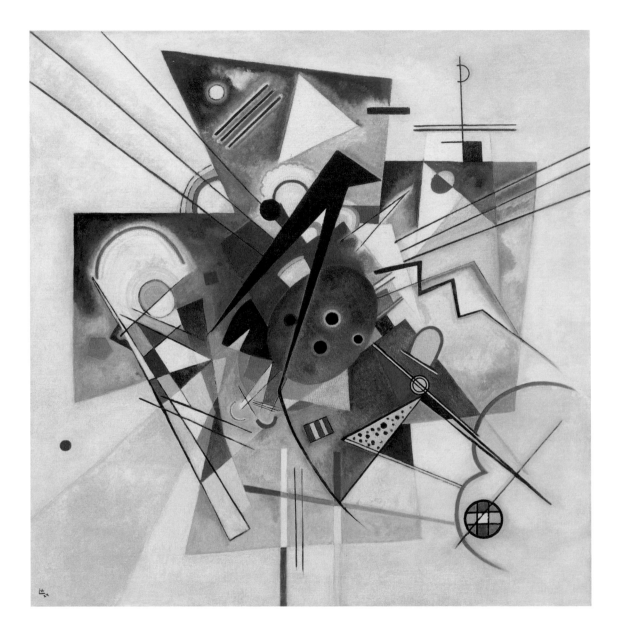

64 *Yellow Accompaniment* (*Gelbe Begleitung*), February–March 1924
Oil on canvas, 99.2 x 97.4 cm
Solomon R. Guggenheim Museum, New York,
Solomon R. Guggenheim Founding Collection, By gift 39.264

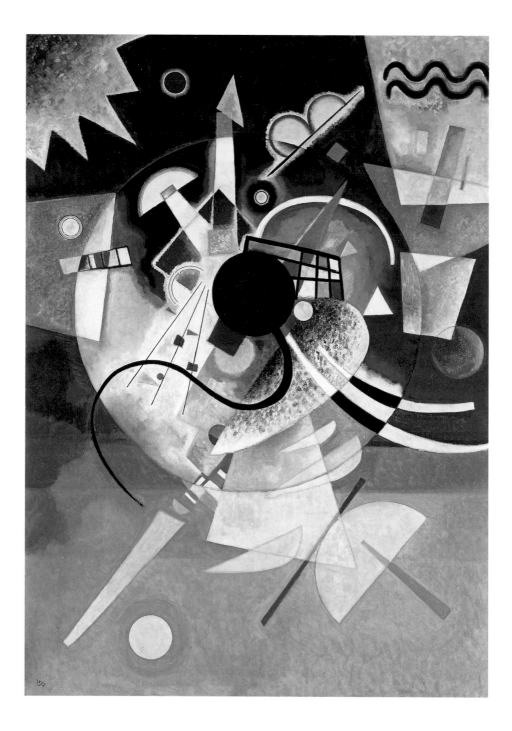

65 *One Center* (*Ein Zentrum*), November–December 1924
Oil on canvas, 140.6 x 99.4 cm
Gemeente Museum, The Hague, Netherlands, on permanent loan
from the Solomon R. Guggenheim Foundation, New York 37.263

• *Yellow–Red–Blue* (*Gelb–Rot–Blau*) is an important painting of the Bauhaus era whose dimensions and formal complexity approximate Kandinsky's ten great *Compositions*. Thanks to such works, Kandinsky's art exerted an influence on later modernism, including, for example, Barnett Newman's series *Who's Afraid of Yellow, Red and Blue* (1966–69).

The theme of the primary colors, addressed in the title, was a major part of Kandinsky's Preliminary Course at the Bauhaus, which covered the analysis of yellow, red, and blue, as well as their assignment to the primary geometric shapes of triangle, square, and circle. Three different sections of this large work can almost be assigned to this constellation. The large yellow plane on the left is given an open triangular form by the diagonal position of one of the strong black lines. From the center of the painting, red is the primary color of two overlapping rectangular forms. These in turn are inseparable from the large bluish-violet circle, which, in an upward movement, completes the composition toward the upper-right corner. These main elements, however, are accompanied by a variety of other forms, for example, colorful chessboard patterns in small distorted trapezoidal squares and more circles or dots. The black lines of various widths are like examples from Kandinsky's book *Punkt und Linie zu Fläche. Beitrag zur Analyse der malerischen Elemente* (*Point and Line to Plane: A Contribution to the Analysis of Pictorial Elements*, 1926), in which the line is treated in detail as horizontal, vertical, diagonal, curved, free, "wavy," or sweeping. The primary colors also vary with the secondary colors green, orange, and violet; in the yellow part of the painting they deepen into brown and in the reddish-blue area into violet and black.

The three sections form two centers, in a composition he often used, according to Kandinsky in a commentary on the 1913 work *Painting with White Border (Moscow)* (*Bild mit weißem Rand [Moskau]*, plate 35), and both centers conjure anthropological associations. While in the yellow field one might see a human profile due to the structure of the lines and circles, the intertwining of red and blue forms with the black diagonal is reminiscent of the theme of the battle between Saint George and the dragon, as in *St George III* (*St Georg III*, 1911, plate 24). – A. H.

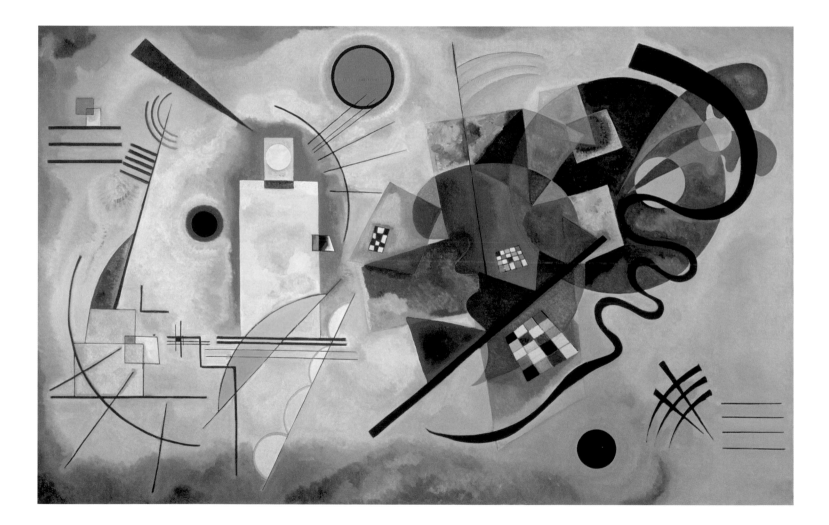

66 *Yellow–Red–Blue* (**Gelb–Rot–Blau**), March–May 1925
Oil on canvas, 128 x 201.5 cm
Musée national d'art moderne, Centre Pompidou, Paris, Gift of Nina Kandinsky, 1976

239

● Part geometric forms, part magical intuition, *Several Circles* (*Einige Kreise*) is a painting of multicolored constellations that speaks of a harmonious cosmic order. This superb canvas epitomizes Kandinsky's Bauhaus period, during which he became a German citizen. At the Bauhaus he actively participated in one of the most productive episodes in German art. In his volume *Punkt und Linie zu Fläche. Beitrag zur Analyse der malerischen Elemente* (*Point and Line to Plane: A Contribution to the Analysis of Pictorial Elements*), published in 1926, the same year this work was painted, he analyzed the geometric elements of painting and revealed his interest in scientific phenomena. Kandinsky applied many theories to his work, including associating colors with geometric shapes, such as yellow with triangles, red with squares, and blue with circles, as in *Several Circles*.

In a letter to his friend, German art historian Will Grohmann, Kandinsky described the circle as "(1) the most modest form, but [it] asserts itself unconditionally, (2) a precise but inexhaustible variable, (3) simultaneously stable and unstable, (4) simultaneously loud and soft, (5) a single tension that carries countless tensions within it."[1] The circle certainly possessed evocative powers of a celestial order, but Kandinsky used it as a formal device, a perfect form enabling infinite spatial structures and possibilities, intersecting planes of brilliant hues and transparent colors. Recognizing its dynamic force as endlessly inspirational, the artist repeatedly used the circle in his late 1920s and 1930s paintings.
– K. V.

1 Vasily Kandinsky to Will Grohmann, October 12, 1930, quoted in Angelica Zander Rudenstine, *The Guggenheim Museum Collection: Paintings 1880–1945*, vol. 1 (New York: Solomon R. Guggenheim Foundation, 1976), p. 310.

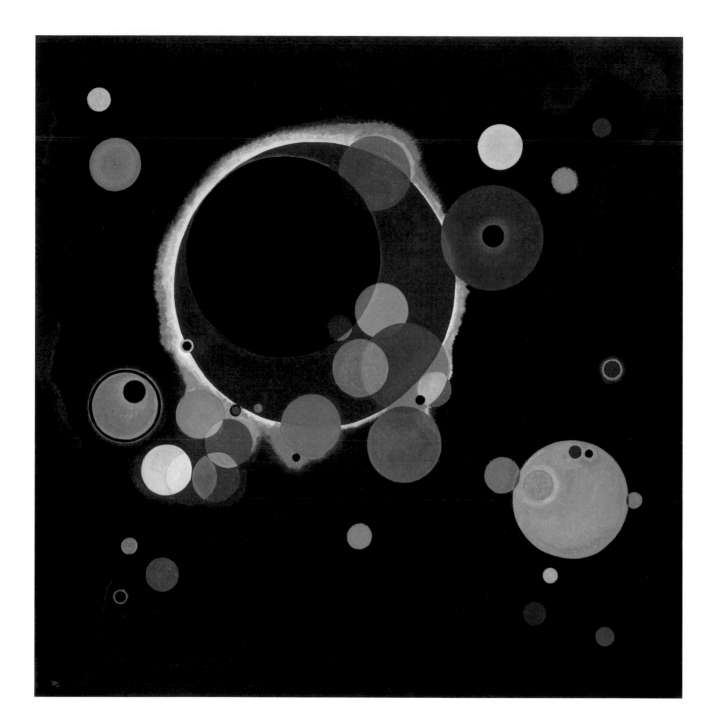

67 *Several Circles* (*Einige Kreise*), January–February 1926
Oil on canvas, 140.3 x 140.7 cm
Solomon R. Guggenheim Museum, New York, Solomon R. Guggenheim Founding Collection, By gift 41.283

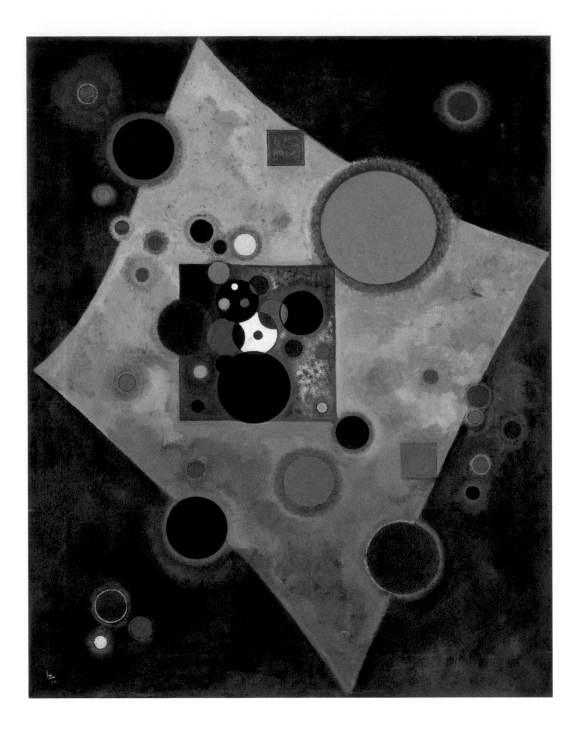

68 *Accent in Pink* (*Akzent in Rosa*), 1926
 Oil on canvas, 100 x 80 cm
 Musée national d'art moderne, Centre Pompidou, Paris, Gift of Nina Kandinsky, 1976

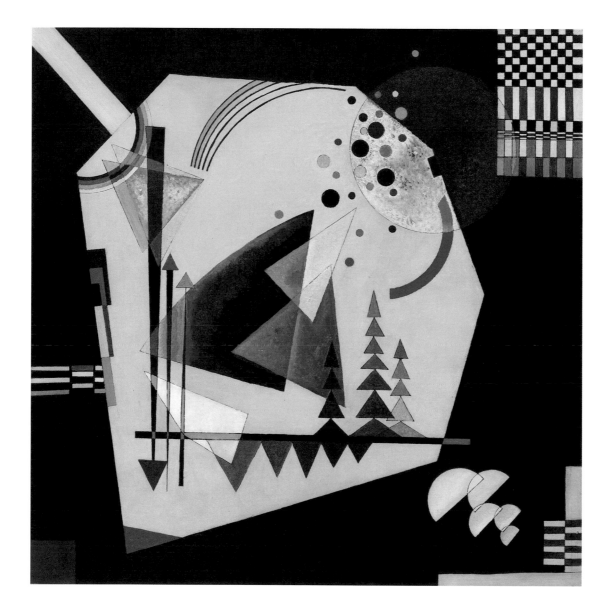

69 *Three Sounds* (*Drei Klänge*), August 1926
Oil on canvas, 59.9 x 59.6 cm
Solomon R. Guggenheim Museum, New York, Solomon R. Guggenheim Founding Collection, By gift 41.282

• Kandinsky regarded *On Points* (*Auf Spitzen*) very highly and exhibited it several times in his Bauhaus and Paris years. Its spare, almost meekly applied color and similarly drawn black outlines designating the geometric forms make it rather unusual in his oeuvre. These objects fan out and up into a large triangle over the painting's square format from a narrow, slightly raised plinth at the lower edge. These shapes consist mostly of larger, greatly elongated triangles standing on their tips and of small equilateral ones that at the top serve as arrow-shaped ends either opposing the direction of the lower tips or suggesting upward movement. Another dominant element is the large circle hovering at the top of the fan of forms, expanding its narrow base. This circle is accompanied by six small floating circles that seem drawn with a compass and distributed around the given space. The paint is applied in cloudy patches mainly on these geometric figures, while at the edges the yellowish background is left largely free.

Hans K. Roethel, who, with Jean K. Benjamin, compiled the catalogues raisonnés of Kandinsky's oil paintings, sees this work in connection with the artist's striving to enable the viewer to experience time in a painting. "The dimension of time, however, took on quite a different, nonsubjective quality for Kandinsky during the Bauhaus period. Because the circle possessed for him 'the clearest indication of the fourth dimension,' he preferred it as an element to such other geometric forms as the triangle or square. Thus by using the circle, movement—as the very essence of time—became a visual component of his paintings. . . . As in counterpoint music, there is no one theme, formally speaking, to which the other forms are subordinated, but all the elements have an independent life of their own, and it is by their 'constellation' that both movement and emotion become evident as a result."[1] – A. H.

1 Hans K. Roethel, *Kandinsky* (New York: Hudson Hills Press, 1979), p. 136.

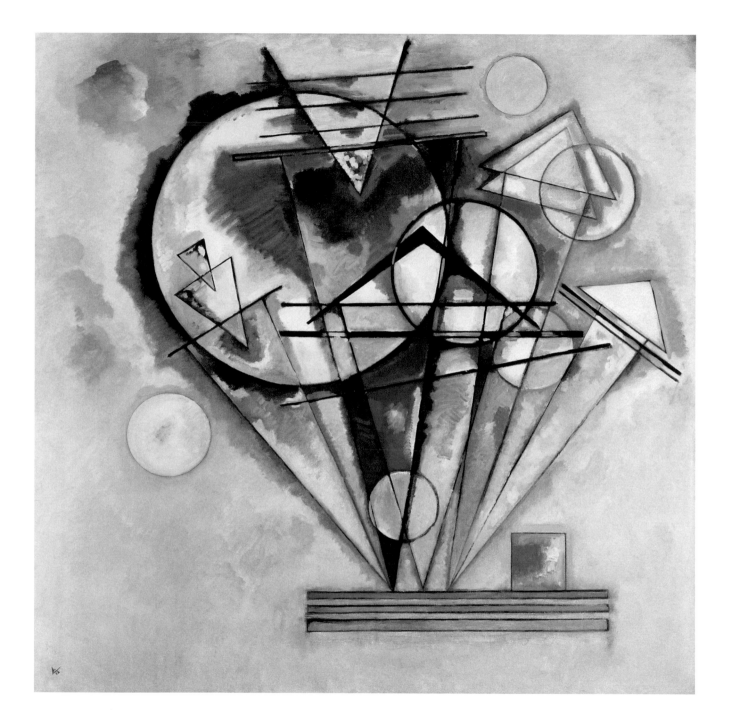

70 *On Points* (*Auf Spitzen*), 1928
Oil on canvas, 140 x 140 cm
Musée national d'art moderne, Centre Pompidou, Paris, Gift of Nina Kandinsky, 1976

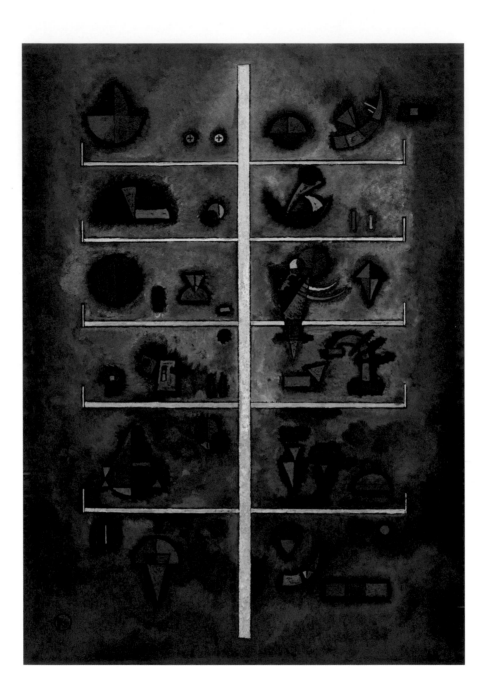

71 *Levels* (*Etagen*), March 1929
Oil on Masonite, mounted on wood, 56.6 x 40.6 cm
Solomon R. Guggenheim Museum, New York, Solomon R. Guggenheim Founding Collection 46.1049

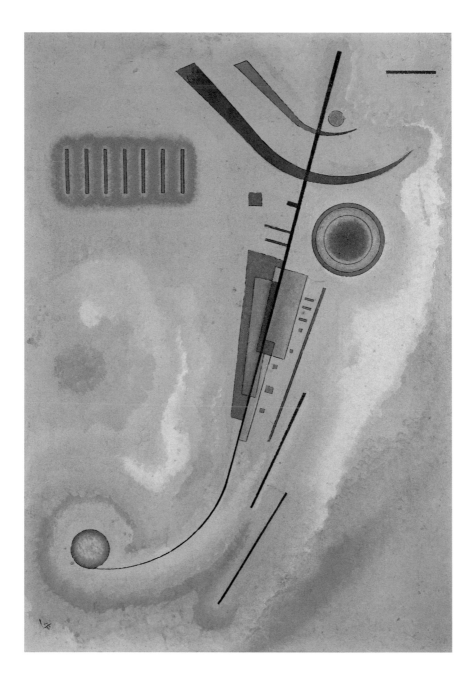

72 *Light* (*Leichtes*), April 1930
 Oil on cardboard, 69 x 48 cm
 Musée national d'art moderne, Centre Pompidou, Paris, Purchase of the State, 1974

• "The last Berlin painting is named *Development in Brown* (*Entwicklung in Braun*). It is a large piece painted in brown and at its center, there is an opening light like hope, which lends an extraordinary strength to this work. At the same time, it makes us dream about infinity, something that our lives in every sense constrict."[1]

In October 1932, Kandinsky left Dessau, Germany, for Berlin where the Bauhaus was still operating, for worse rather than for better, in a former factory. The artist was overwhelmed by political events and the demands that he was receiving from every direction and did not have much time to paint. Between the closure of the school in July 1933 and his move to Paris at the end of December, he only completed the impressively large painting *Development in Brown* in August.

A sense of materiality is absent; the lines are thin; and the brush is imperceptible. The diluted colors sparsely cover the surface. The composition is based on the opposition between the two large brown masses, between which a white plane opens up in the center. Against the luminous ground, overlapping and fragile triangles waver in a precarious balance. The painter adopted this monumental arrangement—

minus the circles—nine years later for *Reciprocal Accord* (*Accord réciproque*, 1942, plate 93).

Development in Brown integrates several ideas Kandinsky had been exploring for years during the time that photography was first being taught at the Bauhaus. His experiments with color involved transposing the effects of László Moholy-Nagy's photograms by masking sections of the work and airbrushing the pigments.

Pleased with this work, Kandinsky showed it at the Galerie Cahiers d'Art in 1934, then in London and in Oxford in 1935–36 at the international *Abstract & Concrete* exhibition, organized by *Axis* magazine. It was included in his retrospective at the Kunsthalle Bern in 1937 and was also one of his few works chosen for the exhibition *Origines et développement de l'art international indépendant* (*Origins and Development of International Independent Art*) at the Jeu de Paume that same year. Kandinsky allowed it to be reproduced in *Abstraction-Création*, no. 4 in 1934, and in *Circle: International Survey of Constructive Art*, edited by Ben Nicholson and Naum Gabo in 1937. – C. D.

1 Christian Zervos, "Notes sur Kandinsky à propos de sa récente exposition à la Galerie des *Cahiers d'Art*," *Cahiers d'Art* 5–8 (1934), p. 154. Translated by Molly Stevens, New York.

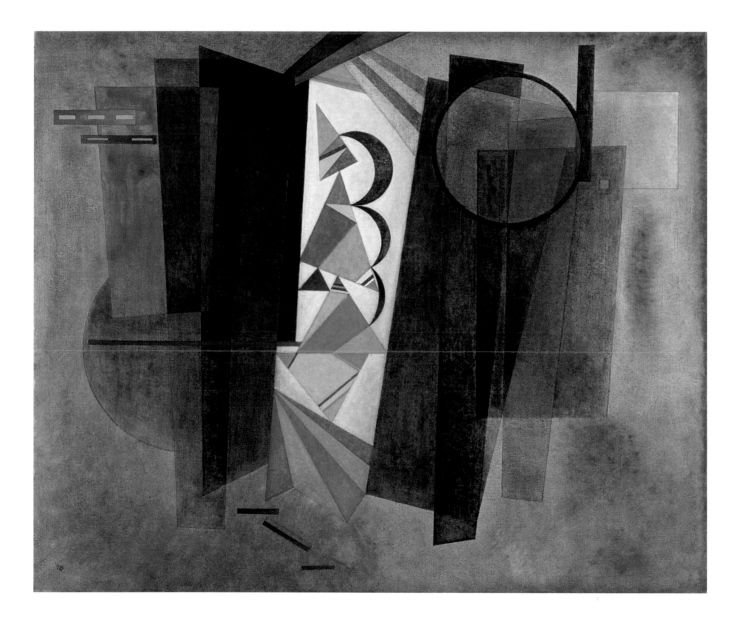

73 *Development in Brown* (*Entwicklung in Braun*), August 1933
Oil on canvas, 105 x 120.5 cm
Musée national d'art moderne, Centre Pompidou, Paris, Purchase of the State, 1959

PARIS AND NEUILLY-SUR-SEINE

1933-44

• "In *Blue World* (*Monde bleu*), one feels the emergence of joyfulness and youth, of a deep knowledge that never weakens. One also feels a kind of memory of tradition. Through its tone and distribution of color forms, it is indeed reminiscent of certain great Chinese paintings; for, although the artist has never lived in Mongolia, through his family, he has undeniable affinities with the Far East."[1]

No longer distracted by teaching at the Bauhaus, Kandinsky stopped using a ruler and compass—both intransigent and conventional tools—as soon as he moved to Neuilly-sur-Seine, France. Rectangles and various squares build the composition against a somewhat neutral bluish background. The materiality of the rectangles is dense, opaque, consisting of a coarse, matte color—with neither black nor white, but only dull tints—obtained from a mixture of pigment and sand. Soft cursive forms—part protozoan, part fantasy—dance or float in the translucent foreground. The lines are carved as in champlevé enameling.

Kandinsky constructed his composition on an ordinary sheet of paper, which is in the Centre Pompidou's collection of graphic works, and then transferred it rather faithfully to the canvas. While many of his other notes and ideas may have been destroyed after the painting was completed, this piece of paper is less interesting for the drawing and more so for the notes indicating the colors: they are in Russian. Although the artist gave his paintings French titles once he moved to Neuilly-sur-Seine, he resorted to his mother tongue while painting. This transformation gradually intensified to the point that it would be appropriate to name the period that began in 1940 his second Russian period, when he was surrounded only by his wife Nina and his nephew Alexandre Kojève. – C. D.

1 Christian Zervos, "Notes sur Kandinsky à propos de sa récente exposition à la Galerie des *Cahiers d'Art*," *Cahiers d'Art* 5–8 (1934), pp. 154 and 156. Translated by Molly Stevens, New York.

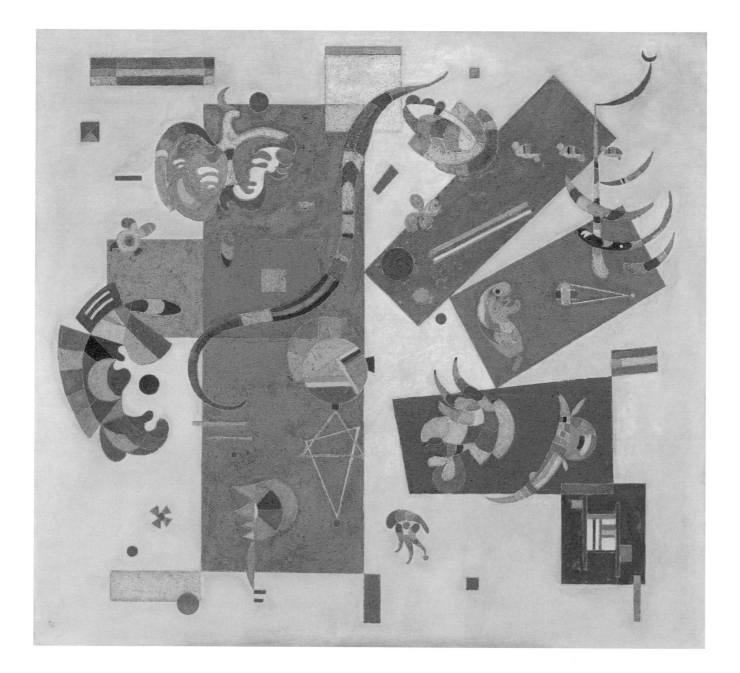

74 *Blue World* (*Monde bleu*), May 1934
Oil with sand on canvas, 110.6 x 120.2 cm
Solomon R. Guggenheim Museum, New York, Solomon R. Guggenheim Founding Collection 45.969

• Once transplanted into France, Kandinsky continued to contribute to the artistic debates of his day and at times shocked his acquaintances. As he bitterly observed in his tribute to artist Franz Marc in 1936: "The times were difficult, but heroic. We painted our pictures. The public spat. Nowadays, we paint our pictures and the public says, 'That's pretty.' This change does not mean that the times have become easier for the artist."[1]

Striped (Rayé), painted in autumn 1934, was shown at the second Galerie Cahiers d'Art exhibition in 1935. The composition is based on the contrast between a background of alternating vertical stripes with cut-out shapes placed side by side. In keeping with his new method, Kandinsky used paint mixed with sand. In Paris he used sizeable canvases; between 1934 and 1942 he painted fifty-five very large pictures. The format of this work is a "figure forty" (81 x 100 cm), a standard size sold by French art suppliers. Aware that he was changing more than just the texture of the support, Kandinsky expressed his thoughts about the new surfaces in his 1935 article "Toile vide, etc." ("Empty Canvas, etc."). With regard to paints, Kandinsky preferred German suppliers, and he asked his nephew Alexandre Kojève, who was in Berlin in August 1935, to bring some paints back with him: "I am sending you a list of colors, you could perhaps phone Leopold Hess again. . . . I don't know whether the Neisel factory in Dresden still exists. If not, you can also get the paints at Schmincke's." – C. D.

1 Vasily Kandinsky, "Franz Marc" (1936), in Kandinsky, Kandinsky: Complete Writings on Art, ed. Kenneth C. Lindsay and Peter Vergo (1982; repr., New York: Da Capo Press, 1994), p. 795.

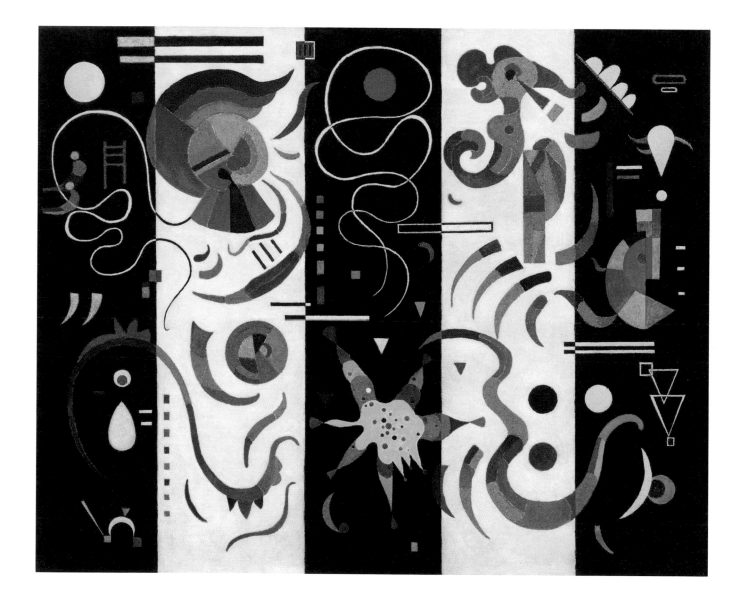

75 *Striped* (*Rayé*), November 1934

Oil with sand on canvas, 81 x 100 cm

Solomon R. Guggenheim Museum, New York, Solomon R. Guggenheim Founding Collection 46.1022

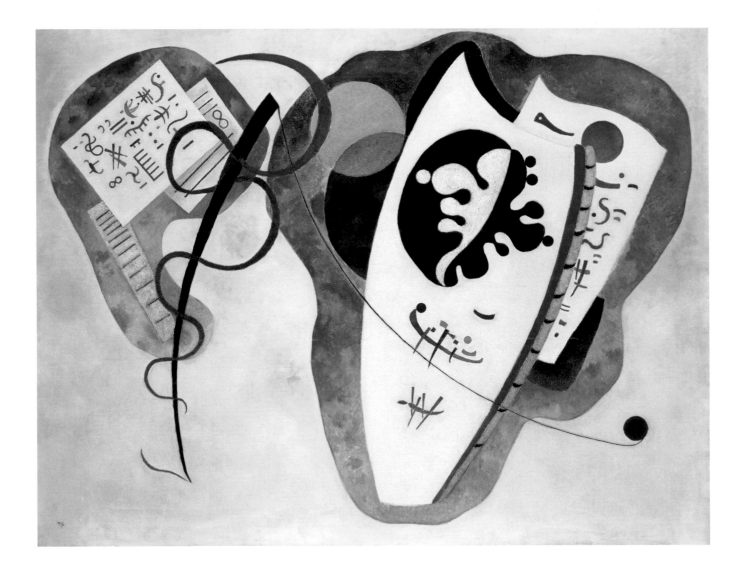

76 *Two Surroundings* (*Deux Entourages*), November 1934
Oil on canvas, 89 x 116 cm
Stedelijk Museum, Amsterdam

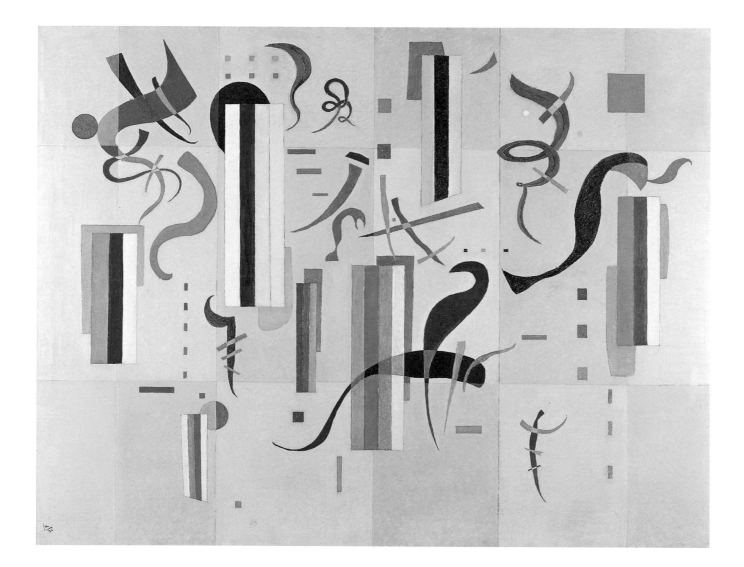

77 *Delicate Accents* (*Accents délicats*), November 1935
Oil on canvas, 89 x 116 cm
Private collection, courtesy Pierre Sebastien Fine Art

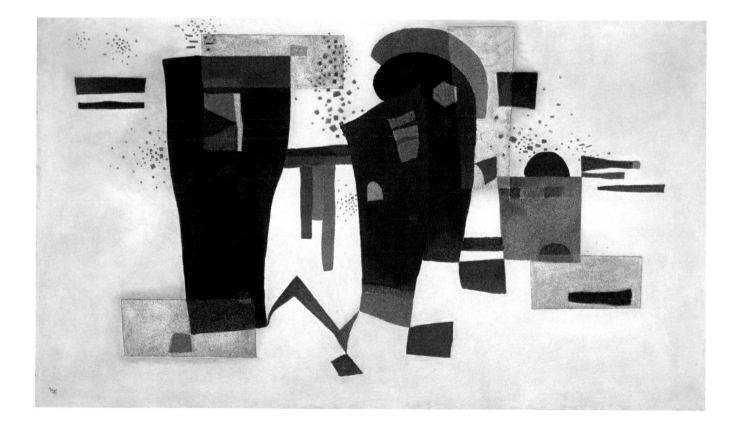

78 *Accompanied Contrast* (**Contraste accompagné**), March 1935
Oil with sand on canvas, 97.1 x 162.1 cm
Solomon R. Guggenheim Museum, New York, Solomon R. Guggenheim Founding Collection, By gift 37.338

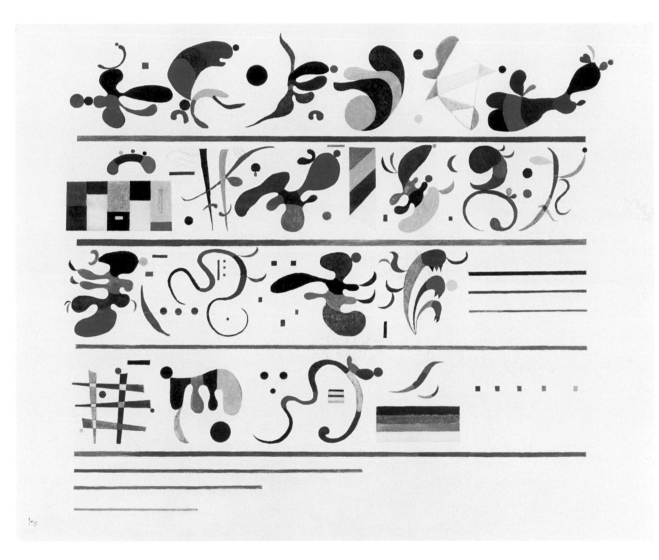

79 *Succession*, April 1935
Oil on canvas, 81 x 100 cm
The Phillips Collection, Washington, D.C.

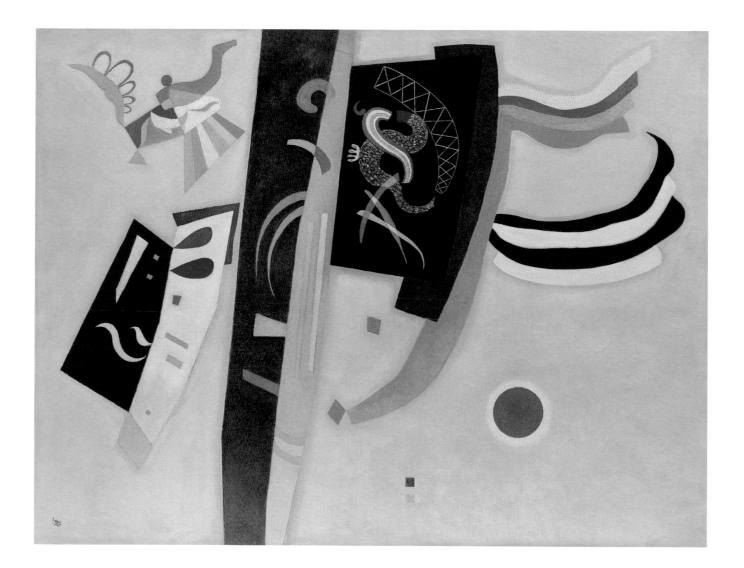

80 *Violet–Orange*, October 1935
Oil on canvas, 88.9 x 116.2 cm
Solomon R. Guggenheim Museum, New York, Solomon R. Guggenheim Founding Collection, By gift 37.334

• This cosmic painting, *Movement I* (*Mouvement I*), is related to Kandinsky's masterpiece *Several Circles* (*Einige Kreise*, plate 67), painted in Dessau, Germany, in 1926. The colored circles in the background of *Movement I* have become heavy, flaccid spheres with uncertain edges. Irregular large strips and complex geometric structures overlap and twirl in a constellation of luminous points, creating a starry void.

The dreaminess of this work, which was painted in July 1935 and then exhibited in December at Jeanne Bucher's gallery, corresponds to a debate that was sparked in Montparnasse, France, by the Congrès international pour la défense de la culture (International Congress for the Defence of Culture). The Association des écrivains et des artistes révolutionnaires (Association of Revolutionary Writers and Artists) waged a serious offensive, championing what would become Socialist Realism. The Surrealists countered this retrograde vision of the arts in the service of the proletarian revolution and proposed passionate alternatives. The journal *Cahiers d'Art* became involved and launched an investigation in its pages, to which Kandinsky responded: "If a 'simple' man (a worker or peasant) says: 'I don't understand a thing about this art, but I feel as if I were in a church,' he proves that his head has not yet been thrown into confusion. He does not understand, but he feels. A worker said once: 'We do not want art that has been manufactured for us, but rather a true, free art, a great art.'"[1]

In 1978, Nina Kandinsky called for the unification, in Paris, of all of her husband's paintings that were in Soviet museums—a challenging feat. The authorities granted her request by loaning thirty paintings to the Centre Pompidou in 1979. In thanks, she bequeathed three paintings to Russian museums, *Blue over Multicolored* (*Blau über Bunt*, 1925), *Angular Structure* (*Winkelblau*, 1930), and *Movement I*. Two of these works currently belong to the State Tretyakov Gallery, Moscow, and the third is owned by the State Pushkin Museum of Fine Arts in Moscow. – C. D.

1 Vasily Kandinsky, "Art Today" (1935), in Kandinsky, *Kandinsky: Complete Writings on Art*, ed. Kenneth C. Lindsay and Peter Vergo (1982; repr., New York: Da Capo Press, 1994), p. 766.

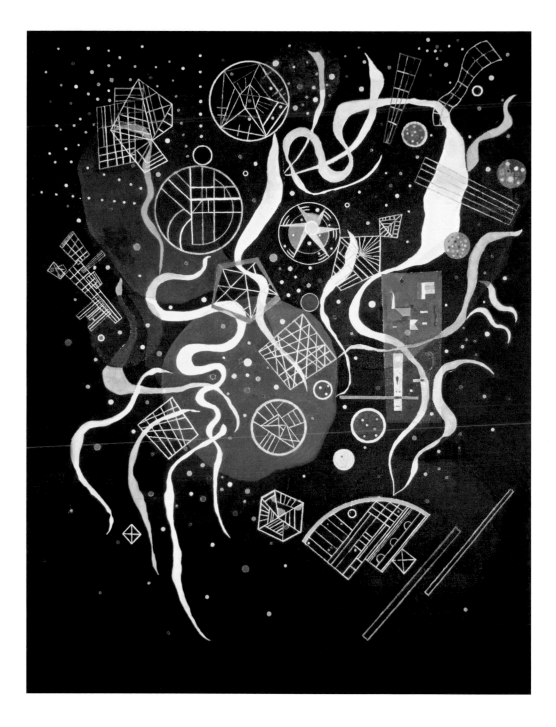

81 *Movement I* (*Mouvement I*), July 1935
Mixed media on canvas, 116 x 89 cm
The State Tretyakov Gallery, Moscow

• At first glance, *Composition IX* is difficult to understand as there is such a contrast between the diagonal strips that form its bland geometric background and the soft shapes overlying them. Less successful than the larger *Dominant Curve* (*Courbe dominante*, 1936, plate 83) in Kandinsky's mind, it appears in the catalogue of Kandinsky's retrospective at the Kunsthalle Bern in 1937 under the title of *L'Un et l'autre* (*The One and the Other*). Though one may question the criteria that led the artist to relabel it a *Composition*, it seems to be for some strategic or commercial motive that he adopted the term that had last been used in 1923.

In Jeanne Bucher's gallery at 9, boulevard du Montparnasse, Kandinsky met André Dézarrois, curator of the Écoles étrangères at the Jeu de Paume. Dézarrois purchased *La Ligne Blanche* (*White Line*, 1936), one of the gouaches on view.

In late summer and autumn 1938, Kandinsky entrusted *Composition IX* to this museum. Georges Huisman, director general of the Beaux-Arts, and Dézarrois decided to integrate this important painting into the collection of the Écoles étrangères. Haggling about the price of the work delayed its final purchase until 1939. Kandinsky refused the derisory payment suggested to him, but then changed his mind. On February 24, 1939, he proposed a deal to Dézarrois: "For every day that passes, it is becoming more and more necessary for me to have a big retrospective exhibition in Paris. . . . I would be content with 5,000 francs."[1] The painting was acquired in March. – C. D.

1 Vasily Kandinsky to André Dézarrois, February 24, 1939, quoted in Christian Derouet, "On War in General and Vasily Kandinsky in Particular," in Bengt Lärkner, Peter Vergo, et al., *Nya perspektiv på Kandinsky/New Perspectives on Kandinsky* (Malmö, Sweden: Malmö Konsthall/Sydsvenska Dagbladet, 1990), p. 147.

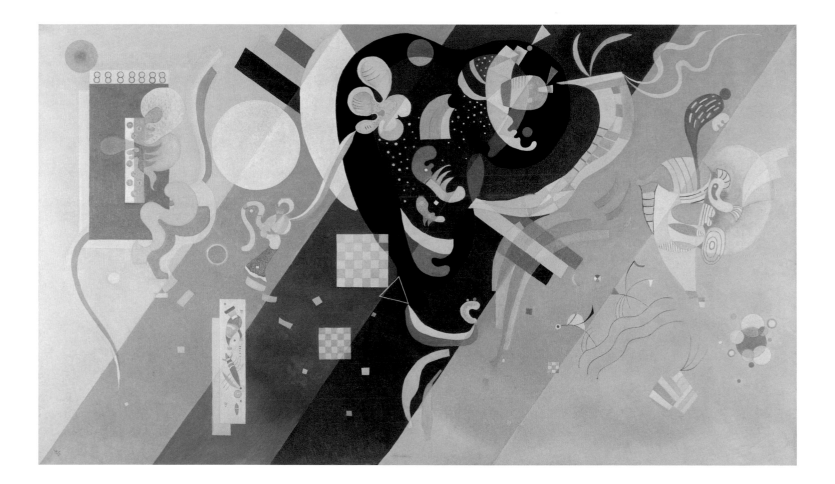

82 *Composition IX*, February 1936
Oil on canvas, 113.5 x 195 cm
Musée national d'art moderne, Centre Pompidou, Paris, Attribution by and Purchase of the State, 1939

• Though his last decade of creativity has often been criticized and less appreciated than his groundbreaking earlier work, Kandinsky's years in France were prolific in spite of difficult wartime conditions. When he arrived in France, Kandinsky found French modernists engaged in a dialectical controversy pitting the artists of Abstraction-Création (Abstraction-Creation), a loose association of artists who promoted abstract art through group exhibitions and a journal, against the Surrealists, headed by André Breton, and Kandinsky participated in the dialogue.

During these twilight years, Kandinsky's work underwent stylistic changes, and he introduced an astonishing variety of organic and playful motifs inspired by biological and zoological imagery culled from scientific writings. At the Bauhaus, he had assiduously collected reproductions from technical and encyclopedic volumes and used them for his lectures.

Kandinsky was inspired as well by the diversity of forms used by Jean Arp, Max Ernst, Paul Klee, and Joan Miró, but created an original biomorphic style, an automatic language of sorts, blending the infinite pictorial possibilities of Surrealism and formal abstraction with those of the natural sciences. Vestiges of favorite geometric elements remain in Kandinsky's oeuvre, such as the circle and the grid. His late works suggest ideas of transformation and rebirth, as exemplified by *Dominant Curve* (*Courbe dominante*), a vigorous painting that nonetheless has an astonishingly light touch. The enigmatic feeling pervading this mature work is reinforced by a set of mysterious steps at the right, which lead nowhere in particular but are possibly emblematic of an ascent to a higher spiritual plane. Kandinsky considered this harmonious canvas to be one of his most important works of that time. – K. V.

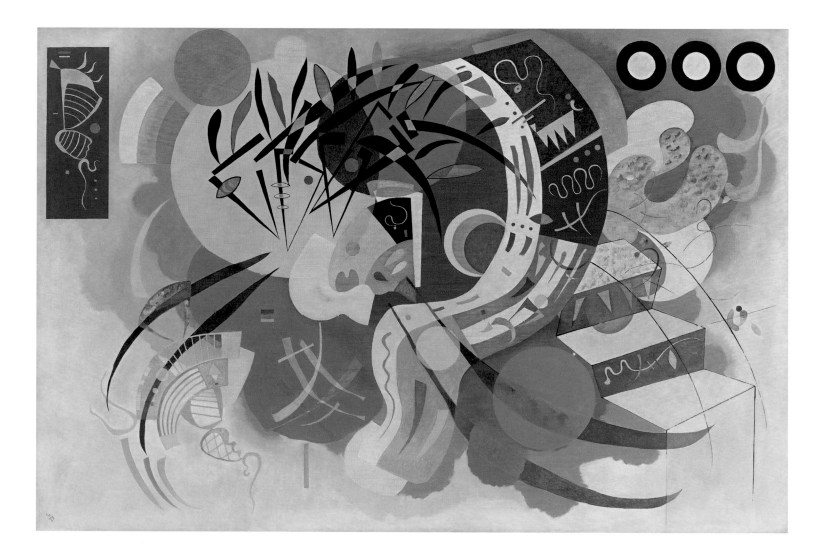

83 *Dominant Curve* (*Courbe dominante*), April 1936
Oil on canvas, 129.4 x 194.2 cm
Solomon R. Guggenheim Museum, New York, Solomon R. Guggenheim Founding Collection 45.989

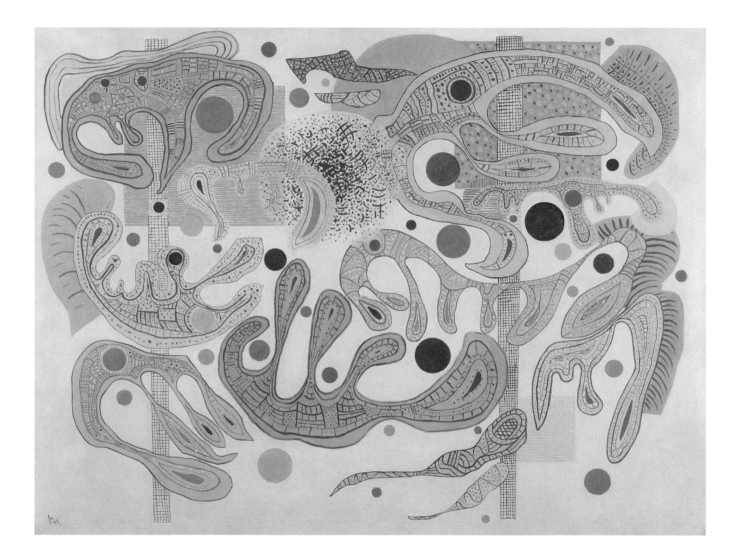

84 *Capricious Forms* (*Formes capricieuses*), July 1937
Oil on canvas, 88.9 x 116.3 cm
Solomon R. Guggenheim Museum, New York, Solomon R. Guggenheim Founding Collection 45.977

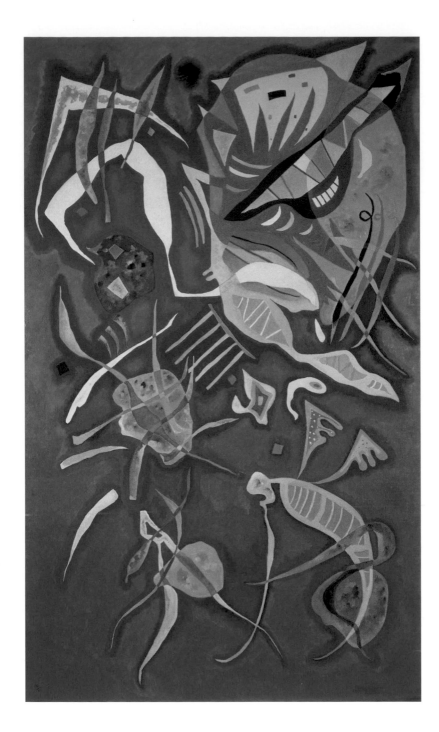

85 *Grouping* (*Groupement*), September–October 1937
 Oil on canvas, 146 x 88 cm
 Moderna Museet, Stockholm

86 *Thirty* (*Trente*), 1937
 Oil on canvas, 81 x 100 cm
 Musée national d'art moderne, Centre Pompidou, Paris, Gift of Nina Kandinsky, 1976

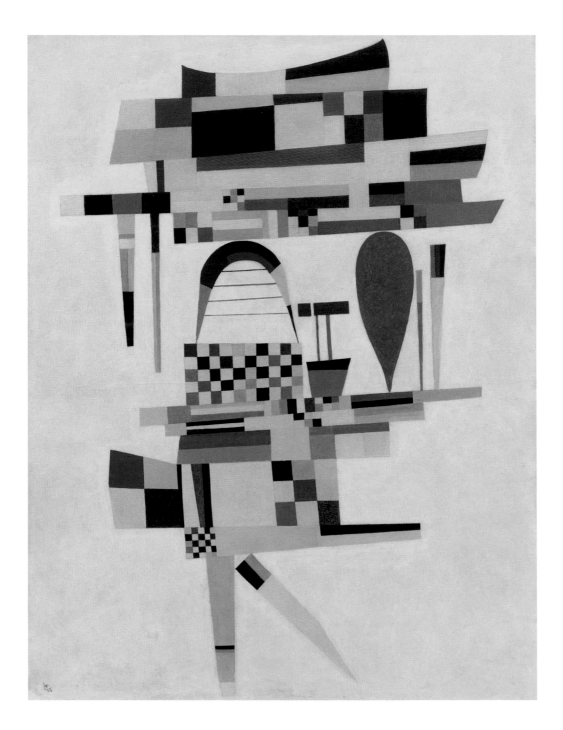

87 *Yellow Painting* (*La toile jaune*), July 1938
Oil and enamel on canvas, 116.4 x 88.8 cm
Solomon R. Guggenheim Museum, New York, Solomon R. Guggenheim Founding Collection 45.964

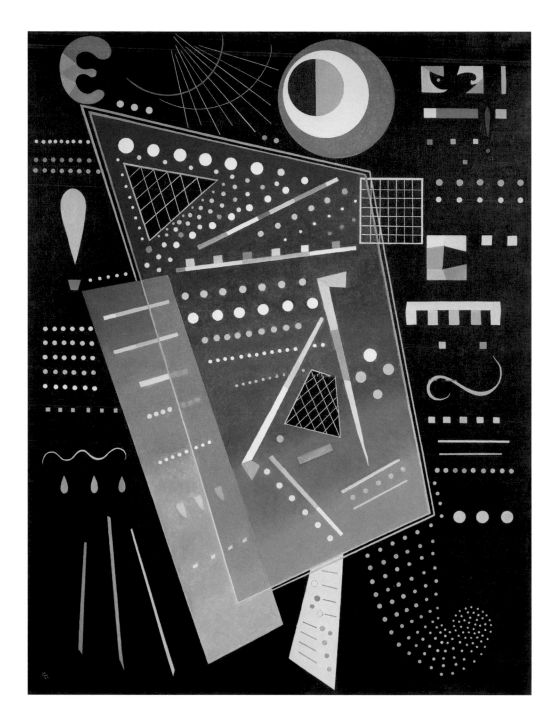

88 *Upward* (*Vers le haut*), June 1939
Oil on canvas, 116 x 89 cm
Nahmad Collection

• *Various Parts* (*Parties diverses*) is characteristic of works produced during Kandinsky's later years in Paris, a period that began with his emigration following the closure of the Bauhaus in Berlin in 1933 and that ended with his death in 1944. Once again, his formal vocabulary underwent a decisive change, especially vis-à-vis the appearance of the organic, amoeba-like miniature structures and microorganisms. Such forms are particularly evident in the pictures of the 1940s, partly as anthropomorphic, comical, hybrid creatures, and are treated with forensic detachment, arranged in contrived figure and reference systems and painted in an artificial, Asiatic palette.

Various Parts is divided up into a number of differently colored geometric fields whose structure is ultimately symmetrical. In a somewhat muted form, the work once more invokes the principle of dualism, the sense of opposition and contradiction that had been one of the most prominent features of Kandinsky's art ever since his pre-1914 abstract-expressive phase. The oppositions in pictures such as *Various Parts* and *Accord réciproque* (*Reciprocal Accord*, 1942,

plate 93) are anticipated by the "constructive" structures of, for example, *Development in Brown* (*Entwicklung in Braun*, 1933, plate 73). As Pierre Volboudt has pointed out, "Kandinsky's art can be defined, as a whole, as the synthesis of divided, conflicting forces."[1]

In Kandinsky's late work this conflict is shaped not only by archetypal, multicolored, microscopically observed forms that evoke connotations of the East, according to German art historian and his contemporary Will Grohmann, but also by the artificial colors and decorative forms of the modern everyday world. Besides this ambiance, the division of the background into five rectangular zones (between which there are subtle overlaps, like the structure of a folding altarpiece) creates a notable effect: With their pistachio green, pink, lilac, yellow, and white, these monochrome grounds evoke distant memories of Kandinsky's description of Moscow at sunset in his essay "Rückblicke" ("Reminiscences") of 1913. – A.H.

1 Pierre Volboudt, quoted in Helmut Friedel and Annegret Hoberg, *The Blue Rider in the Lenbachhaus, Munich*, trans. John Ormrod (Munich: Prestel, 2000), cat. 36.

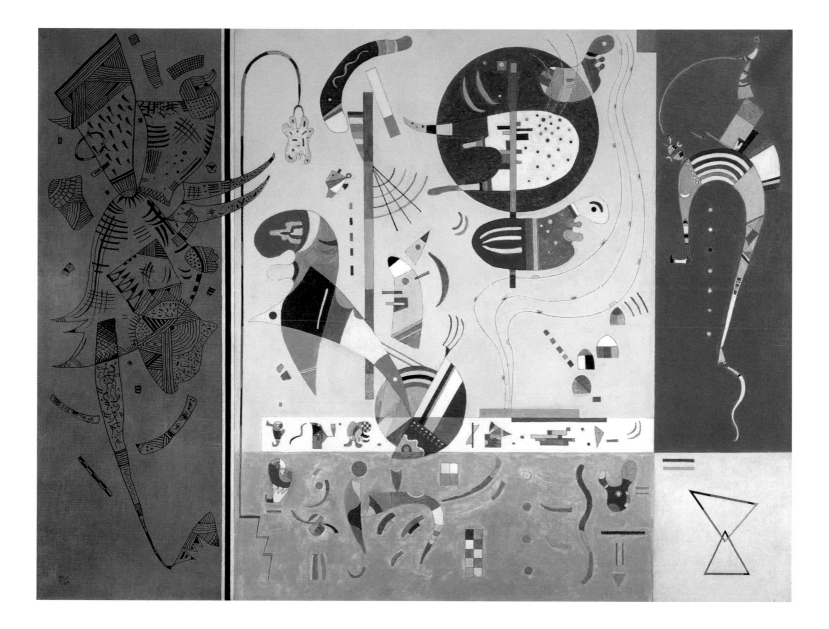

89 *Various Parts* (*Parties diverses*), February 1940

Oil on canvas, 89 x 116 cm

Gabriele Münter- und Johannes Eichner-Stiftung, Munich, on deposit at the Städtische Galerie im Lenbachhaus, Munich

• *Sky Blue* (*Bleu de ciel*) is a picture of enchantment. A shower of little animals, unidentifiable in the medley of colors, fall gently and freely like snowflakes. This painting is Kandinsky's reaction to World War II, which had just begun and was the third war to occur during his lifetime. The blue sky suggests that the spring air was once more coming in through his studio's windows. A lively painting, it lies somewhere between the *Constellations* (1940–41), which Joan Miró was working on in the same period at Varengeville-sur-Mer, France, where Kandinsky visited him with Alberto Magnelli, and the patterns which Kandinsky was perfecting in 1942–43 for fabric curtains printed by Jean Bauret and the Lys manufacturing company.

This exceptional painting should be seen in the context of a description that Kandinsky's wife Nina wrote at the request of dealer René Drouin in 1949: "Kandinsky lives in Neuilly-sur-Seine, near the Bois [de Boulogne] and the [Parc de] Bagatelle, which he loves above all things. He loves nature, less inhibitedly now [that] it no longer 'poses' for him. . . . Kandinsky had a predilection for juggling performances. No doubt that's why white balls figure so much in his compositions, playing a game of hide and seek before the eyes of the admiring spectator. A painter of the poetic and the fantastic, he always seems to have more than one trick up his sleeve in his canvases. Children's games find a place there, too, especially the magic of those jack-in-the-boxes which open and shut, always leaving you with a secret in your eyes. Each painting is a world in itself." – C. D.

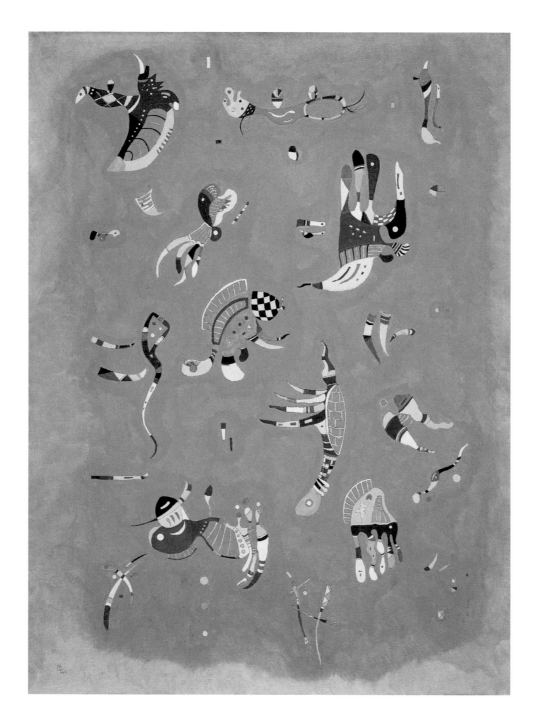

90 *Sky Blue* (*Bleu de ciel*), March 1940
Oil on canvas, 100 x 73 cm
Musée national d'art moderne, Centre Pompidou, Paris, Gift of Nina Kandinsky, 1976

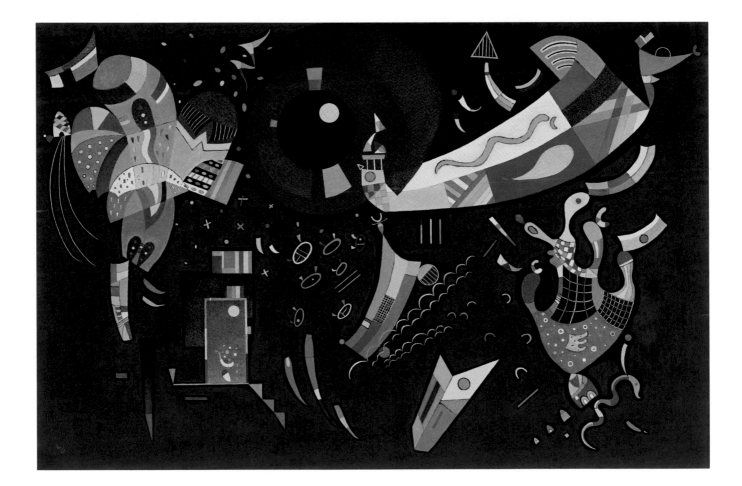

91 *Around the Circle* (*Autour du cercle*), May–August 1940
Oil and enamel on canvas, 96.8 x 146 cm
Solomon R. Guggenheim Museum, New York, Solomon R. Guggenheim Founding Collection 49.1222

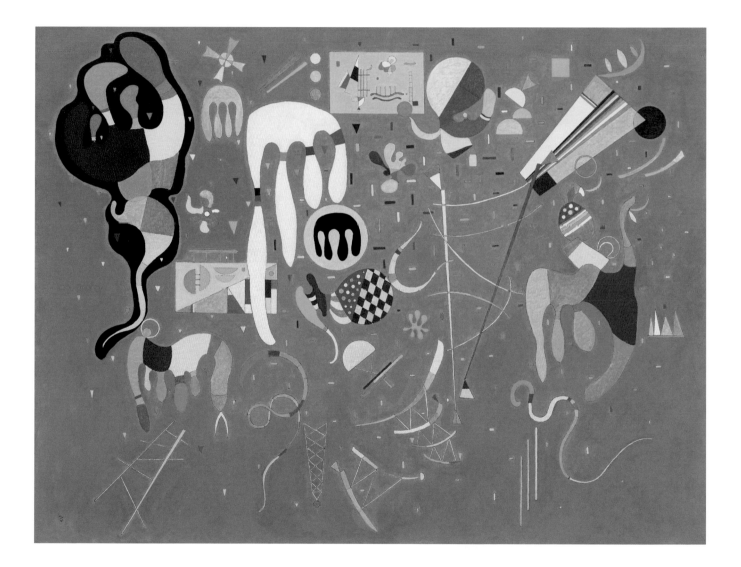

92 *Various Actions* (*Actions variées*), August–September 1941
Oil and enamel on canvas, 89.2 x 116.1 cm
Solomon R. Guggenheim Museum, New York, Solomon R. Guggenheim Founding Collection 47.1159

• According to the artist's records, *Reciprocal Accord* (*Accord réciproque*) was painted in late January and February 1942, after a really cold winter when he had to draw near his stove. It is the last large-format painting that Kandinsky produced in his studio where, because of low ceilings like those in many apartments of the time, he had to paint horizontal, rather than vertical, canvases. The painting is the final outburst of energy against age, isolation, stagnation, and the humiliation of living in an occupied country. Like many works created by dissidents, strength of conviction and great firmness brings a measure of gravity, even coldness in compensation. The white central opening of *Development in Brown* (*Entwicklung in Braun*, 1933, plate 73) is increasingly transparent here in a way that was perhaps prophetic about the unknown future.

In summer 1942, when he no longer had any white canvas, Kandinsky started painting flat on card. This change of register and work surface made him more meticulous and spontaneous. The taste for his mostly representational subjects that he had once classed as "bagatelles" returned, a sort of private amusement.

After Kandinsky's death on December 13, 1944, his wake was in his studio, and his body lay on view with *Movement I* (*Mouvement I*, 1935, plate 81) and *Reciprocal Accord* on easels at either side. In this setting, photographer Rogi André composed the last likeness of the painter after he died, his eyes closed and without his glasses. The graves of Vasily and Nina Kandinsky lie in the new cemetery in Neuilly, France, on the bank of the Seine, in the shadow of the skyscrapers of the La Défense business district. – C. D.

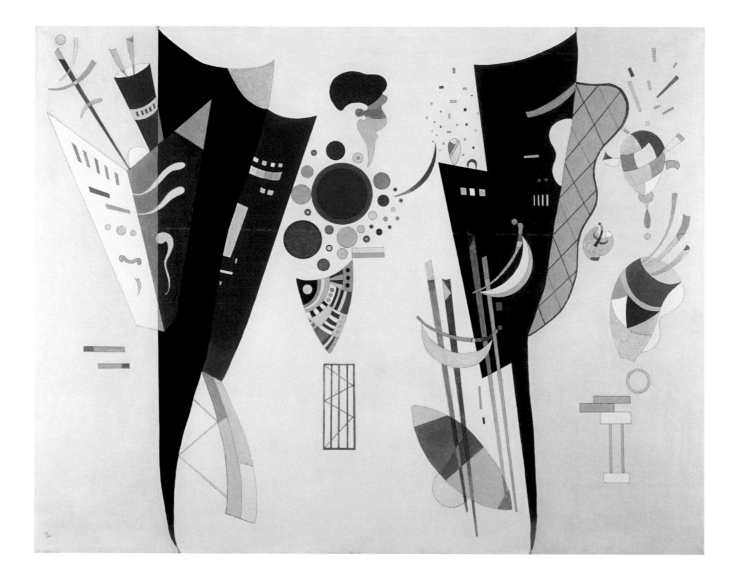

93 *Reciprocal Accord* (***Accord réciproque***), January–February 1942
Oil and varnish on canvas, 114 x 146 cm
Musée national d'art moderne, Centre Pompidou, Paris, Gift of Nina Kandinsky, 1976

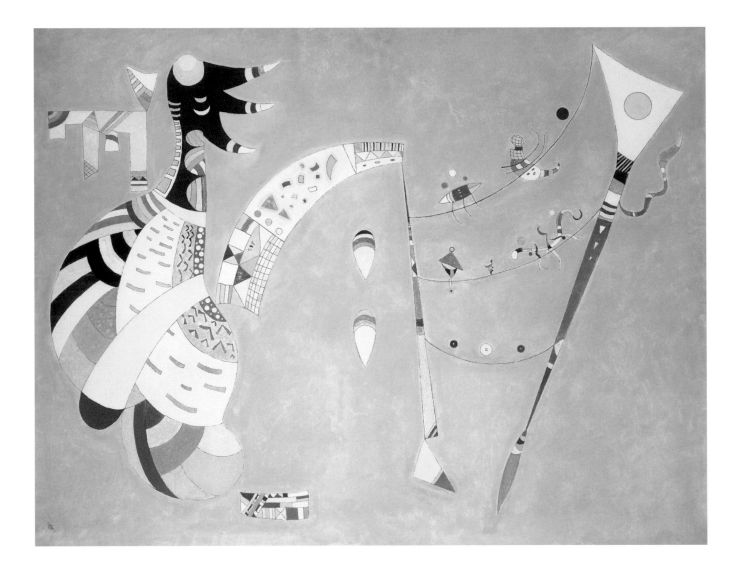

94 *Balancing* (*Balancement*), January 1942
Mixed media on canvas, 89 x 116 cm
Nahmad Collection

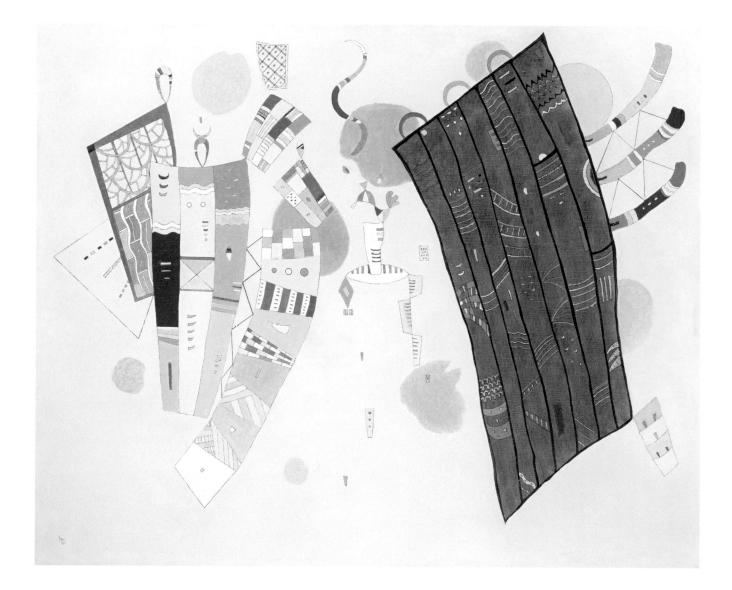

95 *Delicate Tensions* (*Tensions délicates*), June–July 1942
 Oil on canvas, 81 x 100 cm
 Collection J. Shafran, London

CHRONOLOGY COMPILED BY ANNEGRET HOBERG

1866

Vasily Kandinsky, the son of Vasily Silvestrovich Kandinsky and his wife Lidia Ticheeva, is born on December 4 in Moscow. His father, the head of a tea-importing company, comes from Kyakhta in eastern Siberia, which is on the southern border with Mongolia and is where his ancestors had been banished from western Siberia. His mother comes from Moscow's upper-middle class, while his maternal grandmother is Baltic German.

1869

The Kandinskys take their three-year-old son with them to northern Italy, including Venice.

1871

Because of his father's fragile health, Kandinsky's family moves to Odessa, Russia (now Ukraine), on the Black Sea coast. His parents divorce soon after. His mother remarries, leaving Kandinsky with his father, but his parents remain in contact. Kandinsky is often with his half-brothers Vladimir, Nikolai, and Alexei Kojevnikov and his half-sister Lisa. His mother's highly educated

elder sister Elizabeth Ticheeva looks after his schooling, and Kandinsky later dedicates his book *Über das Geistige in der Kunst. Insbesondere in der Malerei* (*On the Spiritual in Art: And Painting in Particular*, 1912) to her.

1876–85

He attends the secondary school in Odessa but regularly spends the summer holidays with his father in Moscow, which throughout his childhood he feels is his real home.

1885

Kandinsky returns to Moscow and enrolls at the university as a student of law, economics, and statistics. His teachers include economics professor Alexander Chuprov, with whom he develops a close relationship.

1889

Kandinsky does fieldwork, June 9–July 15, in the province of Vologda on behalf of the Tsarist Society for Natural Science, Ethnography, and Anthropology to investigate what remains of the

pagan Zyrian religion and the province's judicial system. He records this trip in his Vologda diary. Later, in his "Rückblicke" ("Reminiscences," 1913), he recalls the gaily painted farmhouses in this area, which gave him the feeling of moving within a picture.

On his return, his experiences are published in two essays, "On the Punishments Given in Accordance with the Regional Courts of Moscow Province" and "From Material on the Ethnography of the Sysolsk and Vychegodsk Zyriane: National Deities." In addition, he writes several book reviews in the ethnographic journal *Etnograficheskoe obozrenie* between 1889 and 1900.

He travels to St. Petersburg and in October makes his first trip to Paris.

1892

Kandinsky marries his cousin Anja Shemiakina. Her sister is married to the owner of the Abrikosov chocolate factory based in the Tverskoy district in Moscow. The family has a large estate, outside the city in Akhtyrka,

which later turns up as a subject in several of Kandinsky's pictures.

1893
In November he graduates from the University of Moscow, becoming an academic assistant in economics and statistics. He begins writing his dissertation, supervised by Chuprov, on the Iron Law of Wages and the legality of laborers' wages.

1895
Kandinsky writes to Chuprov on November 7 that he is not finishing his dissertation.

In winter he starts to work as an artistic director at the printing company N. Kushnerev in Moscow.

1896
Two important incidents related to Kandinsky's subsequent career as an artist occur this year: during an exhibition of French art in Moscow, he sees one of Claude Monet's *Haystack* paintings and is strongly impressed by its nonobjective

effect, and he attends a performance of Richard Wagner's *Lohengrin* (1850) at the Bolshoi Theatre in Moscow.

He receives but turns down an offer of a teaching post at the University of Dorpat, Russia (now Tartu, Estonia).

In December he moves with his wife Anja to Munich to study painting. At the time the city is attracting many Eastern European and Russian art students.

1897
For the next two years, Kandinsky attends the distinguished and popular private art school run by Slovene artist Anton Azhbe. Other students include fellow Russians Igor Grabar, Alexei Jawlensky, Dmitry Kardovsky, Nikolai Seddeler, and Marianne von Werefkin.

1898
He first participates in Odessa's Association of South-Russian Artists annual exhibition, to which he submits works each year until 1910.

1899
Kandinsky applies to join Franz von Stuck's classes at the Akademie der Bildenden Künste (Munich Academy of Fine Arts) and is turned down.

His first two articles about art, concerning the Munich Secession and the wonders of photography respectively, appear in the Moscow newspaper *Novosti dnia*.

1900
In February Kandinsky takes part in the exhibition of the Association of Moscow Artists, which organizes such events annually. He submits works each year until 1908.

After reapplying, Kandinsky attends Stuck's painting class for one year. Along with numerous other rising avant-garde artists, particularly representatives of the Art Nouveau movement, his fellow students include Hans Purrmann, Alexander von Salzmann, Ernst Stern, and Albert Weisgerber.

Pages 284–85: Detail of *Succession*, 1935 (plate 79)

Left to right: **Vasily Kandinsky's mother Lidia Ticheeva with Kandinsky, age three, Moscow, 1869**

Kandinsky's father Vasily Silvestrovich Kandinsky, ca. 1866

Kandinsky, age eight, Odessa, December 1874

Kandinsky's aunt Elizabeth Ticheeva, ca. 1870

1901

Dissatisfied with academic teaching, Kandinsky increasingly paints on his own, creating small oil studies direct from nature, such as views of Munich or its hinterland. He also makes works with a completely different technique and subject matter—fairy-tale tempera pictures, often in historic Russian settings.

In May Kandinsky, Salzmann, and Stern, along with sculptors Waldemar Hecker and Wilhelm Hüsgen plus other progressive personalities of Munich's Schwabing art scene, establish the Phalanx artists' association.

In July Kandinsky and his wife Anja rent a larger apartment at 1 Friedrichstraße, having previously lived on Georgenstraße and Giselastraße, all in the Schwabing neighborhood.

The Phalanx organizes its first exhibition, which opens August 17. Eleven more follow over the next three years, showing works by members and other avant-garde artists, such as Alfred Kubin and Monet, who have not previously shown work in Munich. In fall, Kandinsky is elected chair of the Phalanx.

In September he travels to Odessa and Moscow, where he has inherited a tenement block from his uncle. The income from this

building, inherited money, and funds from his father give him financial independence until 1914.

1902

In winter the Phalanx group establishes a private painting school in Schwabing, where Kandinsky teaches painting and nude drawing. One of his pupils is twenty-four-year-old Gabriele Münter.

In summer he takes his Phalanx class, which includes Emmy Dressler, Olga Meerson, and Carl Palme, to Kochel am See and Schlehdorf near Garmisch in Upper Bavaria to paint for several weeks at the foot of the German Alps. Kandinsky and Münter, both keen cyclists, develop a friendship.

The distinguished St. Petersburg art journal *Mir Iskusstva* publishes "Korrespondentsiia iz Miunkhena" ("Correspondence from Munich"), Kandinsky's report on the Munich art scene.

1903

Kandinsky travels to Vienna in April, where he visits the Vienna Secession's spring exhibition, which inspires him to try what becomes a favorite medium, the woodcut. The majority of his printed graphic work is created in this period through

1907 with numerous woodcuts in both black-and-white and color.

In summer he and his Phalanx painting class spend several weeks in Kallmünz in the Upper Palatinate north of Regensburg, Germany. He and Münter become a couple.

In August he travels with Münter to other old southern German cities such as Nabburg, Landshut, and Regensburg.

Peter Behrens invites him to run a course in decorative painting at the Kunstgewerbeschule Düsseldorf (School of Arts and Crafts Düsseldorf), but he turns down the offer.

In Moscow his album of fifteen black-and-white woodcuts *Stikhi bez slov* (*Poems without Words*) is published by Stroganov.

In fall he travels to Odessa and Moscow, via Venice and Vienna. On the way back to Munich, he visits Berlin.

He exhibits for the first time at both the Salon d'Automne in Paris, October 15–November 15, and the Berlin Secession in December.

1904

Avoiding his marriage, in May Kandinsky begins traveling with Münter for several years with the occasional stop in Munich. They initially stay in Holland for a month and visit Amsterdam, Arnhem, Rotterdam, and Scheveningen.

He begins writing his ideas on painting techniques and the symbolism of color. His notes on the language and definition of color are later integrated into *On the Spiritual in Art*.

Kandinsky takes part in various exhibitions, such as those at the gallery of *Les Tendances Nouvelles* magazine (opens June 1), the Salon d'Automne in Paris (October 15–November 15), and others in Kraków, Poland; Krefeld, Germany; Vienna; and Warsaw throughout fall and winter.

In fall Kandinsky moves out of the apartment he is sharing with his wife Anja at 1 Friedrichstraße.

On December 6, Kandinsky and Münter set off for Tunisia via Lyon and Marseille, arriving in Tunis on December 25 and staying at the Hôtel de Suisse for more than three months.

In Darmstadt, Germany, the twelfth and last Phalanx exhibition opens in December. With Kandinsky's departure from Munich, the association dissolves.

Left to right: **Kandinsky and his uncle Alexander Silvestrovich Kandinsky, Moscow, ca. 1885**

Kandinsky's first wife Anja Shemiakina, Moscow, ca. 1892

Dmitry Kardovsky, Nikolai Seddeler, and Kandinsky at the Anton Azhbe school, Munich, ca. 1897

Anja Kandinsky in the studio apartment in Schwabing, Munich, presumably at 1 Friedrichstraße, ca. 1901

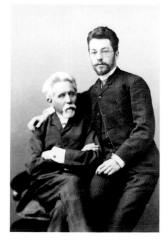

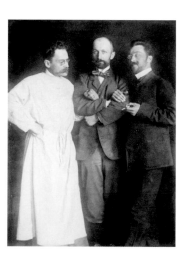

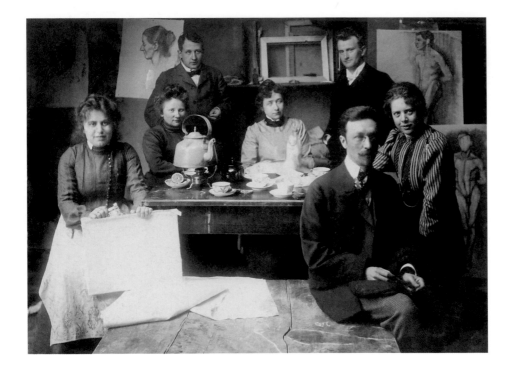

Left: **Phalanx-Schule (Phalanx School) staff and students, Munich, 1902.** Left to right: Olga Meerson, Emmy Dressler, Wilhelm Hüsgen, Gabriele Münter, Richard Kothe, Kandinsky (seated), and Maria Strakosch-Giesler

Below: **Kandinsky, Dresden, summer 1905**

Opposite: **Kandinsky and Münter on the Parc de Saint-Cloud terrace, France, ca. 1906–07**

1905

In early February, Kandinsky and Münter visit Carthage, followed by trips to Sousse and Kairouan, all in Tunisia, in March. Worried about his half-brother Vladimir Kojevnikov, reported missing in the Russo-Japanese War, Kandinsky sets off on April 5 for Munich via Palermo, Rome, Florence, and Bologna. In May Vladimir is killed in battle.

As early as late May, the couple goes to Dresden for a lengthy summer holiday, leaving there for an extended cycling trip around Saxon Switzerland and the Elbe Valley in Germany.

In mid-August they separate again, with Münter going to the Rhineland in Germany while Kandinsky rents a small studio apartment at 72 Amalienstraße in Schwabing for three months.

In fall Kandinsky first participates in the Salon des Indépendants in Paris. He regularly submits works to this exhibition and the Salon d'Automne until 1912.

In early October, Kandinsky travels with his father for several weeks via Budapest, Austria-Hungary (now Hungary), and L'viv, Austria-Hungary (now Ukraine), to Odessa, where he witnesses the Revolution of 1905.

Back in Munich, he and Münter leave in November for a trip via Cologne, Brussels, and Milan to the Italian Riviera, where, after some time in Sestri Levante, they rent a house in Rapallo, Italy, on December 23.

1906

Kandinsky and Münter remain in Rapallo for five months and are visited by his father and fellow artists Dressler and Palme.

They then travel directly from Rapallo to Paris, where on May 22 they take an apartment in the rue des Ursulines for four weeks. Kandinsky longs for seclusion away from the arts scene in the capital though he stays connected, particularly through the journal and exhibition

association *Les Tendances Nouvelles*. In late June, they move to a quieter location in Sèvres, a suburb near Saint-Cloud, west of Paris.

In fall Kandinsky exhibits twenty-one works at the Salon d'Automne and wins a Grand Prix.

Kandinsky and Münter spend more than a year in Paris. They live apart some of the time since he feels guilty about his relationship with his wife Anja.

1907

Kandinsky's links with *Les Tendances Nouvelles* enable him to exhibit 109 works at the Musée du Peuple in Angers, France, in May, but few members of the public or press see the show. Throughout their travels since 1904, he and Münter paint small-scale oil studies made with a palette knife, en plein air. Kandinsky also creates his nostalgic, fairy-tale tempera pictures, culminating in the two masterpieces *Riding Couple* (*Reitendes Paar*, 1907, plate 1) and *Colorful Life (Motley Life)* (*Das bunte Leben*, 1907, plate 2), painted during this last year in Paris.

On June 9, the couple leaves Paris, with Kandinsky initially traveling to Bad Reichenhall, Germany, for five weeks to restore his impaired health, which stems from his marital difficulties and feeling of artistic stagnation. He and Münter later leave for a summer cycling trip around Switzerland.

In September they settle in Berlin for six months. Kandinsky learns of Rudolf Steiner's Theosophy via lectures. He is also greatly influenced by Max Reinhardt's and Edward Gordon Craig's ideas on modern theater aesthetics.

1908

From April 28 to June 8, Kandinsky and Münter leave Berlin and spend several weeks in the South Tirol region in Italy, with most of their time in Lana.

In June they return to Munich and settle there. Searching the German countryside for inspiring scenery, they find the town of Murnau close to Garmisch, by Lake Staffel in the foothills of the Bavarian Alps. From August to late September, they, with fellow painters Jawlensky and Werefkin, take rooms at the Griesbräu Inn on Murnau's Obere Hauptstraße, where they produce many works. Here, they quickly develop a new vividly colored, expressive painting style, which eventually leads to Der Blaue Reiter (The Blue Rider), the epochal breakthrough to modernism, and in Kandinsky's case, abstract painting.

While still in Murnau, on September 4 Kandinsky rents an apartment of his own in Munich, in the back building of 36 Ainmillerstraße in Schwabing, initially on the first floor and later on the third floor. It will become a meeting place for his associates until 1914.

In winter Kandinsky works with Russian composer and musician Thomas von Hartmann, whom he has met in Munich during the summer,

on drafts for his first theatrical work, in which color, sound, language, and movement are combined in an artistic synthesis.

Also in winter, he participates in Sergei Markovsky's salon in St. Petersburg.

1909

Prompted by their continuing productive collaboration since their time in Murnau, Jawlensky, Kandinsky, Münter, and Werefkin establish the artists' group Neue Künstlervereinigung München (NKVM) (New Artists' Association of Munich) on January 22. Other members include Vladimir G. Bekhteyev, Erma Bossi, Adolf Erbslöh, Karl Hofer, Alexander Kanoldt, Moissey Kogan, Kubin, dancer Alexander Sakharov, plus collectors Heinrich Schnabel and Oskar Wittenstein. Kandinsky is elected chair and drafts a group prospectus, which in May is sent to gallery owners, collectors, and museums.

In February and March, Kandinsky and Münter spend two weeks in Kochel am See with their friends Thomas and Olga von Hartmann.

Kandinsky and Münter return to Murnau in May with Jawlensky and Werefkin to paint. During their stay they discover Bavarian religious glass painting. The medium's intense color and modest, unassuming form inspires them to experiment with this technique. They also begin to collect folk art and *Hinterglasbilder* (reverse glass painting), which add a distinctive, humble note to the general avant-garde discovery of so-called primitive art.

In June Kandinsky and Münter move to a small villa, built only recently for summer guests in Kottmüllerallee on Murnau's eastern edge, with a view of the church hill and the Murnau marshes.

At Kandinsky's enthusiastic urging, Münter buys the house on August 21. The couple

spends many months there until the outbreak of World War I.

Beginning in October, Kandinsky contributes, over the course of a year, several reports called "Pismo iz Miunkhena" ("Letters from Munich") to the art periodical *Apollon*, which Markovsky publishes.

After great effort, including that of Hugo von Tschudi, director of the Bayerische Staatsgemäldesammlungen in Munich, whom Kandinsky had contacted, NKVM's first exhibition takes place, December 1–15, at Heinrich Thannhauser's Moderne Galerie in Munich. Kandinsky shows eight paintings and five woodcuts. The press reviews are devastating.

Kandinsky is also represented at Vladimir Izdebsky's large-scale First International Salon Izdebsky, which opens in December in Odessa and subsequently tours to Kiev, Russia (now Ukraine); Riga, Russia (now Latvia); and St. Petersburg.

1910

Kandinsky and Münter spend the spring and summer mainly in Murnau.

The NKVM has a second exhibition at Thannhauser's gallery, September 1–14, this time with guest artists from France and Russia, including Georges Braque, David and Vladimir Burliuk, Vasily Denisov, André Derain, Henri Le Fauconnier, and Pablo Picasso. Kandinsky's works include his large-format canvases *Boat Trip* (*Kahnfahrt*), *Improvisation 10*, and *Composition II* (*Komposition II*, 1910). The exhibition once again attracts violent hostility from the press and public. Munich painter Franz Marc's positive review brings him in contact with the group.

From October to December, Kandinsky is initially in Moscow and later with his family in Odessa. Moscow fills him with enthusiasm, after five years away from Russia and seven from his native city. He meets and renews contact with numerous people in the art and music scenes, including Natalia Goncharova, Hartmann, Pyotr Konchalovsky, Mikhail Larionov, Ilya Mashkov, and composer and Pyotr Tchaikovsky's pupil Sergei Taneyev.

At the Second International Salon 1910/11, organized by Izdebsky in Odessa in December, Kandinsky shows fifty-four works. The exhibition

Left to right: **Münter's house in Murnau, ca. 1910**

Kandinsky in the garden of the house in Murnau, ca. 1910–11

Kandinsky at his desk in his apartment at 36 Ainmillerstraße, Munich, June 1911

Opposite: **Installation view: *Die erste Ausstellung der Redaktion Der Blaue Reiter (First Exhibition of the Blaue Reiter Editorial Office)*, Moderne Galerie, Munich, 1911–12. Room 2 with *Improvisation 22* (1911) at far right**

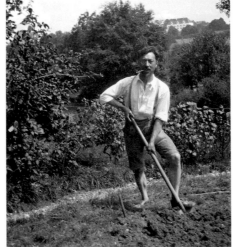

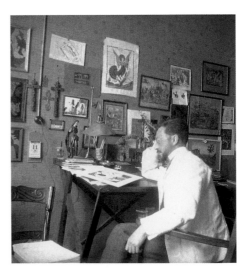

catalogue with a cover designed by him appears in March 1911. It contains his commentary on Arnold Schönberg called "Soderzhanie i forma" ("Content and Form") and his Russian translation of a chapter from Schönberg's *Theory of Harmony* (1911), preceding the publication of the original German text in Vienna. Through Kandinsky, Schönberg is introduced to the Russian public early in his career.

Also in December, Kandinsky takes part in the exhibition of work by Jack of Diamonds, a new artists' group in Moscow run by Larionov. Shortly before Christmas, he returns to Munich.

1911

On January 1, Kandinsky and Marc meet at a New Year's reception at Jawlensky and Werefkin's apartment in Giselastraße. They soon become close friends, visiting Munich, Murnau, and nearby Sinelsdorf, Germany, where Marc had moved.

On January 2, Kandinsky and other NKVM artists attend a concert by Schönberg in Munich. Deeply impressed, Kandinsky immediately contacts the Viennese composer, beginning a lively correspondence between the two men over the next few years.

Kandinsky resigns as chair of NKVM on January 10 because of conflict with the more conservative members over his move toward near total abstraction. Jawlensky succeeds him.

Kandinsky and Anja divorce in St. Petersburg in February.

The progressive ideas of Kandinsky and Marc, who joins NKVM in February, bring them increasingly into conflict with the moderates in the group.

In June Kandinsky informs Marc of his plan to publish an art almanac that will provide a forum for artists from various fields at home and abroad. He intends to design a comparative

presentation of works of different genres and periods, including non-European and folk art. Soon after, Kandinsky comes up with the title *Der Blaue Reiter*, and in the following months, he and Marc work intensely on the project.

After years of preparatory work, Kandinsky's book *On the Spiritual in Art* is published in December by R. Piper und Co. in Munich but dated 1912. Chapters of the Russian version of the book, his most important written work prior to World War I, are read aloud to great acclaim by painter Nikolai Kulbin at the second All-Russian Artists' Congress on December 29 and 31.

During a jury session on December 2 for the planned third NKVM exhibition, the panel rejects Kandinsky's almost abstract *Composition V* (*Komposition V*, fig. 50). Kandinsky, Marc, and Münter resign. Within two weeks, they organize an exhibition that runs parallel to the NKVM show at Moderne Galerie, December 18, 1911–January 1, 1912 (and extended to January 3). *Die erste Ausstellung der Redaktion Der Blaue Reiter* (*First Exhibition of the Blaue Reiter Editorial Office*) includes works by the Burliuks, Heinrich Campendonk, Robert Delaunay, Kandinsky, August Macke, Marc, Münter, Henri Rousseau, and Schönberg. In addition to *Composition V*, Kandinsky presents the now destroyed *Impression of Moscow* (*Impression Moskau*) and *Improvisation 22*.

1912

Die zweite Ausstellung der Redaktion Der Blaue Reiter. Schwarz-Weiß (*Second Exhibition of the Blaue Reiter Editorial Office: Black and White*) is presented at Galerie Hans Goltz in Munich from February to April and contains only works on paper, including those by Die Brücke (The Bridge) artists, Paul Klee, and Kubin.

Der Blaue Reiter (*The Blaue Reiter Almanac*) appears in May, published by R. Piper und Co. in Munich. It contains Kandinsky's great essays "Über die Formfrage" ("On the Question of Form") and "Über Bühnenkomposition" ("On Stage Composition"), plus the first printing of the text and directions for his stage composition *Der gelbe Klang* (*Yellow Sound*).

The great Sonderbund exhibition, surveying the international avant-garde, opens in Cologne, May 25–September 30. Some artists, including Kandinsky, participate, but feel that, since some of their pictures are rejected, they are not appropriately represented. Under the Blaue Reiter label, they organize an exhibition of works refused by the Sonderbund. Herwarth Walden opens Der Sturm gallery in Berlin with this show in June and July.

Kandinsky exhibits with Klee, Marc, and Münter at the Moderner Bund exhibition in Zurich, July 7–31, at Cuno Amiet and Jean Arp's invitation.

Walden mounts Kandinsky's first solo show al Der Sturm, October 2–30. *Kandinsky. Kollektiv-Ausstellung 1902–1912* (*Kandinsky:*

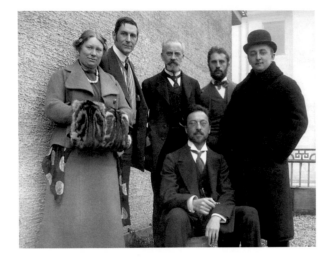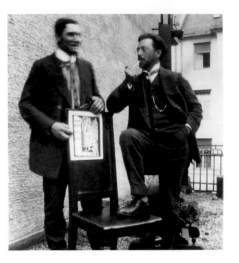

Left to right: **Members of the Blaue Reiter on the 36 Ainmillerstraße balcony, Munich, ca. 1911–12.** Left to right: Maria and Franz Marc, Bernhard Koehler, Kandinsky (seated), Heinrich Campendonk, and Thomas von Hartmann

Marc with the cover woodcut for *Der Blaue Reiter* (*The Blaue Reiter Almanac*, 1912, fig. 11) **and Kandinsky on the 36 Ainmillerstraße balcony, Munich, ca. 1911–12**

Kandinsky. Published in *Kandinsky 1901–1913. Album* (Berlin: Verlag Der Sturm, 1913)

Retrospective 1902–1912), with more than seventy paintings, is on view during winter 1912–13 at Galerie Hans Goltz. Kandinsky travels to Berlin to see the exhibition before heading to Odessa and Moscow for two months.

Kandinsky's album *Klänge* (*Sounds*), long in preparation, is published in December by Piper with twelve color and forty-four black-and-white woodcuts as well as his poetry in a special bibliophile edition.

1913

Kandinsky takes part in the *International Exhibition of Modern Art* (popularly known as the Armory Show) in New York, February 17–March 15, which subsequently travels to Chicago and Boston. At the exhibition, artist Alfred Stieglitz buys *Improvisation 27 (Garden of Love II)* (*Improvisation 27 [Garten der Liebe II]*, 1912, plate 30) for his New York gallery. Other American collectors take note of Kandinsky.

In spring Marc decides to make an illustrated Blaue Reiter Bible, with work by Erich Heckel, Kandinsky (assigned the Apocalypse), Klee, Kubin, Oskar Kokoschka, and himself.

Lawyer and collector Arthur Jerome Eddy from Chicago and collector Willem Beffie from Holland visit Kandinsky in Murnau in the summer and buy several paintings.

Kandinsky travels via Berlin to Moscow, July 5–September 6. Back in his native city, he sells his house and builds a new six-story tenement house with twenty-four apartments on Dolgy Street in Zubovsky Square.

Kandinsky exhibits seven large paintings in Walden's Der Sturm gallery, September 20–December 1, at the major *Erster deutscher Herbstsalon* (*First German Autumn Salon*), the most important gallery exhibition of the international avant-garde in Europe before World War I. His works include *Improvisation 31 (Sea Battle)* (*Improvisation 31 [Seeschlacht]*, plate 33) and *Sketch for Painting with White Border* (*Entwurf zu Bild mit weißem Rand*).

In October Der Sturm publishes the representative album *Kandinsky 1901–1913. Album* with more than eighty illustrations. It contains the first reprint of Kandinsky's autobiographical memoir "Reminiscences," plus his short texts for the great paintings *Composition IV* (*Komposition IV*, 1911), *Composition VI*

(*Komposition VI*, fig. 39), and *Painting with White Border (Moscow)* (*Bild mit weißem Rand* [*Moskau*], plate 35). Walden becomes Kandinsky's dealer for the next few years.

1914

Kandinsky has a solo exhibition at the Kreis für Kunst gallery in Cologne, January 30–February 15. Unable to attend the opening, Kandinsky writes an autobiographical text later called "Kandinsky über seine Entwicklung" ("Cologne Lecture"), which is read aloud at the event.

The second edition of *The Blaue Reiter Almanac* is published in March with two new forewords by its editors Kandinsky and Marc. However, a long-envisaged second volume never comes to fruition.

Kandinsky's treatise *On the Spiritual in Art* is published in London and Boston in April, translated by Michael T. H. Sadler, as *The Art of Spiritual Harmony*. The Russian edition is published in October.

Kandinsky, his mother, and other relatives spend two weeks, April 9–20, in Merano, Italy. His relationship with Münter increasingly deteriorates.

Hugo Ball proposes a performance of Kandinsky's stage composition *Yellow Sound* at the Künstlertheater in Munich.

World War I breaks out on August 1. Kandinsky and Münter rush back to Munich from Murnau and on August 3 set off for Switzerland, since Kandinsky, like Jawlensky, Werefkin, and other Russians, is now an enemy alien in Germany.

Kandinsky and Münter settle in a house belonging to their Munich landlord in Goldach, near Rorschach on Lake Constance in Switzerland, August 6–November 16. Here, Kandinsky starts his notes for what later becomes his 1926 book *Punkt und Linie zu Fläche*.

Beitrag zur Analyse der malerischen Elemente (*Point and Line to Plane: A Contribution to the Analysis of Pictorial Elements*). Later, Kandinsky and Münter go to Zurich, where they separate in November. He returns to Moscow via the Balkans and Odessa with a group of relatives and other Russians on a difficult journey lasting more than six weeks. He leaves almost all his possessions and pictures in Münter's care. More than seventy other works are with Walden in Berlin.

1915

In Moscow Kandinsky soon moves into a just-vacated five-room apartment on the top floor of his tenement building in Dolgy Street near Zubovsky Square.

Along with Natan Altmann, the Burliuks, Goncharova, and Larionov, he takes part in the *Vystavka zhivopisi 1915* (*Painting 1915*) exhibition in Moscow in April.

Throughout the year, Kandinsky finds it hard to work. He produces no paintings, only works on paper. In May, Münter shuts her house in Murnau, vacates the apartment on Ainmillerstraße in Schwabing, stores her possessions in Munich including all works, and goes to Stockholm with the hope of seeing Kandinsky in neutral Sweden. Münter writes imploring letters and arranges solo shows for both herself and Kandinsky at Gummesons Konsthandel, owned by Carl Gummeson. Kandinsky leaves Moscow and arrives in the Swedish capital on December 23.

1916

A solo show of Kandinsky's work opens February 1 at Gummesons Konsthandel, which is partnered with Walden's Der Sturm gallery. In Stockholm, Kandinsky and Münter associate with psychiatrist Poul Bjerre, artist couple Isaac

Grünewald and Sigrid Hjertén, and other members of the Swedish avant-garde. Also during his stay in Sweden, Kandinsky does a series of etchings and watercolors with mostly representational subjects, which he terms "bagatelles" in his Handlist, his personal inventory of his works. In early March, Münter's solo show follows Kandinsky's at Gummesons. On this occasion, Kandinsky writes "Über den Künstler" ("On the Artist") for the catalogue brochure *Om Konstnären* (Swedish for "On the Artist"), which he dedicates to her.

Kandinsky breaks up with Münter for good, though they continue to correspond, and leaves Stockholm on March 16 for Moscow. In summer, Der Sturm presents in Oslo *Kandinsky–Gabriele Münter*, a selection of the paintings shown at Gummeson's gallery in Stockholm.

In May Kandinsky meets twenty-year-old Nina Andreevskaya during a telephone conversation in Moscow. She is the daughter of a deceased Russian officer and an acquaintance of his nephew Analoij Scheiman. Attracted by her voice, he arranges a rendezvous after the summer break at the Museum Alexander III (now the State Pushkin Museum of Fine Arts).

In fall Kandinsky returns to creating oil paintings, including *Moscow I* (*Moskau I*, plate 47). Most of the paintings of the view from his Dolgy Street apartment overlooking Zubovsky Square date from this year.

1917

In January Kandinsky sells his tenement building on Dolgy Street but retains ownership of the residence on the top floor. He also acquires the neighboring plot, with a view to constructing another home and a studio building.

He marries Andreevskaya on February 11 in a Russian Orthodox wedding in Moscow. They honeymoon in Finland, traveling via

St. Petersburg. While staying in a hotel in Helsinki, they learn of the February Revolution.

The Kandinskys spend the summer holiday on the Akhtyrka estate of Kandinsky's Abrikosov relatives, the family of his previous wife Anja Shemiakina. Their son Vsevolod is born in September.

The Sturm-organized double exhibition of Kandinsky's and Münter's work tours Helsinki and Petrograd (formerly St. Petersburg). A series of paintings remains in Russia after the tour.

After the October Revolution breaks out and the Bolsheviks overthrow the social democratic Provisional Government, Kandinsky's property, including the land he has just bought, is expropriated.

1918

From the beginning of the year and for the rest of his time in Russia, Kandinsky is co-opted onto various committees relating to art education and museums. Initially he is a member of Vladimir Tatlin's Department of Art (IZO) in the newly founded People's Commissariat for Enlightenment (Narkompros), like Liubov Popova,

Alexander Rodchenko, and Olga Rosanova. In July, he is also put in charge of the Department of Art's theater and film academy. Starting in October, he leads the painting studio of the Free State Art Studios (SVOMAS) in Moscow, founded in spring. It has other branches in Petrograd, run by Antoine Pevsner, and Vitebsk (now in Belarus), run by Kazimir Malevich.

The Russian translation of "Reminiscences" is published by the IZO in Moscow with a number of alterations, including its new title *Tekst Khudozhnika* (*Artist's Text*) and subtitle *Stupeni* (*Steps*).

In November Berlin's Der Sturm gallery exhibits his work in the *Marc Chagall, Vasili Kandinsky, William Wauer* and *Russische Expressionisten* (*Russian Expressionist*) exhibitions.

In December he takes part in the *V State Exhibition of Paintings*, which closes in February 1919, at the Museum of Fine Arts in Moscow.

Kandinsky is fully occupied with his educational and cultural activities and produces no oil paintings this year. Rodchenko and Varvara Stepanova live and work in his flat for part of the time.

Left to right: **Kandinsky and Münter, Stockholm, 1916**

Kandinsky, Moscow, 1918. Published in *Tekst Khudozhnika* (Moscow: Izdanie Otdela Izobrazitelnykh Iskusstv Narodnago Kommissariata po Prosveshcheniyu, 1918)

Kandinsky with his son Vsevolod in their Moscow apartment, ca. 1919

Kandinsky's building at the corner of Dolgy and Neopalimovskiy streets, Moscow, 1978

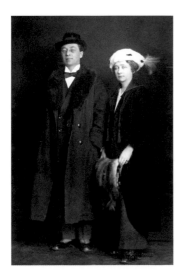

1919

In February Kandinsky is appointed the first director of the Museum of Painterly Culture in Moscow and with Rodchenko commits to setting up twenty-two provincial museums to decentralize publicly owned art holdings, which have grown considerably through expropriations. The Museum of Painterly Culture acquires his works for some of these provincial institutions, including those in Astrakhan, Krasnodar, and Novgorod.

He is part of a committee charged with publishing *Entsiklopediia izobrazitelnogo iskusstva,* an encyclopedia of art, which never appears. The entry he writes about himself is published in German as "W. Kandinsky. Selbstcharakteristik" ("Self-Characterization") in June in *Das Kunstblatt.*

Other essays, such as "Malenkie stateiki o bolshim voprosam. 1. O tochke" ("Little Articles on Big Questions 1. On Point") and "2. O linii" ("2. On Line"), are published in the journal *Iskusstvo* in the February 1 and 22 issues respectively. His output of paintings (six this year, ten the following year) remains minimal.

His wife Nina works for Narkompros, initially as Kandinsky's secretary and subsequently as office manager and secretary at the Department for Materials Procurement at the Academic Center, sometimes earning more there than her husband. Even so, the Kandinskys increasingly experience privation, food shortages, and difficulty in obtaining goods for their son Vsevolod.

Kandinsky is appointed chair of the All-Russia Purchasing Committee for Museums at IZO NKP in November.

1920

Between January and April, Kandinsky publishes three articles in the Moscow art periodical *Khudozhestvennaia Zhizn,* which, published by the IZO NKP, replaced *Mir Iskusstva* in 1919. His writings include "O velikoi utopii" ("The

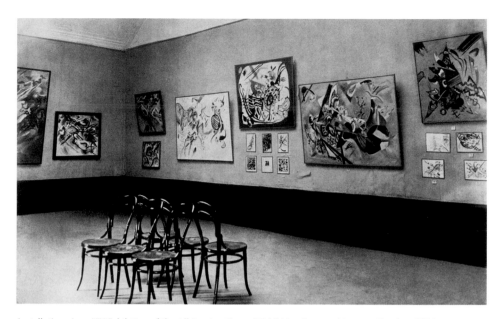

Installation view: *XIX Exhibition of the All-Russian Central Exhibition Bureau,* Moscow, October 1920

Great Utopia") and "Programma Instituta Khudozhestvennoi Kultury" ("Program for the Institute of Artistic Culture").

The Institute of Artistic Culture (INKhuk) is founded in Moscow in May, with Kandinsky as head of the Department of Monumental Art. Branches are soon opened in Petrograd, Vitebsk, and other cities in the Soviet Union and Europe.

His son Vsevolod dies at age two on June 16. In the same month, during the First Pan-Russian Conference of Teachers and Students at the Moscow SVOMAS, Kandinsky presents the INKhuk pedagogical program, which the Constructivists reject. He is appointed honorary professor at the University of Moscow. Also in June, he, Rodchenko, Nikolai Sinesubov, and Stepanova are featured in the *Exhibition of the Four* in Moscow.

In September the Higher State Artistic and Technical Workshops (VKhuTEMAS), where Kandinsky teaches, replace the SVOMAS, which were founded in 1918.

In November and December, he exhibits at a Société Anonyme exhibition in New York and shows fifty-four works at the *XIX Exhibition of the All-Russian Central Exhibition Bureau,* produced by the IZO NKP.

On behalf of INKhuk, Kandinsky delivers a report to the first pan-Russian conference of the heads of Narkompros art sections, December 19–25. His report is rejected, and he leaves INKhuk toward the end of the year.

1921

At INKhuk Kandinsky is appointed cochair with A. M. Rodionov and Pyotr Kogan of the advisory committee for the establishment of the Russian Academy of Artistic Sciences (RAKhN). At the same time, he is designated chair of the subcommittee for Physio-Psychology and Fine Arts. He draws up a program for the Physio-Psychology Department in June, which the academic committee accepts on July 21.

In a summer lecture to the academy's arts committee, he outlines his ideas about the basic elements of painting. However, the Department of Fine Arts at RAKhN is not established until January 22, 1922, after he emigrates to Germany.

Kandinsky cofounds RAKhN in October. As Kandinsky is not a member of the Communist Party, Kogan becomes president, Kandinsky vice-president. This disappointment, the rejection of his INKhuk program and departure from that organization, his artistic and philosophical isolation together with the everyday privation following the revolution and civil war, strengthen his resolve to leave Russia. His last Russian exhibitions are *Mir Iskusstva* and *Third Traveling Art Exhibition of the Soviet Regional Subdivision of the Museum Directorship* in Sovetsk.

According to Nina Kandinsky's memoir *Kandinsky und ich* (*Kandinsky and I*), Kandinsky receives, through Russian contacts, an invitation to the Bauhaus in Weimar, Germany.

Thanks to the German ambassador in Moscow, the Kandinskys are able to take paintings with them, but only take a dozen, as they see their stay in Germany as temporary. In late December, they leave the Soviet Union and arrive in Berlin, exhausted and malnourished. They take a furnished room in Charlottenburg. Soon after his arrival Kandinsky meets Lyonel Feininger and visits Walden at Der Sturm gallery, where he learns that the dealer has sold all his paintings without his consent during the war. Because of the economy, little money is left from the sales.

1922

In Berlin Kandinsky spends the first six months in seclusion though the art world welcomes him. He meets only a few artists such as George Grosz and Jawlensky, who travels from Wiesbaden, Germany, to see his friend again.

Walter Gropius, director of the Bauhaus, and artist Alma Mahler visit Kandinsky in Berlin

in March to offer a teaching post at the institute, which he accepts.

Galerie Goldschmidt-Wallerstein in Berlin shows the twelve paintings he brought from Russia and two new paintings from the previous six months in Berlin. This is his first solo exhibition in postwar Germany and is on view April 30–June 5.

In June he begins work as a master in the Wall Painting Workshop while teaching the theory of form in the Preliminary Course at the Bauhaus. Among other staff members such as Feininger, Johannes Itten, and Oskar Schlemmer, he meets his old friend Klee. In the same month, the Kandinskys move to Weimar.

Two new paintings are shown in the Foreign Artists/Russia section of the *Internationale Kunstausstellung Düsseldorf* (*International Art Exhibition Düsseldorf*), May 28–July 3. Thannhauser's Moderne Galerie in Munich opens a solo show of his work, July 1–14.

In summer Kandinsky designs large-format murals for the entrance of an imaginary art museum, executing them with Herbert Bayer and his Bauhaus students in Weimar for the *Juryfreie Kunstschau* (*Juryless Art Show*) in the fall at the regional exhibition building in the Lehrter Bahnhof, a train station in Berlin.

In September the Kandinskys spend the summer holidays at Gropius's mother's house near Timmendorf, Germany, on the Baltic coast.

A new solo Kandinsky show is organized at Gummesons in Stockholm, September 1–October 15. He also presents six works at the extensive *Erste russische Kunstausstellung* (*First Russian Art Exhibition*) at the Galerie van Diemen in Berlin, which opens October 15 and includes the work of the Burliuks, Marc Chagall, Denisov, El Lissitzky, Malevich, Rodchenko, and numerous other representatives of the 1900 generation.

Kandinsky and his Narkompros colleagues, Moscow, 1921. Left to right: painter Robert Falk, musician Yuri Shor, physicist Pyotr Ouspensky, Kandinsky, choreographer E. Pavlov, and musician Alexander Shenshin

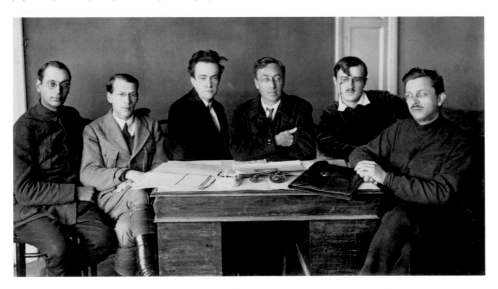

Toward the end of the year, Kandinsky's portfolio of twelve prints *Kleine Welten* (*Small Worlds*) is printed at the Bauhaus and a Weimar press on behalf of publishers Propyläen Verlag in Berlin.

1923

In early January, Kandinsky's work is featured in the *Zehn Jahre Neue Kunst in München* (*Ten Years of New Art in Munich*) exhibition at Galerie Hans Goltz.

The Société Anonyme in New York presents a solo exhibition of his work, March 23–May 4, and appoints him the first honorary vice-president. He befriends Katherine Dreier.

A close correspondence begins with Dresden-based art historian, writer, and teacher Will Grohmann, whom he has known since 1921.

Staff and students from all departments show work, August 15–September 30, in the Bauhaus's first major exhibition, celebrating five

Kandinsky, Berlin, January 1922

years of its existence. In the Bauhaus Week program, Kandinsky gives a lecture on synthetic art, and Gropius and J. J. P. Oud give talks as well.

As part of the celebrations, Schlemmer's *Triadic Ballet* and Igor Stravinsky's *Soldier's Tale* premiere. The accompanying book *Staatliches Bauhaus, Weimar, 1919–1923* features Kandinsky's essays "Die Grundelemente der Form" ("The Basic Elements of Form"), "Farbkurs und Seminar" ("Color Course and Seminar"), and "Über die abstrakte Bühnensynthese" ("Abstract Synthesis on the Stage").

The Kandinskys spend the summer holiday at the Baltic Sea resorts of Müritz and Binz on Germany's Rügen island.

The Kandinskys' social circle includes Lyonel and Julia Feininger, Paul and Lily Klee, Georg and El Muche, and Oskar and Anna Schlemmer.

1924

In March, Galka Scheyer sets up the Blue Four comprising Feininger, Jawlensky, Kandinsky, and Klee as a marketing entity to promote their works in the United States through exhibitions. A former artist and dealer who has been acquainted with Jawlensky and his family since 1916, Scheyer emigrates in 1924 to the United States, initially to New York and later to Hollywood. She represents Kandinsky in the United States until his death.

The Kandinskys spend the summer holidays in Wenningstedt, Germany, on Sylt island in the North Sea.

Kandinsky shows work in the *Internationale Kunstausstellung* (*International Art Exhibition*) at the Vienna Secession, September 11–October 20, as do Klee and, for the first time Fernand Léger. Kandinsky gives a lecture as part of the exhibition's program. His journey to Vienna is presumably via Munich.

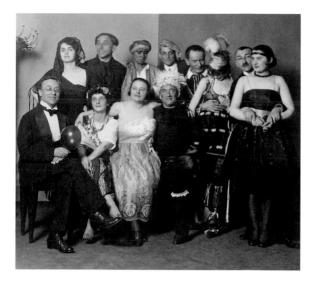

Party at the Bauhaus, Weimar, Germany, ca. 1923.
Seated far left: Kandinsky with his second wife Nina

With the well-entrenched National Socialist (Nazi) Party exerting pressure, the Weimar city council terminates its agreement with the Bauhaus on December 26.

1925

In February the Kandinskys make one of their frequent visits to Grohmann and collector Ida Bienert in Dresden. From there they, with the Muches, go briefly to Dessau, Germany, to assess the possibility of the Bauhaus moving there.

Works by the Blue Four are shown at Daniel Gallery in New York, February 20–March 10. Though an attractive catalogue is produced, no sales result.

The *Zehnte Jahres-Ausstellung* (*Tenth Annual Exhibition*), on view February 22–March 31 at the Städtisches Museum in Leipzig, Germany, includes the Bauhaus Masters section with one painting each from Feininger, Kandinsky, Klee, László Moholy-Nagy, Muche, and Schlemmer.

In March Kandinsky and Klee take part in the exhibition organized by the Nassauischer

Kunstverein (Nassau Art Association) at Wiesbaden's Neues Museum, where *Composition 8* (*Komposition 8*, 1923, plate 63) is shown. Kandinsky gives a lecture at the museum.

On April 1, the Bauhaus in Weimar closes under pressure from the Nazis.

On May 25, Gropius signs the contract for the Bauhaus to move to Dessau. In summer construction begins on the Gropius-designed Bauhaus building and seven master houses for the teachers—a separate house for Gropius and double units for Kandinsky and Klee, Feininger and Moholy-Nagy, and Muche and Schlemmer. The Bauhaus moves to Dessau in June. The Kandinskys initially live in a furnished apartment at 7 Moltkestraße, subletting one room to Klee.

Kandinsky shows five paintings at the *Große Kunstausstellung, Jubiläums-Ausstellungen Düsseldorf* (*Great Anniversary Exhibition Düsseldorf*), held from May to October.

In June *Der Cicerone* publishes his article "Abstrakte Kunst" ("Abstract Art").

The Kandinskys spend their summer holiday in Binz on Rügen island.

Otto Ralfs with other German collectors sets up the Kandinsky Gesellschaft in Brunswick, modeled after the Klee Gesellschaft founded a year earlier. It is intended to help the artist financially by purchasing his works.

Toward the end of the year, Kandinsky completes the manuscript of *Point and Line to Plane*.

1926

Point and Line to Plane is published by Albert Langen in Munich as volume 9 in the Bauhaus Bücher (Bauhaus Books) series.

A major Kandinsky exhibition, organized by the Gesellschaft der Freunde junger Kunst (Society for the Friends of Young Art), opens in May at Brunswick Palace in Germany in honor of his sixtieth birthday. It contains fifty-two paintings and an equal number of watercolors. The exhibition subsequently tours to the Galerie Arnold in Dresden and to Berlin, Dessau, and other cities. The accompanying catalogue

contains articles by Dreier, Grohmann, art historian Fannina Halle from Vienna, and Klee.

During the summer, the Bauhaus artists take part in a major exhibition of abstract art in Berlin, *Ausstellung der Abstrakten. Große Berliner Kunstausstellung* (*Exhibition of the Abstract: Great Berlin Exhibition*). They design the catalogue and decorate the exhibition rooms.

In June the Kandinskys move into one of the double master houses designed by Gropius at 6 Burgkühnauer Allee (now Ebertallee) in Dessau.

Art journal *Das Kunstblatt* publishes Kandinsky's essay on modern dance and dancer Gret Palucca, "Tanzkurven: Zu den Tänzen der Palucca" ("Dance Curves: The Dances of Palucca"), whose body language was already mentioned in *Point and Line to Plane*.

Kandinsky's father dies in Odessa. His mother had died in the war and revolution years, even before Kandinsky left for Germany again in 1921.

In September after years of legal dispute with Münter, Kandinsky receives some of his

Kandinsky's dining room with furniture by Marcel Breuer, Dessau, Germany, 1926. Photo: Lucia Moholy

Bauhaus faculty, Dessau, ca. 1926. Front row, far left: Kandinsky, far right: Lyonel Feininger and Georg Muche

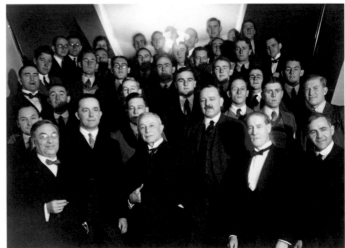

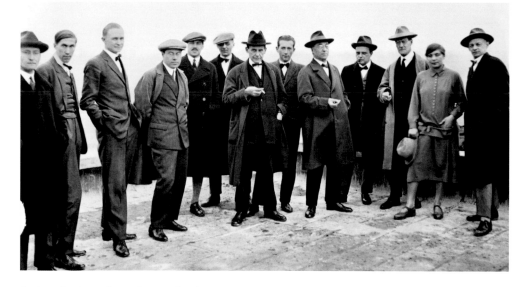

Bauhaus faculty on the Bauhaus roof at the Dessau opening ceremony, December 4, 1926. Left to right: Josef Albers, Hinnerk Scheper, Muche, László Moholy-Nagy, Herbert Bayer, Joost Schmidt, Walter Gropius, Marcel Breuer, Kandinsky, Paul Klee, Feininger, Gunta Stölzl, and Oskar Schlemmer

Kandinsky's staff ID at the Bauhaus, Dessau, 1926

belongings from Munich back, including some paintings and various domestic items.

In November Kandinsky takes part in Société Anonyme's *An International Exhibition of Modern Art* at the Brooklyn Museum in New York.

The periodical *bauhaus* is established in December, with a minimalist design. The first issue is devoted to Kandinsky for his sixtieth birthday and contains his essay "der wert des theoretischen unterrichts in der malerei" ("The Value of Theoretical Instruction in Painting").

On December 4, the Bauhaus building in Dessau opens to great ceremony. Former students Josef Albers, Bayer, Marcel Breuer, Hinnerk Scheper, Joost Schmidt, and Gunta Stölzl are given the title of young master, joining the permanent staff.

1927

The international periodical *i10* in Amsterdam features Kandinsky's important theoretical essay "Und. Einiges über synthetische Kunst" ("And, Some Remarks on Synthetic Art") in its January issue.

Gustav Hartlaub, director of the Kunsthalle Mannheim, gives Kandinsky a prominent position at the important abstract art exhibition *Wege und Richtungen der abstrakten Malerei in Europa* (*Paths and Directions of Abstract Painting in Europe*), which is the first survey of international abstract art in Germany and on view January 30–March 27. Others represented include Alexander Archipenko, Willi Baumeister, Robert and Sonja Delaunay, Albert Gleizes, Juan Gris, Klee, Léger, Moholy-Nagy, Piet Mondrian, Picasso, Schlemmer, Kurt Schwitters, and Friedrich Vordemberge-Gildewart. Kandinsky has the largest number of paintings on view and also numerous watercolors, including some from the 1926 touring exhibition.

Feininger, Kandinsky, and Klee give classes on free (easel) painting, which are held in their private studios in the master houses.

The Kandinskys spend their summer holiday in Pörtschach on the Wörthersee lake in Austria and in Switzerland. They pass through Munich, which Kandinsky visits for the second and last time since the war. In Pörtschach, they happen to meet Schönberg and his second wife Gertrud and enjoy some pleasant days together. The previous ill-will occasioned by Kandinsky's alleged anti-Semitism—presumably due to rumors started by Mahler—is dispelled, but regular correspondence is not resumed.

In Dessau in the fall, Kandinsky meets Christian Zervos, the Greek-born publisher of the newly founded periodical *Cahiers d'Art* in Paris. Kandinsky is enthusiastic about the journal, which through 1935 will serve as a Paris-based forum for his ideas, along with the associated art gallery founded subsequently.

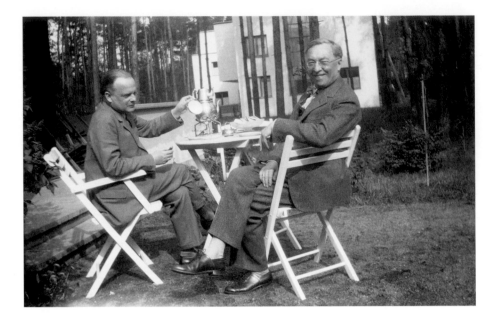

Kandinsky and Klee at the coffee table in their garden, Dessau, ca. 1927

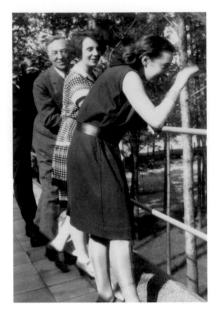

The Kandinskys and Gret Palucca on a terrace at the Bauhaus, Dessau, May 1928

1928

On March 8, the Kandinskys are granted German citizenship, applied for years previously, and can travel abroad. To celebrate, they organize a fancy dress party at home.

Swiss architect Hannes Meyer, previously Gropius's assistant, succeeds Gropius as director of the Bauhaus on April 1. Under his management, the conflict between painting and applied art, free art and industrial design intensifies. Bayer, Breuer, and Gropius leave the Bauhaus simultaneously and set up private offices in Berlin.

Kandinsky creates the dramatic adaptation *Bilder einer Ausstellung* of Modest Mussorgsky's piano suite *Kartinki s vystavki* (*Pictures at an Exhibition*, 1874) and designs the sets for the theatrical version, directed by Georg Hartmann with the assistance of Felix Klee, at the Friedrich Theater in Dessau. Premiering on April 4, Kandinsky's only stage work performed in his lifetime is repeated on April 8.

His essays "kunstpädagogik" ("Art Pedagogy") and "analytisches zeichnen" ("Analytical Drawing") are published in *bauhaus*.

Artists whose works are shown in the summer exhibition of Frankfurt's Galerie Ludwig Schames, June 18– July 31, include Otto Dix, Feininger, Heckel, Hofer, Jawlensky, Kandinsky (paintings and watercolors), Ernst Ludwig Kirchner, Klee, Kokoschka, Emil Nolde, and Karl Schmidt-Rottluff.

In summer the Kandinskys holiday in Nice and Juan-les-Pins on the French Riviera and in Les Sables d'Olonne, France, on the Atlantic coast.

In October a major exhibition of Kandinsky's watercolors is on view at Galerie Ferdinand Möller in Berlin with fifty-four new works. The artist writes a brief introduction to the catalogue.

The show is soon followed by a Kandinsky solo exhibition, October 12–November 5, at

Rudolf Probst's Galerie Neue Kunst Fides. Probst is also the dealer of the late Marc.

1929

Galerie Zak presents Kandinsky's first solo exhibition in Paris, January 15–31. It includes sixty-six watercolors from the previous three years. The foreword to the small catalogue brochure is written by E. Tériade. André Breton buys two pictures. In *Cahiers d'Art*, Zervos writes his first accompanying text about Kandinsky.

Another Blue Four exhibition, this time at the Oakland Art Gallery, opens in April.

On April 20, a major exhibition of Bauhaus artists opens at the Kunsthalle Basel. The catalogue, designed in Bauhaus fonts, includes full-page illustrations of some of Kandinsky's twenty-eight works in the show as well as the first showing of Albers's *fenster-bilder* (window pictures) and *wand-bilder* (wall pictures).

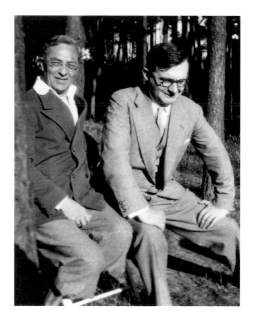

Left to right: **Kandinsky and Ludwig Grote** in the Bauhaus garden, Dessau, 1929

The Kandinskys in the Bauhaus garden, Dessau, ca. 1931

Albers, Kandinsky, and Anni Albers in the Bauhaus garden, Dessau, summer 1932

In early May, Marcel Duchamp and Dreier visit Kandinsky at the Bauhaus.

In the summer, the Kandinskys and Klees holiday together at Hendaye on the French Atlantic coast. On the way there, Kandinsky travels via Belgium to visit artist James Ensor in Ostend.

Kandinsky participates with the November gruppe (November Group) in the *Juryfreie Kunstschau*, which opens on August 31.

The first and only German exhibition of the Blue Four is held in October at Ferdinand Möller's Berlin gallery. The extensive show features works by Feininger, Jawlensky, and Klee along with eighteen paintings by Kandinsky. The catalogue contains an introduction by art critic Ernst Kállai.

A lengthy article on Kandinsky by Grohmann appears in November in *Cahiers d'Art*.

Rudolf Bauer buys several works by Kandinsky, two of which were shown with the Novembergruppe at the end of the summer,

on behalf of collector Solomon R. Guggenheim in November.

This year, Kandinsky participates in other group exhibitions in Berlin, Cologne, and Wiesbaden. His largest contribution is thirty-two works to the Gesellschaft der Kunstfreunde (Society of the Friends of Art) exhibition at the Schlesisches Museum in Wrocław, Poland, in December.

1930

In January Michel Seuphor invites Kandinsky to join the brief-lived Cercle et Carré (Circle and Square) group. Other members include Baumeister, with whom Kandinsky begins a correspondence in the following year; Le Corbusier; Léger; and Mondrian.

The year begins with a major retrospective of more than fifty works by Kandinsky shown at the Staatliches Museum in Saarbrücken, Germany, January 12–February 9. Kandinsky and Nina travel there for a lecture. The Bauhaus also organizes an exhibition at the Museum

Folkwang in Essen, Germany, where he shows some new paintings.

Wassily Kandinsky, a significant book written by Grohmann, is printed on January 15 by Editions des Cahiers d'Art as part of a series. Apart from a slender book by Hugo Zehder in 1920, it is the artist's first monograph and is also released in German as a special publication by the Kandinsky Gesellschaft in Brunswick.

Kandinsky's two-week solo exhibition at the Braxton Art Gallery in Hollywood in March is the first of a series of one-person exhibitions of the Blue Four, which continues through May 15. Film director Josef von Sternberg supports the exhibitions financially, but he soon withdraws from involvement with Scheyer's activities.

Kandinsky has his second solo exhibition in Paris, at Galerie de France, March 14–31. While there for the show, he meets artist Jean Hélion and young art writer Gualtieri di San Lazzaro, later the publisher of *XXe Siècle*.

Two Kandinsky works are shown at the exhibition organized by Cercle et Carré at Galerie 23 in Paris in April.

Bauer visits Kandinsky in Dessau and announces Guggenheim's imminent visit. In July Guggenheim and his wife Irene arrive with artist and art advisor Hilla Rebay, who is steadily building up his collection of nonobjective art. Guggenheim buys four works on this occasion, including *Composition 8*.

Shortly after, the Kandinskys travel through Italy via Genoa and Bologna to Cattolica on the Adriatic coast. During excursions to Urbino, Italy; Ravenna, Italy; and Venice, Kandinsky is particularly impressed by the mosaics in Ravenna.

On the instructions of architect and art writer Paul Schultze-Naumburg, following pressure from the Nazi head of the Weimarer Kunsthochschule (Weimar Art College), works by Kandinsky and Klee are removed from the museum in Weimar, while the murals by Schlemmer in the stairwell of the former Bauhaus are destroyed.

Das Kunstblatt, run by editor Paul Westheim, publishes Kandinsky's essay "Der Blaue Reiter (Rückblick)" ("The Blaue Reiter [Recollection]").

In Dessau the conflicts involving Meyer and the Bauhaus student body sharpen. During summer vacation, Communist-oriented Meyer is ousted, and Kandinsky is involved in the plot.

In August architect Ludwig Mies van der Rohe is appointed the new director of the Bauhaus.

1931

Zervos's *Cahiers d'Art* presents Kandinsky's first written work published in France, the extensive theoretical essay "Réflexions sur l'art abstrait" ("Reflections on Abstract Art").

Berlin's Galerie Alfred Flechtheim organizes an extensive solo exhibition of Kandinsky's work in February, with forty-five paintings and twenty-two watercolors. Extracts from Grohmann's recently published monograph are reprinted in the foreword to the catalogue. Kandinsky attends the opening.

The Abstraction-Création (Abstraction-Creation) group is founded in Paris on February 15. Contributions to its periodical include articles on Albers, Baumeister, Otto Freundlich, Moholy-Nagy, and Schwitters.

In spring Kandinsky is offered, but turns down, a teaching post at the Art Students League in New York.

Two double exhibitions of the Blue Four—Kandinsky and Feininger as well as Jawlensky and Klee—are shown in San Francisco in April

Frank Lloyd Wright, Hilla Rebay, and Solomon R. Guggenheim at the unveiling of the Guggenheim Museum model, New York, September 20, 1945

and May respectively. The two shows are combined and travel to Mexico, with Scheyer prevailing on Diego Rivera to write essays about Kandinsky and Klee for the Spanish-language catalogue.

In May Kandinsky edits a special issue of *bauhaus*, devoted to Klee on the occasion of his departure from the school. It also contains Kandinsky's essay on his colleague and friend.

In his second and last commission for a wall piece, Kandinsky designs wall ceramics for a music room in Mies van der Rohe's pavilion at the *Deutsche Bauausstellung* (*German Construction Exhibition*) in Berlin, held in the exhibition halls in the radio tower site, May 9–August 2 (fig. 23).

In summer the Kandinskys go on a four-week Mediterranean cruise departing from France and visiting Egypt, Palestine, Turkey, Greece, and Italy. Kandinsky is particularly impressed by the pyramids.

Amédée Ozenfant visits the Bauhaus and meets Kandinsky, Klee, and Mies van der Rohe.

1932

In February Galerie Ferdinand Möller in Berlin mounts another Kandinsky solo show, *W. Kandinsky. Zeichnungen 1910–1931, Neue Aquarelle. Graphik* (*Drawings 1910–1931, New Watercolors, Graphic Works*). This is the first exhibition to contain purely black-and-white drawings, which the artist writes about in a brief text in the catalogue.

In March a Blue Four touring exhibition goes to the Faulkner Memorial Art Gallery in Santa Barbara, California. The catalogue quotes Rivera's enthusiastic comments about Kandinsky.

On August 22, the Dessau community council, in which the Nazi Party is the biggest party, decides to close the Bauhaus on

October 1. Employment contracts are terminated and salaries stopped.

In September the Kandinskys holiday in Dubrovnik, Yugoslavia (now Croatia), on the Adriatic coast.

The Bauhaus moves into a former telegraph-equipment factory in Steglitz in Berlin in October. Mies van der Rohe runs it, with the remaining staff, as a private institute. Classes begin again in January 1933.

The Valentine Gallery in New York, headed by Curt Valentin, Alfred Flechtheim's former assistant in Berlin, organizes an exhibition with paintings by Kandinsky that runs November 15–December 10.

The Kandinskys leave the master house in Dessau on December 10 and move to one floor of the Henning Villa at 9 Bahnstraße in Berlin's Südende neighborhood, where they spend a year. Other Bauhaus staff, including Albers, Friedrich Engemann, Walter Peterhans, and Scheper, also move to Berlin to continue working with Mies van der Rohe.

1933

Shortly after Hitler gains power, Berlin police and Sturm Abteilung (SA) agents raid and close the Bauhaus on April 11. Mies van der Rohe endeavors to negotiate its reopening.

On July 20, the Bauhaus closes for good, following the staff's unanimous vote.

In August Kandinsky travels via Paris to Les Sablettes, France, for a long summer holiday on the Mediterranean coast.

Kandinsky stops off in Paris on the way back in October and meets Duchamp, Paul Éluard, and Tristan Tzara.

He presents work at the sixth exhibition of the Salon des Surindépendants, October 27–November 26, as guest of honor.

Back in Berlin, the Kandinskys prepare to

move to Paris, leaving on December 16. After a stopover in Bern, they arrive on December 21, and later that month they move into a sixth-floor apartment of a new block at 135, boulevard de la Seine (now boulevard du Général Koenig) in Neuilly-sur-Seine, a suburb west of Paris. Duchamp had drawn their attention to the building.

1934

Having set up a studio in the three-room flat, Kandinsky begins to paint again in February. Several of Kandinsky's relatives, including Manya Abrikosov (sister of his first wife Anja) and his nephew Alexandre Kojève (son of his half-brother Alexei Kojevnikov) also live in Paris.

Galleria Il Milione in Milan presents a solo exhibition of Kandinsky's work titled *45 acquerelli e disegni dal 1924 al 1933 per la prima volta in Italia* (*45 Watercolors and Drawings from 1924 to 1933 for the First Time in Italy*), April 24–May 9.

Kandinsky on the Villa Henning balcony, Berlin, 1933

Christian and Yvonne Zervos open *Kandinsky. Peintures de toutes les époques, aquarelles, dessins* (*Paintings of All Periods, Watercolors, Drawings*), May 23–June 9. It is Kandinsky's first solo show at the Galerie Cahiers d'Art at 14, rue du Dragon, Paris.

Kandinsky stays in contact with the Delaunays, Léger, and Joan Miró, and briefly with Max Ernst, gallery owner Pierre Loeb, Man Ray, and others in the Parisian art scene though he gradually reduces his social circle to Arp, Breton, Alberto Magnelli, Mondrian, and Sophie Taeuber-Arp.

Gummesons Konsthandel in Stockholm opens *Kandinsky 1924–1934,* an extensive exhibition of forty-two paintings, and prints a small-format double card instead of a catalogue.

1935

Kandinsky participates in the exhibition *Thèse, antithèse, synthèse* (*Thesis, Antithesis, Synthesis*) at the Kunstmuseum Luzern in Switzerland, February 24–March 31, along with Arp, Braque, Alexander Calder, Derain, Hans Erni, Ernst, Hélion, Klee, Léger, Miró, Mondrian, Ben Nicholson, Ozenfant, Picasso, and Taeuber-Arp. A brief essay by him is included in the catalogue along with others by Siegfried Giedion, Hélion, and Léger.

In March his former Bauhaus colleague Albers, who has been teaching at Black Mountain College in North Carolina, secures an artist-in-residence post for Kandinsky, who has thought about emigrating to the United States on several occasions. Again, he decides against it.

Kandinsky publishes a large number of theoretical works this year, mainly in defence of abstract art. Another long article called "L'Art aujourd'hui est plus vivant que jamais" ("Art Today") appears in *Cahiers d'Art,* while the following issue runs the more poetic essay "Toile Vide, etc." ("Empty Canvas, etc."). The Dutch periodical *Kroniek van hedendaagse kunst en kultuur* publishes his essay "Abstrakte Malerei" ("Abstract Painting"), and "to retninger" ("Two Directions") appears in *Konkretion* in Copenhagen.

In May he takes part in a lecture with Filippo Marinetti and a meeting of the Italian Futurists at the Galerie Bernheim-Jeune in Paris.

Kandinsky's second solo show at Galerie Cahiers d'Art is on view June 21–September 10.

In November works by Kandinsky are shown alongside Klee's at Jsrael Ben Neumann's New Art Circle in New York. An immigrant from

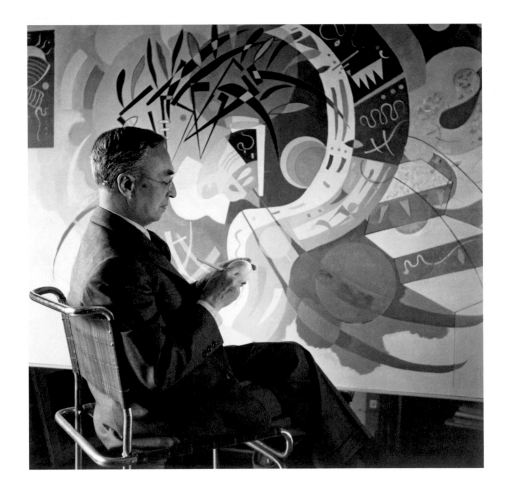

Kandinsky in front of his painting *Dominant Curve* (*Courbe dominante,* 1936, plate 83), 1936. Photo: Boris Lipnitzki

Berlin, Neumann becomes Kandinsky's representative on the East Coast.

1936

Neumann's New Art Circle in New York and Stendhal Galleries in Los Angeles organize solo shows in February in honor of Kandinsky's seventieth birthday.

In spring he takes part in two important exhibitions: *Abstract & Concrete* at the Lefevre Gallery in London, which brings together a range of artists, including Calder, Barbara Hepworth, Miró, Moholy-Nagy, and Nicholson, and *Cubism and Abstract Art,* curated by Alfred Barr, Jr., at the Museum of Modern Art in New York, with an extensive catalogue.

At Kandinsky's request, Zervos publishes a memorial text on Marc for the twentieth anniversary of his death in *Cahiers d'Art*. Kandinsky writes a second text about Marc for a German book that remains unpublished for years because of Nazi repression.

Gallery owner Jeanne Bucher presents a solo show, December 3–19, called *Kandinsky. Toiles récentes, aquarelles, graphiques de 1910–1935 (Recent Canvases, Watercolors, Woodcuts, Etchings, 1910–1935)*. At the show Kandinsky meets André Dézarrois, a curator at the Écoles étrangères at the Jeu de Paume.

1937

A Kandinsky retrospective, the largest since 1926 and the last major one in his lifetime, is on view from February 21 to March 29 at the Kunsthalle Bern in Switzerland. It brings together seventy-one paintings from all creative periods plus fifteen watercolors under the title *Wassily Kandinsky. Französische Meister der Gegenwart (Contemporary French Masters)*, together with works by Raoul Dufy, Le Fauconnier, Roger de la Fresnay, Othon Friesz, Maurice

Utrillo, and Maurice Vlaminck. Kandinsky goes to the exhibition with the terminally ill Klee, who in 1933 had moved back to his native Bern after Nazi persecution in Germany. It is the last meeting of the two friends and colleagues.

The Kandinskys holiday during the winter in Mürren, Switzerland, meeting up with collectors Hermann and Margrit Rupf.

During the year, fifty-seven works by Kandinsky are among the numerous modern artworks confiscated from German museums. Two of his paintings and twelve works on paper are shown at the exhibition *Entartete Kunst (Degenerate Art)* that opens at the Hofgarten-Arkaden in Munich on July 19 before touring to many other German cities.

During the Paris World's Fair, an alternative exhibition of work by abstract and Surrealist artists, *Origines et développement de l'art international indépendant (Origins and Development of International Independent Art)*, opens July 30 at the Jeu de Paume in Paris, parallel to the official show at the Petit Palais, *Les Maîtres de l'art indépendant, 1895–1937 (The Masters of Independent Art, 1895–1937)*. Kandinsky is represented along with artists such as Arp, Baumeister, Ernst, Klee, František Kupka, Magnelli, René Magritte, Man Ray, Louis Marcoussis, Miró, Mondrian, Yves Tanguy, and Theodor Werner. He also helps organize the exhibition after Zervos pulls out and negotiates with Dézarrois.

Efter-Expressionisme, Abstrakt Kunst, Neo-plasticisme, Surrealisme (After Expressionism, Abstract Art, Neoplasticism, Surrealism), a retrospective put together by artists Ejler Bille and Richard Mortensen, is shown in Copenhagen, September 1–13. Kandinsky writes an essay for its publication *Linien* titled "Tilegnelse af kunst" ("Assimilation of Art"), which is published in Danish.

In winter Kandinsky sees exhibitions of the work of Arp, Miró, and Taeuber-Arp in Parisian galleries.

Karl Nierendorf interviews the artist (published in *Essays über Kunst und Kunstler* [1955], edited by Bauhaus alumnus and Swiss artist Max Bill) and organizes a Kandinsky exhibition in New York, December 1–10. The show travels to the Cleveland Museum of Art and the Germanic Museum (now the Busch-Reisinger Museum) at Harvard University.

1938

In February Kandinsky writes a brief article "Abstract of concreet?" ("Abstract or Concrete?") for the catalogue of the major exhibition *Tentoonstelling abstracte kunst (Abstract Art)*, on view April 2–24, at the Stedelijk Museum in Amsterdam, in which Constantin Brancusi, César Domela, Freundlich, Kandinsky, Léger, Moholy-Nagy, Mondrian, Vordemberge-Gildewart, and other abstract artists are represented.

In the same month, Kandinsky has a solo show at the Guggenheim Jeune gallery in London, at a time when exhibitions of his work have long since ceased to be possible in Germany. He shows thirty-eight paintings, including some early ones. The catalogue includes Breton's article "Some Appreciations of the Work of Wassily Kandinsky" alongside brief quotations from Grohmann, Rivera, Sadler, Alberto Satoris, and Zervos. Kandinsky's essay "L'art concret" ("Concrete Art") is published in March in the first issue of San Lazzaro's periodical *XXe Siècle*.

In June at Galerie Jeanne Bucher, Kandinsky meets Freundlich, who has also emigrated to Paris and is a particular target of the Nazis. The following month, Kandinsky signs a petition for him.

Herbert Read's *Exhibition of 20th Century German Art*, held at the New Burlington

View of Kandinsky's apartment building on boulevard de la Seine, Neuilly-sur-Seine, France, 1938. Photo: Josef Breitenbach

The Kandinskys (seated) in front of Paul Nelson's house in Varengeville-sur-Mer, France, 1934

Galleries in London in July, is the final exhibition of modern German art before World War II. It presents works by Ernst Barlach, Baumeister, Dix, Ernst, Feininger, Freundlich, Grosz, Heckel, Kirchner, and Klee, and includes six paintings and four watercolors by Kandinsky. The catalogue treats the difficult situation of the artists labeled as degenerate in Germany with caution. To protect those still living there from Nazi persecution, it insists that none were asked for consent to be in the show since all works were submitted from outside the country.

The Kandinskys' German passports expire in August. After they discover from the German embassy that they need proof of Aryan ancestry for new documents, Kandinsky decides not to apply.

1939

Kandinsky completes his last large-scale painting *Composition X* in January. He negotiates with the Jeu de Paume in Paris about a possible retrospective. The museum acquires *Composition IX* (1936, plate 82), and along with a gouache,

they are the only works the French government buys in his lifetime.

Kandinsky's "The Value of a Concrete Work," his last expansive theoretical treatise, is published in *XXe Siècle* in two parts.

He participates in the exhibition *Abstract and Concrete Art* at Guggenheim Jeune in London, May 10–27. He writes a short foreword for the accompanying catalogue, which is published the same month in the *London Bulletin*.

In June Bucher organizes a solo exhibition of watercolors and gouaches.

The *Art of Tomorrow* exhibition opens on June 1 at the Museum of Non-Objective Painting, New York, which contains numerous works by Kandinsky.

The first of the Galerie Charpentier series of *Réalités nouvelles: 1er Exposition (2me Série)* (*New Realities: First Exhibition [Second Series]*) exhibitions, at which a number of Kandinskys are shown, is on view in Paris, June 30–July 15.

Thanks to young lawyer and collector Pierre Bruguière, the Kandinskys gain French citizenship in July.

The Kandinskys spend their summer holiday in La Croix-Valmer on the French Mediterranean coast.

World War II breaks out on September 3 as Germany invades Poland. At the end of the month, Kandinsky has seventy-five of his paintings sent to a friend in central France for storage.

1940

On May 10, the German invasion of France begins, and in a few weeks Germany occupies the northern half of the country. To escape the occupation, the Kandinskys stay in Cauterets in the French Pyrenees, June–August. German troops march into Paris on June 14. The armistice with Hitler is signed a week later, ushering in four years of German occupation.

On June 29 in Cauterets, Kandinsky receives a telegram with the news of Klee's death and is greatly upset.

Thinking the Germans are about to confiscate their apartment in Neuilly-sur-Seine, the Kandinskys rush back to Paris via Vichy in late August. However, they are left alone.

1941

At the instigation of the Emergency Rescue Committee, based in America and established by German émigrés such as Albert Einstein and Thomas Mann along with art collectors and museum staff, Varian Fry, who has been called the American Schindler, aids thousands of European intellectuals and artists in escaping through Marseille in 1940 and 1941 and offers to help the Kandinskys. They decide to remain in Paris.

Despite the turbulence of the war, the Kandinskys have their usual holiday in September, at Marlotte in the Île de France, south of Paris.

1942

From the middle of the year, Kandinsky paints only small-format paintings on wood or canvas board.

For the *10 Origin* collection published by Bill, Kandinsky produces a woodcut and writes a brief foreword. The other contributors of the ten printed graphics are Arp, Bill, Sonja Delaunay, Domela, Leo Leuppi, Richard Lohse, Magnelli, Taeuber-Arp, and Georges Vantongerloo. Kandinsky's prints for the book are sent to Switzerland via the south of France.

Galerie Jeanne Bucher puts on a small solo show for him, July 21–August 4, but is kept secret because of the German occupation.

A Kandinsky exhibition is mounted at the Nierendorf Gallery in New York, December 1942–February 1943.

1943

Paris, including factories west of the city not far from Neuilly-sur-Seine, is heavily bombed by the Allied Forces in March.

In June Kandinsky writes a foreword to an album of Domela's work and his last essay, on the colored reliefs of Taeuber-Arp, after hearing the news of her death.

The Kandinskys holiday in Rochefort-en-Yvelines, France, in September.

1944

In January Bucher organizes another exhibition of the work of Domela, Kandinsky, and Nicolas de Staël.

In March Kandinsky completes *Tempered Elan* (*L'Élan tempéré*), the last painting in his Handlist.

In March and April, his work is included in *Konkrete Kunst* (*Concrete Art*), the last important group exhibition during his lifetime, at the Kunsthalle Basel. It also contains works by Arp, Bill, Klee, Leuppi, Mondrian, Taeuber-Arp, and Vantongerloo.

In April he, Domela, Magnelli, and de Staël show work at the Galerie l'Esquisse in Paris.

Kandinsky falls ill in the spring, showing symptoms of serious arteriosclerosis. He continues working until the end of July.

The Allies liberate Paris on August 24. The Germans suffer catastrophic losses on the eastern front during the Russian summer offensive.

The last small solo show during Kandinsky's lifetime is on view at Galerie l'Esquisse, November 7–December 15.

On December 13, Kandinsky dies of a stroke at age seventy-eight in his home in Neuilly-sur-Seine.

Kandinsky on his apartment balcony in Neuilly-sur-Seine, ca. 1938

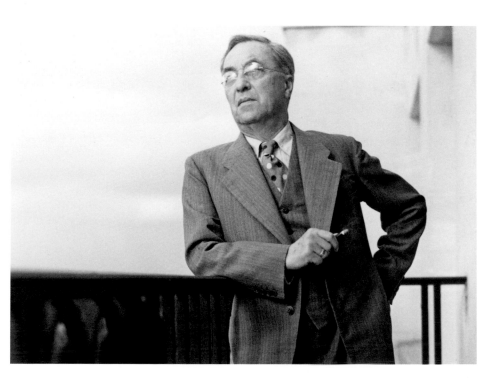

EXHIBITION CHECKLIST

Kandinsky, Solomon R. Guggenheim Museum, New York, September 18, 2009–January 13, 2010

The artworks are numbered according to the systems indicated in the following catalogues raisonnés:

• Vivian Endicott Barnett, *Kandinsky Watercolours: Catalogue Raisonné, Volume One, 1900–1921* (Ithaca, N.Y.: Cornell University Press, 1992)

• Hans K. Roethel and Jean K. Benjamin, *Kandinsky: Catalogue Raisonné of the Oil Paintings, Volume One, 1900–1915* (Ithaca, N.Y.: Cornell University Press, 1982)

• Hans K. Roethel and Jean K. Benjamin, *Kandinsky: Catalogue Raisonné of the Oil Paintings, Volume Two, 1916–1944* (Ithaca, N.Y.: Cornell University Press, 1984)

Titles. Titles of works were provided by the lending institutions or individuals. Russian-language titles were provided by the Centre Pompidou, Paris. Kandinsky specified titles for most of his works in Handlists or *Hauskataloge*, and these are recorded in the catalogues raisonnés. All alternate titles reflect those provided and explained in the Roethel catalogues raisonnés. Key: **K** = alternate title provided by Kandinsky; **M** = alternate title provided by Gabriele Münter; **A** = title under which the work has also been known.

Dates. Months are occasionally given for a particular work and reflect the months listed in the catalogues raisonnés.

N.B. The medium lines for Kandinsky paintings owned by the Städtische Galerie im Lenbachhaus, Munich, dating between 1910 and 1914, appear as "oil and tempera on canvas." This ascription is the result of a conservation study conducted by the Lenbachhaus.

1 *Riding Couple* (*Reitendes Paar*), 1907
Oil on canvas, 55 x 50.5 cm
Städtische Galerie im Lenbachhaus, Munich, Gabriele Münter-Stiftung, 1957
Roethel 180

2 *Colorful Life* (*Motley Life*) (*Das bunte Leben*), 1907
Tempera on canvas, 130 x 162.5 cm
Bayerische Landesbank, on permanent loan to the Städtische Galerie im Lenbachhaus, Munich
Barnett 219

3 *Murnau–Landscape with Tower* (*Murnau–Landschaft mit Turm*), 1908
Oil on cardboard, 74 x 98.5 cm
Musée national d'art moderne, Centre Pompidou, Paris, Gift of Nina Kandinsky, 1976
Roethel 220

4 *Landscape near Murnau with Locomotive* (*Landschaft bei Murnau mit Lokomotive*), 1909
Alternate title: *Murnau–Landschaft* (A)
Oil on cardboard, 50.5 x 65.1 cm
Solomon R. Guggenheim Museum, New York
50.1295
Roethel 303

5 *Blue Mountain* (*Der blaue Berg*), 1908–09
Alternate title: *Blauer Berg mit Reiterei* (K)
Oil on canvas, 106 x 96.6 cm
Solomon R. Guggenheim Museum, New York, Solomon R. Guggenheim Founding Collection, By gift 41.505
Roethel 260

6 *Mountain* (*Berg*), 1909
Alternate title: *Improvisation Berg* (A)
Oil and tempera on canvas, 109 x 109 cm
Städtische Galerie im Lenbachhaus, Munich, Gabriele Münter-Stiftung, 1957
Roethel 293

7 *Improvisation 3*, 1909
Alternate titles: *Bild mit gelber Wand* (K); *Reiter über der Brücke* (A)
Oil on canvas, 94 x 130 cm
Musée national d'art moderne, Centre Pompidou, Paris, Gift of Nina Kandinsky, 1976
Roethel 276

8 *Improvisation 4*, 1909
Alternate titles: *Bild mit Reiter hinter Baum* (K); *Abend* (A)
Oil on canvas, 108.5 x 159.7 cm
State Art Museum, Nizhny Novgorod, Russia
Roethel 282

9 *Picture with an Archer* (*Bild mit Bogenschützen*), 1909
Oil on canvas, 177 x 147 cm
The Museum of Modern Art, New York, Gift and bequest of Louise Reinhardt Smith, 1959
Roethel 270

10 *Improvisation 6 (African)* (*Improvisation 6 [Afrikanisches]*), 1909
Alternate title: The word *African* was added by Münter.
Oil and tempera on canvas, 107 x 99.5 cm
Städtische Galerie im Lenbachhaus, Munich, Gabriele Münter-Stiftung, 1957
Roethel 287

11 *Improvisation 7 (Storm)* (*Improvisation 7 [Sturm]*), 1910
Alternate title: *Storm* (K)
Oil on canvas, 131 x 97 cm
The State Tretyakov Gallery, Moscow
Roethel 333

12 *Sketch for Composition II* (*Skizze für Komposition II*), 1909–10
Oil on canvas, 97.5 x 131.2 cm
Solomon R. Guggenheim Museum, New York, Solomon R. Guggenheim Founding Collection
45.961
Roethel 326

13 *Improvisation 9*, 1910
Alternate title: *Wolke* (K)
Oil on canvas, 110 x 110 cm
Staatsgalerie Stuttgart, Germany
Roethel 335

14 *Landscape with Factory Chimney* (*Landschaft mit Fabrikschornstein*), 1910
Alternate title: *Landschaft mit Schornstein* (K)
Oil on canvas, 66.2 x 82 cm
Solomon R. Guggenheim Museum, New York, Solomon R. Guggenheim Founding Collection, By gift 41.504
Roethel 343

15 *Improvisation 14*, 1910
Oil on canvas, 73 x 125.5 cm
Musée national d'art moderne, Centre
Pompidou, Paris, Gift of Nina Kandinsky, 1966
Roethel 356

16 *Improvisation 18 (With Tombstone)*
(*Improvisation 18 [mit Grabstein]*), March 1911
Alternate titles: *Improvisation 18 (With
Tombstones)* (A); *Improvisation 18 (Royal
Court)* (M)
Oil and tempera on canvas, 141 x 121 cm
Städtische Galerie im Lenbachhaus, Munich,
Gabriele Münter-Stiftung, 1957
Roethel 384

17 *Picture with a Circle* (*Bild mit Kreis*), 1911
Oil on canvas, 139 x 111 cm
Georgian National Museum, Tbilisi
Roethel 405

18 *Impression III (Concert)*
(*Impression III [Konzert]*), January 1911
Oil and tempera on canvas, 77.5 x 100 cm
Städtische Galerie im Lenbachhaus, Munich,
Gabriele Münter-Stiftung, 1957
Roethel 375

19 *Lyrical* (*Lyrisches*), January 1911
Oil on canvas, 94 x 130 cm
Museum Boijmans Van Beuningen,
Rotterdam, Netherlands
Roethel 377

20 *Romantic Landscape* (*Romantische
Landschaft*), January 1911
Oil and tempera on canvas, 94.3 x 129 cm
Städtische Galerie im Lenbachhaus, Munich,
Gabriele Münter-Stiftung, 1957
Roethel 374

21 *Impression IV (Policeman)* (*Impression IV
[Gendarme]*), March 1911
Alternate title: *Fackelzug* (A)
Oil and tempera on canvas, 95 x 107.5 cm
Städtische Galerie im Lenbachhaus, Munich,
Gabriele Münter-Stiftung, 1957
Roethel 392

22 *Impression VI (Sunday)* (*Impression VI
[Sonntag]*), March 1911
Oil and tempera on canvas, 107.5 x 95 cm
Städtische Galerie im Lenbachhaus, Munich,
Gabriele Münter-Stiftung, 1957
Roethel 390

23 *Improvisation 19*, March 1911
Alternate title: *Blauer Klang* (K)
Oil and tempera on canvas, 120 x 141.5 cm
Städtische Galerie im Lenbachhaus, Munich,
Gabriele Münter-Stiftung, 1957
Roethel 385

24 *St George III* (*St Georg III*), March 1911
Oil and tempera on canvas, 97.5 x 107.5 cm
Städtische Galerie im Lenbachhaus, Munich,
Gabriele Münter-Stiftung, 1957
Roethel 391

25 *Improvisation 20*, April 1911
Alternate title: *Zwei Pferde* (K)
Oil on canvas, 94.5 x 108 cm
The State Pushkin Museum of
Fine Arts, Moscow
Roethel 394

26 *Improvisation 21*, October 1911
Alternate title: *Mit dem gelben Pferd* (K)
Oil and tempera on canvas, 108 x 108 cm
Franz Marc Museum, Kochel am See, Germany,
on permanent loan
Roethel 395

27 *Impression V (Park)*, March 1911
Oil on canvas, 106 x 157.5 cm
Musée national d'art moderne, Centre
Pompidou, Paris, Gift of Nina Kandinsky, 1976
Roethel 397

28 *Improvisation 21A*, 1911
Oil and tempera on canvas, 96 x 105 cm
Städtische Galerie im Lenbachhaus, Munich,
Gabriele Münter-Stiftung, 1957
Roethel 399

29 *Improvisation 26 (Rowing)*
(*Improvisation 26 [Rudern]*), 1912
Alternate title: Roethel subtitles this work *Rowing*
without explanation. Kandinsky inscribed the
work on the reverse as *Improvisation 26*.
Oil and tempera on canvas, 97 x 107.5 cm
Städtische Galerie im Lenbachhaus, Munich,
Gabriele Münter-Stiftung, 1957
Roethel 429

30 *Improvisation 27 (Garden of Love II)*
(*Improvisation 27 [Garten der Liebe II]*), 1912
Oil on canvas, 120.3 x 140.3 cm
The Metropolitan Museum of Art, New York,
Alfred Stieglitz Collection, 1949
Roethel 430

31 *Painting with a Black Arch* (*Bild mit
schwarzem Bogen*), autumn 1912
Oil on canvas, 188 x 196 cm
Musée national d'art moderne, Centre
Pompidou, Paris, Gift of Nina Kandinsky, 1976
Roethel 436

32 *Improvisation 28 (Second Version)*
(*Improvisation 28 [zweite Fassung]*), 1912
Alternate title: The Handlist entry for this work has
no title.
Oil on canvas, 111.4 x 162.1 cm
Solomon R. Guggenheim Museum, New York,
Solomon R. Guggenheim Founding Collection,
By gift 37.239
Roethel 443

33 *Improvisation 31 (Sea Battle)*
(*Improvisation 31 [Seeschlacht]*), 1913
Oil on canvas, 140 x 120 cm
National Gallery of Art, Washington, D.C.,
Ailsa Mellon Bruce Fund, 1978
Roethel 455

34 *Landscape with Rain* (*Landschaft
mit Regen*), January 1913
Oil on canvas, 70.2 x 78.1 cm
Solomon R. Guggenheim Museum, New York,
Solomon R. Guggenheim Founding Collection
45.962
Roethel 458

35 *Painting with White Border (Moscow)*
(*Bild mit weißem Rand [Moskau]*), May 1913
Alternate title: Handlist III as well as notations made
by Kandinsky mention *Moscow 2*, however, Roethel
subtitles this work *Moscow*.
Oil on canvas, 140.3 x 200.3 cm
Solomon R. Guggenheim Museum, New York,
Solomon R. Guggenheim Founding Collection,
By gift 37.245
Roethel 465

36 *Small Pleasures* (*Kleine Freuden*), June 1913
Oil on canvas, 109.8 x 119.7 cm
Solomon R. Guggenheim Museum, New York,
Solomon R. Guggenheim Founding Collection
43.921
Roethel 466

37 *Sketch 2 for Composition VII* (*Entwurf
2 zu Komposition VII*), 1913
Oil and tempera on canvas, 100 x 140 cm
Städtische Galerie im Lenbachhaus, Munich,
Gabriele Münter-Stiftung, 1957
Roethel 472

38 *Light Picture* (*Helles Bild*), December 1913
Oil on canvas, 77.8 x 100.2 cm
Solomon R. Guggenheim Museum, New York,
Solomon R. Guggenheim Founding Collection,
By gift 37.244
Roethel 479

39 *Black Lines* (*Schwarze Linien*),
December 1913
Oil on canvas, 129.4 x 131.1 cm
Solomon R. Guggenheim Museum, New York,
Solomon R. Guggenheim Founding Collection,
By gift 37.241
Roethel 480

40 *Little Painting with Yellow* (*Kleines Bild
mit Gelb*), February 1914
Oil on canvas, 78 x 100 cm
Philadelphia Museum of Art, The Louise and
Walter Arensberg Collection, 1950
Roethel 484

41 *Painting with Red Spot* (*Bild mit rotem
Fleck*), February 1914
Oil on canvas, 130 x 130 cm
Musée national d'art moderne, Centre
Pompidou, Paris, Gift of Nina Kandinsky, 1976
Roethel 486

42 *Improvisation 35*, May 1914
Oil on canvas, 110 x 120 cm
Kunstmuseum und Museum für
Gegenwartskunst, Basel
Roethel 491

43 *Fugue* (*Fuga*), 1914
Alternate title: In Handlist III, the words *Beherrschte
Improvisation = Fuga* appear in Kandinsky's hand-
writing, indicating a possible title; *Fuge* (K); *Great
Fugue* (A)
Oil on canvas, 129.5 x 129.5 cm
Fondation Beyeler, Riehen/Basel
Roethel 487

44 *Improvisation Gorge* (*Improvisation
Klamm*), 1914
Alternate title: This title does not appear in the
Handlists. The phrase *Kandinsky 1014 (Klamm)*
appears in Münter's writing on the reverse of the
painting.
Oil and tempera on canvas, 110 x 110 cm
Städtische Galerie im Lenbachhaus, Munich,
Gabriele Münter-Stiftung, 1957
Roethel 503

45a *Panel for Edwin R. Campbell, No. 1*, 1914
Alternate title: *Spring* (A)
Oil on canvas, 162.5 x 80 cm
The Museum of Modern Art, New York,
Mrs. Simon Guggenheim Fund
Roethel 492

45b *Panel for Edwin R. Campbell, No. 2*, 1914
Alternate title: *Autumn* (A)
Oil on canvas, 162.6 x 122.7 cm
The Museum of Modern Art, New York,
Nelson A. Rockefeller Fund (by exchange)
Roethel 494

45c *Panel for Edwin R. Campbell, No. 3*, 1914
Alternate title: *Summer* (A)
Oil on canvas, 162.5 x 92.1 cm
The Museum of Modern Art, New York,
Mrs. Simon Guggenheim Fund
Roethel 497

45d *Panel for Edwin R. Campbell, No. 4*, 1914
Alternate titles: *Winter* (A); *Carnival* (A)
Oil on canvas, 163 x 122.5 cm
The Museum of Modern Art, New York,
Nelson A. Rockefeller Fund (by exchange)
Roethel 499

46 *Painting on Light Ground*
(*Na Svetlom Fone*), 1916
Oil on canvas, 100 x 78 cm
Musée national d'art moderne, Centre
Pompidou, Paris, Gift of Nina Kandinsky, 1976
Roethel 597

47 *Moscow I* (*Mockba I*), 1916
Alternate title: *Roter Platz* (A)
Oil on canvas, 51.5 x 49.5 cm
The State Tretyakov Gallery, Moscow
Roethel 605

48 *Overcast* (*Smutnoe*), September 1917
Oil on canvas, 105 x 134 cm
The State Tretyakov Gallery, Moscow
Roethel 615

49 *White Oval* (*Bely Oval*), January 1919
Alternate title: *Schwarzer Rand* (A)
Oil on canvas, 80 x 93 cm
The State Tretyakov Gallery, Moscow
Roethel 661

50 *In Gray* (*V Serom*), 1919
Oil on canvas, 129 x 176 cm
Musée national d'art moderne, Centre
Pompidou, Paris, Bequest of Nina Kandinsky, 1981
Roethel 663

51 *Red Oval* (*Krasny Oval*), 1920
Oil on canvas, 71.5 x 71.2 cm
Solomon R. Guggenheim Museum,
New York 51.1311
Roethel 668

52 *White Line* (*Bely Shtrikh*), 1920
Oil on canvas, 98 x 80 cm
Museum Ludwig, Cologne, Germany
Roethel 673

53 *Black Lines II* (*Chyorny Shtrikh II*), 1920
Oil on canvas, 57 x 71 cm
Georgian National Museum, Tbilisi
Roethel 667

54 *Red Spot II* (*Krasnoe Pyatno II*), 1921
Oil on canvas, 137 x 181 cm
Städtische Galerie im Lenbachhaus, Munich
Roethel 675

55 *Blue Segment* (*Siny Segment*), 1921
Oil on canvas, 120.6 x 140.1 cm
Solomon R. Guggenheim Museum, New York,
Solomon R. Guggenheim Founding Collection
49.1181
Roethel 676

56 *White Center* (*Bely Tsentr*), 1921
Alternate title: *Earth Center* (A)
Oil on canvas, 118.7 x 136.5 cm
Solomon R. Guggenheim Museum, New York,
The Hilla Rebay Collection 71.1936.R98
Roethel 677

57 *Multicolored Circle* (*Pestry Krug*), 1921
Oil on canvas, 138 x 180 cm
Yale University Art Gallery, New Haven,
Gift of Collection Société Anonyme
Roethel 679

58 *Circles on Black* (*Krugi na Chyornom*), 1921
Alternate titles: *Russian Carnival* (A);
Black Composition (A)
Oil on canvas, 136.5 x 120 cm
Solomon R. Guggenheim Museum, New York,
Solomon R. Guggenheim Founding Collection
46.1050
Roethel 682

59 *Blue Circle* (*Blauer Kreis*), 1922
Oil on canvas, 109.2 x 99.2 cm
Solomon R. Guggenheim Museum, New York,
Solomon R. Guggenheim Founding Collection
46.1051
Roethel 683

60 *White Cross* (*Weißes Kreuz*),
January–June 1922
Oil on canvas, 100.5 x 110.6 cm
Solomon R. Guggenheim Foundation, New York,
Peggy Guggenheim Collection, Venice 76.2553.34
Roethel 684

61 *Black Grid* (*Schwarzer Raster*), 1922
Oil on canvas, 96 x 106 cm
Musée national d'art moderne, Centre
Pompidou, Paris, Bequest of Nina Kandinsky, 1981
Roethel 687

62 *In the Black Square*
(*Im schwarzen Viereck*), June 1923
Oil on canvas, 97.5 x 93 cm
Solomon R. Guggenheim Museum, New York,
Solomon R. Guggenheim Founding Collection,
By gift 37.254
Roethel 700

63 *Composition 8* (*Komposition 8*), July 1923
Oil on canvas, 140 x 201 cm
Solomon R. Guggenheim Museum, New York,
Solomon R. Guggenheim Founding Collection,
By gift 37.262
Roethel 701

64 *Yellow Accompaniment* (*Gelbe Begleitung*),
February–March 1924
Oil on canvas, 99.2 x 97.4 cm
Solomon R. Guggenheim Museum, New York,
Solomon R. Guggenheim Founding Collection,
By gift 39.264
Roethel 712

65 *One Center* (*Ein Zentrum*),
November–December 1924
Alternate title: *A Center* (A)
Oil on canvas, 140.6 x 99.4 cm
Gemeente Museum, The Hague, Netherlands, on
permanent loan from the Solomon R. Guggenheim
Foundation, New York 37.263
Roethel 728

66 *Yellow–Red–Blue*
(*Gelb–Rot–Blau*), March–May 1925
Oil on canvas, 128 x 201.5 cm
Musée national d'art moderne, Centre
Pompidou, Paris, Gift of Nina Kandinsky, 1976
Roethel 757

67 *Several Circles* (*Einige Kreise*),
January–February 1926
Oil on canvas, 140.3 x 140.7 cm
Solomon R. Guggenheim Museum, New York,
Solomon R. Guggenheim Founding Collection,
By gift 41.283
Roethel 767

68 *Accent in Pink* (*Akzent in Rosa*), 1926
Oil on canvas, 100 x 80 cm
Musée national d'art moderne, Centre
Pompidou, Paris, Gift of Nina Kandinsky, 1976
Roethel 769

69 *Three Sounds* (*Drei Klänge*), August 1926
Alternate title: *Sounds* (A)
Oil on canvas, 59.9 x 59.6 cm
Solomon R. Guggenheim Museum, New York,
Solomon R. Guggenheim Founding Collection,
By gift 41.282
Roethel 787

70 *On Points* (*Auf Spitzen*), 1928
Oil on canvas, 140 x 140 cm
Musée national d'art moderne, Centre
Pompidou, Paris, Gift of Nina Kandinsky, 1976
Roethel 876

71 *Levels* (*Etagen*), March 1929
Oil on Masonite, mounted on wood,
56.6 x 40.6 cm
Solomon R. Guggenheim Museum, New York,
Solomon R. Guggenheim Founding Collection
46.1049
Roethel 896

72 *Light* (*Leichtes*), April 1930
Oil on cardboard, 69 x 48 cm
Musée national d'art moderne, Centre
Pompidou, Paris, Purchase of the State, 1974
Roethel 949

73 *Development in Brown* (*Entwicklung
in Braun*), August 1933
Oil on canvas, 105 x 120.5 cm
Musée national d'art moderne, Centre
Pompidou, Paris, Purchase of the State, 1959
Roethel 1031

74 *Blue World* (*Monde bleu*), May 1934
Alternate title: *Blue Theme* (A)
Oil with sand on canvas, 110.6 x 120.2 cm
Solomon R. Guggenheim Museum, New York,
Solomon R. Guggenheim Founding Collection
45.969
Roethel 1039

75 *Striped* (*Rayé*), November 1934
Oil with sand on canvas, 81 x 100 cm
Solomon R. Guggenheim Museum, New York,
Solomon R. Guggenheim Founding Collection
46.1022
Roethel 1047

76 *Two Surroundings* (*Deux Entourages*),
November 1934
Oil on canvas, 89 x 116 cm
Stedelijk Museum, Amsterdam
Roethel 1046

77 *Delicate Accents* (*Accents délicats*),
November 1935
Oil on canvas, 89 x 116 cm
Private collection, courtesy
Pierre Sebastien Fine Art
Roethel 1062

78 *Accompanied Contrast*
(*Contraste accompagné*), March 1935
Oil with sand on canvas, 97.1 x 162.1 cm
Solomon R. Guggenheim Museum, New York,
Solomon R. Guggenheim Founding Collection,
By gift 37.338
Roethel 1051

79 *Succession*, April 1935
Oil on canvas, 81 x 100 cm
The Phillips Collection, Washington, D.C.
Roethel 1055

80 *Violet–Orange*, October 1935
Oil on canvas, 88.9 x 116.2
Solomon R. Guggenheim Museum, New York,
Solomon R. Guggenheim Founding Collection,
By gift 37.334
Roethel 1060

81 *Movement I* (*Mouvement I*), July 1935
Mixed media on canvas, 116 x 89 cm
The State Tretyakov Gallery, Moscow
Roethel 1056

82 *Composition IX*, February 1936
Alternate title: *L'Un et L'autre* (K)
Oil on canvas, 113.5 x 195 cm
Musée national d'art moderne, Centre
Pompidou, Paris, Attribution by and
Purchase of the State, 1939
Roethel 1064

83 *Dominant Curve (Courbe dominante)*,
April 1936
Oil on canvas, 129.4 x 194.2 cm
Solomon R. Guggenheim Museum, New York,
Solomon R. Guggenheim Founding Collection
45.989
Roethel 1069

84 *Capricious Forms (Formes capricieuses)*,
July 1937
Oil on canvas, 88.9 x 116.3 cm
Solomon R. Guggenheim Museum, New York,
Solomon R. Guggenheim Founding Collection
45.977
Roethel 1081

85 *Grouping (Groupement)*,
September–October 1937
Oil on canvas, 146 x 88 cm
Moderna Museet, Stockholm
Roethel 1082

86 *Thirty (Trente)*, 1937
Oil on canvas, 81 x 100 cm
Musée national d'art moderne, Centre
Pompidou, Paris, Gift of Nina Kandinsky, 1976
Roethel 1074

87 *Yellow Painting (La toile jaune)*, July 1938
Alternate title: *Yellow Canvas* (A)
Oil and enamel on canvas, 116.4 x 88.8 cm
Solomon R. Guggenheim Museum, New York,
Solomon R. Guggenheim Founding Collection
45.964
Roethel 1091

88 *Upward (Vers le haut)*, June 1939
Oil on canvas, 116 x 89 cm
Nahmad Collection
Roethel 1100

89 *Various Parts (Parties diverses)*,
February 1940
Oil on canvas, 89 x 116 cm
Gabriele Münter- und Johannes Eichner-Stiftung,
Munich, on deposit at the Städtische Galerie im
Lenbachhaus, Munich
Roethel 1110

90 *Sky Blue (Bleu de ciel)*, March 1940
Oil on canvas, 100 x 73 cm
Musée national d'art moderne, Centre
Pompidou, Paris, Gift of Nina Kandinsky, 1976
Roethel 1111

91 *Around the Circle (Autour du cercle)*,
May–August 1940
Oil and enamel on canvas, 96.8 x 146 cm
Solomon R. Guggenheim Museum, New York,
Solomon R. Guggenheim Founding Collection
49.1222
Roethel 1115

92 *Various Actions (Actions variées)*,
August–September 1941
Oil and enamel on canvas, 89.2 x 116.1 cm
Solomon R. Guggenheim Museum, New York,
Solomon R. Guggenheim Founding Collection
47.1159
Roethel 1121

93 *Reciprocal Accord (Accord réciproque)*,
January–February 1942
Alternate title: *Beiderseitige Übereinstimmung* (A)
Oil and varnish on canvas, 114 x 146 cm
Musée national d'art moderne, Centre
Pompidou, Paris, Gift of Nina Kandinsky, 1976
Roethel 1125

94 *Balancing (Balancement)*, January 1942
Mixed media on canvas, 89 x 116 cm
Nahmad Collection
Roethel 1124

95 *Delicate Tensions (Tensions délicates)*,
June–July 1942
Oil on canvas, 81 x 100 cm
Collection J. Shafran, London
Roethel 1128

SELECTED BIBLIOGRAPHY

Artist's Monographs
(first publication, in chronological order)

Über das Geistige in der Kunst. Insbesondere in der Malerei. Munich: R. Piper und Co., 1912. (Published December 1911, but dated 1912.)

English
The Art of Spiritual Harmony. Translated and with an introduction by Michael T. H. Sadler. London: Constable and Company Limited, 1914.

Italian
Della Spiritualità nell' arte, particolamente nella pittura. Translated by G. A. Colonna di Cesarò. Rome: Edizioni di "Religio," 1940.

French
Du spirituel dans l'art et dans la peinture en particulier. Translated by Mr. and Mrs. DeMan (Pierre Volboudt). Paris: Galerie René Drouin, 1949.

Spanish
De lo Espiritual en el arte y la pintura en particular. Translated from the French by Edgar Bayley. Buenos Aires: Ediciones Galatea, 1956.

Japanese
Chūshō geijutsu-ron: Geijutsu ni okeru seishinteki na mono. Translated from the German by Nishida Hideho. Tokyo: Bijutsu Shuppan-sha, 1958.

Russian
"O duchovnom v iskusstve." In *Trudy Vserossiiskago sezda khudozhnikov*. Vol. I (Petrograd: Golike and Vilborg, October 1914), pp. 47–76. [This book was written in Russian and differs substantially from the 1967 book of the same name, which is a translation of the German version.]

O duchovnom v iskusstve. Translated from the German. Edited by Andrei Lisovsky, Nina Kandinsky, and E. V. Ziglevich. New York: Mezhdunarodnoe Literaturnoe sodruzhestvo, 1967.

Kandinsky, Vasily, and Franz Marc, eds. *Der Blaue Reiter*. Munich: R. Piper und Co., 1912. Second edition, *Der Blaue Reiter Almanach*, 1914.

English
The Blaue Reiter Almanac. Documentary edition. Translated by Klaus Lankheit. New York: Viking Press; London: Thames and Hudson, 1974.

French
L'Almanach du "Blaue Reiter." (Le Cavalier bleu) Edited by Klaus Lankheit. Collection L'Esprit des Formes. Paris: Editions Klinaksieck, 1981.

Klänge. Munich: Piper, 1912.

English
Sounds. Translated by Elizabeth R. Napier. New Haven: Yale University Press, 1981.

French
Klänge. Poèmes. Translated from the German by Inge Hanneforth and Jean-Christophe Bailly. Collections "Détroits." Paris: Editions Christian Bourgois, 1987.

"Rückblicke." In *Kandinsky 1901–1913. Album*. Berlin: Verlag Der Sturm, 1913. [Although this was first published as an essay, it was subsequently published in book format.]

Russian
Tekst Khudozhnika, Stupeni. Moscow: Izdanie Otdela Izobrazitelnykh Iskusstv Narodnago Kommissariata po Prosveshcheniyu, 1918.

English
"Text Artista: Autobiography by Wassily Kandinsky." Translated from the Russian by Boris Berg. In *Wassily Kandinsky Memorial*, edited by Hilla Rebay, exh. cat., pp. 49–73. New York: Solomon R. Guggenheim Foundation, 1945.

French
Regard sur le passé. Translated by Gabrielle Buffet-Picabia. Paris: Galerie René Drouin, 1946.

Punkt und Linie zu Fläche. Beitrag zur Analyse der malerischen Elemente. Edited by Walter Gropius and László Moholy-Nagy. Bauhaus Bücher 9. Munich: Albert Langen, 1926.

English
Point and Line to Plane: A Contribution to the Analysis of the Pictorial Elements. Translated from the German by Howard Dearstyne and Hilla Rebay. New York: Museum of Non-Objective Painting, 1947.

Japanese
Ten, sen, men: Chūshō geijtutsu no kiso. Translated from the German by Nishida Hideho. Tokyo: Bijutsu Shuppan-sha, 1959.

French
Point–ligne–plan. Contribution à l'analyse des éléments picturaux. [Pour une grammaire des formes]. Translated by Suzanne and Jean Lepien. Paris: Editions Denoël/Gonthier, 1972.

Collected Writings
(in chronological order)

Essays über Kunst und Künstler. Edited by Max Bill. Stuttgart, Germany: G. Hatje, 1955. Second extended edition, Bern: Benteli Verlag, 1963; third edition, Bern: Benteli Verlag, 1973.

Wassily Kandinsky, Écrits complets. Edited by Philipp Sers. 3 vols. Paris: Denoël/Gonthier, 1970–75. Vol. 1: not published; vol. 2, "La forme," 1970; vol. 3, "La synthèse des arts," 1975.

Kandinsky. "Regards sur le passé" et autres textes 1912–1922. Edited by Jean Boullion. Paris: Hermann, 1974.

Vasilij Kandinskij, Testo d'autore e altri scritti russi 1902–1922. Edited by Cesare G. de Michelis. Bari, Italy: De Donato Editore, 1975.

Kandinsky. Die gesammelten Schriften. Vol. I. Edited by Hans K. Roethel and Jelena Hahl-Koch. Bern: Benteli, 1980; re-edited as *Autobiographische Schriften*, Bern: Benteli, 2004.

Kandinsky: Complete Writings on Art. Edited by Kenneth C. Lindsay and Peter Vergo. 2 vols. Boston: G. K. Hall and Co.; London: Faber and Faber, 1982; reprint in one vol., New York: Da Capo Press, 1994.

Wassily Kandinsky. Über das Theater. Du théâtre. O Teatpe. Edited by Jessica Boissel, with the cooperation of Jean-Claude Marcadé. Cologne: DuMont; Paris: Société Kandinsky, 1998.

Wassily Kandinsky. Gesammelte Schriften 1889–1916. Farbensprache, Kompositionslehre und andere unveröffentlichte Texte. Edited by Helmut Friedel. Munich: Prestel, 2007.

Letters

(in chronological order)

Kandinsky, Vasily. "Korrespondentsiia iz Miunkena." *Mir Iskusstva* (St. Petersburg), nos. 5–6 (1902).

——. "Pismo iz Miunkhena I." *Apollon* (St. Petersburg), no. 1 (October 1909), pp. 17–20.

——. "Pismo iz Miunkhena II." *Apollon* (St. Petersburg), no. 4 (January 1910), pp. 28–30.

——. "Pismo iz Miunkhena III." *Apollon* (St. Petersburg), no. 7 (April 1910), pp. 12–15.

——. "Pismo iz Miunkhena IV." *Apollon* (St. Petersburg), no. 8 (May/June 1910), pp. 4–7.

——. "Pismo iz Miunkhena V." *Apollon* (St. Petersburg), no. 11 (October/November 1910), pp. 13–17.

——. Letters to A. J. Eddy. *Cubists and Post-Impressionism*, by Arthur Jerome Eddy, pp. 125–26, 130–31, 135–37. Chicago: A. C. McClurg, 1914.

——. "Some Unpublished Letters by Kandinsky." Edited by Troels Andersen. *Artes. Periodical of the Fine Arts* (Copenhagen) no. 2 (October 1966), pp. 90–110.

——. "Briefe an Will Grohmann" 1924–1927. In *Künstler schreiben an Will Grohmann*, edited by Karl Gutbrod, pp. 45–71. Cologne: DuMont, 1968.

Kandinsky, Vasily, and Karl Wolfskehl. "Briefe an Karl Wolfskehl 1911–1913." In *Karl Wolfskehl, 1869–1969. Leben und Werk in Dokumenten*, pp. 334–37. Darmstadt, Germany: Agora Verlag, 1969.

Kandinsky, Vasily. "Kandinsky–Briefe an Hermann Rupf 1931–1943." Edited by Sandor Kuthy. *Berner Kunstmitteilungen* (Bern) 150/151 (May/July 1974), pp. 1–13, and 152/153 (August 1974), pp. 5–19.

——. "Briefe von Kandinsky an Paul Klee." In *Hommage à Wassily Kandinsky*, pp. 130–33. Wiesbaden, Germany: Ebeling, 1976.

——. "Zwölf Briefe von Wassily Kandinsky an Hans Thiemann 1933–1939." Edited by Christian Beutler. *Wallraf-Richartz-Jahrbuch*, no. 38 (1976), pp. 155–66.

Kandinsky, Vasily, and Robert Delaunay. "Kandinsky–Delaunay." Edited by Michel Hoog. In *Wassily Kandinsky à Munich. Collection Städtische Galerie im Lenbachhaus*, exh. cat., pp. 63–65. Bordeaux, France: Galerie des Beaux Arts, 1976.

Kandinsky, Vasily, and Arnold Schönberg. *Wassily Kandinsky und Arnold Schönberg, Briefe, Bilder und Dokumente einer außergewöhnlichen Begegnung*, edited by Jelena Hahl-Koch. Salzburg/Vienna: Residenz Verlag, 1980.

Kandinsky, Vasily. "Kandinsky–Briefe an Otto Nebel 1926–1940." Edited by Therese Bhattacharya-Stettler. *Berner Kunstmitteilungen* (Bern) 203 (January/February 1981), pp. 1–19.

Derouet, Christian. "Notes et documents sur les dernières années du peintre Vassily Kandinsky. 25 lettres de Kandinsky à Pierre Bruguière." *Les Cahiers du musée national d'art moderne*, no. 9 (1982), pp. 96–97.

Kandinsky, Vasily, and Franz Marc. *Wassily Kandinsky und Franz Marc, Briefwechsel. Mit Briefen von und an Gabriele Münter und Maria Marc*, edited by Klaus Lankheit. Munich: Piper, 1983.

Kandinsky, Vasily, and Paul Klee. "Kandinsky und Klee. Aus dem Briefwechsel der beiden Künstler und ihrer Frauen. 1912–1940." Edited by Sandor Kuthy and Stefan Frey. *Berner Kunstmitteilungen* (Bern) 234/236 (December 1984–February 1985), pp. 1–24.

Kandinsky, Vasily, and Werner Drewes. "Briefe an Werner Drewes." In *Bauhaus Berlin. Auflösung Dessau 1932, Schließung Berlin 1933, Bauhäusler und Drittes Reich. Eine Dokumentation, zusammengestellt vom Bauhaus-Archiv Berlin*, edited by Peter Hahn, under the cooperation of Christian Wolsdorff, pp. 27, 89–91, 126, 144. Weingarten, Germany: Kunstverlag Weingarten, 1985.

Kandinsky, Vasily, Robert Delaunay, and Sonja Delaunay. "Briefe Kandinsky–Robert und Sonja Delaunay 1911/12." In *Delaunay und Deutschland*, edited by Peter Klaus Schuster, exh. cat., pp. 483–93. Munich: Staatsgalerie moderner Kunst, 1985.

Kandinsky, Vasily, and Dmitry Kardovsky. "Die Briefe Wassily Kandinskys an Dmitrij Kardovskij." Edited by Natalia Avtonomova. In *Wassily Kandinsky. Die erste sowjetische Retrospektive. Gemälde, Zeichnungen und Graphik aus sowjetischen und westlichen Museen*, exh. cat., pp. 47–54. Frankfurt: Schirn Kunsthalle; Moscow: State Tretyakov Gallery; St. Petersburg: State Russian Museum, 1989.

Kandinsky, Vasily, and Christian Zervos. *Vassily Kandinsky. Correspondances avec Zervos et Kojève*. Edited by Christian Derouet, translated by N. Ivanoff. Hors Série/Archives. *Les Cahiers du musée d'art moderne*. Paris: Editions du Centre Georges Pompidou, 1992.

Kandinsky, Vasily, and Gabriele Münter. *Wassily Kandinsky und Gabriele Münter in Murnau und Kochel 1902–1914. Briefe und Erinnerungen*, edited by Annegret Hoberg. Munich: Prestel, 1994.

Kandinsky, Vasily. "Schriftwechsel. Korrespondenz zwischen Kandinsky, privaten Sammlern, Künstlerfreunden und Schweizer Museumsdirektoren. 1912–1943." In *Kandinsky nelle collezioni svizzere/in den Schweizer Sammlungen/dans les collections suisses*, edited by Manuela Kahn-Rossi, exh. cat., pp. 261–91. Lugano, Switzerland: Museo cantonale d'arte; Milan: Skira, 1995.

Kandinsky, Vasily, and Giovanni Antonio Colonna di Cesarò. "Vasilii Kandinsky and Giovanni Antonio Colonna di Cesarò, Correspondence Regarding 'On the Spiritual in Art.' Editorial Comment." Edited by Myriam Beck. *Experiment. A Journal of Russian Culture* (Los Angeles) 1 (1995), pp. 82–139.

Kandinsky, Vasily, and Albert Bloch. "Briefe Kandinsky–Albert Bloch 1936–1937." In *Albert Bloch. Ein amerikanischer Blauer Reiter*, edited by Henry Adams and Annegret Hoberg, pp. 185–91. Kansas City, Mo.: Nelson-Atkins Museum of Art; Munich: Städtische Galerie im Lenbachhaus; New York: Prestel, 1997.

Wörwag, Barbara. "'Von Haus zu Haus, Ihr Kandinsky.' Wassily Kandinsky schreibt an den Kunstkritiker Will Grohmann." In *Grenzgänger. Wassily Kandinsky–Maler zwischen Murnau, Moskau und Paris*, edited by Christoph Hölz, pp. 118–31. Munich: Bayerische Vereinsbank 1997.

Kandinsky, Vasily, and Josef Albers. *Kandinsky–Albers. Une correspondance des années trente. Ein Briefwechsel aus den dreißiger Jahren*. Edited by Jessica Boissel. Paris: Centre Pompidou, 1998.

Kandinsky, Vasily, and Robert Delaunay. "Kandinsky–Delaunay. Un échange de lettres en avril 1912." Edited by Christian Derouet. *Les Cahiers du musée national d'art moderne*, no. 73 (2000), pp. 74–85.

Wünsche, Isabel, ed. *Galka E. Scheyer und Die Blaue Vier. Briefwechsel 1924–1945*. Wabern/Bern: Benteli, 2006.

Catalogues Raisonnés

(in chronological order)

Roethel, Hans Konrad. *Kandinsky. Das graphische Werk*. Cologne: Verlag M. DuMont Schauberg, 1970.

Roethel, Hans K., and Jean K. Benjamin. *Kandinsky: Catalogue Raisonné of the Oil Paintings, Volume*

One, 1900–1915. Ithaca, N.Y.: Cornell University Press, 1982.

——. *Kandinsky: Catalogue Raisonné of the Oil Paintings, Volume Two, 1916–1944*. Ithaca, N.Y.: Cornell University Press, 1984.

Barnett, Vivian Endicott. *Kandinsky Watercolours: Catalogue Raisonné, Volume One, 1900–1921*. Ithaca, N.Y.: Cornell University Press, 1992.

——. *Kandinsky Watercolours: Catalogue Raisonné, Volume Two, 1922–1944*. Ithaca, N.Y.: Cornell University Press, 1994.

——. *Kandinsky Drawings: Catalogue Raisonné, Volume One, Individual Drawings*. London: Philip Wilson, 2006.

——. *Kandinsky Drawings: Catalogue Raisonné, Volume Two, Sketchbooks*. London: Philip Wilson, 2007.

Monographs and Books

(Alphabetical by author. Where possible, the English-language version of each book is the one referenced.)

Aronov, Igor. *Kandinsky's Quest: A Study in the Artist's Personal Symbolism, 1866–1907*. New York: Peter Lang, 2006.

Avtonomova, Natalia B., et al. *Mnogogranny mir Kandinskogo*. (International Conference, State Tretyakov Gallery Moscow, 1994.) Moscow: Nauka, 1998.

Bamberg, Juliann Leila. "Kandinsky as Poet: The *Klänge*." Ph.D. diss., Florida State University, 1981.

Baraev, Vladimir Vladimirovich. *Drevo: Dekabristy i semeystvo Kandinskich*. Moscow: Izdvo politicheskoy literatury, 1991.

Becks-Malorny, Ulrike. *Wassily Kandinsky 1866–1944. Aufbruch zur Abstraktion*. Cologne: B. Taschen, 1993.

Bill, Max. *Wassily Kandinsky*. With the cooperation of Jean Arp, Charles Estienne, Carola Giedion-Welcker, Will Grohmann, Ludwig Grote, Nina Kandinsky, and Alberto Magnelli. Paris: Maeght, 1951.

Bovi, Arturo. *Kandinsky*. New York: Hamlyn, 1971.

Bowlt, John E., and Rose-Carol Washton Long, eds. *The Life of Vasilii Kandinsky in Russian Art: A Study of "On the Spiritual in Art."* Translation by Bowlt. Newtonville, Mass.: Oriental Research Partners, 1980.

Brion, Marcel. *Kandinsky*. New York: Harry N. Abrams, 1962.

Brucher, Günter. *Kandinsky. Wege zur Abstraktion*. Munich: Prestel, 1999.

Cassou, Jean. *Interférences. Aquarelles et dessins de Wassily Kandinsky*. Paris: Delpire, 1960.

Conil-Lacoste, Michel. *Kandinsky*. Translated by Alice Sachs. New York: Crown Publishers, 1979.

Düchting, Hajo. *Wassily Kandinsky, 1866–1944: A Revolution in Painting*. Cologne: B. Taschen, 1993.

Dziersk, Hans-Martin. *Abstraktion und Zeitlosigkeit. Wassily Kandinsky und die Tradition der Malerei*. Ostfildern, Germany: Editium Tertium, 1995.

Eichner, Johannes. *Kandinsky und Gabriele Münter. Von Ursprüngen moderner Kunst*. Munich: F. Bruckmann, 1957.

Eller-Rüter, Ulrika-Maria. *Kandinsky. Bühnenkomposition und Dichtung als Realisation seines Synthese-Konzepts*. Hildesheim, Germany: Olms, 1990.

Estienne, Charles. *Kandinsky*. Paris: Editions de Beaune, 1950.

Fineberg, Jonathan David. "Kandinsky in Paris 1906–1907." Ph.D. diss., Harvard University, 1975. Ann Arbor, Mich.: UMI Research Press, 1984.

Fuhr, James Robert. "*Klänge:* The Poems of Wassily Kandinsky." Ph.D. diss., Indiana University, 1983. Ann Arbor, Mich.: UMI Research Press, 1982.

Golding, John. *Paths to the Absolute: Mondrian, Malevich, Kandinsky, Pollock, Newman, Rothko, and Still*. Princeton, N.J.: Princeton University Press, 2000.

Grohmann, Will. *Wassily Kandinsky*. Leipzig, Germany: Volksaug, 1924. (*Junge Kunst* 42)

——. *Wassily Kandinsky*. Paris: Editions Cahiers d'Art, 1930.

——. *Wassily Kandinsky: Life and Work*. Translated by Norbert Guterman. New York: Harry N. Abrams, 1958.

Grohmann, Will, et al. *Wassily Kandinsky*. Anvers, France: Editions Sélection, 1933.

Hahl-Koch, Jelena. *Kandinsky*. New York: Rizzoli, 1993.

Haldemann, Matthias. *Kandinskys Abstraktion. Die Entstehung und Transformation seines Bildkonzepts*. Munich: W. Fink, 2001.

Halle, Fannina. *Kandinsky, Archipenko, Chagall*. Vienna: Die Bildenden Kunste, 1921.

Henry, Michel. *Seeing the Invisible*. Translated by Scott Davidson. New York: Continuum, 2009.

Herbert, Barry. *German Expressionism: Die Brücke and Der Blaue Reiter*. New York: Hippocrene Books, 1983.

Hoberg, Annegret, and Helmut Friedel, eds. *Vasily Kandinsky*. Munich: Prestel, 2008.

Hölz, Christoph, and Johannes Langner. *Grenzgänger. Wassily Kandinsky–Maler zwischen Murnau, Moskau und Paris*. Munich: Bayerische Vereinsbank, 1997.

Hüneke, Andreas, ed. *Der Blaue Reiter. Dokumente einer geistigen Bewegung*. Leipzig, Germany: P. Reclam, 1986.

Illetschko, Georgia. *Kandinsky und Paris. Die Geschichte einer Beziehung*. Munich: Prestel, 1997.

Kandinsky, Nina. *Kandinsky und ich*. Munich: Kindler, 1976.

Kleine, Gisela. *Gabriele Münter und Wassily Kandinsky. Biographie eines Paares*. Frankfurt: Insel Verlag, 1990.

Klumpp, Hermann. *Abstraktion in der Malerei. Kandinsky, Feininger, Klee*. Berlin: Deutcher Kunstverlag, 1932.

Kojève, Alexandre. *Die konkrete Malerei Kandinskys*. Translated and edited by Hans Jörg Glattfelder. Bern: Gachnang und Springer, 2005.

Lankheit, Klaus, ed. *Der Blaue Reiter Dokumentarische Neuausgabe*. Munich: Piper, 1965.

Lassaigne, Jacques. *Kandinsky: Biographical and Critical Study*. Geneva: Skira, 1961.

Le Targat, Francois. *Kandinsky*. New York: Rizzoli, 1986.

Lindsay, Kenneth Clement Eriksen. "An Examination of the Fundamental Theories of Wassily Kandinsky." Ph.D. diss., University of Wisconsin, Madison, 1951.

Lipsey, Roger. *An Art of Our Own: The Spiritual in Twentieth-Century Art*. Boston: Shambhala, 1988.

Luksin, Igor P. *Govorit o misterii na yazyke misterii. Esteticeskaya koncepciya i tvorchestvo V. Kandinskovo*. Moscow: Izdat. Znanie, 1991.

Marcadé, Jean-Claude. *Le futurisme russe*. Paris: Dessain et Tolra, 1989.

Marcadé, Valentine. *Le renouveau de l'art pictural russe, 1863–1914*. Lausanne, Switerland: Editions l'Age d'homme, 1971.

Mazur-Keblowski, Eva. *Apokalypse als Hoffnung. Die russischen Aspekte der Kunst und Kunsttheorie Vasilij Kandinskys vor 1914*. Tübingen, Germany: Wasmuth, 2000.

Lärkner, Bengt, Peter Vergo, et al. *Nya perspektiv på Kandinsky/New Perspectives on Kandinsky*. Conference publication. Malmö, Sweden: Malmö Konsthall/Sydsvenska Dagbladet, 1990.

Nishida, Hideho. *Kandinsky*. Tokyo: Bijutsu Shuppansha, 1993.

Overy, Paul. *Kandinsky: The Language of the Eye*. New York: Praeger Publishers; London: Elek, 1969.

Pevitts, Robert Richard. "Wassily Kandinskys 'The Yellow Sound': A Synthesis of the Arts for the Stage." Ph.D. diss., Southern Illinois University, 1980.

Podzemskaia, Nadia. *Colore, simbolo, immagine. Origine della teoria di Kandinsky*. Florence: Alinea, 2000.

Poling, Clark V. *Kandinsky's Teaching at the Bauhaus: Color Theory and Analytical Drawing*. New York: Rizzoli, 1986.

Read, Herbert. *Kandinsky (1866–1944)*. New York: G. Wittenborn, 1959.

Riedl, Peter Anselm. *Wassily Kandinsky in Selbstzeugnissen und Bilddokumenten*. Reinbek bei Hamburg, Germany: Rowohlt, 1983.

——. *Wassily Kandinsky. Kleine Welten*.

Werkmonographien zur Bildenden Kunst 78. Stuttgart, Germany: Reclam, 1962.

Ringbom, Sixten. *The Sounding Cosmos: A Study in the Spiritualism of Kandinsky and the Genesis of Abstract Painting*. Abo, Finland: Abo Akademi, 1970.

Roethel, Hans K., with Jean K. Benjamin. *Kandinsky*. Oxford, England: Phaidon, 1979.

Roskill, Mark. *Klee, Kandinsky, and the Thought of Their Time: A Critical Perspective*. Urbana: University of Illinois Press, 1992.

San Lazzaro, Gualtieri di, ed. *Hommage à Wassily Kandinsky*. Paris: Société internationale d'art XXe siècle; Secaucus, N.J.: Amiel Book Distributors Corp., 1974.

———. *Wassily Kandinsky 1866–1944*. XXe siècle, Nouvelle série, no. 27. Paris: Société internationale d'art XXe siècle, 1966.

Sarabianov, Dmitry, and Natalia Avtonomova. *Vasilii Kandinskii*. Moscow: Moskva Galart, 1994.

Schreyer, Lothar. *Erinnerungen an Sturm und Bauhaus. Was ist des Menschen Bild?* Munich: Langen/Müller, 1956.

Sers, Philippe. *Kandinsky. Philosophie de l'abstraction, l'image métaphysique*. Geneva: Skira, 1995.

———. *Kandinsky. Philosophie de l'art abstrait, peinture, poésie, scénographie*. Milan: Skira, 2003.

Seuphor, Michel, and Hans-Peter Rasp. *Ein halbes Jahrhundert abstrakte Malerei. Von Kandinsky bis zur Gegenwart*. Munich: Droemer; Zurich: Knaur, 1962.

Sihare, Laxmi Prasad. "Oriental Influences on Wassily Kandinsky and Piet Mondrian. 1909–1917." Ph.D. diss., New York University, 1967. Ann Arbor, Mich.: UMI Research Press, 1970.

Sinn, Anneliese. "Kandinsky's Theory of Inner Necessity." Ph.D. diss., University of Chicago, 1966.

Smolik, Noemi. *Ikonen der Moderne? Zur Entstehung des abstrakten Bildes bei Kandinsky und Malewitsch*. Stuttgart, Germany: Hatje, 1999.

Thürlemann, Felix. *Kandinsky über Kandinsky. Der Künstler als Interpret eigener Werke*. Bern: Benteli, 1986.

Tower, Beeke Sell. *Klee and Kandinsky in Munich and at the Bauhaus*. Ann Arbor, Mich.: UMI Research Press, 1981.

Vergo, Peter. *The Blue Rider*. Oxford, England: Phaidon Press, 1977.

———. *Kandinsky Cossacks*. London: Tate Gallery, 1986.

Versari, Maria Elena. *Wassily Kandinsky e l'astratismo*. Milan: Il Sole 24 ore; Florence: Education.it, 2007.

Vezin, Annette, and Luc Vezin. *Kandinsky et le cavalier bleu*. Paris: Pierre Terrail, 1991.

Volboudt, Pierre. *Les dessins de Kandinsky*. Paris: Galerie Claude Bernard, 1963.

———. *Kandinsky: 1896–1921. Kandinsky: 1922–1944*. London: Methuen; Paris: F. Hazan, 1963.

Washton Long, Rose-Carol. *Kandinsky: The Development of an Abstract Style*. Oxford: Clarendon Press; New York: Oxford University Press, 1980.

Weiss, Peg. *Kandinsky and Old Russia: The Artist as Ethnographer and Shaman*. New Haven: Yale University Press, 1995.

———. *Kandinsky in Munich: The Formative Jugendstil Years*. Princeton, N.J.: Princeton University Press, 1979.

Whitford, Frank. *Kandinsky*. London: Hamlyn, 1967.

Zehder, Hugo. *Wassily Kandinsky. Unter autorisierter Benutzung der russischen Selbstbiographie*. Dresden: R. Kaemmerer Verlag, 1920.

Zimmermann, Reinhard. *Die Kunsttheorie von Wassily Kandinsky*. 2 vols. Berlin: Gebr. Mann, 2002.

Collection and Exhibition Catalogues

(in chronological order)

Rebay, Hilla, ed. *In Memory of Wassily Kandinsky: The Solomon R. Guggenheim Foundation Presents a Survey of the Artist's Paintings and Writings*. Exh. cat. New York: Museum of Non-Objective Painting, 1945.

Der Blaue Reiter und die Kunst des 20. Jahrhunderts 1908–1914. Exh. cat. Munich: Haus der Kunst, 1949.

Kandinsky und Gabriele Münter. Werke aus fünf Jahrzehnten. Exh. cat. Munich: Städtische Galerie im Lenbachhaus, 1957.

Kandinsky: The Road to Abstraction. Exh. cat. London: Marlborough Fine Art Ltd., 1961.

Vasily Kandinsky, 1866–1944: A Retrospective Exhibition. Exh. cat. New York: Solomon R. Guggenheim Foundation, 1963.

Vasily Kandinsky: Painting on Glass (Hinterglasmalerei), Anniversary Exhibition. Exh. cat. New York: Solomon R. Guggenheim Foundation, 1966.

Kandinsky and His Friends: Centenary Exhibition. Exh. cat. London: Marlborough Fine Art Ltd., 1968.

Hommage de Paris à Kandinsky. La conquête de l'abstraction l'époque parisienne. Exh. cat. Paris: Museé d'art moderne de la ville de Paris, 1972.

Kandinsky. Exh. cat. Zurich: Galerie Maeght, 1972.

Kandinsky. Aquarelle und Zeichnungen. Exh. cat. Basel: Galerie Beyeler, 1972.

Gollek, Rosel. *Der Blaue Reiter im Lenbachhaus München. Katalog der Sammlung in der Städtischen Galerie*. Munich: Prestel, 1974. Extended edition, 1988.

Hanfstaengl, Erika. *Wassily Kandinsky. Zeichnungen und Aquarelle. Katalog der Sammlung in der Städtischen Galerie im Lenbachhaus München*. Munich: Prestel, 1974.

Rudenstine, Angelica Zander. *The Guggenheim Museum Collection: Paintings 1880–1945*. 2 vols. New York: Solomon R. Guggenheim Foundation, 1976.

Wassily Kandinsky à Munich. Collection Städtische Galerie im Lenbachhaus. Städtische Galerie, Munich, and Galerie des beaux-arts, Bordeaux, France. Exh. cat. Munich: Prestel; Bordeaux: Galerie des beaux-arts, 1976.

Messer, Thomas M., ed., *Wassily Kandinsky, 1866–1944*. Exh. cat. Munich: Haus der Kunst, 1976/77.

Derouet, Christian, ed. *Kandinsky. Trente peintures des musées soviétiques*. Exh. cat. Paris: Musée national d'art moderne, Centre Pompidou, 1979.

Droste, Magdalena, ed. *Klee und Kandinsky. Erinnerung an eine Künstlerfreundschaft anlässlich Klees 100. Geburtstag*. Exh. cat. Stuttgart, Germany: Staatsgalerie, 1979.

Kandinsky Watercolors: A Selection from the Solomon R. Guggenheim Museum and the Hilla von Rebay Foundation. New York: Solomon R. Guggenheim Foundation, 1980.

Terenzi, Claudia, ed. *Wassili Kandinski. 43 opere dai Musei Sovietici*. Musei Capitolini, Rome; Museo Correr Sala Napoleonica, Venice. Exh. cat. Milan: Silvana Editoriale, 1980.

Weiss, Peg, ed., *Kandinsky in Munich, 1896–1914*. Exh. cat. New York: Solomon R. Guggenheim Foundation; San Francisco: San Francisco Museum of Modern Art, 1982.

Barnett, Vivian Endicott. *Kandinsky at the Guggenheim*. New York: Solomon R. Guggenheim Foundation, 1983.

Poling, Clark V. *Kandinsky: Russian and Bauhaus Years, 1915–1933*. Exh. cat. New York: Solomon R. Guggenheim Foundation, 1983.

Derouet, Christian, and Jessica Boissel. *Kandinsky. Oeuvres de Vassily Kandinsky, 1866–1944*. Paris: Musée national d'art moderne, Centre Pompidou, 1984.

Hahn, Peter, ed. *Kandinsky. Russische Zeit und Bauhausjahre, 1915–1933*. Berlin: Bauhaus-Archiv, Museum für Gestaltung, 1984.

Kandinsky. Album de l'exposition. Exh. cat. Paris: Musée national d'art moderne, Centre Pompidou, 1984.

Vassily Kandinsky. Collection Les Grandes Expositions 5. Exh. cat. Paris: Musée national d'art moderne, Centre Pompidou, 1984.

Kandinsky in Paris, 1934–1944. Exh. cat. New York: Solomon R. Guggenheim Foundation, 1985.

Tuchman, Maurice, et al. *The Spiritual in Art: Abstract Painting 1890–1985*. Los Angeles County Museum of Art; Museum of Contemporary Art, Chicago; Haags Gemeentemuseum, Netherlands. Exh. cat. New York: Abbeville Press, 1986.

Wassily Kandinsky (1866–1944). National Museum of Modern Art, Tokyo; National Museum of Modern Art, Kyoto. Exh. cat. Tokyo: Nihon Keizai Shinbunsha, 1987.

Barnett, Vivian Endicott, ed., *Kandinsky and Sweden.* Exh. cat. Malmö, Sweden: Konsthall; Stockholm: Moderna Museet, 1989.

Kandinsky. Die erste sowjetische Retrospektive. Gemälde, Zeichnungen und Graphik aus sowjetischen und westlichen Museen. Exh. cat. Frankfurt: Schirn Kunsthalle; Moscow: State Tretyakov Gallery; St. Petersburg: State Russian Museum, 1989.

Zweite, Armin, ed. *The Blue Rider in the Lenbachhaus Munich: Masterpieces by Franz Marc, Vassily Kandinsky, Gabriele Münter. Alexei Jawlensky, August Macke, Paul Klee.* Translated by John Ormrod. Munich: Prestel, 1989.

Watercolors by Kandinsky: A Selection from the Solomon R. Guggenheim Museum and the Hilla von Rebay Foundation. New York: Solomon R. Guggenheim Foundation, 1991.

Barnett, Vivian Endicott, and Armin Zweite, eds. *Kandinsky. Kleine Freuden, Aquarelle und Zeichnungen.* Exh. cat. Düsseldorf: Kunstsammlung Nordrhein-Westfalen; Stuttgart, Germany: Staatsgalerie; Munich: Prestel, 1992.

Levin, Gail, and Marianne Lorenz, eds. *Theme and Improvisation: Kandinsky and the American Avant-Garde, 1912–1950.* Dayton Art Institute, Ohio. Exh. cat. Boston: Little Brown, 1992.

Misler, Nicoletta, ed. *Wassily Kandinsky tra Oriente e Occidente. Capolavori dei musei russi.* Palazzo Strozzi, Florence. Exh. cat. Florence: Artificio, 1993.

Petrova, Evgenia, and Jochen Poetter, eds. *Russische Avantgarde und Volkskunst.* Exh. cat. Baden-Baden, Germany: Staatliche Kunsthalle; St. Petersburg: State Russian Museum; Stuttgart, Germany: Verlag Gerd Hatje, 1993.

Vasilij Kandinskij. Galleria d'arte moderna e contemporanea, Verona, Italy. Exh. cat. Verona: Palazzo Forti; Milan: Mazzotta, 1993.

Kandinsky, Mondrian. Dos caminos hacia la abstracción. Exh. cat. Barcelona: Fundación "La Caixa," 1994.

Moeller, Magdalena M., ed. *Der frühe Kandinsky 1900–1910.* Brücke-Museum, Berlin; Kunsthalle Tübingen, Germany. Munich: Hirmer, 1994.

Barnett, Vivian Endicott, and Helmut Friedel, eds. *Vasily Kandinsky: A Colorful Life, The Collection of the Lenbachhaus, Munich.* Exh. cat. Cologne: DuMont, 1995.

Dabrowski, Magdalena, ed. *Kandinsky. Compositions.* Exh. cat. New York: Museum of Modern Art, 1995.

Kahn-Rossi, Manuela, ed. *Kandinsky nelle collezioni svizzere/in den Schweizer Sammlungen/dans les collections suisses.* Lugano, Switzerland: Museo cantonale d'arte; Milan: Skira, 1995.

Barnett, Vivian Endicott, and Josef Helfenstein, eds. *The Blue Four: Feininger, Jawlensky, Kandinsky and Klee in the New World.* Kunstmuseum Bern; Kunstsammlung Nordrhein-Westfalen, Düsseldorf. Exh. cat. Cologne: DuMont, 1998.

Farben-Klänge. Wassily Kandinsky, Bilder 1908 bis 1914. Arnold Schönberg, Konzerte und Dokumentation. Exh. cat. Riehen/Basel: Fondation Beyeler, 1998.

Janssen, Hans, ed. *Kandinsky rond 1913. De wensdroom van een nieuwe kunst.* Exh. cat. Zwolle, Netherlands: Waanders; The Hague, Netherlands: Haags Gemeentemuseum, 1998.

Schneede, Uwe M., ed. *Chagall, Kandinsky, Malewitsch und die russische Avantgarde.* Hamburger Kunsthalle, Hamburg; Kunsthaus Zurich. Exh. cat. Ostfildern-Ruit, Germany: Hatje Cantz, 1998.

Kandinsky, Chagall, Malevich e lo spiritualismo russo dalle collezioni del Museo Statale Russo 'di San Pietroburgo. Palazzo Forti, Verona. Exh. cat. Milan: Electa, 1999

Kandinsky. Hauptwerke aus dem Centre Georges Pompidou Paris. Kunsthalle Tübingen, Germany. Exh. cat. Cologne: DuMont, 1999.

Whitford, Frank, ed. *Kandinsky: Watercolours and other Works on Paper.* Royal Academy of Arts, London. Exh. cat. New York: Thames and Hudson, 1999.

Friedel, Helmut, and Annegret Hoberg, *The Blue Rider in the Lenbachhaus, Munich.* Translated by John Ormrod, Almuth Seebohm, and Ishbel Flett. New York: Prestel, 2000.

Meyer, Christian, ed., *Schönberg–Kandinsky. Blaue Reiter und die Russische Avantgarde. Die Kunst gehört dem Unbewußten.* Exh. cat. Vienna: Arnold Schönberg Center, 2000.

Romachkova, Lidia I., ed. *Kandinsky et la Russie.* Exh. cat. Martigny, Switzerland: Fondation Pierre Gianadda, 2000.

Wassily Kandinsky. Tra Monaco e Mosca. 1896–1921. Complesso del Vittoriano, Rome. Exh. cat. Milan: Mazzotta, 2000.

Kandinsky, Retour en Russie, 1914–1921. Musée d'art moderne et contemporain, Strasbourg, France. Exh. cat. Paris: Hazan; Strasbourg, France: Musées de Strasbourg, 2001.

Vassily Kandinsky. Rétrospective. Exh. cat. Saint-Paul, France: Fondation Maeght, 2001.

Wassily Kandinsky. Tradizione e astrazione in Russia 1896–1921. Exh. cat. Milan: Fondazione Antonio Mazzotta, 2001.

Barnett, Vivian Endicott. *The Blue Four Collection at the Norton Simon Museum.* New Haven: Yale University Press in association with the Norton Simon Art Foundation, 2002.

Arnaldo, Javier, ed. *Analogias Musicales. Kandinsky y sus contemporáneos.* Exh. cat. Madrid: Museo Thyssen-Bornemisza, 2003.

Kandinsky: The Dissolution of Form, 1900–1920. Barcelona: Fundació Caixa Catalunya, 2003.

Meyer, Esther da Costa, ed. *Schoenberg, Kandinsky, and the Blue Rider.* Exh. cat. New York: Jewish Museum; London: Scala, 2003.

Benesch, Evelyn. *Wassily Kandinsky. Der Klang der Farbe, 1900–1921.* BA-CA Kunstforum, Vienna; Von-der-Heydt-Museum, Wuppertal, Germany. Exh. cat. Bad Breisig, Germany: Palace Ed. Europe, 2004.

Kandinsky e l'anima russa. Galleria d'Arte Moderna, Palazzo Forti, Verona, Italy. Exh. cat. Venice: Marsilio, 2004.

Wagner, Christoph, ed. *Johannes Itten, Wassily Kandinsky, Paul Klee: Das Bauhaus und die Esoterik.* Gustav-Lübcke-Museum, Hamm, Germany; Museum im Kulturspeicher, Würzburg, Germany. Exh. cat. Bielefeld, Germany: Kerber, 2005.

Berswordt-Wallrabe, Kornelia von, ed. *Von Kandinsky bis Tatlin. Konstruktivismus in Europa/From Kandinsky to Tatlin, Constructivism in Europe.* Staatliches Museum Schwerin, Germany; Kunstmuseum Bonn. Exh. cat. Schwerin, Germany: Staatliches Museum, 2006.

Derouet, Christian. *Cahiers d'Art. Musée Zervos à Vézelay.* Paris: Editions Hazan; Perrigny, France: Conseil Général de l'Yonne, 2006.

Fischer, Hartwig, and Sean Rainbird, eds. *Kandinsky: The Path to Abstraction.* Exh. cat. London: Tate, 2006.

Haldemann, Matthias, ed. *Harmonie und Dissonanz. Gerstl, Schönberg, Kandinsky. Malerei und Musik im Aufbruch.* Zug, Switzerland: Kunsthaus Zug; Ostfildern, Germany: Hatje Cantz, 2006.

Tupitsyn, Margarita, ed. *Gegen Kandinsky/Against Kandinsky.* Museum Villa Stuck, Munich. Exh. cat. Ostfildern, Germany: Hatje Cantz, 2006.

Caramel, Luciano, ed. *Kandinsky e l'astrattismo in Italia 1930–1950.* Palazzo Reale, Milan. Exh. cat. Milan: Mazzotta, 2007.

PHOTO CREDITS AND COPYRIGHT NOTICES

Arp, Moholy: © 2009 Artists Rights Society (ARS), New York/VG Bild-Kunst, Bonn; Calder: © 2009 Calder Foundation, New York/ Artists Rights Society (ARS), New York; Kandinsky, Léger: © 2009 Artists Rights Society (ARS), New York/ADAGP, Paris; Miró: © 2009 Successió Miró/Artists Rights Society (ARS), New York/ADAGP, Paris

BY PLATE NUMBER

Plates 1, 2, 6, 10, 16, 18, 20, 21, 22, 23, 24, 28, 29, 37, 44, 54: Städtische Galerie im Lenbachhaus, Munich; 3, 15, 27: Collection Centre Pompidou, Paris, diffusion RMN. Photo: Bertrand Prévost; 4, 5, 12, 14, 32, 34, 35, 36, 38, 39, 51, 55, 56, 58, 59, 60, 62, 63, 64, 65, 67, 69, 71, 74, 75, 78, 80, 83, 84, 87, 91, 92: The Solomon R. Guggenheim Foundation, New York; 7, 41, 66: Collection Centre Pompidou, Paris, diffusion RMN. Photo: Adam Rzepka; 8: State Art Museum, Nizhny Novgorod, Russia; 9, 45 a–d: Digital Image © The Museum of Modern Art/Licensed by SCALA/Art Resource, NY; 11, 47, 48, 49, 81: The State Tretyakov Gallery, Moscow; 13: Staatsgalerie Stuttgart, Germany; 17, 53: Georgian National Museum, Tbilisi; 19: Museum Boijmans Van Beuningen, Rotterdam, Netherlands; 25: © The State Pushkin Museum of Fine Arts, Moscow; 30: Image © The Metropolitan Museum of Art; 31, 70, 86, 90: Collection Centre Pompidou, Paris, diffusion RMN. Photo: Philippe Migeat; 33: Image courtesy of the Board of Trustees, National Gallery of Art, Washington, D.C.; 40: Philadelphia Museum of Art; 42: Kunstmuseum und Museum für Gegenwartskunst, Basel. Photo: Martin P. Bühler; 43: Fondation Beyeler, Riehen/Basel. Photo: Robert Bayer, Basel; 46: Collection Centre Pompidou, Paris, diffusion RMN. Photo: Jacques Faujour; 50: Centre Pompidou, Bibliothèque Kandinsky, Paris; 52: Rheinisches Bildarchiv, Cologne; 57: Yale University Art Gallery, New Haven; 61: Collection Centre Pompidou, Paris, diffusion RMN. Photo: Gérard Blot; 68, 72, 73, 82: Collection Centre Pompidou, Paris, diffusion RMN. Photo: DR; 76: Stedelijk Museum, Amsterdam; 79: The Phillips Collection, Washington, D.C.; 85: Moderna Museet, Stockholm; 88, 94: Helly Nahmad Gallery, New York; 89: Gabriele Münter- und Johannes Eichner-Stiftung, Munich; 93: Collection Centre Pompidou, Paris, diffusion RMN. Photo: Georges Meguerditchian; 95: Theobald Jennings, London

BY FIGURE NUMBER

Figures 1, 6, 10, 14, 15, 20, 21, 23, 24, 25, 30, 32, 54, 59, 60, 61, 65, 67, 78, 79, 80: Bibliothèque Kandinsky, Centre Pompidou, Paris. Photo: Centre Pompidou, Bibliothèque Kandinsky, Paris; 2, 5, 7, 11, 35, 36: Städtische Galerie im Lenbachhaus, Munich; 3, 40: The State Russian Museum, St. Petersburg; 4: Miyagi Museum of Art, Sendai; 8, 9: Gabriele Münter- und Johannes Eichner-Stiftung, Munich; 12, 51: The State Tretyakov Gallery, Moscow; 13: © The State Pushkin Museum of Fine Arts, Moscow; 33: Bibliothèque Kandinsky, Centre Pompidou, Paris. Photo courtesy Centre Pompidou, Bibliothèque Kandinsky, Paris. © Lipnitzki/Roger Violett/Getty Images; 37: Stedelijk Museum, Amsterdam; 39: State Hermitage Museum, St. Petersburg; 42: Museum Boijmans Van Beuningen, Rotterdam, Netherlands; 44: Kunstmuseum Bern; 45, 76, 84, 87, 93, 101, 105: The Solomon R. Guggenheim Foundation, New York; 46: Kunsthaus Zurich; 50: Neue Galerie, New York; 52: Bibliothèque nationale de France, Paris; 55: Collection Centre Pompidou, Paris, diffusion RMN. Photo: DR; 57, 58, 62, 63, 64, 70, 75: Collection Yves de Fontbrune, galerie Cahiers d'Art, Paris; 66, 69, 72, 73, 74: Fonds Kandinsky, Bibliothèque Kandinsky, Centre Pompidou, Paris. Photo: Centre Pompidou, Bibliothèque Kandinsky, Paris; 68: Musée Zervos, Vézelay, France; 81: Hilla von Rebay Foundation Archive, M0007, Solomon R. Guggenheim Museum Archives, New York; 82: Archiv der Galerie Nierendorf, Berlin; 83: Exhibition files, A0003, Solomon R. Guggenheim Museum Archives, New York; 85, 86, 89, 91, 94, 95, 96, 97, 98, 99, 100, 102, 103, 104, 106, 107: Conservation Department, Solomon R. Guggenheim Museum, New York; 88: Courtesy Dr. L. Robinson, Opus Instruments Ltd., © Dr. Laurence Robinson; 90, 92: Infrared images taken with short-wave infrared (SWIR) area cameras supplied by Sensors Unlimited, Inc., a part of Goodrich Corporation

BY PAGE NUMBER

Frontispiece, 304: Bibliothèque Kandinsky, Centre Pompidou, Paris. Photo courtesy Centre Pompidou, Bibliothèque Kandinsky, Paris. © Lipnitzki/Roger Violett/Getty Images; 134–35: Pavilion of Asiatic Russia at the Trocadéro, World's Fair, Paris, 1900. Bibliothèque Kandinsky, Centre Pompidou, Paris. Photo: Centre Pompidou, Bibliothèque Kandinsky, Paris; 140–41: Entrance to the arts pavilion at a festival, Munich, October 1903. Bibliothèque Kandinsky, Centre Pompidou, Paris. Photo: Centre Pompidou, Bibliothèque Kandinsky, Paris; 204–5: Zubovsky Square, Moscow. Bibliothèque Kandinsky, Centre Pompidou, Paris. Photo: Centre Pompidou, Bibliothèque Kandinsky, Paris; 224–25: The Bauhaus school during construction, Dessau, Germany, 1926. Bibliothèque Kandinsky, Centre Pompidou, Paris. Photo: Centre Pompidou, Bibliothèque Kandinsky, Paris; 250–51: The German and Russian pavilions at the World's Fair, Paris, 1937. Bibliothèque Kandinsky, Centre Pompidou, Paris. Photo: Centre Pompidou, Bibliothèque Kandinsky, Paris; 286 left, right center, and right, 287 left and right center, 294 (all), 296–301 (all), 303, 306–7 (all): Bibliothèque Kandinsky, Centre Pompidou, Paris. Photo: Centre Pompidou, Bibliothèque Kandinsky, Paris; 286 left center, 287 left center and right, 288–92 (all): Gabriele Münter- und Johannes Eichner-Stiftung, Munich; 295: Fonds Kandinsky, Bibliothèque Kandinsky, Paris, AM 1981-65-682. Photo: Centre Pompidou, Bibliothèque Kandinsky, Paris; 302: AP Images